Literary Admirers of
ALFRED STIEGLITZ

F. Richard Thomas

SOUTHERN ILLINOIS UNIVERSITY PRESS
Carbondale and Edwardsville

11/1983
am. Lit.

Printed in the United States of America
Edited by *Dan Seiters*
Designed by *Design for Publishing*, *Bob Nance*
Production supervised by *John DeBacher*

LIBRARY OF CONGRESS CATALOGING IN PUBLICATION DATA

Thomas, F. Richard.
 Literary admirers of Alfred Stieglitz.

 Bibliography: p.
 Includes index.
 1. American literature—20th century—History and criticism. 2. Photography in literature. 3. Stieglitz, Alfred, 1864–1946—Influence. 4. Stein, Gertrude, 1874–1946—Criticism and interpretation. 5. Williams, William Carlos, 1883–1963—Criticism and interpretation. 6. Crane, Hart, 1899–1932—Criticism and interpretation. 7. Anderson, Sherwood, 1876–1941—Criticism and interpretation. I. Title.
 PS228.P48T5 1983 810'.9'0052 82-10543
 ISBN 0-8093-1097-X
 83 84 85 86 4 3 2 1

Excerpts used in the text are quoted with permission from:
 The book *Winesburg, Ohio* by Sherwood Anderson Copyright © 1961 by Viking Penguin Inc.
 The book *A Story Teller's Story* by Sherwood Anderson, Ed. Ray Lewis White, 1924, by the Sherwood Anderson Estate. Copyright © 1968 by The Press of Case Western Reserve University.
 The book *The Complete Poems and Selected Letters and Prose of Hart Crane*, Edited by Brom Weber, Copyright 1933, © 1958, 1966 by Liveright Publishing Corporation. World rights granted by Laurence Pollinger, Ltd.
 The poem "Lines Sent to Alfred Stieglitz, July 4, 1923" by Hart Crane by the Hart Crane Estate, David Mann, Literary Executor.
 The book *Gertrude Stein and the Present* by Allegra Stewart Copyright © 1967 by Harvard University Press.
 The book *Portraits and Prayers* by Gertrude Stein, 1934, by the Estate of Gertrude Stein.
 The book *Selected Writings* by Gertrude Stein 1945, © 1972 Random House, Inc., Edited by Carl Van Vechten.
 The chapter "When a Man Goes Down" from *Autobiography* by William Carlos Williams Copyright 1951 by New Directions.
 The poem "Bird" from *Pictures from Brueghel and Other Poems* by William Carlos Williams Copyright © 1962 by New Directions.
 The poems "The Locust Tree in Flower," "The Red Wheelbarrow," "Between Walls," and "The Attic Which Is Desire" from *The Collected Earlier Poems* by William Carlos Williams Copyright 1938 by New Directions.
 The poem "The Yellow Chimney" from *The Collected Later Poems* by William Carlos Williams Copyright 1944 by William Carlos Williams. Published by New Directions.
 An earlier version of the chapter on Hart Crane appears as "Hart Crane, Alfred Stieglitz, and Camera Photography," *Centennial Review*, 21 (Summer 1977), 294–310.
 Portions of this book were previously published as an article, "Photography and Literature: An Introduction to Stieglitz and His Literary Admirers," *Journal of American Culture*, 4 (Spring 1981), 144–48.

for John Mills
artist, scientist, seeker of quality

Contents

List of
Illustrations
(following page 32)

Preface

This book investigates the impact of photography on modern literature. Specifically, the book proposes that Alfred Stieglitz, the most influential practitioner of the art of traditional photography in his time, had a profound impact on the aesthetics, the styles, and the Weltanschauungs of four of his literary friends and admirers: Gertrude Stein, William Carlos Williams, Hart Crane, and Sherwood Anderson.

Written for students and scholars of literature, history, and American studies who have little or casual familiarity with the medium of camera photography,* the first chapter introduces and provides some of the basic vocabulary needed to study the relationships between literature and photography. While persons

*I use the phrase "camera photography" purposely. Much photography is and has been done without a camera. See, for example, some of the cameraless photographs of Man Ray and Henry Holmes Smith. This book deals exclusively with camera photography.

See also Susan Sontag's *On Photography* (1977) for a clear demonstration of the effect of photography on our way of seeing.

trained in the visual arts will perhaps find some of the points made here all too obvious, this rudimentary investigation of Stieglitz and photography is necessary to an understanding of the enormous impact photography has had on our ways of seeing, thinking, and, therefore, writing.

Although this study is confined to a certain historical period (c. 1900–1940), I hope that the implications of the thesis transcend the period, for the visual revolution that began with the advent of photography is now a constant, unrelenting aspect of our lives: we are bombarded daily with artificial visual works through books, magazines, TV, films, photo albums, and slides projected on the living room wall. The photographic technology that caused excitement in Stieglitz's time by allowing an image to be stopped for close observation, can now similarly stir us by offering stunning photographs, via the scanning electron microscope, of the texture of the surface of a cell magnified 200,000 times, or relay to us the texture of the surface of one of Saturn's moons from 900 million miles.

As observers and critics of literature and culture, we, along with our colleagues in the visual arts, are obliged to make sense of this technological and artistic revolution in which we are necessarily participating. To do this requires standing outside of the subject for a time, just as one might purposely avoid getting involved in a film at the theater in order to study the artist's method and the use of film technology. To familiarize oneself with some of the characteristics and terminology of this revolution, Alfred Stieglitz provides a good starting point. His life and work centered around photography, and he played a significant role in the visual enlightenment of four of our major American writers: Stein, Williams, Crane, and Anderson.

Acknowledgments

Of the many people who gave their support during the writing of this book, the following deserve special mention: Bruce Curtis, Philip Korth, Donald Kummings, Larry Landrum, Nancy Milford, Douglas Noverr, Dan Seiters, Henry Silverman, Caerllion Thomas, Lydia K. Thomas, Severn Thomas, and Linda Wagner.

The writers, photographers, artists, and scholars who provided technical assistance at various stages of writing, but who have no responsibility for the shortcomings of the book, include David D. Anderson, Peter C. Bunnell, Charles Eckert, Juan Hamilton, Charles Higgins, Justin Kestenbaum, Frank Kolodny, Dorothy Norman, Russel B. Nye, Georgia O'Keeffe, Roger Pfingston, David E. Smith, Henry H. Smith, and Samuel Yellen.

I also thank the Department of American Thought and Language at Michigan State University, which helped with the purchase of photography and permission fees; and the MacDowell Colony in Peterborough, New Hampshire, which provided the time and supportive friends to help me rethink the original manuscript.

Finally, the realization of the original idea in book form is especially rewarding to me because it reflects the shared time of many good discussions with my friend and partner, Sharon K. Thomas.

F. RICHARD THOMAS

East Lansing, Michigan
June 1982

Literary Admirers of
**ALFRED
STIEGLITZ**

Photography and
Alfred Stieglitz
(1864–1946)

M ore than a quarter of a century after his death, Alfred
Stieglitz (Plate 1) is once again becoming a prominent, al-
most popular, figure. Some of this recognition results from the
fact that almost every family in the United States has the where-
withal, and perhaps even the social obligation, to own and use a
photographic camera. But the reawakening of interest in Stieglitz
can also be attributed to the growing popularity of Georgia O'Keeffe
(Stieglitz was her husband), and the untiring efforts of Dorothy
Norman, a fine photographer herself, as well as a writer. (See
Plate 2.)

Since Norman's *Alfred Stieglitz: An American Seer* (1973), William
Innes Homer's *Alfred Stieglitz and the American Avant-Garde* (1977),
Weston J. Naef's *The Collection of Alfred Stieglitz* (1978), and Bram
Dijkstra's *The Hieroglyphics of a New Speech: Cubism, Stieglitz, and
the Early Poetry of William Carlos Williams* (1969)—to mention only
four recent major works—it is virtually redundant to reiterate
either Stieglitz's technical accomplishments or his propagandiz-

ing for photography. That he was hated as well as adored is well known. But even among those who could not tolerate Stieglitz, few would deny his indefatigable efforts: as propagandist for the Photo-Secessionists; as publisher of magazines of Modern Art and photography (like the incomparable *Camera Work*); as an organizer for the Albright Museum of the International Exhibition of Pictorial Photography in 1910; and as director of his galleries (291, for example, in which he introduced virtually every major European and American Modern Artist and photographer to the American public). These efforts at the turn of the century placed him at the center of the Modern Art movement, as well as the concurrent movement to have traditional photography recognized as a fine art.

The purpose of this book, however, is not to draw more well-deserved attention to Stieglitz, but to focus attention on his medium, camera photography, and the relationship of that medium to literature—especially the writings of Gertrude Stein, William Carlos Williams, Hart Crane, and Sherwood Anderson.

Those of us who enjoyed "The Man from U.N.C.L.E." when it first flashed onto our TV screens and into our minds were startled by the quick scene shifts, discontinuities in time, and fast pace. Now, years later, when films sometimes seem little more than showcases for the latest in special visual effects, we have become sophisticated viewers, accustomed to visual innovations. Today when we re-view "The Man from U.N.C.L.E." we find it dull, slow, predictable. Just as our brains can right the view from a pair of upside-down glasses within a few days, so can our brains learn to see and understand the novel visions, sights, and images that are placed before us; and our perceptions change every time we are confronted with novel phenomena.

We all have first-hand familiarity with the ways in which cinema and television have dramatically altered our way of seeing. There is no question that camera photography has also had an effect. On the most general level this book on Stieglitz and his literary admirers speaks to that effect by suggesting answers to

the question, "How has photography altered perception?" Specifically, I have chosen four writers who overtly acknowledged their debt to Stieglitz and to the medium of photography that he represents, in order to show how the medium influenced their aesthetics and Weltanschauungen.

Characteristics of Camera Photography

To understand the influence of Stieglitz's photographic aesthetic and Weltanschauung on his admirers, one must understand the medium with which he had to work, and the characteristics inherent in that medium. Photographers and students of photography might want to skim the following brief, elementary discussion of the characteristics of the medium. Readers unfamiliar with the field of photography will find this discussion of terminology and the types of photographs to which they apply essential for the understanding of the examples and the thesis.

A Reportorial Medium

Nineteenth-century writers recognized that a special characteristic of the photographic camera was its ability to capture and record reality. As Hawthorne's photographer, Holgrave, remarks in *The House of the Seven Gables*, "There is, at least, no flattery in my humble line of art."[1] Oliver Wendell Holmes was also fascinated by the camera's ability to capture and record the immediate and actual: "attitudes, dresses, features, hands, feet, betray the social grade of the candidates for portraiture. The picture tells no lie about them." As a member of the Photographic Exchange Club he exchanged photographs with other members of the club: the "artist sends his own presentment," says Holmes, "not in the stiff shape of a purchased *carte de visite*, but as seen in his own study or parlor, surrounded by domestic accidents which so add to the individuality of the student or artist."[2]

Camera photography is first of all a reportorial medium. One

need only aim a camera, and that which appears in fact has
remarkable resemblance to that which will appear on the photo-
graphic print. The camera virtually records what is "out there"
—the immediate and actual. The photographer cannot manipu-
late what is "out there" in the way that the painter can. As John
Szarkowski, director of photography at the Museum of Modern
Art, pointed out, "The invention of photography provided a
radically new picture-making process—a process based not on
synthesis but on selection."[3] One points the camera at something
and clicks the shutter. The resultant photograph closely resem-
bles the real thing; it "evokes," said Szarkowski, "the tangible
presence of reality."[4]

Turn-of-the-century reactions to photography as an art form
were vehemently negative. Because the photograph so closely
resembled reality, photography was considered by many people,
especially establishment painters and critics, to be a reportorial
medium exclusively. Even the early Photo-Secessionists—the group
of photographers headed by Stieglitz who were committed to
having the artistic merit of their work recognized—deliberately
used soft-focus lenses, or darkroom tricks (including brushing or
penciling the negative) to make their photographs look like paint-
ings. (See Steichen's "Self Portrait," Plate 3, and compare with
his "Sunday Papers," Plate 4.)

Certain Photo-Secessionists and others began to realize (c. 1907)
that if photography were to compete with painting as an expres-
sive form, its proponents would have to respect and emphasize
the characteristics, some of which were limitations, inherent in
the medium and not try to imitate the surface articulation of the
painter. Consequently, Stieglitz and his followers abandoned their
painterly posturing in favor of making only "straight" photographs.

A photograph by the straight or traditional photographer is for
the most part the same as the natural image that appears on the
ground glass at the time the photographer clicks the shutter. The
straight photographer accepts the factual world, and therefore

would not, like the painter, eliminate a mountain or a tree from a natural composition.

The most prominent characteristic of the medium—and the one that every major camera company advertises—is its reportorial ability. But the photograph does not merely relate the thing-itself seen; it does not merely repeat the immediate and actual. Other characteristics include: the ability of the camera-machine to stop time and motion; the necessary frame, that is different from the painter's; versatility with point of view; variable focus—including great depth of field; and the ability of the camera to capture details. (See plate 5 for illustrations of each of these characteristics.) The straight photographer explored these characteristics that ultimately defined the photographic aesthetic.*

The Captured Moment

One of the visual characteristics the camera has that the eye does not is its ability to capture a moment: a splash of water, a man in midair, a bird in flight, a gesture in the making. (See Plates 5b, 12, 14 and 20.) The eminent literary critic and contemporary of Stieglitz, Paul Rosenfeld, said, "Not a tool, save the camera, is capable of registering such complex ephemeral responses, and expressing the full majesty of the moment. No hand can express it, for the reason that the mind cannot retain the unmutated truth of a moment sufficiently long to permit the slow fingers to notate large masses of related detail."[5] Correspondingly, the camera can "extend" an instant of time; it can make the visual moment last as long as the photograph lasts. The photograph is, according to the popular phrase, "a mirror with a memory."

*In this discussion I introduce the limiting and liberating characteristics imposed by the use of the camera-machine only. I do not deal with qualities of light—texture, tonal value, and so forth—that also must be considered when one makes aesthetic distinctions between good and bad photographs.

Frame

Further, the photographer necessarily works with a frame—a frame that the eye does not have. While the frame might be considered a limitation, it can also create a balanced design, and as such becomes another of the characteristics that allows an infinite variety within any given scene. Rosenfeld, who saw Stieglitz's photographs before and after final framing, said that "the difference of a fraction of a centimeter in the position of the limiting mat can make or unmake certain of the designs."[6] The frame also forces relationships to exist between objects—relationships that would not have ordinarily existed. Suppose, for example, that the photographer isolates two people in a crowd entering a football stadium. A relationship between those two people, that may not have existed in reality, is created. In other words, by abstracting from nature with the frame, the photographer creates new thoughts and new ideas by creating new relationships. The difference between the painter's frame and the photographer's frame is that the painter *sets up* relationships and the photographer *finds* relationships in the world. Furthermore, the photographer imposes a frame on the subject whereas the painter builds within the frame.

Point of View

The photographer can also manipulate point of view with much greater facility than the painter because the camera provides great mobility and flexibility. The photographer, with a hand camera especially, can take pictures that the painter could not easily make. Painters would find themselves in contortionist postures, for example, if they were to set up their easels and paints and remain in position long enough to "transcribe" an oncoming train from the middle of a pair of railroad tracks five inches above the ground. Aerial painting would be virtually impossible. No wonder, since the advent of photography, so many painters have learned to use the camera as a tool in their own art.

by painting from photographs. (See Plates 6a and 6b to compare a Sheeler photograph with the resultant painting.)

Focus

The photographer can also focus selectively to emphasize visual qualities and relationships within a composition. We have all seen the use of variable focus in movies and TV ads. A dramatic illustration of the use of variable focus is seen by students of the traveling Nikon School of Photography. Here, in photographs by Fred Sisson, the student first views a beach scene of stunning natural beauty. The next photograph shows a mound of litter—from hamburger wrappers to broken bottles and beer cans. The third photograph reveals that both the first and the second photograph were actually taken from the same point of view and taken of the same natural scene. Sisson simply focused selectively with the first two shots, and in the third shot he chose a great depth of field to create the total relationship—in this case a relationship that makes a comment on the trashing of the environment.

Whereas the eye can also focus selectively, most of us have not learned to maintain the relationship that exists between what is focused and what is not focused. That the camera stops motion and time allows us to study indefinitely the quality of relationships between focused and nonfocused. Furthermore, it is virtually impossible for the human eye to see with great depth of field, as the simple experiment of focusing both on your finger and the house down the street will prove.

Details

Finally, the photographer can and does use detail that the painter cannot use. As Rosenfeld excitedly revealed, Stieglitz's photographs not only "conform . . . to the appearances of the actual world . . . [but also] with appearances hitherto unrecorded. . . . They bring the eye close to the human epidermis, to the pores, the fine hair on the shin bone, the veins of the wrist, the

moisture on the lips."[7] Few painters had expressed these details, partly because few had seen them. Not many people stand still long enough for an observer to focus intensely on details for extended periods of time. Through a photograph one can focus on these details indefinitely.

Rosenfeld's excitement over Stieglitz's photographs may seem excessive today, but the ability mechanically to reproduce easily and in great quantity photographs of the technical quality achieved by Stieglitz is only a recent development. Even in Stieglitz's and Rosenfeld's time (despite more than a half-century since Daguerre's perfection in 1839 of silver-plate images) the concern with the importance of detail, of the trivia of life, was blossoming. Indeed, a good part of the modern movement finds inspiration in those things that were, before photography, thought to be unworthy of artistic expression.

Furthermore, photography, because of its objective and representational capabilities to record detail and trivia, released painters from their predilection for representation and forced them to look within their minds, instead of without, for fresh and meaningful modes of expression. As Charles Sheeler, photographer and painter, said, "Photography is nature seen with the eyes outward, painting from the eyes inward,"[8] (See Plates 6a and 6b, which compare a Sheeler painting and a Sheeler photograph.) The photograph not only freed painters for nonrepresentational work, it showed them that trivial details could be aesthetically significant.

In fact, the very presence of the trivial detail forced the photographer into symbolic rather than narrative presentation. Unlike the painter who could fill the canvas with anything—real or not—the straight photographer had to work with what actually existed and could not create a story on paper as the painter could on canvas. Stieglitz, for example, had to select a shot in which all of the details contributed to his "theme." In short the photographer concentrated on finding the significant detail that would reveal emotional experience.

Equivalents

The photograph must, then, be studied for its subjective and symbolic content as well as its objective and literal content. Herbert Seligmann, the respected poet, critic, and contemporary of Stieglitz, recognized this fact after viewing an exhibition of Stieglitz's photographs: "The translation of experience through photography, the storing up of energy, feeling, memory, impulse, will, which could find release through subject matter later presenting itself to the photographer, were thus made evident [by the exhibition]. This should have ended for all time the silly and unthinking talk to the effect that the photographer was limited to a literal transcript of what was before him."[9] As Henry H. Smith suggested in an essay on the photographer Aaron Siskind, Stieglitz was the predecessor of the great modern photographers who were able to "place the . . . power of descriptive illusion (which had always been the chief public virtue of the photograph) at the service of allusion."[10] In his book *Adventures in the Arts* the American painter Marsden Hartley commented on Stieglitz's portraits; "I am willing to assert now that there are not portraits in existence in all the history of portrait realization either by the camera or in painting, which so definitely present, and in many instances with an almost haunting clairvoyance, the actualities existing in the sitter's mind and body and soul."[11] To understand how the photographer presents the objective actualities of the body is comparatively easy; but to see how the subjective "actualities" of the mind and soul are presented is more difficult.

The term that Stieglitz applied to the presentation of these subjective "actualities" is *equivalent*. "All my photographs," said Stieglitz, "are equivalents of my basic philosophy of life. All art is but a picture of certain basic relationships; an equivalent of the artist's most profound experience of life."[12] A series of his photographs titled *Equivalents* and subtitled *Songs of the Sky*, were described by Stieglitz in a catalogue as "tiny photographs, direct

revelations of man's world in the sky, documents of eternal rela-
tionship."[13] (See Plates 7and 8 for two examples.)

Paul Strand, a highly respected photographer and contempo-
rary of Stieglitz (see Plate 16 for a Strand photograph), elaborat-
ed on the definition of the equivalent: "What did Stieglitz mean
when he called his many photographs of sky, cloud forms, *Equiv-
alents*, not cloud pictures? He meant that in the abstract relations
of these shapes, tones, and lines, he was expressing equivalents
of human relationships and feelings. . . . They contain feelings of
grandeur, of conflict, of struggle and release, of ecstasy and de-
spair, life and the blotting out of life."[14] Thus a person seeing a
photograph could say, as Rosenfeld did, that the "clouds have the
released energy of hillsides dynamited," or, that a "head is a
mighty cannon ball."[15] Or one might react in the same way
Lewis Mumford did when he saw the Georgia O'Keeffe "por-
trait": "In a part by part revelation of a woman's body, in the
isolated presentation of a hand, a breast, a neck, a thigh, a leg,
Stieglitz achieved the exact visual equivalent of the report of the
hand or the face as it travels over the body of the beloved."[16] (See
Plates 9 and 10 for two examples from this portrait.) If one reacts
to the photographs as Rosenfeld and Mumford did, then one has
come in contact with the subjective, symbolic presentation that
Stieglitz attempted.

Explaining his intentions when he made the photograph enti-
tled "The Terminal" (Plate 11), Stieglitz said, "What made me
see the watering of the horses as I did was my loneliness."[17] He
found and reported a visual objective equivalent of the subjec-
tive, emotional experience of loneliness.

Stieglitz's cloud pictures may be his best rendering of the
subjective feelings through the presentation of the objective world.
He recognized this himself: "In looking at the photographs of
clouds, people seem to feel freed to think more about the actual
relationships in the pictures and less about the subject-matter as
such, so that what I have been trying to say through my photo-
graphs seems most clearly communicated in the series of *Songs of*

the Sky where the true meaning of the *Equivalents*, as I have called these photographs, (in reality all my photographs are *Equivalents*) comes through directly, without any extraneous or distracting pictorial or representational factors coming between the person and the picture."[18]

The "meaning" rendered by the *Equivalents* is dependent upon the real, the objective, the immediate and actual; but it is also dependent upon the photographer, who must "shoot" at the "decisive moment" (as Cartier-Bresson called it in his book by that title),[19] when the frame, point of view, focus, detail, and subject are in harmony. (See Plate 12 for a Cartier-Bresson example.) Knowing or finding this precise moment is the major subjective and artistic decision the straight photographer must make. The stories about Stieglitz waiting for hours in the worst weather for the exact moment are not exaggerated. The photograph of the truly committed photographer is a reflection of that moment in which the objective equivalent of emotional experience is found in the real world. "Photography," said Stieglitz, "brings what is not visible to the surface"[20]—through symbol,* one might add, as well as through the literal forcing of the observer's attention upon real detail.

Stieglitz's Photographic Philosophy

As pointed out in the introduction to this chapter, camera vision necessarily influences retinal vision, and therefore alters our perception of the world. The consequence of working with a camera is that one begins to think photographically: "I am the moment with all of me," said Stieglitz, "and anyone is free to be the moment with me. I want nothing from anyone. I have no

*A discussion of the photograph as "symbol" and the hazards of using this term appears in the W. C. Williams chapter.

theory about what the moment should bring. I am not attempting
to be in more than one place at a time. I am merely the moment
with all of me." And again: "When I am no longer thinking but
merely am, then I may be said to be truly living; to be truly
affirming life. Not to know, but to let exist what is, that alone,
perhaps, is truly to know."[21] Stein, Williams, and Anderson also
developed philosophies of the moment; but a photographer espe-
cially would be predisposed to develop a Weltanschauung out of
reacting to the moment. The very tool the photographer uses—
the camera—to create works of art is a machine, a special charac-
teristic of which is capturing the moment.

Stieglitz's reverence for the moment was noticeable in his ac-
tions. Seligmann wondered, for example, if the many people—
nonartists as well as artists—who brought their problems to
Stieglitz, "felt he was the only person in America, if not in the
world, who would receive them in a disinterested—a photo-
graphic—spirit, for very nearly exactly what they were. . . . It
was his spirit—photographic—that enabled [a] picture to live its
own life in relation to other works, that evoked from those with
whom he came in contact aspects of themselves of which they
had never become aware."[22]

Stieglitz's camera-philosophy included more, however, than
just reacting to the moment. "America," said Waldo Frank, nov-
elist, critic, and contemporary of Stieglitz, "is the land of the
Machine. In no other nation is the mechanical fact so close a part
of life and growth. . . . Perhaps therefore it is not accident, that
the powerful vision which is Stieglitz should first have found
itself through a machine."[23] Because Stieglitz used a machine to
produce beauty, he saw the potential of the machine for America—
where the machine was being used to make things faster, cheaper,
and of inferior quality. Stieglitz deplored the commercialization
and standardization that misuse of the machine was producing,
and he took it upon himself to show the world, and especially
America, that with proper use the machine was capable of thwarting
standardization and commercialization. Through his photographs

Stieglitz succeeded in showing Crane and Anderson that it could be used correctly.

Another aspect of Stieglitz's photographic philosophy was revealed in his fight for the quality worker. "This fight [for photography] includes everything in my life as far as I am concerned. A fight for my own life as well as a fight for the lives of all true workers, whether American or any other—with perhaps an emphasis on Americans because I believe they have needed it most, since the true worker in America has seemed to become rarer in the sense in which I use the term 'true worker.' . . . By that I mean the 'quality worker,' not in a theoretical but in a living sense."[24] Stieglitz was a "true worker," denounced by those artists and critics who believed photography was an inferior art and by those institutions—almost all of the major museums until after Stieglitz's International Exhibition of Pictorial Photography in 1910—that implicitly supported this attitude.

Stieglitz was, therefore, against institutions that supported a view of art contrary to his own observations about the meaning of art, which he discovered by working with the camera. "Institutionalism," he said, "is contrary to the spirit of art and the artist when there is no complete clarity about seeing through what is done in the name of art; in the same spirit in which the art is undertaken. No: rather that all the pictures and museums be burned if they are not used as instruments for the proper end and in the proper spirit. Art will always arise again, for the need for it is in man, but why perpetuate a dead thing that may interfere with, rather than help the living?"[25] Stieglitz believed the museums perpetuated a "dead thing" by recognizing representational paintings only, and by refusing to recognize photographers and modern artists.

Because he used the camera, which necessarily records the immediacy of the world-lived-in, Stieglitz believed that all art must be a manifestation of life, and relevant to the people in the world. True art was socially constructive. America could learn through art, which was nothing but the best work a person could

produce with the available tools. Ultimately, Stieglitz was a reformer. He said of America, "They had promised me something that I did not find, and all of my life has been spent in search of that thing, even to the point where I have had to create a world of my own, wherein the principles they preached to me, can actually be practised."[26] His use of the camera led him into "the struggle for true liberation of self and so of others."[27] Without freedom from standardization (which denied workers respect for their tools) people could not have the freedom to do their best work. Without the freedom to do their best work, art—as a symbol of life—could not exist. Without the possibility of art, workers were demeaned: they could not have the true freedom for which America stood. Stieglitz was not wholly reactionary. He knew and proved that the machine could be used as a tool to create quality work. But he also saw that the manufacturers were more interested in the machine's speed, efficiency, and cheapness than in its ability to produce quality work.

Stieglitz's photographic Weltanschauung is indeed an outgrowth of this aesthetic; and his aesthetic is an outgrowth of his use of a moment-capturing machine. As the living and renowned embodiment of camera photography during the first third of the twentieth century, Stieglitz had indirect as well as direct influence on many people. The words *Stieglitz* and *photography* were virtually synonymous. He stood for the medium of photography and all of the characteristics inherent in that medium. He stood for a new photographic way of seeing. As Gertrude Stein said, "There are some who are important to every one whether any one knows anything of that one or not and Stieglitz is such a one. . . ."[28]

Stieglitz, Imagism, and Modernism

Because Stieglitz, a photographer, an "image-maker," was at the center of the modern art movement in America, the question about his relationship to the Modernist movement in American

poetry, and the Imagism that helped initiate it, is naturally raised. Imagism (which is said to have begun in 1909 with T. E. Hulme's Poet's Club) had ancient roots in *haiku, tanka*, and Greek and Roman poetry, and more recent roots in Blake, Coleridge, and the French Symbolists. Nevertheless, the "new" Imagism was different, as Hyatt Waggoner pointed out in *American Poets*, in that it was grounded in the mechanistic and materialistic scientific philosophy of the time. The new Imagist's image, unlike that of the *haiku*—which elicited an identification on the part of the reader with the thing, so that the thing and the self became one (see chapter three)—was simply presented without comment or interpretation, much as the scientist would look at evidence and present the data. Furthermore, the Imagist's image was concerned not only with the natural, but also with the man-made and even the ugly and traditionally insignificant. In fact, as Waggoner suggests, the Imagists tried to write as if their vision were like the camera's—simply recording passively things in the world.[29]

The Imagists's efforts to imitate the impersonal recording capabilities of the machine parallel the initial and popular opinion of the camera, that it was *simply* a machine for recording what is "out there." But just as the Imagist movement was to fade quickly (and become part of the basis for the broader American Modernist movement), so did the narrow opinion of photography fade with the help of Alfred Stieglitz and the Photo-Secessionists, who ultimately fought to inject a transcendental element (via Equivalents) into the mechanistic and materialistic world. This they did, not by denying the material world, but by embracing it, just as the Imagists did.

Of the writers here—Stein, Crane, Williams, and Anderson—only Williams is recognized as being part of the early Imagist movement. But all of them were modern, and, therefore, part of that larger group of writers greatly influenced by the Imagists. Furthermore they were all caught up, just as the Imagists, modern painters, and Stieglitz were caught up, in a technological world to which they had to adapt.

To say that Stieglitz and the traditional camera photography he represents explain once and for all the writings of these four writers would be foolish. On the other hand, to say there was no influence of photography on literature would be naïve. Stieglitz's (photography's) influence is profound. Bram Dijkstra's *Hieroglyphics of a New Speech* (mentioned earlier) convincingly demonstrates Stieglitz's substantial influence on Williams. Stieglitz provided an example for Williams and other artists in that his own art was fully and unquestionably grounded in the real world—real things, real objects—the basis of the Modernist movement in art and literature. In fact, all four of these writers overtly acknowledged their debt to photography, and all were preoccupied with finding answers to the problems created by living in a world increasingly dominated by science and its technological child—the machine. Stein, Williams, Crane, and Anderson looked to photography and its machine (the camera) to better understand and formulate their own aesthetics—aesthetics that reflected characteristics of the medium of photography.

Stein and Williams illustrate the democratic aspect of Stieglitz's aesthetic, which contends that an immediate and actual moment is worthy of celebration and preservation simply because the real world exists—even the small, dirty, and trivial aspects of the world. Crane, too, was interested in this aspect of Stieglitz's aesthetic; but he was also concerned (as was Williams) with Stieglitz's ability to find the objective equivalent of emotional experience in the real world. Anderson was taken by both of these aspects of Stieglitz's aesthetic, but he was also fascinated by a third aspect, that the camera provided examples of the beauty a machine could produce in a world becoming more and more standardized because of misuse of the machine. All of these writers also explored other individual characteristics—for example, frame, point of view, focus—inherent in the medium of photography. Their friendship with and admiration for Stieglitz clearly encouraged this interdisciplinary exchange of ideas.

Gertrude Stein

(1874–1946)

Because he had visited Leo and Gertrude Stein in Paris during the first decade of the twentieth century, Stieglitz already knew Gertrude when he introduced her to the American reading public through his magazine *Camera Work*. In February, 1912, Stein received a letter from Stieglitz asking her if he could publish her written portraits of Matisse and Picasso that a friend of hers had shown him. When she accepted Stieglitz's offer of publication, Stein asked him to be careful with the punctuation: she wanted none added or deleted. In August of 1912 "Matisse" and "Picasso" were published in a special number of *Camera Work* that included reproductions of the painters' work. This was not only Stein's first appearance in a periodical, but, according to John Malcolm Brinnin, it was the first time that Picasso had ever been appreciated publicly in any publication.[1] (See Picasso's, "Gertrude Stein," Plate 13.)

Later in his life Alfred Stieglitz gave an account of the publication in a memoir entitled "*Camera Work* Introduces Gertrude

Stein to America." Having been told that there was no value in Stein's "gibberish," Stieglitz answered, "I have had to listen to similar charges all along the line, about Matisse, Cezanne and Picasso, Marin, Hartley, Weber, Henri Rousseau, and what not. It has ever been the same story when I have introduced a new worker in whatever field."[2]

Of course Stein's work has remained gibberish to many people—even to those with whom she maintained a friendship. Hart Crane, for example, confessed his "indifference" to her work; and even Stieglitz was uncertain about the value of her later work. Nevertheless, if Stein's glowing portrait entitled "Stieglitz," written in the 1930s, is any indication, their respect for one another remained intact.

That Stein and Stieglitz knew each other does not, of course, prove that Stein *consciously* began verbally exploiting characteristics of camera photography. Nevertheless, Stein was deeply interested in photography and was aware of its influence on vision. She was, for example, a great admirer of the works of Picabia (a good friend of Stieglitz, whom the photographer introduced to America in 1913). She believed Picabia was probably right to attribute his development as a modern painter to his early years as a photographer with his grandfather and Daguerre.

Stein was also aware of the impact that photography had on the cubistic vision and was "very much struck . . . with the way Picasso could put objects together and make a photograph of them. . . . To have brought the objects together already changed them to other things, not to another picture but to something else, to things as Picasso saw them."[3]

Picasso's cubistic vision was not only influenced by photography but, at times, could be explained by photography, as Stein noted in her explanation of the beginning of cubism. In 1909 Picasso returned from Spain with "some landscapes which were, certainly were, the beginning of cubism. These three landscapes were extraordinarily realistic and all the same the beginning of

cubism. Picasso had by chance taken some photographs of the village that he had painted and it always amused me when every one protested against the fantasy of the pictures to make them look at the photographs which made them see that the pictures were almost exactly like the photographs."[4]

Stein, then, not only recognized the contribution of photography to the development of modern painting, but also attempted to explain that contribution. Further, the impact of photography on her own aesthetic can be seen by comparing her aesthetic with Stieglitz's. Indeed one could take isolated statements of hers and mistake them for Stieglitz's. Stein, like Stieglitz, was truly a philosopher of the immediate and actual. She held that the writer's knowledge and understanding of the world depended upon "being existing."[5] She could say, therefore, that she knew everything when she was existing in and for the moment. Like the camera (and like Stieglitz) she reacted to the moment: "At any moment when you are you you are you without memory of yourself because if you remember yourself while you are you you are not for the purposes of creating you."[6] Stieglitz agreed: "When I am no longer thinking, but simply *am*, then I may be said to be truly affirming life."[7] The artist, according to Stein, is virtually the living equivalent of the camera: "An artist puts down what he knows and at every moment it is what he knows at that moment."[8] Furthermore, "The business of Art is to live in the actual present, that is the complete actual present, and to express that complete actual present."[9]*

"To show the moment to itself is to liberate the moment,"[10] said Stieglitz. Stieglitz liberated the moment with the camera; Stein tried to do it with words. In fact Stein's experiments with revealing moments of immediate and actual existence through the written word were among the first, the most radical and,

*W. C. Williams expressed a similar view: "A life that is here and now is timeless. That is the universal I am seeking: to embody that in a work of art, a new world that is always 'real.'" [In "Against the Weather: A Study of the Artist," *Twice a Year*, 2 (1939), 53.]

even today, the least understood. But her work becomes more clear if her relationship to camera photography is better understood.

Portraits

Many of Stein's works can be discussed in terms of the characteristics inherent in the medium of photography. "Melanctha,"for example, in her most popular book, *Three Lives*, shows an early preoccupation with the "continuous present," as she called it.[11] *Four in America*, written approximately thirty years later, exemplifies her method of bringing history out of the past and into the present, much as Williams does in *In the American Grain*. But the most photographic of all of her works are some of her early portraits, including "Matisse," "Picasso," "Four Dishonest Ones," "Manguin A Painter," "Nadelman," and "Harriet," and *Tender Buttons* (a book of "poems" on existing physical objects).

Reportorial

Like the photographer, Stein, in her portraits and in *Tender Buttons*, does not try to control what she sees: she observes and records. Also like the photographer, however, she does stop particular moments in time for observation. In her works the thing seen, the angle of vision, the trivial, the detail, and focus—all become important. The importance of all of these was amplified— if not first recognized—with the advent of camera vision.

Stein began writing portraits after finishing *The Making of Americans*. Her account of the way portrait writing began is given in *The Autobiography of Alice B. Toklas*. Gertrude was writing, Alice was protesting that supper was cooling, then Gertrude forced her to read the portrait (a portrait of Alice entitled "Ada") while supper got cold: "Ada was followed by portraits of Matisse and Picasso, and Stieglitz who was much interested in them and in Gertrude Stein printed them in a special number of *Camera Work*.

"She then began to do short portraits of everybody who came in and out."[12]

The method of Stein's portraits is explained in two lectures, "Composition as Explanation," and "Portraits and Repetition." "In making these portraits," said Stein, "I naturally made a continuous present an including everything and a beginning again and again within a very small thing. That started me into composing anything into one thing" (*Selected Writings*, p. 518).

A section from one of her portraits, "Four Dishonest Ones: Told By a Description of What They Do," (which she uses in her lecture entitled "Portraits and Repetition" to help explain repetition in her portraiture) is valuable for revealing Stein's photographic method:

They are what they are. They have not been changing. They are what they are.

Each one is what that one is. Each is what each is. They are not needing to be changing.

One is what she is. She does not need to be changing. She is what she is. She is not changing. She is what she is.

She is not changing. She is knowing nothing of not changing. She is not needing to be changing.

What is she doing. She is working. She is not needing to be changing. She is working very well, she is not needing to be changing. She has been working very hard. She has been suffering. She is not needing to be changing.

She has been living and working, she has been quiet and working, she has been suffering and working, she has been watching and working, she has been waiting, she has been working, she has been waiting and working, she is not needing to be changing.[13]

This portrait could be taken as a description of a photograph. The reader/viewer is forced to look at an unchanging scene. Gertrude Stein has captured a moment, as does the photograph,

for perusal. Her constant repetition forces the reader/viewer's attention on continual attention to selected phenomena. The photograph, of course, is constantly repetitious: viewers can look at a detail within the photograph and let their eyes wander to another detail, but when their eyes return to the original detail it is still there, repeating its significance to the rest of the portrait. The repetition, then, in Stein's portrait, reinforces the idea that the person viewed is constantly existing, that the portrait is a thing in itself and the details within it are not related to that which exists outside the portrait. In other words the portrait, like the photograph, is what Stein calls "a continuous present." (See Plates 4 and 11 for examples.) There is no narrative here as there is in most other written works; there is only a scene, a thing existing without changing, an immediate and actual moment presented for the reader/viewer to look upon. Stein draws the reader's mind away from chronological, linear thinking, and the need for memory is diminished.

Focus

The significance of the scene that Stein has presented in "Four Dishonest Ones" is obtained in part by her use of the photographic method of selective focus. In the first paragraph the viewer sees four people together not changing. In the second paragraph the viewer's vision is narrowed so that each person is seen individually. In the third paragraph the eye is focused on one individual. In the succeeding paragraphs the eye is trained on specific details of the one individual. One sees her working hard; then the viewer comes in very close to see her suffering and watching. And throughout the rest of the portrait (not given here) the eye is focused on other details about the woman. But when the viewer is finished reading, the woman still exists just as she did in the beginning of the portrait. The viewer has looked at the portrait, trained eyes on specific aspects of the portrait, and then come back to view it as a whole—a picture made up of certain insistent, unchanging details.

The method used here can be compared to the process of looking through a camera at a given scene. Some of the details are in focus, some are not. The focus is adjusted to bring the different details more sharply into view. The scene never changes, only the focus changes, until the focus that best presents the significance of the scene or idea in the photographer's mind is found—the focus that emphasizes those details that contribute to the photographer's theme. (See Plates 5e, 12, 18, and 19 for examples.)

Point of View

In addition to selective focus, Stein also shifted point of view in her portraits much as Stieglitz did in his camera portraits. A portrait, for Stieglitz, was not a single shot of one person, but rather a group of shots, each of the same subject but from different points of view. Taken together the group of shots made the resulting portrait. His O'Keeffe portrait consisting of prints of her from about 500 negatives is one of Stieglitz's major examples of portraiture. (See Plates 9, and 10 for 2 examples.)

Similarly Stein changes the point of view at least five times within her portrait entitled "Matisse" (*Selected Writings*, pp. 329–33)* and at the same time maintains a constant scene so that a composite portrait is obtained. In one instant we look at Matisse from the point of view of the writer of the portrait. In another instant Stein shows Matisse from the point of other artists. And again she shows him from the point of "very many wanting to be doing what he was doing" (*Selected Writings*, p. 231). The Matisse portrait, in other words, does not capture just one visual moment, for Stein shifts the point of view slightly from time to time within the same frame. In this respect the portrait resembles a montage. As in "Four Dishonest Ones," time in "Matisse" is also reduced to a continuous present; Stein's repetition destroys the

*Also collected in her *Portraits and Prayers* (New York: Random House, 1934), which is dedicated to the photographer Carl Van Vechten: "Who knows what a portrait is because he makes and is them."

narrative and focuses the reader's attention on the selected details
that contribute to the whole portrait.

Captured Moment

The portrait entitled "Picasso" represents another of Stein's
attempts to produce a portrait that consisted of moments cap-
tured. Stein said she was trying to make a portrait of someone
"as they are existing and as they are existing has nothing to do
with remembering any one or anything" (*Writings and Lectures*, p.
104). Her problem was to get rid of the need for memory and
historical time. She wanted to capture the immediacy and actual-
ity of people by freeing them from past and future. Essentially
she wanted to take a photograph without a camera. "Funnily
enough," she said, "the cinema has offered a solution of this
thing. By a continuously moving picture of any one there is no
memory of any other thing and there is that thing existing, it is
in a way if you like one portrait of anything not a number of
them. . . . I will read you some portraits to show you . . . [that] I
was doing what the cinema was doing, I was making a continu-
ous succession of the statement of what that person was until I
had not many things but one thing" (*Writings and Lectures*, p.
104). Stein went on to say, "I doubt whether at that time I had
ever seen a cinema but, and I cannot repeat this too often any one
is of one's period and this our period was undoubtedly the period
of the cinema and series production. And each of us in our own
way are bound to express what the world in which we are living
is doing" (*Writings and Lectures*, p. 105). Indeed Stein may not
have seen the cinema at that time, but she had certainly seen
series productions. (See Plate 14 for an example of series produc-
tion.) This may be the reason her portraits more closely resemble
a series of still photographs than they do the continuous action of
the cinema.

As Brinnin remarked: "In a Stein portrait the movement of
figures has been slowed down to such an extent that it is as if the

reader were looking at a film strip rolled out on a flat surface. A figure is not seen as moving in time, but as many static moments presented in succession. Yet the meaning is intended to be communicated summarily and at once."[14]

Stein's method is indeed more like Stieglitz's method in his composite portraits, or more like the method of series production than it is like the cinema in which the breaks between frames are not noticeable. The first paragraph of "Picasso" illustrates that method:

One whom some were certainly following was one who was completely charming. One whom some were certainly following was one who was charming. One whom some were following was one who was completely charming. One whom some were following was one who was certainly completely charming. (Selected Writings, p. 333)

Details

The "Picasso" portrait provides a good example of the photographic method as it is applied to individual sentences and their relationship to one another. The slight variations from sentence to sentence (or "frame" to "frame") and the repetition of most of the rest of the sentence isolates that word in the sentence that is changed. One notices, then, an amplification of what normally would be thought to be trivial. For example, the reader is forced to recognize the words *completely*, and *certainly;* and by the shifting of these two details the reader is forced to recognize the significant differences in meaning that small details can make in each sentence (or "frame"). As the two details change, the relationship between every other detail in the sentence changes with them. In other words Gertrude Stein illustrates, just as the photographer does, that the apparently trivial is as important as that which is normally thought to be important. Words take on the aspect of objects—all of which are equally important. As the portrait

progresses, different words are added and intensified in different sentences, so that by the end of the portrait all words are of equal intensity, just as all objects in the photograph are reduced to a common denominator within a given depth of field (see especially Plate 4.) Stein establishes her depth of field within the first two paragraphs by choosing those words (details/objects) that are to be intensified.

Now listen! [said Gertrude Stein] Can't you see that when the language was new—as it was with Chaucer and Homer—the poet could use the name of a thing and the thing was really there? He could say "O moon," "O sea," "O love" and the moon and the sea and love were really there. And can't you see that after hundreds of years had gone by and thousands of poems had been written he could call on those words and find that they were just wornout literary words? The excitingness of pure being had withdrawn from them; they were just rather stale literary words. Now the poet has to work in the excitingness of pure being; he has to get back that intensity into the language. . . . Now listen! I'm no fool. I know that in daily life we don't go around saying "is a . . . is a . . . is a . . ." Yes, I'm no fool; but I think that in that line the rose is red for the first time in English poetry for a hundred years.[15]

Like the photographer, Stein forces the reader's attention upon the object (in this case a rose); the object cannot possibly be ignored or overlooked.

Tender Buttons

One of Stein's major challenges for herself was to get "the excitingness of pure being" into her writing. Because the objects in a traditional photograph so closely resemble the objects in fact, the photographer virtually by necessity communicated "pure being." Stein tried to do it by intensifying a word to the extent

that it became an object itself, to the extent that it had its own intrinsic significance apart from its usual connotative and denotative significance. "Stein is a revolutionist," said Sherwood Anderson. "If we ever get again a world that knows what pure writing is, the sense and form in Stein's work will come through. She also will stand as a restorer of 'the word.' "[16] "Having taken the words to her choice," William Carlos Williams wrote, "to emphasize further what she has in mind she has completely unlinked them from their former relationships to the sentence. This was absolutely essential and inescapable. Each under the new arrangement has a quality of its own."[17]

She took up the challenge to communicate "pure being" when, she said in *The Autobiography of Alice B. Toklas*, "she first felt a desire to express the rhythm of the visible world."[18] The result was *Tender Buttons*. The exact date of the writing of *Tender Buttons* is not known. All indications, however, point to the probability that it was begun sometime during the summer of 1912, the same summer that her "Picasso" and "Matisse" portraits were published in the special number of *Camera Work*.

Brinnin looks at the relationship between *Tender Buttons* and cubism: "The cubists had turned from the refinements of traditional painting to scenes composed of vulgar, inconsequential elements which they attempted to fuse poetically and make radiant. In a similar turning, Gertrude Stein took naturally to the homely iconography of household life—to 'ObjectsFoodRooms' —in her exploration of the literary possibilities of cubism."[19]

Deeply involved with what the cubist painters were doing, Stein may have been influenced more profoundly by them more than by any given photographer; nevertheless, photographers initiated the preoccupation with "vulgar, inconsequential elements," and their instruments were the only ones capable of recording these elements so well. (See Plates 4 and 17 for examples.) Photographers do exactly what Brinnin says Stein was trying to do: "give [subjects] a reality that would be poetically fresh and new

and yet as solid as the simple reality that might present itself to a household visitor."[20]

Stein's major problem was to find the method that would give her subjects a fresh reality and at the same time maintain their actuality. To do this she tried the virtually impossible task of using each word as an object itself, rather than as an allusion, or suggestion, or reference to something else. Readers of *Tender Buttons* may wonder if the things that Stein "describes" can have any meaning if the language she uses is not traditionally referential.

The fact is, most of the "poems" in *Tender Buttons* do not "mean" anything in the traditional sense; but many of them can elicit emotional response. By looking upon each of the "poems" as a visual photographic moment rather than as a literary description, one can more easily grasp Stein's intentions. "A Method of a Cloak" provides a good example:

A single climb to a line, a straight exchange to a cane, a desperate adventure and courage and a clock, all this which is a system, which has feeling, which has resignation and success, all makes an attractive black silver. (Selected Writings, p. 464)

Stein does not give us what we expect; nevertheless, the words she chooses leave an impression on us—an impression that may even suggest "cloakness." Stein may be said to be operating as the photographer who tries to capture the feeling of a particular moment. The resultant photograph is made up of details that all contribute to the theme or feeling of the moment, if the photograph is to be successful. It is possible to look upon Stein's words as the details within a photograph that give visual meaning to the primary object—in this instance, a cloak. As an experiment, one might read this piece backwards, or from the middle. If the words are separate "objects," one should be able to move back and forth among them, ignoring the linearity of the "sentence." Indeed, "cloakness" can be felt by simply listing some of the

words: clock, courage, success, black silver, system. (This exercise, however, obviously destroys the pleasing literary rhythm.)

One may also look upon the words as a description of a photograph of a cloak. The description cannot of course be literal, for words do not communicate the same way pictures communicate. By erasing the need for memory, however, and intensifying, almost shocking, words into objects, Stein sometimes succeeded in communicating the visual that was inexplicable through traditional verbal formulations. "A Petticoat" offers an example of the way Stein's words create a visual impact, or describe a visual phenomenon, without making literal sense:

A light white, a disgrace, an ink spot, a rosy charm. (Selected Writings, p. 471)

All of the values these words suggest may be taken as independent, significant details that make up the total "picture" of the petticoat.

Sherwood Anderson in his introduction to Stein's *Geography and Plays* suggests that she gives us "words that have a taste on the lips, that have a perfume to the nostrils, rattling words one can throw into a box and shake, making a sharp, jingling sound, words that when seen on the printed page, have a distinct arresting effect upon the eye, words that when they jump out from under the pen one may feel with the fingers as one might caress the cheeks of his beloved."[21] While Anderson does not deal explicitly here with the photographic quality of Stein's words, he does describe the way in which her words take on independent, significant value, just as the details within a photograph are all real objects that, ultimately, contribute to the visual impact of the primary object.

Not all of the objects in *Tender Buttons* communicate as easily as the "Petticoat" and the "Cloak." One of the more difficult objects is "A carafe, That is a Blind Glass":

A kind in glass and a cousin, a spectacle and nothing strange a single hurt color and an arrangement in a system to pointing. All this and not ordinary, not unordered in not resembling. The difference is spreading. (Selected Writings, p. 461)

To explain the words is to take the reader two steps away from the object visualized. Nevertheless Allegra Stewart attempts an explanation that illuminates the type of response the object might arouse if readers visualized the object in the same moment that Stein visualized it. "We know," says Stewart,

that a carafe is a glass water bottle, often round-bellied and with a long neck. If it is a "blind" glass this may be because it has a stopper or because the glass is opaque; but it is a "kind" in (of) glass and a "cousin" to ordinary glasses or eyeglasses. It is also a "spectacle"—notable to look at—and yet familiar enough ("nothing strange"). Perhaps it is a spectacle partly because it is purple in color ("a single hurt color"—the color of bruises) and partly because it can be an aid to vision and is placed at the center of the artist's visual composition ("an arrangement in a system to pointing"). It is "not ordinary" because purple carafes are rare; yet in spite of "not resembling" other glasses, it is "not unordered" —that is, it is one of a kind, or order, of glass.[22]

The clause, "The difference is spreading," leads Stewart into an etymological analysis of the word *carafe*. The clause does indeed require a different response; it is a subjective statement about the object. But if one thinks of the carafe as being at the focal point of the composition, the clause is not troublesome. In any visual composition, such as the painting or the photograph, significance is relayed to viewers by the visual impact of the object or objects that dominate the frame. In this case the carafe, the primary focal point to which all other details contribute, does indeed spread throughout the composition. The words "is spreading" emphasize the immediacy and continuous presence of the

visual moment. The complete object, including all details, is captured (as if it were photographed) in the moment of spreading.

It cannot be said that all of Gertrude Stein's words in *Tender Buttons* are nonliteral and nonreferential. In fact *Tender Buttons* is only partially successful because the referential quality of words, which leads the reader into trying to figure out what each "poem" means rationally, is difficult to escape. Only rarely does the sense of the word as object come through. Nevertheless, her attempt to replicate what the camera must do by necessity was brilliant. Her portraits are more successful than *Tender Buttons* for more readers, because the portraits do not lean so far away from literary conventions; yet—by drawing on visual media—they alter our perceptions about what is possible within the literary medium. There is no doubt, as Sherwood Anderson recognized, that Stein was a radical innovator who provided writers who followed her with a heightened sense of the word, and a heightened sense of immediacy.

Williams's use of language is not as radical as Stein's, but it is similar to Stein's in that he also subscribed to a photographic aesthetic, was preoccupied with the trivial, was concerned with the problems of focus and frame, tried to capture and record an immediate and actual moment of vision, and attempted to use words as details within a composition. Williams was more knowledgeable than Stein about camera photography and was more overt in employing the devices that are inherent characteristics of the medium.

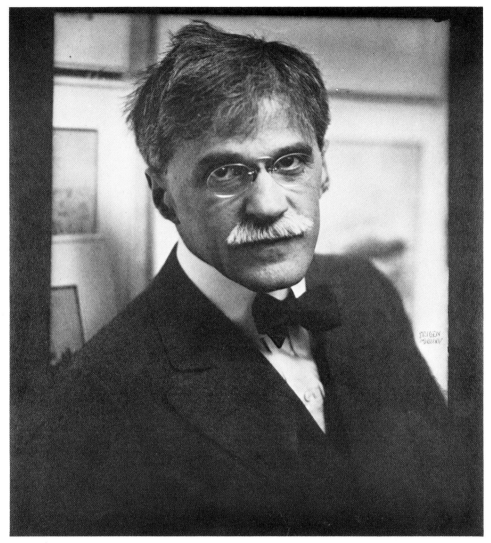

Plate 1. Edward J. Steichen. "Alfred Stieglitz at '291,'" 1915. The Metropolitan Museum of Art, Alfred Stieglitz Collection, 1933.

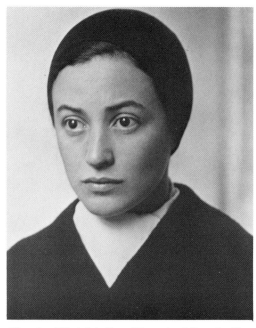

Plate 2. Alfred Stieglitz. "Portrait of Dorothy Norman," c. 1932. Philadelphia Museum of Art: Given by Mr. and Mrs. Carl Zigrosser. Photographed by Philadelphia Museum of Art.

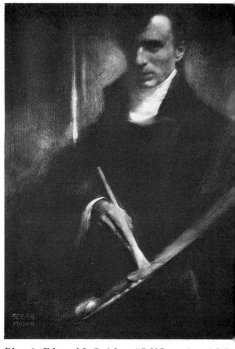

Plate 3. Edward J. Steichen. "Self Portrait, with Br[ush] and Pallette," Paris, 1902. Reprinted from Cam[era] Work, April, 1903.

Plate 4. Edward J. Steichen. "Sunday Papers," c. 19[] Silver Print, 13⅝ x 10⅝". Reprinted with permissio[n] Joanna T. Steichen. Collection, The Museum of Mo[dern] Art, New York. Gift of the photographer.

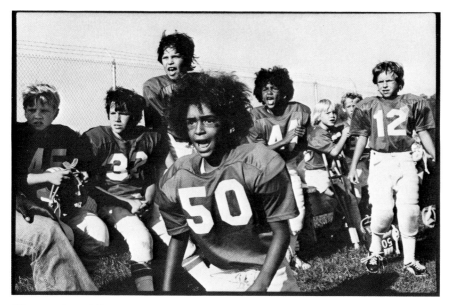

Plate 5a. Roger Pfingston. "Reporting: Boys Club Football," 1977.

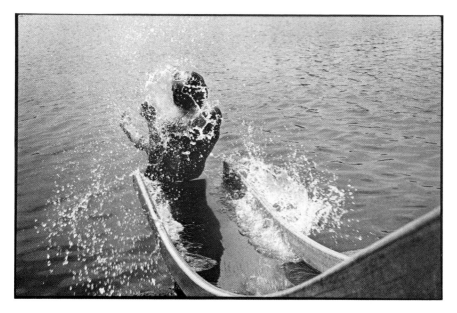

Plate 5b. Roger Pfingston. "Stopping Time: Water Slide," 1980.

Roger Pfingston (b. 1940) uses Plates 5 a-g to illustrate the characteristics of camera photography to his classes on Stieglitz and photography.

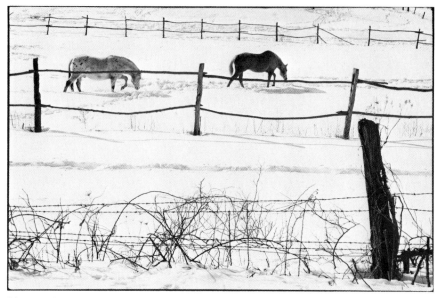

Plate 5c. Roger Pfingston. "The Frame: Two Horses," 1978.

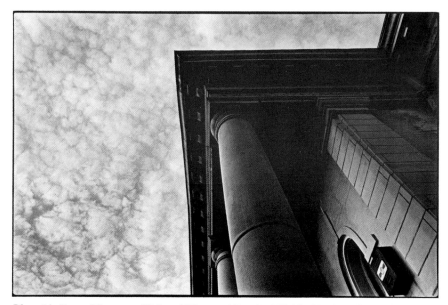

Plate 5d. Roger Pfingston. "Point of View and Depth of Field: Clouds, Library, Hoopeston, Illinois," 1975.

Plate 5e. Roger Pfingston. "Selective Focus: Brett," 1976.

Plate 5f. Roger Pfingston. "Detail: After Running," 1977.

Plate 5g. Roger Pfingston. "Equivalent: The Necklace," 1980.

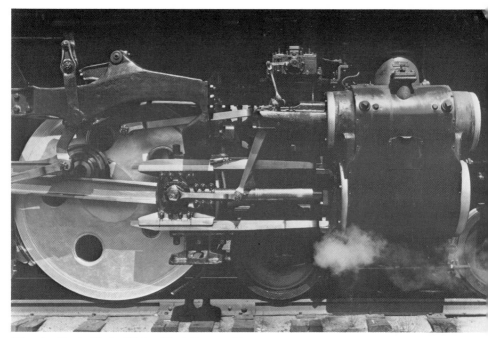

Plate 6a. Charles Sheeler. "Drive Wheels," 1939. (Photograph) Smith College Museum of Art, Northampton, Massachusetts. Gift of Dorothy C. Miller '25 (Mrs. Holger Cahill) 1978.

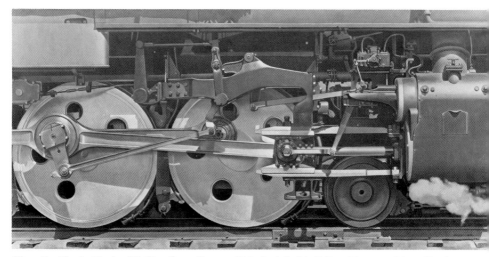

Plate 6b. Charles Sheeler. "Rolling Power," 1939. (Painting) Smith College Museum of Art, Northampton, Massachusetts.

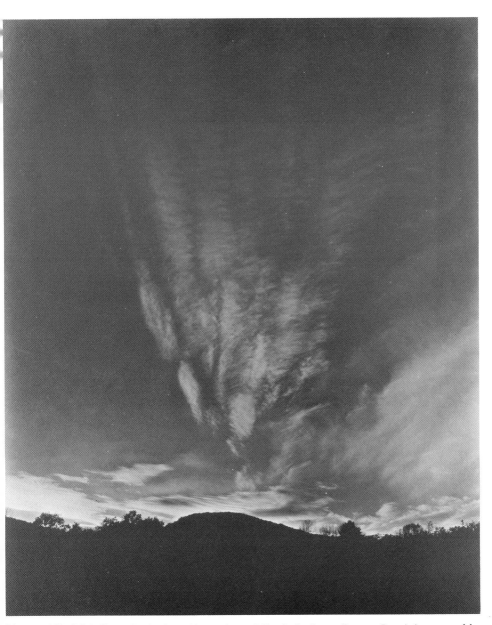

Plate 7. Alfred Stieglitz. "Equivalent, Mountains and Sky, Lake George," 1924. Permission granted by Dorothy Norman. Philadelphia Museum of Art: Given by Carl Zigrosser. Photographed by Philadelphia Museum of Art.

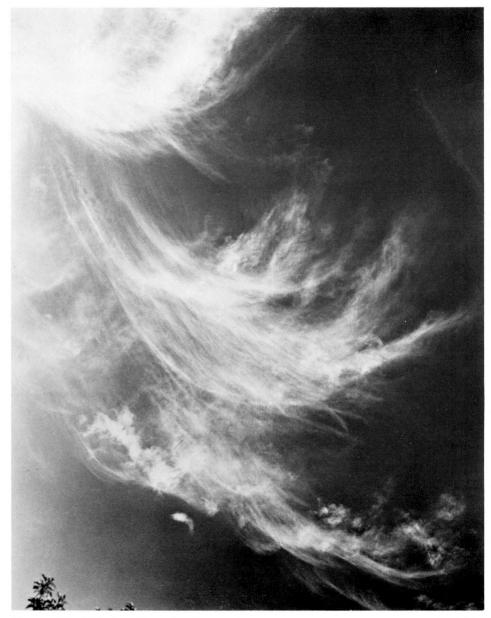

Plate 8. Alfred Stieglitz. "Equivalent," 1930. Permission granted by Dorothy Norman. Philadelphia Museum of Modern Art: From the Collection of Dorothy Norman. Photographed by Eric Mitchell.

te 9. Alfred Stieglitz. From Georgia O'Keeffe:
Portrait, *Plate 31, 1918. The Metropolitan Mu-*
m of Art, on loan from Georgia O'Keeffe. Reprinted
h permission of Georgia O'Keeffe.

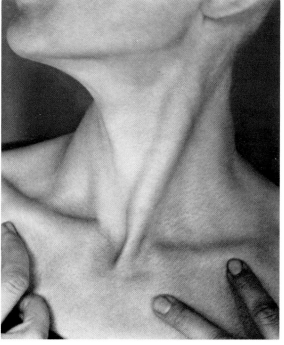

Plate 10. Alfred Stieglitz. From
Georgia O'Keeffe: A Portrait,
Plate 23, 1921. The Metropolitan
Museum of Art, on loan from Geor-
gia O'Keeffe. Reprinted with permis-
sion of Georgia O'Keeffe.

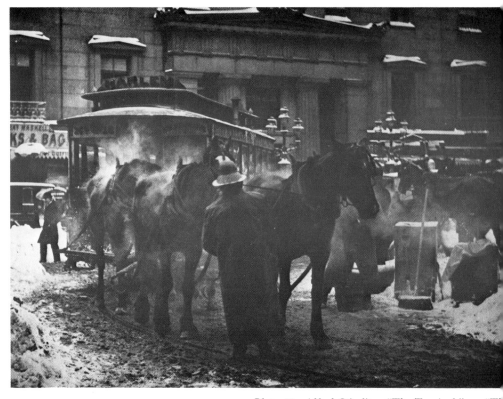

Plate 11. Alfred Stieglitz. "The Terminal," or "Th Car Horses," 1892. Permission granted by Georgia O'Keeff Philadelphia Museum of Art: The Alfred Stieglitz Co lection. Photographed by Eric Mitchell, 1981.

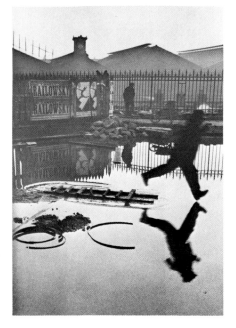

Plate 12. Henri Cartier-Bresson. "Behind the Saint-Lazare Station, Paris," 1932. Reprinted by permission of Henry Cartier-Bresson and Magnum Photos, Inc.

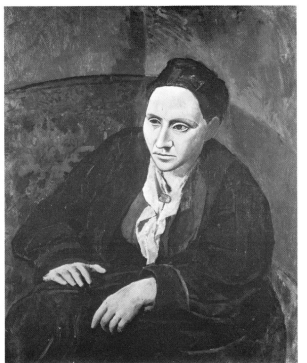

Plate 13. Pablo Picasso. "Gertrude Stein," 1906. Oil on Canvas. The Metropolitan Museum of Art, Bequest of Gertrude Stein, 1946.

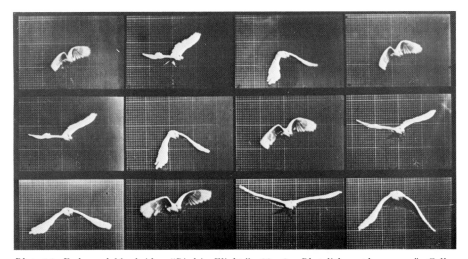

Plate 14. Eadweard Muybridge. "Bird in Flight," 1883–87. Photolithograph, 19 x 24". Collection, The Museum of Modern Art, New York. Gift of the Philadelphia Commercial Museum.

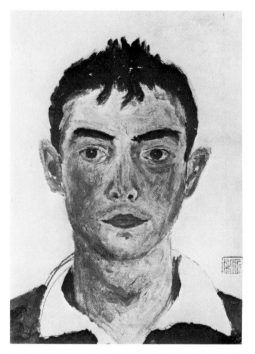

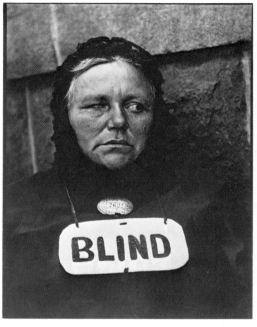

Plate 15. William Carlos Williams. "Self Portrait," 1914. Reprinted with permission of the Rare Book Collection, The University of Pennsylvania Library.

Plate 16. Paul Strand. "Blind," 1916. The Metropolitan Museum of Art, Alfred Stieglitz Collection, 1933.

Fountain by R. Mutt Photograph by Alfred Stieglitz

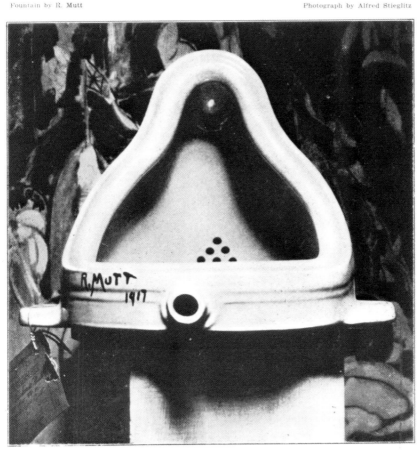

THE EXHIBIT REFUSED BY THE INDEPENDENTS

Plate 17. Marcel Duchamp. Photograph by Alfred Stieglitz. "R. Mutt's Fountain," from The Blind Man, *1917. Philadelphia Museum of Art: The Louise and Walter Arensberg Collection. Photographed by Philadelphia Museum of Art.*

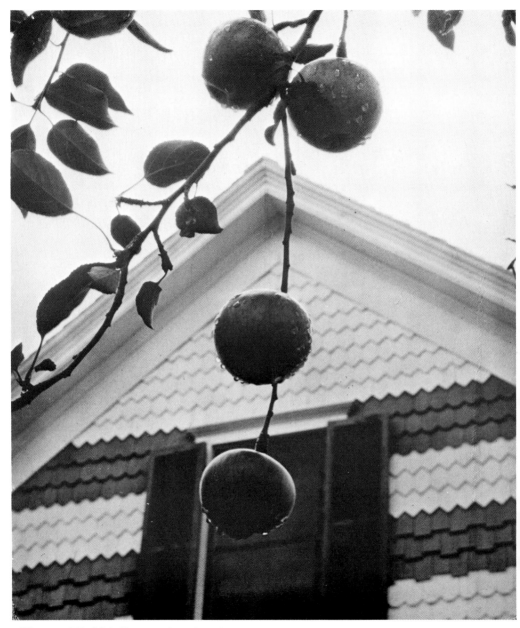

Plate 18. Alfred Stieglitz. "Apples and Gable, Lake George," 1922. Permission granted by Georgia O'Keeffe. Philadelphia Museum of Modern Art: The Alfred Stieglitz Collection. Photographed by Eric Mitchell.

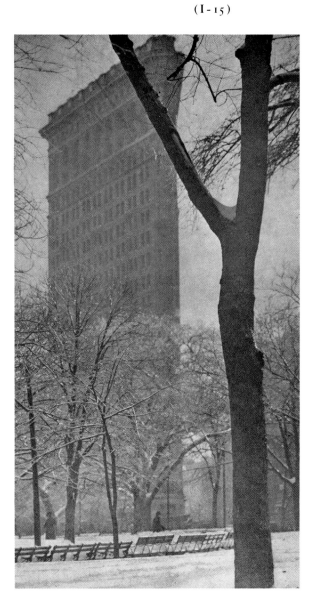

Plate 19. Alfred Stieglitz. "The Flat Iron Building, New York," 1903. Permission granted by Dorothy Norman. Philadelphia Museum of Modern Art: Given by Carl Zigrosser. Photographed by Eric Mitchell.

Plate 20. Alfred Stieglitz. "Sherwood Anderson," n.d. Photograph by courtesy of National Gallery of Art, Washington. Permission granted by Georgia O'Keeffe.

Williams Carlos Williams

(1883–1963)[1]

Even though *In the American Grain* was a commercial flop it made several friends for Williams, one of whom was Stieglitz: "Steiglitz found the book somewhere," said Williams, "and wrote enthusiastically to me about it. He even said it had given him the name, An American Place, when he moved to the new site for his gallery on Madison Avenue. From that time [c. 1924] for many years until Stieglitz's somewhat crotchety old age I frequented that gallery."[2] Indeed, Williams visited Stieglitz "fairly regularly at one time. There'd be no one at all in the gallery. He'd recognize me, and after I had had a chance to look around he'd come out from behind his partition and we'd begin to talk." After meeting with Stieglitz, Williams would "come home and think— that is to say, to scribble, I'd scribble for days, sometimes, after such a visit, or even years, it might be, trying to discover how my mind had readjusted itself to its contacts" (*Autobiography*, p. xii-xiii). (See Williams' "Self Portrait," Plate 15.)

In 1934 Williams published the essay "The American Back-

ground," which was a tribute to Stieglitz's immense contribution to the arts in the United States. Stieglitz, according to Williams, was the one person able to fuse the cultural influences of Europe while at the same time maintaining, supporting, and fostering, the integrity of American art: "Using his own art, photography," said Williams, "[Stieglitz] still, by writing, by patronage, by propaganda and unstinted friendship, carried the fullest load forward. The photographic camera and what it could do were peculiarly well suited to a place where the immediate and actual were under official neglect. . . . Stieglitz inaugurated an era based solidly on a correct understanding of the cultural relationships."[3]

In his own work, Williams succeeded in creating a poetry of the immediate and actual. Not all of his poems are simply arrested visual images; Williams, working with words, was also naturally concerned with capturing the speech rhythms of America. But indeed the visual was important for him. In fact in William's work, more than in the work of most of his predecessors or contemporaries, the many instances of the use of camera techniques compel one to look upon certain poems or sections within poems as photographic images. One thinks of the Imagist poets who surrounded Pound and Hulme: "Concretion," said John Malcolm Brinnin, "exactitude, observation without comment, vulgar subject matter, common speech, homely details glittering with a mineral clarity—Williams exhibits them all and achieves over and over again that complexity of emotion within an instant of time that was the true goal of the Imagist."[4] Except for the comment about "common speech" Brinnin could just as easily have been speaking of a group of photographers. Williams was part of the Imagist movement; but his poetry actually came to be more photographic than the Imagists' poetry because he eschewed the striking metaphors (that so frequently characterized Imagist poems) and let the objects of his vision carry their own significance.

Painters

Williams was aware of the influence of photography on paint-ing. His good friend, the painter Charles Sheeler, used the cam-era to obtain images that he would then intensify with paint. (See Plate 6.) "Sheeler," Williams wrote in the Introduction to *Charles Sheeler—Paintings—Drawings—Photographs*, "had especially not to be afraid to use the photographic camera in making up a picture. It could perform a function unduplicatable by other means."[5]

That Williams was influenced by painters, including Sheeler, is undoubtedly true. For him the Armory Show of 1913 (in which Stieglitz played a significant role) represented something new in the air for poets: "There had been a break somewhere, we were streaming through, each thinking his own thoughts, driv-ing his own designs toward his self's objectives. Whether the Armory Show in painting did it or whether that also was no more than a facet—the poetic line, the way the image was to lie on the page was our immediate concern."[6]

Brinnin believes that Williams borrowed from two different kinds of painting: The Ash Can school of America, and Cubism from Paris. Both of these schools were indebted to photography. The eye was first introduced to ash cans through the photo-graph, which did not sentimentalize or edit the thing seen, but rather recorded the trivial and the ugly and fixed it for observa-tion with superb clarity. (See Plates 4, 16, and 17 for examples.) The French painters were of course discovered for the United States by Stieglitz. They created new (nonrepresentational) ob-jects (paintings) to which all details inhered, by externalizing in paint the emotion they felt within themselves. Furthermore, ac-cording to Gertrude Stein, the Cubists "faith in what their eyes were seeing—commenced to diminish,"[7] and they had photo-graphs to prove that their loss of faith was justified. Therefore they began to celebrate their own personal vision by painting things as they struck their own mind's eye.

Objectivist and Photographic Aesthetic

Williams' interest in and friendship with modern painters and photographers may explain his participation in the official movement Objectivism. The Objectivists, said Williams, argued that

the poem, like every other form of art, is an object, an object that in itself formally presents its case and its meaning by the very form it assumes. . . .

The poem being an object (like a symphony or cubist painting) it must be the purpose of the poet to make of his words a new form: to invent, that is, an object consonant with his day. . . .

It all went with the newer appreciation, the matter of paint upon canvas as being of more importance than the literal appearance of the image depicted. (Autobiography, pp. 264–65)

The Objectivists (like all traditional photographers) placed emphasis on presentation of the thing; they wanted the thing itself to carry its own meaning: "In my own work," said Williams, "it has always sufficed that the object of my attention be presented without further comment. This in general might be termed the objective method. . . . It doesn't declaim or explain; it presents."[8] "There is nothing here," he said, "that seductively leads the sense to acceptance by sensuous intrigue. Nor can it be called parody since there is no exaggeration or warping for false emphasis. Nor is reason used to cudgel the mind into unwilling submission. The attack is by simple presentation, perhaps confrontation would be the better term."[9] One of the Objectivists' tasks was to try to de-emphasize the linear syntax and the referential meaning of words so that the poem could become more objective and photographic. The Objectivists had had a predecessor, to whom Williams acknowledged a debt: "I for one believe that it was Gertrude Stein, for her formal insistence on words in their literal, structural quality

of being words, who had strongly influenced us" (*Autobiography*, p. 265). With Stein the words had become details within a composition that was to be apprehended at once. "The poem," said Williams, "is made up of things—on a field" (*Autobiography*, p. 333). A good example of the way in which Williams uses words in this way is the poem entitled "The Locust Tree in Flower":

<div align="center">

Among

of

green

stiff

old

bright

broken

branch

come

white

sweet

May

again[10]

</div>

Because of the way the words in "The Locust Tree in Flower" are arranged on the page, and because the first two words appear at first to repel each other, the reader cannot help reading each word separately: each word has a special existence independent from the other words. Yet the words presented—like details in a photograph—are to be apprehended at once as a complete composition.

Williams' aesthetic is truly grounded in the immediate and actual. Like the photograph, the poem, according to Williams, is concerned with "the lifting of an environment to expression."[11] Like the photographer, Williams is concerned with the moment:

"And this moment is the only thing in which I am at all interested." The purpose of his book *Spring and All* is, through the imagination, "to refine, to clarify, to intensify that eternal moment in which we alone live."[12] He forces the trivial into the foreground. Focus becomes important. And finally the detail is used to carry the meaning or significance of the composition: "It is his eye for the thing," said Williams, "that most distinguishes Charles Sheeler—and along with it to know that every hair on every body, now and then, in its minute distinctiveness is the same hair, on every body everywhere, at any time changed as it may be to feather, quill or scale. . . . The local is the universal."[13]

Williams' Longer Works

Although individual shorter poems provide the best and clearest examples of Williams' technique, his longer works also show his use of characteristics inherent in the medium of photography. *In the American Grain* provides an excellent example of his attempt to bring the past into the present moment, to create living history. For example, the "Discovery of the Indies" chapter is told from the point of view of Columbus himself; other chapters are written in the present tense. Not only does Williams achieve, stylistically, the immediacy of American history, but one of the themes of the book is that few Americans are capable of living life immediately, for the present moment. Throughout the text he exhorts the reader into involvement with the story: "Do you feel it?" he asks the reader. And in another place: "Come, then, let's look inside."[14] One thinks of *In the American Grain* in the terms of the often-used description of the photograph: the mirror with a memory. One cannot say the same of traditional history books, for these do not use the devices that provide the immediacy, the now-ness of the past.

Paterson is Williams' attempt to do in a long poem what he did

with prose in *In the American Grain*; but the full range of his use of photographic characteristics is best illustrated in many of his shorter poems.

Williams' Shorter Poems

Some of the most striking examples of his use of a characteristic of photography are found in poems that actually capture a moment so that motion is stopped. "Bird" reads as follows:

> Bird with outstretched
> wings poised
> inviolate unreaching
>
> yet reaching
> your image this November
> planes
>
> to a stop
> miraculously fixed in my
> arresting eyes[15]

The eye itself is actually incapable of arresting the motion of a bird in flight. One can blink one's eyes and then remember the image. But one must somehow capture the motion indefinitely so that memory is obliterated. This is what Williams attempts to do in the poem. The poem itself becomes a photograph, a mirror with a memory. (Plates 5b, 12, and 14 provide the best examples of motion/time captured.)

The most popular of his poems, "The Red Wheelbarrow," provides another of Williams' attempts to capture a moment in time:

so much depends
upon

a red wheel
barrow

glazed with rain
water

beside the white
chickens.

(*Earlier Poems,* p. 277)

This poem is not primarily a study of arrested motion (although the reader is not aware of movement within the poem). Instead the emphasis here is on the relationships between the objects or details within the poem. Like the objects in a photograph, the objects in this poem do not mean anything except as they exist in relation to one another. Like the photographer, Williams has abstracted from nature and framed his "picture" within the boundaries of the words of the poem. The photographer tells the viewer that "so much depends" upon the relationship between these objects by the very act of taking the picture and inviting the public to view it; Williams, here, but not always, chose to force the reader's mind on the objects by telling the reader how to look upon them. In this, as in many of his poems, Williams revealed in the first two lines ("so much depends/upon") the feeling he got from seeing the objects. Often this information is introduced in the title. But to suggest a feeling one gets from things as they exist by themselves or in relationship to one another is different from declaring that the things have a meaning apart from their actual existence.

The poem "Between Walls" gives an excellent example of the way in which the objects in a poem express their own significance:

the back wings
of the

hospital where
nothing

will grow lie
cinders

in which shine
the broken

pieces of a green
bottle

(*Earlier Poems*, p. 343)

The feeling suggested here can be discerned if the poem is looked upon as a photograph in which objects must necessarily communicate nonliterally, nonreferentially, but only as each object exists in relationship to the other objects around it. First the reader sees the objects framed within the back wings of the hospital. It may be inferred that the hospital is the epitome of the place of birth, death, and the preservation of life. Secondly, the cinders are seen where growth is impossible; the lack of life is made more vivid by the relationship that is set up between the objects (cinders and hospital) by the poem itself, which frames, or abstracts, the objects from nature. Thirdly the reader's eye is forced to focus upon the shining broken pieces of a green bottle, the bottle (the reader might imagine) having been used in the hospital to sustain life. Of course the reader might not imagine any of this, or a completely different set of relationships might be imagined. Nevertheless the relationships between the objects are *felt*. The poem itself is the beauty created by the relationships that exist between the objects. There is no discussion of meaning anywhere within the poem, and indeed it would be difficult to say what the poem means. The poem simply presents the illu-

sion of real objects in a moment of time (like the photograph) and preserves them for the reader to observe and feel. Furthermore, the reader will notice that in this poem, and in Williams' poetry generally, one finds the elevation of the trivial to a level of importance that is not found in writing that precedes the advent of photography.

At times Williams consciously elicits a visual response from the reader not through the words, but through the form of the poem itself. Like the photographer, he abstracts from nature a real concrete image and places it on the page for observation. "The Yellow Chimney" provides an example:

> There is a plume
> of fleshpale
> smoke upon the blue
>
> sky. The silver
> rings that
> strap the yellow
>
> brick stack at
> wide intervals shine
> in this amber
>
> light—not
> of the sun not of
> the pale sun but
>
> his born brother
> the
> declining season[16]

This poem, like "Between Walls" and "The Red Wheelbarrow," is to be apprehended in a single glance, but in this poem there is a further visual aid: "The Yellow Chimney" is like a concrete poem in that its form helps to illustrate its content. At least the

form and content are complementary. Williams' attempt to present the reader with visual experience is even more startling in the poem "The Attic Which Is Desire" that includes the lines,

Here

from the street
by

* * *
* S *
* O *
* D *
* A *
* * *

ringed with
running lights

the darkened
pane

exactly
down the center

is
transfixed (*Earlier Poems*, p. 353)

The use of pictorial images within the poem is not confined to the "Attic" poem. One of Williams' earlier poems from *Della Primavera Trasportata Al Morale* entitled "April" turns out to be a collage of signs that include a skull and crossbones, arrows, a menu, stop-and-go signs, a political platform, a for sale sign, and so forth. The reader is confronted with a whole group of images that, taken together, form a kind of portrait—in the way that Stieglitz thought of the portrait—of April. Stieglitz made a portrait of Georgia O'Keeffe, for example, out of 500 different nega-

tives, all from different points of view. (Plates 9 and 10 provide
two examples.) Williams made a portrait of April out of a dozen
or so different objects that are signs of April.

The elevation of the immediate and actual object—regardless
of popular preconceptions about its aesthetic significance—was
shockingly displayed when Marcel Duchamp ("R. Mutt") placed
a urinal in an art show. (Plate 17.) Williams shared a common
bond with this aesthetic of Duchamp's, just as he shared a com-
mon bond with the traditional photographer who had for years
taken ordinary real objects and created new thoughts for those
objects by abstracting them from nature and presenting them for
observation.[17]

Williams' use of the frame in his compositions is also compara-
ble to the photographer's use of the frame. Williams abstracts
from nature (witness for example "Between Walls" or "The Red
Wheelbarrow"). He does not, like the painter, select objects to be
placed within a composition, but rather he sees what is before
him as it exists and records it. He records those objects and
details that by themselves relate to one another. The photogra-
pher finds these relationships existing in nature and records them;
and Williams, in keeping with his objective aesthetic says that
the good poet "doesn't *select* his material. What is there to select?
It is."[18] This does not mean that Williams does not select the
composition from nature; it means only that, like the traditional
camera photographer, Williams does not manipulate the details
within the natural composition. He sees, and records, and pres-
ents the real world—real objects, real things. (Examples of selecting
and framing: Plates 5c, 8, 10 and 18.)

Like the photographer, Williams also uses focus. He selects his
depth of field and intensifies the significant object or objects
within the field, as "Between Walls" illustrates. He is also adept,
like Gertrude Stein, at using variable focus. In other words he
narrows and expands his depth of field within a single poem. In
"Queen-Ann's-Lace," for example, the depth of field includes

first the whole field of Queen-Ann's-Lace, then narrows to the close-up of "the purple mole at the center of each flower," and then expands again to include the whole field. The scene does not change, only the focus changes to emphasize those details that contribute to the emotional impact of the poem.

Equivalents

There are obvious parallels between Stieglitz's and Williams' methods of conveying emotion in their respective media—photograph and poem. For example the objects that Williams sees are included in his poem at the "decisive moment" when a design in nature calls up the emotion within him. Stieglitz, speaking of one of his photographs—"The Terminal" (Plate 11)—said, "What made me see the watering of the horses as I did was my loneliness."[19] Similarly, Williams sees, feels, and records. He, like the photographer, finds the objective equivalent of emotional experience in the real world, real things, and forces the reader's, or observer's, attention on those real things. "Between Walls" or "The Red Wheelbarrow" are the equivalents in the real, objective world of a subjective, emotional experience. William's poems, like Stieglitz's photographs, "lie," to repeat Rosenfeld, "at the point where the objective and the subjective world coincide."[20] But unlike the Romantics, who looked for relationships between the otherworldly and the things of this world, Williams and Stieglitz denied obvious romantic symbolism and looked to the relationships between the objective things of this world in order to convey a subjective feeling. This "equivalent" aesthetic parallels the rise of photography. It may be argued that it is not strictly speaking an aesthetic grounded in symbol; but it comes very close to it, if one defines "symbol," not loosely to connote metaphor, simile, and other figures of speech, but in the strict sense: what is presented provokes the reader to infer additional

meaning; but what is presented is also what is *meant* and does not only *stand for* something else.[21]

Williams defined this aesthetic in terms of the "radiant gist." In other words the power, strength, energy *immanent* in an object is immanent in all objects, including the viewer of the object: "In looking at some apparently small object one feels the swirl of great events."[22] The poem should, ideally, shock one into that mystic—one might even call it transcendental—identification of the reader with the objective world, much as the ancient *haiku* or *tanka* intended. Obviously this is what Stieglitz intended in many of his Equivalents. A problem for literary and art critics grounded in a scientific culture is that they cannot discuss such an aesthetic without turning to terminology associated with religion. With recent verifications of quantum theory in physics, however, it can almost be said, rather simply in terms that Stieglitz and Williams would have approved, that matter does not *stand for* spirit; matter *is* spirit, or energy. Williams said essentially the same thing when he said, there are "no ideas but in things,"[23] and "the local is the universal,"[24] and "in the pitch-blend/the radiant gist."[25]*

Whereas words and the letters within words are "real," the fact that they also refer to other things is undeniable. Poets, like Williams and Stein, who work with words that are necessarily referential cannot actually "present" reality. Photography is also defined by limitations: frame, focus, point of view, time stopping, and so forth. Neither can the photographer actually "present" reality. The best that either photographer or poet can hope to do is "represent" reality, or present the "illusion of reality."

By presenting the illusion of reality, Stieglitz and Williams really do, at their best, inform us of the radiant gist through

*Considering what we know today from quantum theory, the logical—and perhaps actual—extension of this aesthetic would incorporate the converse of Williams' statements: there are no things but in ideas; the universal is the local; in the radiant gist, the pitch-blend. I include these reversals to help the reader understand the aesthetic ideal.

which we recognize our spiritual identification with the material world. At second best, we feel the loneliness of the watering of the horses, or the swirl of events to which the objects in poems like "Between Walls" allude.

Like Williams, Stein and Hart Crane also found the universal in small objects. Crane, particularly, was highly enthusiastic about the relationship between objects and emotional suggestion in Stieglitz's work, and he wrote explicitly (whereas Williams did not) about the photographer's Equivalents. Both Williams and Crane considered it the poet's job to present these objects for observation so that the observer/reader could see the relationships that exist between the local and the universal. "Photography," said Stieglitz, "brings what is not visible to the surface."[26] Williams' and Crane's poetry brings the not-visible to the surface in the same way that the photographer does, by focusing intensely upon objective details that become Equivalents of emotional experience.

Hart Crane

(*1899–1932*)

In an uncompleted essay and in his letters Hart Crane wrote with enthusiasm about a great affinity between his poetry and Stieglitz's photographs.

I don't know whether I mentioned to you yesterday [said Crane in a letter to Stieglitz] that I intend to include my short verbal definition of your work and aims in a fairly comprehensive essay on your work. I had not thought of doing this until you so thoroughly confirmed my conjectures as being the only absolutely correct statement that you had thus far heard concerning your photographs. That moment was a tremendous one in my life because I was able to share all the truth toward which I am working in my own medium, poetry, with another man who had manifestly taken many steps in that same direction in *his* work.[1]

Crane's excitement resulted from his having seen the photograph "Apples and Gable" (Plate 18) at an exhibition of Stieglitz's work, and subsequently meeting him. Immediately thereafter,

Crane defined his own poetry in terms of Stieglitz's photograph aesthetic.

The uncompleted, untitled essay that Crane wrote on Stieglitz and his photographs deserves to be quoted at length:

> The camera has been well proved the instrument of personal perception in a number of living hands,[2] but in the hands of Alfred Stieglitz it becomes the instrument of something more specially vital—apprehension. . . . Speed is at the bottom of it all—the hundredth of a second caught so precisely that the motion is continued from the picture infinitely: the moment made eternal.
>
> This baffling capture is an end in itself. It even seems to get at the motion and emotion of so-called inanimate life. It is the passivity of the camera coupled with the unbounded respect of this photographer for its mechanical perfectibility which permits nature and all life to mirror itself so intimately and so unexpectedly that we are thrown into ultimate harmonies by looking at these stationary, yet strangely moving pictures.
>
> If the essences of things were in their mass and bulk we should not need the clairvoyance of Stieglitz's photography to arrest them for examination and appreciation. But they are suspended on the invisible dimension whose vibrance has been denied the human eye at all times save in the intuition of ecstasy. (Letters, p. 132)

Three elements in this essay are important to Crane's aesthetic: 1) that Stieglitz used a machine 2) that he was capable of making a moment eternal, and 3) that in his ability to apprehend and fix a moment he could reveal "harmonies" that existed beyond the actual depiction of the real objects.

The Machine

That the machine is an important element in Crane's aesthetic is not surprising. "America," wrote Waldo Frank, "is the land of

the Machine. In no other nation is the mechanical fact so close a part of life and growth. . . . Perhaps therefore it is not accident, that the powerful vision which is Stieglitz should first have found itself through a machine."[3] Indeed the medium of photography as represented by Stieglitz was positive proof for Crane that the machine was capable of creating beauty, and he was fascinated with Stieglitz's art because he wanted to do what the photographer was already doing: creating beauty out of the stuff of the real world, a world manifestly a machine world. In another essay entitled "Modern Poetry," Crane wrote, "For unless poetry can absorb the machine, i.e., *acclimatize* it as naturally and casually as trees, cattle, galleons, castles and all other human associations of the past, then poetry has failed of its full contemporary function." This acclimatization "demands, however, along with the traditional qualifications of the poet, an extraordinary capacity for surrender, at least temporarily, to the sensations of urban life."[4] Acceptance of the machine, then, meant acceptance of the world of which the machine was the dominant symbol and also recognition that the machine is a symbol of man's creativity.

Crane found symbols of creativity in a trolley car, a factory, an airplane, a bridge, and even in the more trivial ash can. "The Bridge of Estador" is an early example of Crane's recognition of the beauty that exists within, and even because of, the machine culture. High on the bridge the poet sees

Bellies and estuaries of warehouses,
Tied bundle-wise with cords of smoke.

Do not think too deeply, and you'll find
A soul, an element in it all.

How can you tell where beauty's to be found?
I have heard hands praised for what they made;
I have heard hands praised for line on line;
Yet a gash with sunlight jerking through
A mesh of belts down into it, made me think

I had never seen a hand before.
And the hand was thick and heavily warted. (*Complete Poems*, p. 142)

The poem "Episode of Hands" from which the hand image was drawn makes it more clear that the gash was made in a factory, in which

> a shaft of sun
> That glittered in and out among the wheels,
> Fell lightly, warmly, down into the wound. (*Complete Poems*, p. 141)

The importance of the poems lies not only in the fact that they show Crane's attempt to surrender himself to the machine culture and his recognition that he can find beauty therein; these poems also make the reader aware of the photographic quality of the image. The beauty exists as a result of the slant of light that jerked or glittered among the wheels and belts. A relationship is set up between the machines and the bleeding hand, and the beauty apprehended by Crane is new to him, as if he "had never seen a hand before." In other words, as in a photograph, a new thought is created for that object (the hand) by its relationship to other objects (belts and wheels in a factory) and a novel slant of light. In this instance there is no literal meaning to the image, there is only visual significance. The thick, heavily warted hand is presented directly, brutally, much as a photograph would present an object. In the ugly hand, beauty is seen. One must see, "not think too deeply" to find the "soul, an element in it all."

"For the Marriage of Faustus and Helen" is Crane's major attempt before *The Bridge* to find the "soul" of the world of the machine. In this poem Helen is "the symbol of this abstract 'sense of beauty,'" said Crane, and "Faustus [is] the symbol of myself, the poetic or imaginative man of all times" (*Letters*, p. 120). Crane, as Faustus, sees that

Across the stacked partitions of the day—
Across the memoranda, baseball scores,
The stenographic smiles and stock quotations
Smutty wings flash out equivocations. (*Complete Poems*, p. 27)

Then Faustus is found riding in a streetcar. In this machine he gets his first glimpse of Helen's eyes "before the jerky window frame" (*Complete Poems*, p. 28). "The street car device," said Crane, "is the most concrete symbol I could find for the transition of the imagination from quotidian details to the universal consideration of beauty,—the body still 'centered in traffic,' the imagination eluding its daily nets and self consciousness' (*Letters*, p. 120). In poems like "Faustus and Helen" and later in *The Bridge* (where he found another concrete symbol for bridging the quotidian and the universal) Crane not only tried to find the significance of the machine culture in which he was living, but he used the culture to find beauty; as he said in "General Aims and Theories," he was "using our 'real' world somewhat as a spring-board" (*Complete Poems*, p. 220).

Crane wrote to Gorham Munson, "I am even more grateful for your very rich suggestions best stated in your *Frank Study* on the treatment of mechanical manifestations of today as subject for lyrical, dramatic, and even epic poetry. You must already notice that influence in 'F[austus] and H[elen].' It is to figure even larger in *The Bridge*" (*Letters*, p. 125). In a letter to Otto Kahn, Crane said, speaking of *The Bridge*, "What I am after is an assimilation of this [American] experience, a more organic panorama, showing the continuous and living evidence of the past in the inmost vital substance of the present" (*Complete Poems*, p. 248). The present (as it exists in *The Bridge*) for Crane is the machine culture of bridges, subways, airplanes, trucks, winches, engines, whistles, wires, steam, dynamos, oilrinsed circles, and phonographs. To these objects of the present he tries to link American past experience.[5]

In the "Cape Hatteras" section of *The Bridge*, for example, Crane links both the airplane and his admired Walt Whitman: the one made meaningful because of the other's existence. The airplane is symbolic of the New World that Whitman did not know:

Dream cancels dream in this new realm of fact
From which we wake into the dream of act;
Seeing himself an atom in a shroud—
Man hears himself an engine in a cloud! (*Complete Poems*, p. 89)

Nevertheless, if the new age is to survive the airplane, America must apprehend the kind of infinite wisdom that Whitman had. Crane asserts, affirmatively, that humankind will heed the wisdom of Whitman, the poet who "set breath in steel" (*Complete Poems*, p. 94). In fact Crane sees a vision of the ultimate absorption of the machine by the spiritual Whitman:

And, now as launched in abysmal cupolas of space,
Toward endless terminals, Easters of speeding light—
Vast engines outward veering with seraphic grace
On clarion cylinders pass out of sight
To course that span of consciousness thou'st named
The Open Road—thy vision is reclaimed!
What heritage thou'st signalled to our hands!
(*Complete Poems*, p. 95)

Remembering Crane's essay on Stieglitz and his discussion of Stieglitz's use of the machine, one can see that Crane was attempting to do what he imagined Stieglitz to be doing. Crane had an "unbounded respect" for the "mechanical perfectibility" of the airplane (not the camera in this instance) "which permits nature and all life [within the context of the poem] to mirror itself so intimately and so unexpectedly that we are thrown into ultimate harmonies" (*Letters*, p. 132). Crane, like Stieglitz, wanted to use

the machine through which he could apprehend lasting beauty.

On July 4, 1923, before he had written much on *The Bridge*, Crane sent a letter to Stieglitz in which he said, "I feel you as entering very strongly into certain developments in *The Bridge*" (*Letters*, p. 138). In this letter Crane sent "a roughly typed sheet containing some lines from *The Bridge*. They symbolize its main intentions" (*Letters*, p. 139). One of the stanzas (which Crane did not include in the final draft) shows one way in which Stieglitz might have entered into *The Bridge*, for the stanza reveals the interplay between nature and the machine culture; and the object that pulls the machine culture and the natural world together is the machine-bridge, about which Crane is speaking here:

> And, steady as the gaze incorporate
> Of flesh affords, we turn, surmounting all
> With keenest transience to that sear arch-head,—
> Expansive center, purest moment and electron
> That guards like eyes that must look always down
> In reconcilement of our chains and ecstasy
> That crashes manifoldly on us as we hear
> The looms, the wheels, the whistles in concord
> Tethered and welded as the hills of dawn
> Whose feet are shuttles, silvery with speed
> To tread and weave our answering word,—
> Recreate and resonantly risen in this dome.[6]

The bridge, like the camera, is the machine through which beauty is apprehended.

The Eternal Moment

The second element in his uncompleted essay on Stieglitz—that the photographer was capable of making a moment eternal—was also important for Crane's aesthetic. Crane, too, tried to

eternalize the moment. His vision, like the photographer's, was very intense; he could focus on the significant detail within the field of his vision and concentrate on that thing as it existed in that instant. A good example of his ability to capture a moment and thus eternalize it is the poem entitled, not surprisingly, "Moment Fugue." Crane abstracts from nature a picture of a man selling flowers by a subway. But the beauty of the abstraction lies in Crane's photographic ability to capture and concentrate on certain gestures and other details that might go unnoticed to the casual observer. The poem reads as follows:

> The syphilitic selling violets calmly
> and daisies
> By the subway news-stand knows
> how hyacinths
>
> This April morning offers
> hurriedly
> In bunches sorted freshly—
> and bestows
> On every purchaser
> (of heaven perhaps)
>
> His eyes—
> like crutches hurtled against glass
> Fall mute and sudden (dealing change
> for lilies)
> Beyond the roses that no flesh can pass.
>
> (*Complete Poems*, p. 173)

Phrases like "of heaven perhaps," and "like crutches hurtled against glass," and "that no flesh can pass" are literary and not photographic; they record the immediate impression that the objects within the abstraction suggested to the poet. (Photographers have

the option to express literary impressions in the titles to their pictures.) Most of the rest of the poem, however, is calm description of what took place within a particular moment within a particular space filled with certain objects—objects that had significant extraliteral relationships. A syphilitic cripple standing by a subway news-stand surrounded by violets, daisies, hyacinths, and lilies is emotionally significant in a different way from, for example, a syphilitic cripple standing in front of a subway news-stand. But the visual significance of the poem is further heightened by Crane's intense focusing on another real detail. In fact the emotional impact of this poem is dependent upon the relationships between details in the image, the most striking and evocative of which is the relationship established between the flowers he sells and the flowers ("roses"—evidence of his disease) on his body. Literary discussion or explanation can not make the reader feel the emotion delivered by this image. If it has not been done already, one can easily imagine a modern color photographer attempting to capture the emotional impact of this image by focusing closely, for example, on the "roses" on the skin of a syphilitic surrounded by flowers.

"Garden Abstract" similarly evokes emotion through the relationships established between objects. In this poem motion and time are stopped in the young girl, who is entranced, "drowning the fever of her hands in sunlight," who has "no memory, or fear, nor hope/Beyond the grass and shadows at her feet" (*Complete Poems*, p. 9). Much of the significance of the poem is revealed, for example, through the extraliteral relationship of the girl to the tree, the tree suggestively phallic. The photographer uses allusion in a similar way: by abstracting a moment in a field in which certain objects suggest a significance beyond depiction and enter the realm of allusion. The art photographer necessarily deals with visual allusion, whereas, of course, the poet does not.

Crane's preoccupation with capturing and eternalizing the moment was not confined to his shorter poems; readers of Crane

will notice that his longer poems are really a series of short, interconnected moments, the best of which have the visual intensity of "Moment Fugue." One of these moments occurs as the poet is riding on a streetcar in the long poem "For the Marriage of Faustus and Helen:"

> And yet, suppose some evening I forgot
> The fare and transfer, yet got by that way
> Without recall,—lost yet poised in traffic.
> Then I might find your eyes across an aisle,
> Still flickering with those prefigurations—
> Prodigal, yet uncontested now,
> Half-riant before the jerky window frame.
> (*Complete Poems*, p. 28)

This stanza marks the turning point of the poem, where the poet-persona makes an entrance from the actual world (of Faustus) into the eternal world of Helen. That the poet is being carried by a streetcar when he discovers eternity in an extended moment— when he is "lost yet poised in traffic"—indicates once again Crane's belief that beauty can be apprehended through the machine.

The bridge, in the poem *The Bridge*, is part of the eternal moment. For Crane the bridge is the concrete object that is supposed to carry the burden of his feelings about America. It is a machine; it is the epitome of beauty that the machine culture can produce. Crane also tried to invest it with "a motion [that] is continued from the picture infinitely: the moment made eternal" (*Letters*, p. 132), that for which he praised the Stieglitz photographs. Like the camera, said Crane in the poem, the bridge can "condense eternity" (*Complete Poems*, p. 46):

> And, Thee, across the harbor, silver-paced
> As though the sun took step of thee, yet left
> Some motion ever unspent in thy stride,—

Implicitly thy freedom staying thee!
(*Complete Poems*, p. 45)

But the most significant statement of the way in which Crane's poetry paralleled Stieglitz's photographic aesthetic is found in "some lines from *The Bridge*," which "symbolize its main intentions" (*Letters*, p. 139). These "lines" are also included in the letter to Stieglitz in which Crane said he felt the photographer "as entering very strongly into certain developments in *The Bridge*" (Letters, p. 138):

So on this structure [Bridge] I would stand
One moment, not as diver, but with arms
That open to project a salient disk
That winds the moon and midnight in one face.

Water shall not stem that disk, nor weigh
What holds its speed in vantage of all things
That tarnish, creep, or wane; and so in laughter
Blessed and posited beyond even that time
The Pyramids shall falter, slough into sand,—
Fiercely smooth above the wake and claim of wings
And figured in that radiant field that rings
The whispering cosmos, we hold consonance
Kinetic to a poised and deathless dance.[7]

By revealing Crane's preoccupation with the moment, with the way the moment is able to capture and extend motion, and with the way it is able to capture and extend time, these final two stanzas of the "lines" sent to Stieglitz confirm Crane's belief that he and Stieglitz "center[ed] in common devotions, in a kind of timeless vision" (*Letters*, p. 138).

"Sunday Morning Apples"—a poem about the relationship between the real world and art—also captures a moment. In this

poem the reader is given a couple of descriptions of paintings by William Sommer, but then Crane "describes" a natural event:

> A boy runs with a dog before the sun, straddling
> Spontaneities that form their independent orbits,
> Their own perennials of light
> In the valley where you live
> > (called Brandywine).
> > (*Complete Poems*, p. 7)

It is not surprising here to find Crane stopping another moment for observation so that the "essences of things" might be discovered. An event stopped in midair, however, is not really a natural event; it is a photographic event. In fact Crane seems to be describing a photograph, not a natural scene that occupies time as well as space, from which the painter might learn the secrets of nature. The boy and his dog are "snapped in a second, so to speak," wrote R. W. B. Lewis, "by the mind's camera eye."[8]

Equivalents

In "Sunday Morning Apples," Crane said: "I have seen the apples there that toss you secrets" (*Complete Poems*, p. 7). The apples in the Stieglitz photograph that prompted the writing of the essay on the photographer also tossed Crane secrets. First, he learned of the enormous potential of the machine for creating beauty. Second, he learned of the powerful effects of the moment made eternal. The third element in his essay on Stieglitz has to do with the kind of secrets that Crane thought the photograph was capable of tossing. Crane believed that Stieglitz, with his ability to apprehend and fix a moment, could reveal "harmonies" that exist beyond the actual depiction of the real objects. Correspondingly in "Sunday Morning Apples" Crane believed

that the painter William Sommer could also reveal these harmonies. But for capturing and extending motion and time, while at the same time revealing the illusion of reality, the camera was much more sensitive than the eye of the painter. Crane was intensely concerned with the actual things of the world; thus when he saw the Stieglitz photographs, he was aware of a kind of vision that was even more complete and expressive than that of Sommer. Crane, of course, recorded his enthusiasm over Stieglitz's apples in the essay on Stieglitz.

The "Apples and Gable" photograph was what Stieglitz called an "Equivalent"—a concrete visual, objective equivalent of a subjective, emotional experience. Stieglitz once said of the Flat Iron Building (Plate 19), "That is the new America. That building is to America what the Parthenon was to Greece." He said that he "saw the building as I had never seen it before. It looked, from where I stood, as though it were moving toward me like the bow of a monster oceansteamer—a picture, of the new America, that was still in the making."[9] In the same way, Crane's bridge is the concrete equivalent of a feeling he had about America: the bridge is the "symbol of our constructive future, our unique identity, in which is included also our scientific hopes and achievements of the future" (*Letters*, p. 124). The photographer and the poet were both working to find concrete, objective equivalents, or "ultimate harmonies" as Crane called them, of subjective, emotional experience: "That world," said Crane in "Faustus and Helen," "which comes to each of us alone" (*Complete Poems*, p. 29).

Crane began trying to find the equivalents or harmonies between subjective and objective reality very early. In "My Grandmother's Love Letters," he tried to describe the feeling evoked by the tangible presence of a packet of letters. "Sunday Morning Apples," "Praise for an Urn," and "Garden Abstract" are all among his earlier poems that try to express the feelings he got from looking upon objects. Some of his later poems also investi-

gate an object or objects and the feelings triggered by them. "Eternity" exemplifies the way in which he directly presents, almost catalogues, objects as they existed after a hurricane. The title announces the subjective feeling he receives from these objects. All of these poems reflect Crane's emotional response to the real, objective world; and he expressed this response in terms of the objects of the real world. The traditional camera photographer, of course, is forced to convey emotion in this way; he can react only to the objective world, and he can use only objects in the objective world to express himself. Thus Stieglitz said of his photograph entitled "The Terminal," "What made me see the watering of the horses as I did was my loneliness."[10] Similarly Crane found objective equivalents of his subjective emotional experiences in an urn, some love letters, a garden, some apples, and a bridge.

One can understand Crane's excitement over Stieglitz's photographs. By putting illusion at the service of allusion (to borrow H. H. Smith's terminology) Crane noted in his uncompleted essay that Stieglitz could get at the "essences of things . . . [that] are suspended on the invisible dimension whose vibrance has been denied the human eye at all times save in the intuition of ecstasy" (*Letters*, p. 132). Stieglitz could capture and record objects in the real world, and by so doing he could convey moments of ecstasy when the essences of things were revealed. For this reason Crane believed that Stieglitz was the "first, or rather the purest living indice of a new order of consciousness" (*Letters*, p. 138). Just as Stieglitz's photographs are projections of his personal vision, so are Crane's poems projections of his own personal vision. But Crane also expressed his personal vision through the literary metaphor, a device virtually unavailable to the photographer (except perhaps in titling a photograph).

"I have to combat every day those really sincere, but limited people" Crane wrote to Stieglitz, "who deny the superior logic of metaphor in favor of their perfect sums, divisions, and subtrac-

tions" (*Letters*, p. 138). In fact Crane's metaphors are at times so personal that they are probably inscrutable to anyone but Crane himself. Harriet Monroe, editor of *Poetry*, found many of them impossible to understand, and exchanged letters with Crane about them. Crane, of course, defended his metaphors: "The reader's sensibility simply responds by identifying this inflection of experience with some event in his own history of perceptions—or rejects it altogether" (*Complete Poems*, p. 235). Frequently the metaphor must be rejected. But sometimes Crane does find the verbal metaphoric equivalent (which is also frequently a visual equivalent) of subjective emotional experience. Visualize for example "merciless tidy hair," "mammoth turtles climbing sulphur dreams," "a white paraphrase/Among bruised roses," Christ's "tinder eyes" and "Unmangled target smile" (*Complete Poems*, pp. 14, 16, 17, 19). Here, the objects that the reader's vision is focused upon are skewed by Crane's inclusion of usually not more than one highly personal word. Sometimes this word creates a tension that is emotionally evocative, but at other times the word is so personal, so apparently nonreferential, that one wonders if Crane was experimenting with the use of words as objects the way Stein did in *Tender Buttons*. Through a highly personal vision Crane attempted to transform the depictive power of words into powerful allusion, through which he hoped to reveal the hidden beauty and meaning ("harmonies") of the real, machine dominated world. This was one of the ways in which he felt that he was an "accomplice" with Stieglitz.

That Stieglitz could reveal the hidden beauty and meaning of the real world, that he was capable of eternalizing a moment, and that he used a machine: these abilities Crane admired in Stieglitz, believing that he was doing in poetry what Stieglitz was doing in photography. Crane, however, could not ultimately do what Stieglitz did, for he could not finally "surrender to the sensations of urban life" (*Complete Poems*, p. 262) and the machine culture the way the photographer necessarily did. Allen Tate, for example,

could see no reason why the airplane could be in Crane's poetry a symbol of salvation, whereas the subway is a symbol of damnation. They are both machines, "produced by the same mentality on the same moral plane."[11] Alan Trachtenburg has suggested in his *Brooklyn Bridge* that Crane failed because he tried too hard to invest his bridge with symbolic significance, and as a result lost its significance as a real, concrete object.[12]

If Crane's failure occurred in part because he could not accept the real, concrete world that the photographer had to accept, it also occurred in part because his personal outlook, for long poems like "Faustus and Helen" and *The Bridge*, was *too* photographic—in the sense that he thought in terms of moments. As the longer poems reveal, we are treated to striking and beautiful moments, but not to the sustained vision necessary for a work of purported mythic proportions.

Williams, Stein, and Anderson also thought in terms of moments. But Stein was able to create a "continuous present" with a series of interrelated moments; and Williams' ability to use the very short form lent itself well to the striking image. Anderson was able to cluster his moments, or impressions, around a central idea and, thus, create a highly evocative tale. Crane's major successes are not his long poems, but those poems that are the most "photographic": the poems in which he accepts and uses the things of the world to create and eternalize a moment of experience; the poems that are brief equivalents of his feelings; the poems that most closely relate to the photograph of the apples that prompted the writing of his essay on Stieglitz.

Sherwood Anderson

(1876–1941)

Anderson spent approximately forty years of his life in business—as an advertiser, a columnist defending advertising, and president of United Factories Company, a mail-order jobbing agency. His imaginative writing career began, at least according to the popular story he told of himself, when he finally severed relationships (in the middle of a business letter) with the business world. He spent the rest of his life disclosing the evils of the business world—industrialism, the lying advertiser (himself included), the modern factory, and the machines therein, which robbed the worker of pride in his work.

Winesburg (the first of his more famous books) exposes the troubled lives of the small-town individuals who feel the impact of the new industrialism on a formerly agrarian society. Subsequently *Poor White* tells the story of Hugh McVey who, by inventing machines and making money, finds that "His own machines," as Hart Crane wrote, "have robbed him of something and left nothing in its place."[1] "The Egg," the central story in *The Triumph of*

the Egg, shows what happened when a couple "became ambitious,"
—when "the American passion for getting up in the world took
possession of them."[2] In *Horses and Men* the story "The Sad Horn
Blowers" reveals the fate of Will Appleton for whom there "was
nothing in the factory where he was now employed upon which
he could put down his feet. All day he stood at a machine and
bored holes in pieces of iron. A boy brought to him the little,
short, meaningless pieces of iron in a boxlike truck and, one by
one, he picked them up and placed them under the point of a
drill. . . . It had nothing to do with him. He had nothing to do
with it."[3]

Anderson's autobiographical works, like *A Story Teller's Story*,
provide the record of a man's conflict with industrial America.
And *Sherwood Anderson's Notebook* includes two major essays ("Stand-
ardization" and "Alfred Stieglitz") concerning the quest for iden-
tity in the new machine-dominated world. In *Perhaps Women*
Anderson said that "modern man is losing his ability to retain his
manhood in the face of the modern way of utilizing the ma-
chine."[4] Man feels emasculated in face of the machine because he
"feels too small. He is working all day and every day in the
presence of something apparently stronger than himself, more
efficient. It makes him feel inferior. His spirit gets tired. The
spirit of the machine doesn't tire—it hasn't any" (*Perhaps Women*,
p. 46). In 1931 Anderson spoke to a group of workers on strike.
A central point in his speech was that "There is a struggle going
on here that far transcends any local struggle. It is the struggle of
all mankind against the dominance of men by the machines and
by the man, or groups of men, who happen because they have
money, to own the machines."[5]

Anderson was not wholly reactionary; he did not completely
detest the machine and what it could produce. In fact he realized
that "there will no man live in my day who does not accept the
machine" (*Perhaps Women*, p. 11). He also realized that "the ma-
chine is only a tool, but for the present, at least, it is too big, too

efficient for us" (*Perhaps Women*, p. 46). The machine created a distinctly American problem—standardization. In Chicago, for example, "the attempt is being made to channel the minds of all men into one iron groove while in [Paris] the idiosyncrasies of individuals and groups are given breathing space and many channels of expression."[6] But he also believed that "Standardization is a phase. It will pass. The tools and materials of the workmen cannot always remain cheap and foul. Someday the workmen will come back to their materials, out of the sterile land of standardization."[7]

The Camera Machine

For Anderson the crucial problem was how to make the machine a tool rather than a dictator. Alfred Stieglitz provided the answer. Stieglitz used a machine—the camera—as a tool to produce beauty. Anderson wrote to Stieglitz in 1923, "dear man, you do so make the world a living place for so many people.... In our age, you know, there is much to distract from the faithful devotion to cleanliness and health in one's attitude toward the crafts, and it takes time to realize what the quality has meant in you. I really think, man, you have registered more deeply than you know on Marin, O'Keeffe, Rosenfeld, myself and others."[8] Anderson expressed his faith in the photographer in the last paragraph of his essay entitled "Alfred Stieglitz": "And perhaps that he is a photographer is significant too. It may well be the most significant thing of all. For has he not fought all of his life to make machinery the tool and not the master of man? Surely Alfred Stieglitz has seen a vision we may all some day see more clearly because of the fight he has made."[9]

Most readers of Sherwood Anderson have seen Stieglitz's photograph of him (Plate 20). "I'll never forget," said Stieglitz in a letter to Anderson, "what you made me feel as you walked into the room at 65th Street last autumn. Strength and Beauty. Or

should I say simply Great Beauty for Beauty is always strong" (*Life*, p. 174). The result of Stieglitz's feeling is one of the best-known photographs of the literary world.

Anderson maintained an interest in Stieglitz and in photography throughout his life. He published two articles on Stieglitz and dedicated a book to him. As late as 1938, three years before Anderson's death, he received a photograph from Stieglitz that he would add to his gallery of "some twelve or fifteen men looking down from the wall of the room" (*Letters*, p. 402). In 1940 he published the long sketch, *Home Town*, which included 142 photographs by such artists as Ben Shahn, Walker Evans, Dorothea Lange, and Arthur Rothstein.[10]

Anderson was not only interested in photography; he subscribed to a photographic aesthetic in that 1) he affected a direct, naïve style, 2) the crucial point in his stories frequently occurs at the moment when time and motion are stopped, 3) he focuses intensely upon the trivial detail that frequently carries major significance in his stories, and 4) he, like the photographer, puts illusion at the service of allusion.

Photographic Style

In a letter to a young writer, Anderson revealed his direct method: "It seems to me that the duty of the storyteller is to study people as they are and try to find the real drama of life just as people live and experience it" (*Letters*, p. 447). Tony Tanner describes Anderson's style as being written from a perspective that is deliberately naïve.[11] Further, Hart Crane observed in his essay on Anderson, "to appreciate [Anderson's] advance from the seductive stagnations of sentimentality to a clear acceptance and description of our life today for what it be worth, is to realize how few other Americans have had the courage, let alone the vision, to do anything like it."[12] Examples of Anderson's direct

method appear on every page of his books. The following is a typical paragraph (from the *Winesburg* story entitled "Adventure") in which the emotional impact is obtained by looking at and describing action directly:

And then one night when it rained Alice had an adventure. It frightened and confused her. She had come from the store at nine and found the house empty. Bush Milton had gone off to town and her mother to the house of a neighbor. Alice went upstairs to her room and undressed in the darkness. For a moment she stood by the window hearing the rain beat against the glass and then a strange desire took possession of her. Without stopping to think of what she intended to do, she ran downstairs through the dark house and out into the rain. As she stood on the little grass plot before the house and felt the cold rain on her body a mad desire to run naked through the streets took possession of her.[13]

Here, as in many instances, Anderson, like Stieglitz, reveals a photographic method. He saw and recorded things as they were, with the deliberate naïvety of the camera, without personal and subjective judgment. Nevertheless, through this direct, objective style, Anderson tried to convey deep personal feelings by selecting what he wanted to present to the reader, not by interpreting and evaluating.

The following example further illustrates this method: "Once he killed a dog with a stick. The dog belonged to Win Pawsey, the shoe merchant, and stood on the sidewalk wagging its tail. Tom King killed it with one blow. He was arrested and paid a fine of ten dollars" (*Winesburg*, p. 108). By affecting an objective and naïve prose style, Anderson makes a highly charged emotional indictment of both society and Tom King. The traditional novelist might be expected to elaborate on the incident. Anderson found a new, direct way to communicate subjective feelings by refusing to elaborate on what was directly perceived, by reporting

the incident photographically: "stark, sharp, and motionless," says Tanner, "—as though in crystal."[14]

Aside from real objects, like Duchamp's fountain-urinal (see Plate 17), the traditional photograph is the primary example of the artist having simply selected and presented. In the photographic aesthetic, that which is presented—that which is named—becomes important *because* it is presented.

The Moment

Anderson's photographic aesthetic also resides in his ability to stop and fix a moment in time and space. In fact the corpus of his work appears as a myriad of significant moments. In *A Story Teller's Story* Anderson said, "I have come to think that the true history of life is but a history of moments. It is only at rare moments we live" (*Story*, p. 224). *Sherwood Anderson's Memoirs* reiterated: "I am trying to give, in this broken way, an impression of a man, a writer in one of the rich moments of his life. I am trying to sing in these words, put down here the more glorious moments in a writer's life."[15] In "Four American Impressions" (the title is significant) Anderson tried to make the reader visualize a significant characteristic of each of four other writers—Gertrude Stein, Ring Lardner, Paul Rosenfeld, and Sinclair Lewis. Anderson said that his book *Perhaps Women* was "nothing but an impression" (*Perhaps Women*, p. 7).

The Triumph of the Egg is, as the subtitle says, "A book of impressions from American life." *No Swank* is a book of "this glance, this flash of light out of darkness . . . myself at the moment gathering impressions swiftly, storing them away" [Anderson's punctuation].[16] Indeed many of Anderson's essays appear to be attempts to understand a significant moment in time and space. Malcolm Cowley in his introduction to *Winesburg, Ohio* said: "Those moments at the center of Anderson's often marvelous stories were moments, in general, without sequel; they existed

separately and timelessly" (*Winesburg*, p. 11). Using an almost photographic analogy Cowley said that "for Anderson there was chiefly the flash of lightning that revealed life without changing it" (*Winesburg*, p. 11). Anderson himself said that his short stories were "the result of a sudden passion. It is an idea grasped whole as one would pick an apple in an orchard.... There are these glorious moments."[17] The stories constructed around these moments are comparable to the "decisive moments" that occur for the photographer when all the objects and motions on the ground glass or in the viewfinder contribute to the significance of the photograph.

With Anderson the decisive moment occurs when all of the separate nonchronological, noncausal episodes within the tale contribute, impressionistically, to the significant and meaningful moment of the tale. One moment from "The Untold Lie" in *Winesburg* illustrates how Anderson stops motion and time photographically to heighten the impact of its significance: "Ray Pearson arose and stood staring. He was almost a foot shorter than Hal, and when the younger man came and put his two hands on the older man's shoulders they made a picture. There they stood in the big empty field with the quiet corn shocks standing in rows behind them and the red and yellow hills in the distance, and from being just two indifferent workmen they had become all alive to each other" (*Winesburg*, p. 205).

In *A Story Teller's Story* Anderson discussed his aesthetic and his desire to arrest a significant moment for observation: "As though anything ever stood still anywhere. It was the artist's business to make it stand still, well, just to fix the moment, in a painting, in a tale, in a poem" (*Story*, p. 312). Anderson then quoted a poem of his that illustrated his desire to stop time and motion. The first paragraph of that poem reads as follows:

> I have wished that the wind would stop blowing,
> that birds would stop dead still in their flight,
> without falling into the sea, that waves would

> stand ready to break upon shores without breaking,
> that all time, all impulse, all movement, mood,
> hungers, everything would stop and stand hushed
> and still for a moment.
> (*Story*, p. 312)

The title of this poem is "One Who Would Not Grow Old," a title that is echoed in the introductory poem to Anderson's essay entitled "Alfred Stieglitz": "Old man—perpetually young—we salute you. Young man—who will not grow old—we salute you."[18]

Significant, Trivial Details

Anderson also focused intensely upon the trivial detail—the detail that in many instances carries the significance of a story. A story in *Winesburg* that illustrates Anderson's use of trivial details is "Paper Pills." The pills are pieces of paper: "In the office [Doctor Reefy] wore also a linen duster with huge pockets into which he continually stuffed scraps of paper. After some weeks the scraps of paper became little hard round balls, and when the pockets were filled he dumped them out upon the floor" (*Winesburg*, p. 36). The paper pills themselves are central to the tale. The messages that Dr. Reefy wanted to communicate to another person, but could not, are written on the pills. They are the trivial details that become symbols of Dr. Reefy's inability to communicate. In this same story Anderson also focuses upon the "twisted little apples that grow in the orchards of Winesburg. . . . Only the few know the sweetness of the twisted apples" (*Winesburg*, p. 36). The apples are associated with the paper pills, and even more particularly, with Doctor Reefy's knuckles. The weight of the whole tale, in fact, rests upon these few seemingly insignificant details. Anderson, like the photographer, called attention to the trivia of life and invested it with broad symbolic significance.

His characters are also the trivial—the unacknowledged, the forgotten men and women—who gain importance through Anderson's stories.

The photograph, by insisting upon every detail regardless of its ugliness, dirtiness, or its trivality (as in Plate 4, for example) forced the viewer to see objects he had rejected before. Anderson, like the artist-photographer, concentrated on these objects, intensified them, enriched them, and interrelated them to make a tale.

Equivalents

The photograph that Stieglitz made of Anderson (Plate 20) does not in fact show Anderson as he looked most of the time; it is an interpretation of Anderson. It illustrates the way reality, or the illusion of reality, can elicit a subjective response from the viewer. Anderson evoked feelings of "Strength and Beauty" in Stieglitz, and Stieglitz tried to capture these qualities in the photograph. But caveats apply to the viewing of photographs, and this one is no exception. First the viewer must remember that the photograph reveals an expression on Anderson's face that may never have existed again after the moment that Stieglitz decided to take the picture. Secondly the point of view in the photograph is literally unduplicable. Thirdly the motion recorded in the head, and especially in the shock of hair on Anderson's forehead, and the preciseness of detail in the rest of Anderson's body is unduplicable as Stieglitz recorded them. The motion in the head tends to blur the very slight details and accentuate the dark heavy lines of Anderson's face. The point of view gives the feeling of a heavy, strong chin and head. The head and body seem to be moving off to the right so that one gets the impression that Anderson turned and looked at the viewfinder as he was passing by. The look he gives is penetrating, accusing, question-

ing. These are the subjective feelings that the objective fact of the photograph of the real Anderson may suggest to a viewer. Stieglitz tried to elicit this kind of subjective response from the viewer in almost all of his photographs. In this instance Stieglitz snapped his photograph at the precise moment that Anderson, as he existed for a second, suggested strength and beauty. If the reader responds similarly, then Stieglitz's photograph has succeeded.

What Stieglitz was after was "a reality so subtle," he wrote to Anderson, "that it becomes more real than reality. That's what I'm trying to get down in photography. . . . I feel you are after a similar thing and are working it out in *your* way as I work it out in *my* way" (*Life*, p. 173). Stieglitz came to call this "more real" reality an *Equivalent*—the photograph created when the photographer's mind finds the presentation of an emotional experience in the real world. "Photography," said Stieglitz, "brings what is not visible to the surface."[19] Both Anderson and Stieglitz attempted to reveal this reality beneath the surface.

As Anderson wrote in a letter to his son, the feelings one expresses through objective reality are important: "Draw things that have some meaning to you. An apple, what does it mean?" He continued: "The object drawn doesn't matter so much. It's what you feel about it, what it means to you" (*Letters*, p. 166). Like Stieglitz and Hart Crane, Anderson tried to put the illusion of reality at the service of allusion. As Paul Rosenfeld said, Anderson "perceives the world and in perceiving it transcends it." Even Anderson's "words are bifurcated in his mind; while the one wing rests on the ground . . . the other points into blue air, becomes symbol of the quality of inner life."[20]

Anderson presented the illusion of life to get at the inner reality of characters. Like the photographer, the things, the objects, he presents are symbolically loaded. Wing Biddlebaum's hands, for example, in the *Winesburg* story entitled "Hands," are the concrete objects that carry the significance of the story. As the story progresses, as several objective incidents about Wing's hands are related, "the hands," said Rex Burbank, "change from

image to symbol . . . and the themes of alienation, fear, love, and shame become in turn associated with them."[21]

The pills of "Paper Pills" become equivalents of Doctor Reefy's attempts to communicate with other people, and the significance of the pills is heightened by the presence of other significant objects, especially the twisted apples. The twisted apples themselves illustrate Anderson's attitude toward the inner significance of objects. These apples are left to rot by the pickers in the orchards because of their appearance; they are, however, among the sweetest apples on the tree. Anderson and Stieglitz, after looking with their own distinctive visions and feelings at an object, tried to invest that object with significance. "What subtle flavors," said Anderson in the foreword to *Horses and Men*, "are concealed in [an apple]—how does it taste, smell, feel? Heavens, man, the way the apple feels in the hand is something—isn't it?"[22]

In most of Anderson's stories, certain (frequently trivial) objects become equivalents of the main themes: loneliness, the mental and physical release from the frustrations of loneliness, or the establishment of communication that dispels loneliness at least temporarily. These themes are revealed most powerfully at the primary significant moments in the stories or tales when the full significance of the objects and their interrelationship with other objects is clear.

Impressionism, Expressionism

Rex Burbank compared Anderson with Gauguin (who frequently painted from photographs): Gauguin, like Anderson, was able to reveal "inner feelings with external forms."[23] The suggestion that Anderson's work is Impressionistic, or Expressionistic, like the painter's, is provocative, for Anderson (like Stieglitz) looked for the external visual equivalent of his own inner feelings.

That Anderson was also a painter surely intensified his preoccu-

pation with visual communication. Although he received little recognition for his painting, he did have two shows, and Stieglitz admired them. Anderson knew he was not an important painter, but he enjoyed laying "one color against another" (*Story,* p. 261), and he also enjoyed looking at "the work of many modern paint-ers [who] had given me a new feeling for form and color" (*Story,* p. 272).

Burbank also compared the *Winesburg* form to techniques of the Impressionists and post-Impressionists. In Impressionism, form grows out of the artist's feelings, so that the unity of any given painting, even though it may be a series of disconnected images, is maintained by the overall impression made by the subject on the painter and, of course, by the inherent relation-ships between the things within the painting. Obviously Anderson used Impressionist techniques. "Hands," "Paper Pills," "The Teacher," "An Awakening," "The Man Who Became a Woman," all of these stories are filled with chronologically unrelated mo-ments. Each tale is made up of a number of sketches that could exist outside of the context of the complete tale. Yet all the sketches combined form a unit and evoke a feeling that would be impossi-ble without all the seemingly disparate parts.

James Schevill compared the *Winesburg* form to Expression-ism: "The Expressionism ideal was to break down the realistic image into its most revealing parts, each part to be important in itself, but all combining to create a more valid emotional portrait of the whole than naturalism could furnish" (*Life,* p. 100).

Stieglitz could "break down the realistic image into its most revealing parts" (as is noticed by the lack of sharp detail in the face of the Anderson portrait, which emphasizes the heavy lines of the face and the large clump of hair). Stieglitz could also unify a series of disconnected images into a single portrait that had no linear significance, as revealed by the portrait of Georgia O'Keeffe (Plates 9 and 10). Furthermore he could take a picture in which all of the details in the photograph contributed to its significance.

He did this by selecting his scene at the precise moment from a particular point of view so that what he saw in the viewfinder matched his inner feelings. Stieglitz, however, did not call himself an Impressionist or an Expressionist; he said that he made *Equivalents*.

Furthermore, Anderson and Stieglitz both stuck closer to nature than the painters did. Anderson used real objective details, details that exist for all people outside of Anderson's consciousness. The painter, on the other hand, frequently used highly subjective details that were at times too personal to be understood by others. Thus one would rather call Anderson (like Stieglitz) a photographic Expressionist, or a photographic Impressionist, for he knew how to make Equivalents while at the same time sticking close to the objective world.

Weltanschauung

Anderson (like Stein, Williams, and Crane) not only subscribed to a photographic aesthetic, but he (like Crane) saw in Stieglitz that the machine could be used as a tool to create beauty. Stieglitz's fight for the quality workman, his fight, said Anderson, for "bringing in something healthy . . . love of work well and beautifully done," became Anderson's fight as well [Anderson's punctuation].[24] "Surely nothing in the modern world," said Anderson in *A Story Teller's Story*, "has been more destructive than the idea that man can live without the joy of hands and mind combined in craftsmanship, that men can live by the accumulation of monies, by trickery" (*Story*, p. 236). Anderson himself had once lived as an advertising man "by the accumulation of monies, by trickery," and *A Story Teller's Story* reveals his escape from the standardized world of the businessman and the dictatorial machine to become a true craftsman. Perhaps that is why Anderson said to Stieglitz: "I believe I have selected the right book [*A Story Teller's*

Story] to bear your name on the title page, because I believe it will have in it the most of you in me" (*Letters*, p. 106). The dedication reads:

To
ALFRED STIEGLITZ
who has been more than father to so many
puzzled, wistful children of the arts in
this big, noisy, growing and groping
America, this book is gratefully
dedicated.

Conclusion

Stieglitz's personal relationships with these twentieth-century writers left an indelible mark upon their aesthetics and Weltanschauungen. These were among the first writers in American to acknowledge their debt to the medium of photography and to incorporate many of the characteristics of that medium in their own work. Through Stieglitz and his photography these writers became aware of the enormous possibilities that the objective world offered for verbal exploitation. They used their words to impress the presence of the real world upon the mind. They forced the reader to look at trivial details that had never been seen before, and they forced the mind's eye upon the "insignificant" and "inconsequential" objects of the world, whereupon the objects became significant by the mere insistence of their presence. A rose is only a rose; but "a rose is a rose is a rose is a rose," is an object that cannot be ignored.

When these writers were able to see and experience the real, objective world, out of joy and not out of habit, they began to

focus, like the photographer, on the personally significant details in the world. They saw the fine hairs on the shinbone and the moisture on the lips in Stieglitz's photographs, and they focused, like Anderson, on the walnut knuckles of Dr. Reefy's hands, or, like Williams, on the purple mole at the center of the Queen-Ann's-Lace. They discovered that they could manipulate their focus, their depth of field, within a single tale, poem, or portrait. Williams' "Queen-Ann's-Lace" provides a major example of manipulated focus, as does Stein's portrait, "Four Dishonest Ones."

The photographer exemplified for the writers how to capture a moment in time. Anderson's tales exist as a series of moments, as do many of Stein's portraits. Many of Williams' poems are moments captured. Crane, in his essay on Stieglitz, discussed the significance of the "moment made eternal" and he used the motionless, timeless moment in many of his poems. The photograph, by stopping time, revealed gestures and physical attitudes that had never before been seen, and offered them to the writers (as well as painters) for their use. The photograph also afforded the writers a different concept of time, which enabled them to experiment with nonlinear time. The writers' narratives were no longer chronological, but impressionistic; and their stories were held together by the "symbolic" associations that existed between objects. They saw visual confirmation from the photograph that significant, trivial details and moments would have to connect with every other detail and moment in order for the central feeling of their stories or poems to be revealed. Revelation was the style and end result of artistic creation; plot gave way to coherence by association.

If the photographer were to convey a feeling, he had to abstract the framed objects of his vision from nature at the exact moment that those objects relayed the feeling to him. The photographer was forced to put the illusion of reality at the service of allusion if he wanted to convey a feeling or a message. Stieglitz called the resultant, emotionally charged photograph an Equiva-

lent: a visual objective equivalent of a subjective emotional experience. The photographer *had* to find the equivalent of emotional experience in the real world. The writers found that they could also express an emotional experience by including certain real (though verbalized, of course) objects within a frame. The result of this organization, or "composition by field," would be an impression, a feeling. A list of the stories and poems that included all of the compositions by Stein, Williams, Crane, and Anderson that are organized in this photographic fashion, would be long. Most of Stein's *Tender Buttons;* many of Williams' poems, including "Between Walls," "The Locust Tree in Flower," "The Red Wheelbarrow," "Jersey Lyric," "April," and "The Girl"; much of Crane's work, including "Episode of Hands," "Moment Fugue," and "Garden Abstract"; almost all of Anderson's stories in *Winesburg, Ohio;* all of these works are equivalents of subjective emotional experience, and they convey feeling through revelation—through the total impact of the subjective relationships that exist between objects on a field.

The admirers of Stieglitz not only explored many of the characteristics of the medium of photography, but they also subscribed to a photographic Weltanschauung. Stieglitz felt that he was not truly living unless he was living in and for the present moment only. To live fully one had to be totally involved in the immediate and actual. "When I am no longer thinking, but simply *am*," said Stieglitz, "then I may be said to be truly affirming life."[1] Likewise Stein, Williams, and Anderson wrote, in their nonimaginative writings, about their own philosophies of the immediate and actual. "The business of Art," said Gertrude Stein, "is to live in the actual present, that is the complete actual present, and to express that complete actual present."[2] "A life that is here and now," wrote Williams, "is timeless. That is the universal I am seeking: to embody that in a work of art, a new world that is always 'real' "[3] Anderson said, "I have come to think that the true history of life is but a history of moments. It is only

at rare moments we live."[4] Crane made no similar explicit statement about his Weltanschauung, but in his essay on Stieglitz he described with enthusiasm the way in which the photographer could catch a hundredth of a second "so precisely that the motion is continued from the picture infinitely: the moment made eternal." Later in a letter to Stieglitz he spoke of the way in which he and the photographer "center[ed] in common devotions, in a kind of timeless vision".[5] The photograph, as a "mirror with a memory," made the timeless vision possible by capturing moments; and it was this timeless vision towards which all of Stieglitz's literary admirers strove—in art and in life.

Both Crane and Anderson learned through Stieglitz that it was possible for the machine to produce good effects in a world that was becoming more standardized. Stieglitz used a machine, the camera, as a tool to produce beauty. "Has [Stieglitz] not fought all of his life," wrote Anderson, "to make machinery the tool and not the master of man?"[6] For Crane, too, the work of Stieglitz was positive proof that beauty could be created with a machine: "It is the passivity of the camera," said Crane in his essay on Stieglitz, "coupled with the unbounded respect of this photographer for its mechanical perfectibility which permits nature and all life to mirror itself so intimately and so unexpectedly that we are thrown into ultimate harmonies by looking at these stationary, yet strangely moving pictures."[7] Stieglitz, through his photography, made it possible for his literary admirers to accept the machine world and recognize its potential for beauty and enlightenment. By comparing the beauty produced by his machine with the lack of beauty produced by other machines, the writers also discovered how far behind Stieglitz the rest of the world was, and they strove in their own writings (both imaginative and nonimaginative) to improve it.

Stieglitz, then, as the most influential practitioner of his art in his time, had a profound impact upon twentieth-century writers. He revealed the value and significance of the objective world—a

world that included the minute, the trivial, and the ugly. By stopping time he revealed the possibilities of the moment, and by stopping motion he showed physical attitudes that had never before been seen, and that the writer could explore. Correspondingly, he released time from its chronological and linear boundaries. Furthermore he showed that feelings and impressions could be revealed through visual equivalents of subjective emotional experience and that a variety of apparently unrelated details on a field or in a frame could reveal a larger significance. He emphasized the fact that the illusion of reality could be put at the service of allusion. Finally, he revealed the possibilities inherent in the machine by using a machine as a tool, like a true craftsman, to produce a personal, significant gift for the world.

As we learn more about Stieglitz and photography, we will be able to evaluate more clearly not only the modern movement in American literature and its concurrent flowering with photography—the medium that epitomizes the artistic expression of the age of the machine—but the visual revolution that began with the invention of photography and continues today.

Notes
Selective Bibliography
Index

Notes

Photography and Alfred Stieglitz

1. Nathaniel Hawthorne, "Maule's Well," *The House of the Seven Gables* (Boston: Ticknor, Reed, and Fields, 1851), p. 101.
2. Oliver Wendell Holmes, "Doings of the Sunbeam," *Atlantic Monthly*, 12 (1863), 9, 15.
3. John Szarkowski, *The Photographer's Eye* (New York: Museum of Modern Art, 1966), p. 6.
4. Szarkowski, p. 12.
5. Paul Rosenfeld, *Port of New York* (1924; rpt. Urbana: Univ. of Illinois Press, 1961), p. 244.
6. Rosenfeld, p. 248.
7. Paul Rosenfeld, "The Boy in the Dark Room," in *America and Alfred Stieglitz*, ed. Waldo Frank, Lewis Mumford, Dorothy Norman, Paul Rosenfeld, and Harold Rugg (Garden City, NY: Doubleday, Doran, 1934), pp. 84–85.
8. Quoted in Frederick Wight, *Charles Sheeler* (Los Angeles: Univ. of California, 1954), p. 26.
9. Herbert J. Seligmann, "291: A Vision through Photography," in *America and Alfred Stieglitz*, ed. Waldo Frank et al. (Garden City, NY: Doubleday, Doran, 1934), p. 121.
10. Henry Holmes Smith, "New Figures in a Classic Tradition," in *Aaron Siskind: Photographer*, ed. Nathan Lyons (Rochester, NY: George Eastman House, 1965), p. 20.
11. Marsden Hartley, *Adventures in the Arts* (New York: Boni and Liveright, 1921), p. 105.
12. Quoted in Dorothy Norman, *Alfred Stieglitz: Introduction to an American Seer* (New York: Duell, Sloan and Pearce, 1960), p. 37.

13. Quoted in Doris Bry, *Alfred Stieglitz: Photographer* (Boston: Museum of Fine Arts, 1965), p. 19.
14. Quoted in Carl Siembab, "Alfred Stieglitz," *Photography Annual* (1969), p. 14.
15. Rosenfeld, *Port of New York*, p. 251.
16. Lewis Mumford, "The Metropolitan Milieu," in *America and Alfred Stieglitz*, ed. Waldo Frank et al. (Garden City, NY: Doubleday, Doran, 1934), p. 57. 17. In Norman, *Alfred Stieglitz*, p. 8.
18. Alfred Stieglitz, "From the Writings and Conversations of Alfred Stieglitz," *Twice A Year*, 1 (1938), 99.
19. Henri Cartier-Bresson, *The Decisive Moment* (New York: Simon and Schuster, 1952).
20. In Norman, *Alfred Stieglitz*, p. 12.
21. In Dorothy Norman, "An American Place," in *America and Alfred Stieglitz*, ed. Waldo Frank et al. (Garden City, NY: Doubleday, Doran, 1934), p. 135.
22. Seligmann, "291," pp. 114, 124.
23. Waldo Frank, *Our America* (New York: Boni and Liveright, 1919), p. 181.
24. Alfred Stieglitz, "The Origin of the Photo-Secession and How it Became 291," *Twice A Year*, 8–9 (1942), 114.
25. Stieglitz, "From the Writings and Conversations," p. 89.
26. In Norman, "An American Place," p. 141.
27. Stieglitz, "From the Writings and Conversations," p. 97.
28. Gertrude Stein, "Stieglitz," in *America and Alfred Stieglitz*, ed. Waldo Frank et al. (Garden City, NY: Doubleday, Doran, 1934), p. 280.
29. See Hyatt Waggoner, "Science and Poetry: Imagism," *American Poets, from the Puritans to the Present* (Boston: Houghton Mifflin, 1968), pp. 331–52.

Gertrude Stein

1. John Malcolm Brinnin, *The Third Rose: Gertrude Stein and Her World* (Boston: Little, Brown, 1959), p. 74.
2. Alfred Stieglitz, "*Camera Work* Introduces Gertrude Stein to America," *Twice A Year*, 14–15 (1946–47), 195.
3. Quoted in Brinnin, p. 157.
4. Gertrude Stein, *Picasso* (1939; rpt. Boston: Beacon Press, 1959), p. 8.
5. See especially Gertrude Stein, *Narration* (Chicago: Univ. of Chicago Press, 1935), and "Portraits and Repetition," in *Writings and Lectures, 1911–1945* (London: Peter Owen, 1967), pp. 98–122. Subsequent references cited in text as *Writings and Lectures*.
6. Gertrude Stein, *What Are Masterpieces* (1940; rpt. New York: Pitman, 1970), pp. 85–86.

7. Quoted in Dorothy Norman, *Alfred Stieglitz: Introduction to an American Seer* (New York: Duell, Sloan and Pearce, 1960), p. 54.

8. Gertrude Stein, *Four in America*, introd. Thornton Wilder (New Haven, CT: Yale Univ. Press, 1947), p. vii.

9. Gertrude Stein, *Lectures in America* (New York: Random House, 1935), pp. 104–05.

10. Quoted in Dorothy Norman, ed. *Twice A Year* 1 (1938), 3.

11. Gertrude Stein, "Composition as Explanation," in *Selected Writings*, ed. Carl Van Vechten (1945; rpt. New York: Vintage, 1972), p. 518. Subsequent references cited in text as *Selected Writings*.

12. Gertrude Stein, *The Autobiography of Alice B. Toklas* (1933; rpt. New York: Vintage Books, 1961), p. 114.

13. Gertrude Stein, *Portraits and Prayers* (New York: Random House, 1934), p. 57.

14. Brinnin, p. 148.

15. Stein, *Four in America*, pp. v–vi.

16. Sherwood Anderson, *No Swank* (Philadelphia: Centaur Press, 1934), pp. 81–85.

17. William Carlos Williams, "The Work of Gertrude Stein," in *Selected Essays of William Carlos Williams* (New York: Random House, 1954), p. 116.

18. Stein, *Alice B. Toklas*, p. 119.

19. Brinnin, p. 157.

20. Brinnin, p. 160.

21. Gertrude Stein, *Geography and Plays*, introd. Sherwood Anderson (Boston: The Four Seas, 1922), p. 7.

22. Allegra Stewart, *Gertrude Stein and the Present* (Cambridge: Harvard Univ. Press, 1967), pp. 87–88.

William Carlos Williams

1. Most of this chapter was written before I read Bram Dijkstra's *The Hieroglyphics of a New Speech* (Princeton, NJ: Princeton Univ. Press, 1969). In some instances I disagree with his interpretation of Stieglitz's influence on Williams; nevertheless, the points at which our ideas are parallel are more plentiful, and the reader's understanding of Stieglitz and Williams would be incomplete without Dijkstra's essential, comprehensive study.

2. William Carlos Williams, *The Autobiography* (1951; rpt. New York: New Directions, 1967), p. 236. Subsequent references cited in text as *Autobiography*.

3. William Carlos Williams, "The American Background," in *Selected Essays of William Carlos Williams* (New York: Random House, 1954), p. 160.

4. John Malcolm Brinnin, *William Carlos Williams* (Minneapolis: Univ. of Minnesota Press, 1963), p. 12. See chapter one for a fuller discussion of Imagism.

5. Williams, *Selected Essays*, p. 234.
6. Williams, *Autobiography*, p. 138.
7. Gertrude Stein, *Picasso* (1939; rpt. Boston: Beacon Press, 1959), p. 12.
8. William Carlos Williams, "A Note on Poetry," in *Oxford Anthology of American Literature*, ed. W. R. Benet and N. H. Pearson (New York: Oxford Univ. Press, 1938), p. 1313.
9. Quoted from manuscript in James Guimond, *The Art of William Carlos Williams* (Urbana: Univ. of Illinois Press, 1968), p. 100.
10. William Carlos Williams, *The Collected Earlier Poems* (New York: New Directions, 1951), p. 93. Subsequent references cited in text as *Earlier Poems*. There are many other examples of this kind of poem, but see especially the following: "Iris," "To Flossie," "The Blue Jay," "It Is a Living Coral," "Rain."
11. William Carlos Williams, *The Selected Letters of William Carlos Williams*, ed. John C. Thirlwall (New York: Mcdowell, Obolensky, 1957), pp. 286–87.
12. William Carlos Williams, *Spring and All* (Dijon, France: Contact Publishing, 1923), p. 3. Dedicated to a "Stieglitz painter," Charles Demuth.
13. Williams, *Selected Essays*, p. 233.
14. William Carlos Williams, *In the American Grain* (1925; rpt. New York: New Directions, 1956), pp. 43, 192.
15. William Carlos Williams, *Pictures from Brueghel and Other Poems* (New York: New Directions, 1962), p. 41. See also "His Daughter," "To a Poor Old Woman," "Proletarian Portrait," "Jersey Lyric," "The Blue Jay."
16. William Carlos Williams, *The Collected Later Poems*, rev. ed. (New York: New Directions, 1963), p. 50.
17. Edward Weston's photographs reveal the true beauty of the toilet.
18. In the Introduction to Byron Vazakas, *Transfigured Night* (New York: Macmillan, 1946), p. xi.
19. Quoted in Dorothy Norman, *Alfred Stieglitz: Introduction to an American Seer* (New York: Duell, Sloan and Pearce, 1960), p. 9.
20. Paul Rosenfeld, *Port of New York* (1924; rpt. Urbana: Univ. of Illinois Press, 1961), p. 269.
21. *Encyclopedia of Poetry and Poetics*, ed. Alex Preminger (Princeton, NJ: Princeton Univ. Press, 1965), p. 833.
22. Williams, *Selected Essays*, p. 294.
23. William Carlos Williams, *Paterson* (1946–58; rpt. New York: New Directions, 1963), p. 14.
24. Williams, *Selected Essays*, p. 233.
25. Williams, *Paterson*, p. 133.
26. In Norman, *Introduction to An American Seer*, p. 12.

Hart Crane

1. Hart Crane, *The Letters of Hart Crane: 1916–1932*, ed. Brom Weber (1952;

rpt. Berkeley: Univ. of California Press, 1965), p. 131. Subsequent references cited in text as *Letters*.

2. Crane was also a friend of the photographer Hervey W. Minns and wrote a short article on his work.

3. Waldo Frank, *Our America* (New York: Boni and Liveright, 1919),p. 181.

4. Hart Crane, *The Complete Poems and Selected Letters and Prose of Hart Crane*, ed. Brom Weber (New York: Liveright Publishing Corporation, 1966), p. 262. Subsequent references cited in text as *Complete Poems*.

5. In this sense he attempted what Williams did in *In The American Grain* (which Crane read), and what Gertrude Stein did in many of her books (e.g. *The Making of Americans*).

6. In Brom Weber, *Hart Crane* (1948; rpt. New York: Russell and Russell, 1970), p. 427.

7. In Weber, *Hart Crane*, p. 427.

8. R. W. B. Lewis, *The Poetry of Hart Crane* (Princeton, NJ: Princeton Univ. Press, 1967), p. 43.

9. Quoted in Dorothy Norman, *Alfred Stieglitz: Introduction to an American Seer* (New York: Duell, Sloan and Pearce, 1960), p. 16.

10. Quoted in Norman, *Alfred Stieglitz: Seer*, p. 8.

11. Allen Tate, "Hart Crane," in *Prose Keys to Modern Poetry*, ed. Karl Shapiro (Evanston, IL: Row, Peterson, 1962), p. 219.

12. Alan Trachtenburg, *Brooklyn Bridge: Fact and Symbol* (New York: Oxford Univ. Press, 1965), p. 168–70.

Sherwood Anderson

1. Hart Crane, "Sherwood Anderson," in *The Complete Poems and Selected Letters and Prose of Hart Crane*, ed. Brom Weber (1966; rpt. London: Oxford Univ. Press, 1968), p. 210.

2. Sherwood Anderson, *The Triumph of the Egg* (New York: B. W. Huebsch, 1921), p. 46.

3. Sherwood Anderson, *Horses and Men* (New York: B. W. Huebsch, 1923), p. 279.

4. Sherwood Anderson, *Perhaps Women* (New York: H. Liveright, 1931), p. 7. Subsequent references cited in text as *Perhaps Women*.

5. Quoted in James Schevill, *Sherwood Anderson: His Life and Work* (Denver: Univ. of Denver Press, 1951), p. 273. Subsequent references cited in text as *Life*.

6. Sherwood Anderson, *Notebook* (New York: Boni and Liveright, 1926), p. 141.

7. Sherwood Anderson, *A Story Teller's Story*, (1924; rpt., ed. Ray Lewis White, Cleveland: The Press of Case Western Reserve Univ., 1968), p. 213. Subsequent references cited in text as *Story*.

8. Sherwood Anderson, *Letters*, ed. Howard Mumford Jones and Walter B. Rideout (Boston: Little, Brown, 1953), p. 99. Subsequent references cited in text as *Letters*.

9. Anderson, *Notebook*, p. 159.

10. In 1964 the photographer Art Sinsabaugh published *6 Mid-American Chants by Sherwood Anderson* (Highlands, NC: J. Williams, 1964), in which he faced each poem with one of his own "midwest photographs."

11. Tony Tanner, *The Reign of Wonder: Naïvety and and Reality in American Literature* (Cambridge, England: University Press, 1965), p. 211.

12. Crane, *Complete Poems, Letters, Prose*, p. 211.

13. Sherwood Anderson, *Winesburg, Ohio*, intro. Malcolm Cowley (1919; rpt. New York: Viking Press, 1961), p. 119. Subsequent references cited in text as *Winesburg*.

14. Tanner, *Reign of Wonder*, p. 211.

15. Sherwood Anderson, *Memoirs* (New York: Harcourt, Brace, 1942), p. 343.

16. Sherwood Anderson, *No Swank* (Philadelphia: Centaur Press, 1934), p. vii.

17. Anderson, *Memoirs*, p. 341.

18. Anderson, *Notebook*, p. 151.

19. Quoted in Dorothy Norman, *Alfred Stieglitz: Introduction to an American Seer* (New York: Duell, Sloan and Pearce, 1960), p. 12.

20. Paul Rosenfeld, *Port of New York*, introd. Sherman Paul (1924; rpt. Urbana: Univ. of Illinois Press, 1961), pp. 179–80.

21. Rex Burbank, *Sherwood Anderson* (New York: Twayne, 1964), p. 64.

22. Anderson, *Horses and Men*, p. ix.

23. Burbank, *Anderson*, p. 62.

24. Sherwood Anderson, "City Plowman," in *America and Alfred Stieglitz: A Collective Portrait*, ed. Waldo Frank et al. (Garden City, NY: Doubleday, Doran, 1934), p. 308.

Conclusion

1. Quoted in Dorothy Norman, *Alfred Stieglitz: Introduction to an American Seer* (New York: Duell, Sloan and Pearce, 1960), p. 54.

2. Gertrude Stein, *Lectures in America* (New York: Random House, 1935), pp. 104–05.

3. William Carlos Williams, "Against the Weather: A Study of the Artist," *Twice A year*, 2 (1939), 53.

4. Sherwood Anderson, *A Story Teller's Story* (1924; rpt. ed. Ray Lewis White, Cleveland: The Press of Case Western Reserve Univ., 1968), p. 213.

5. Hart Crane, *The Letters of Hart Crane: 1916–1932*, ed. Brom Weber (1952; rpt. Berkeley: Univ. of California Press, 1965), pp. 132, 138.

6. Sherwood Anderson, *Notebook* (New York: Boni and Liveright, 1926), p. 159.

7. Crane, *Letters*, p. 132.

Selective
Bibliography

Anderson, David D. *Sherwood Anderson: An Introduction and Interpretation*. New York: Holt, Rinehart, and Winston, 1967.

Anderson, Sherwood. "City Plowman." *America and Alfred Stieglitz*. Ed. Waldo Frank, Lewis Mumford, Dorothy Norman, Paul Rosenfeld, and Harold Rugg. Garden City, NY: Doubleday, Doran, 1934.

——. *Horses and Men*. New York: B. W. Huebsch, 1923.

——. *Letters of Sherwood Anderson*. Ed. Howard Mumford Jones in assoc. with Walter B. Rideout. Boston: Little, Brown, 1953.

——. *No Swank*. Philadelphia: Centaur Press, 1934.

——. *Perhaps Women*. New York: H. Liveright, 1931.

——. *Sherwood Anderson's Memoirs*. New York: Harcourt, Brace, 1942.

——. *Sherwood Anderson's Notebook*. New York: Boni and Liveright, 1926.

——. *Short Stories*. Ed. Maxwell Geismar. New York: Hill and Wang, 1962.

——. and Art Sinsabaugh. *6 Mid-American Chants by Sherwood Anderson and 11 Midwest Photographs by Art Sinsabaugh*. Highlands, NC: Jonathan Williams, 1964.

——. *A Story Teller's Story*. Ed. Ray Lewis White. 1924; rpt. Cleveland: The Press of Case Western Reserve Univ., 1968.

——. *The Triumph of the Egg*. New York: B. W. Huebsch, 1921.

——. *Winesburg, Ohio*. Introd. Malcolm Cowley. 1919; rpt. New York: Viking, 1961.

Blackmur, R. P. *Form and Value in Modern Poetry*. 1946; rpt. Garden City, NY: Doubleday, 1957.

Braive, Michel F. *The Era of the Photograph: A Social History*. Trans. David Britt. London: Thames and Hudson, 1966.

Brinnin, John Malcolm. *The Third Rose: Gertrude Stein and Her World*. Boston: Little, Brown, 1959.

―――. *William Carlos Williams*. Minneapolis: Univ. of Minnesota Press, 1963.

Brown, Milton W. *American Painting from the Armory Show to the Present*. Princeton: Princeton Univ. Press, 1955.

Bry, Doris. *Alfred Stieglitz: Photographer*. Boston: Museum of Fine Arts, 1965.

Bulliet, C. J. *Apples and Madonnas: Emotional Expressionism in Modern Art*, rev. enl. ed. Garden City, NY: Blue Ribbon Books, 1930.

Burbank, Rex. *Sherwood Anderson*. New York: Twayne, 1964.

Cartier-Bresson, Henri. *The Decisive Moment*. New York: Simon and Schuster, 1952.

Cheney, Sheldon. *A Primer of Modern Art*, 11th ed. New York: Liveright, 1949.

Coburn, Alvin Langdon. *Alvin Langdon Coburn, Photographer: An Autobiography*. Ed. Helmut and Alison Gernsheim. London: Faber, 1966.

Coke, Van Deren. *The Painter and the Photograph*. Albequerque: Univ. of New Mexico Press, 1964.

Crane, Hart. *The Complete Poems and Selected Letters and Prose of Hart Crane*. Ed. Brom Weber. 1966; rpt. London: Oxford Univ. Press, 1968.

―――. *The Letters of Hart Crane: 1916–1932*. Ed. Brom Weber. 1952; rpt. Berkeley: Univ. of California Press, 1965.

Craven, Thomas. *Modern Art*, rev. ed. New York: Simon and Schuster, 1940.

Dembo, L. S. *Conceptions of Reality in Modern American Poetry*. Berkeley: Univ. of California Press, 1966.

Deutsch, Babette. *Poetry in Our Time*, 2d ed. rev. and enl. New York: Doubleday, 1963.

Dijkstra, Bram. *The Hieroglyphics of a New Speech: Cubism, Stieglitz, and the Early Poetry of William Carlos Williams*. Princeton: Princeton Univ. Press, 1969.

Doty, Robert. *Photo-Secession: Photography As a Fine Art*. New York: George Eastman House, 1960.

Duchamp, Marcel. "The Richard Mutt Case." *Readings in American Art Since 1900: A Documentary Survey*. Comp. Barbara Rose, New York: Praeger, 1968.

Encyclopedia of Poetry and Poetics. Ed. Alex Preminger. Princeton: Princeton University Press, 1965.

Frank, Waldo. *Our America*. New York: Boni and Liveright, 1919.

―――. Lewis Mumford, Dorothy Norman, Paul Rosenfield, and Harold Rugg, eds. *America and Alfred Stieglitz: A Collective Portrait*. Garden City, NY: Doubleday, Doran, 1934.

Gallup, Donald, ed. *The Flowers of Friendship: Letters Written to Gertrude Stein.* New York: Knopf, 1953.

Geismar, Maxwell. *The Last of the Provincials: The American Novel, 1915–1925.* Boston: Houghton Mifflin, 1947.

Guimond, James. *The Art of William Carlos Williams: A Discovery and Possession of America.* Urbana: Univ. of Illinois Press, 1968.

Hartley, Marsden. *Adventures in the Arts.* New York: Boni and Liveright, 1921.

Hawthorne, Nathaniel. *The House of the Seven Gables.* Boston: Ticknor, Reed, and Fields, 1851.

Hoffman, Frederick J. *Gertrude Stein.* Minneapolis: Univ. of Minnesota Press, 1961.

Holmes, Oliver Wendell. "Doings of the Sunbeam." *Atlantic Monthly,* 12 (1863), 1–15.

Homer, William Innes. *Alfred Stieglitz and the American Avant-Garde.* Boston: New York Graphic Society, 1977.

Horton, Phillip. *Hart Crane: The Life of An American Poet.* 1937; rpt. New York: Viking, 1957.

Ivins, William N. *Prints and Visual Communication.* Cambridge: Harvard Univ. Press, 1953.

Koch, Vivienne. *William Carlos Williams.* Norfolk: New Directions, 1950.

Lewis, R. W. B. *The Poetry of Hart Crane.* Princeton: Princeton Univ. Press, 1967.

Matthiessen, F. O. *American Renaissance.* New York: Oxford Univ. Press, 1941.

Miller, J. Hillis. *Poets of Reality.* Cambridge: Belknap Press of Harvard Univ., 1965.

Minuit, Peter. "291 Fifth Avenue." *Seven Arts,* (Nov. 1916), p. 61.

Moholy-Nagy, L. *Vision in Motion.* Chicago: Paul Theobald, 1947.

Mumford, Lewis. "The Metropolitan Milieu." *America and Alfred Stieglitz.* Ed. Waldo Frank, Lewis Mumford, Dorothy Norman, Paul Rosenfeld, and Harold Rugg. Garden City, NY: Doubleday, Doran, 1934, pp. 35–58.

Naef, Weston J. *The Collection of Alfred Stieglitz.* New York: Metropolitan Museum of Art, 1978.

Neisser, Ulrich. *Cognition and Reality.* San Francisco: W. H. Freeman, 1976.

Norman, Dorothy. *Alfred Stieglitz: An American Seer.* New York: Aperture, 1973.

———. *Alfred Stieglitz: Introduction to an American Seer.* New York: Duell, Sloan and Pearce, 1960.

———. "An American Place." *America and Alfred Stieglitz.* Ed. Waldo Frank,

Lewis Mumford, Dorothy Norman, Paul Rosenfeld, and Harold Rugg. Garden City, NY: Doubleday, Doran, 1934, pp. 126–51.

————. ed. *Twice A Year,* 1–17 (1938–1948).

Pearce, Roy Harvey. *The Continuity of American Poetry,* Princeton: Princeton Univ. Press, 1961.

Quinn, Sister M. Bernetta. "William Carlos Williams: A Testament of Perpetual Change," *The Metamorphic Tradition in Modern Poetry.* New Brunswick, NJ: Rutgers Univ. Press, pp. 89–129.

Rosenfeld, Paul. "The Boy in the Dark Room." *America and Alfred Stieglitz.* Ed. Waldo Frank, Lewis Mumford, Dorothy Norman, Paul Rosenfeld, and Harold Rugg. Garden City, NY: Doubleday, Doran, 1934, pp. 59–88.

————. *Port of New York.* Introd. Sherman Paul. 1924; rpt. Urbana: Univ. of Illinois Press, 1961.

Rosenthal, M. L. *The Modern Poets: A Critical Introduction.* New York: Oxford Univ. Press, 1960.

Schevill, James. *Sherwood Anderson: His Life and Work.* Denver: Univ. of Denver Press, 1951.

Seligmann, Herbert J. "291: A Vision through Photography." *America and Alfred Stieglitz.* Ed. Waldo Frank, Lewis Mumford, Dorothy Norman, Paul Rosenfeld, and Harold Rugg. Garden City, NY: Doubleday, Doran, 1934, pp. 105–25.

Siembab, Carl. "Alfred Stieglitz." *Photography Annual: 1969,* (1969), pp. 10–18.

Smith, Henry Holmes. "New Figures in a Classic Tradition." *Aaron Siskind: Photographer.* Ed. Nathan Lyons. Rochester, NY: George Eastman House, 1965, pp. 15–23.

Sontag, Susan. *On Photography.* New York: Farrar, Straus and Giroux, 1977.

Spears, Monroe K. *Hart Crane.* Minneapolis: Univ. of Minnesota Press, 1965.

Sprigge, Elizabeth. *Gertrude Stein: Her Life and Work.* New York: Coward-McCann, 1957.

Stein, Gertrude. *The Autobiography of Alice B. Toklas.* 1933; rpt. New York: Vintage, 1961.

————. *Four in America.* Introd. Thornton Wilder. New Haven: Yale Univ. Press, 1947.

————. *Geography and Plays.* Introd. Sherwood Anderson. Boston: The Four Seas, 1922.

————. *Lectures in America.* New York: Random House, 1935.

————. *Narration.* Chicago: Univ. of Chicago Press, 1935.

————. *Picasso.* 1939; rpt. Boston: Beacon Press, 1959.

————. *Portraits and Prayers.* New York: Random House, 1934.

————. *Selected Writings*. Ed. Carl Van Vechten. 1945; rpt. New York: Vintage, 1972.

————. "Stieglitz." *America and Alfred Stieglitz*. Ed. Waldo Frank, Lewis Mumford, Dorothy Norman, Paul Rosenfeld, and Harold Rugg. Garden City, NY: Doubleday, Doran, 1934, p. 280.

————. *Three Lives*. Introd. Carl Van Vechten. Norfolk: New Directions, 1933.

————. *What Are Masterpieces*. Los Angeles: The Conference Press, 1940.

————. *Writings and Lectures: 1911–1945*. Ed. Patricia Meyerowitz. Introd. Elizabeth Sprigge. London: Peter Owen, 1967.

Stewart, Allegra. *Gertrude Stein and the Present*. Cambridge: Harvard Univ. Press, 1967.

Stieglitz, Alfred. "Camera Work Introduces Gertrude Stein to America." *Twice A Year*, 14–15 (1946–47), 192–95.

————. "From the Writings and Conversations of Alfred Stieglitz." *Twice A Year*, 1 (1938), 75–110.

————. "Random Thoughts—1942." *Twice A Year*, 10–11 (1943), 262–64.

————. "Ten Stories." *Twice A Year*, 5–6 (1940–1941), 135–63.

————. "The Origin of the Photo-Secession and How It Became 291." *Twice A Year*, 8–9 (1942), 114–36.

————. ed. *291*, 1–12 (1915–16).

Strand, Paul, "Alfred Stieglitz and a Machine." *America and Alfred Stieglitz*. Ed. Waldo Frank, Lewis Mumford, Dorothy Norman, Paul Rosenfeld, and Harold Rugg. Garden City, NY: Doubleday, Doran, 1934, pp. 281–85.

Sutherland, Donald. *Gertrude Stein: A Biography of Her Work*. New Haven: Yale Univ. Press, 1951.

Szarkowski, John. *The Photographer's Eye*. New York: Museum of Modern Art, 1966.

Taft, Robert. *Photography and the American Scene: A Social History, 1839–1889*. 1938; rpt. New York: Dover, 1964.

Tanner, Tony. *The Reign of Wonder: Naïvety and Reality in American Literature*. Cambridge, England: University Press, 1965.

Tate, Allen. "Hart Crane." *Prose Keys to Modern Poetry*. Ed. Karl Shapiro. Evanston, IL: Row Peterson, 1962, pp. 213–22.

Trachtenburg, Alan. *Brooklyn Bridge: Fact and Symbol*. New York: Oxford Univ. Press, 1965.

Waggoner, Hyatt. *American Poets: From the Puritans to the Present*. Boston: Houghton Mifflin, 1968.

Weatherhead, A. Kingsley. *The Edge of the Image*. Seattle: Univ. of Washington Press, 1967.

Weber, Brom. *Sherwood Anderson*. Minneapolis: Univ. of Minnesota Press, 1964.

——. *Hart Crane: A Biographical and Critical Study*. 1948; rpt. corrected edition with a new preface, New York: Russell and Russell, 1970.

Wight, Frederick. *Charles Sheeler*. Los Angeles: Univ. of California Press, 1954.

Williams, William Carlos. "The American Background." *America and Alfred Stieglitz*. Ed. Waldo Frank, Lewis Mumford, Dorothy Norman, Paul Rosenfeld, and Harold Rugg. Garden City, NY: Doubleday, Doran, 1934, pp. 9–32. 1934, pp. 9–32.

——. "Against the Weather: A Study of the Artist." *Twice A Year*, 2 (1939), 53f.

——. *The Autobiography of William Carlos Williams*, New York: Random House, 1959.

——. *The Collected Earlier Poems*. New York: New Directions, 1951.

——. *The Collected Later Poems*. Rev. ed. New York: New Directions, 1963.

——. *In the American Grain*. 1925; rpt. New York: New Directions, 1956.

——. "Introduction" to *Transfigured Night*. Byron Vazakas. New York: Macmillan, 1946.

——. "A Note on Poetry." *Oxford Anthology of American Literature*. Ed. W. R. Benet and N. H. Pearson. New York: Oxford Univ. Press, 1938, pp. 1313–14.

——. *Paterson*. 1946–1958; rpt. New York: New Directions, 1963.

——. *Pictures from Brueghel and Other Poems*. New York: New Directions, 1962.

——. *Spring and All*. Dijon, France: Contact Publishing, 1923.

——. *Selected Essays of William Carlos Williams*. New York: Random House, 1954.

——. *The Selected Letters of William Carlos Williams*. Ed. John C. Thirlwall. New York: McDowell, Obolensky, 1957.

Index

F. Richard Thomas is Professor of American Thought and Language, Michigan State University. He has been a MacDowell Colony Fellow and recipient of a Fulbright Teaching Award. He has been the editor of *Centering*, a magazine of poetry and short fiction, since 1973. Among his publications is *Frog Praises Night* (1980) published by Southern Illinois University Press.

The Literary Admirers of Alfred Stieglitz

Designed by Bob Nance

*Composed by E.T. Lowe Publishing
in Linotron Janson*

*Printed by Thomson-Shore
on Warren's Olde Style text stock
with an illustration insert
of Warren's L.O.E. Dull*

*Bound by John H. Dekker and Sons
in Holliston Roxite Vellum and Elephant Hide
with Elephant Hide endsheets*

The Dow Jones-Irwin Guide to

MUTUAL FUNDS

The Dow Jones-Irwin Guide to

MUTUAL FUNDS

DONALD D. RUGG, Ph.D.

NORMAN B. HALE

Revised Edition

DOW JONES-IRWIN
Homewood, Illinois 60430

ISBN 0-87094-352-9
Library of Congress Catalog Card No. 82-71381
Printed in the United States of America

1 2 3 4 5 6 7 8 9 0 D 0 9 8 7 6 5 4 3

To Beverlyann

Preface

This book presents a *complete do-it-yourself* investment program for the investor willing to bear limited risks to stay ahead of inflation and taxes. The program is based on intermediate to long-term trading of money market funds and no-load equity funds. This book shows you how to set up your own personal investment program, how to select the best objective for yourself, how to pick the best no-load stock and money market funds, and, finally, how to time the market. You are also shown how to use *IRA, Keogh,* and *corporate retirement plans* to minimize your taxes.

To clearly describe this program, we have divided the book into four major parts. Part 1 emphasizes the importance of developing a sound investment program—one that is tailored specifically to your own special needs and circumstances. Specific self-tests are provided which show you how to select your investment objective by evaluating your own family situation, financial position, and attitudes toward risk. Part 2 shows you how to pick the *no-load mutual funds* and *money market funds* that are likely to perform best in the future. Part 3 is devoted to market timing. Three of the best monetary, psychological, and cyclical *stock market indicators* are discussed in detail. By using these indicators you will

learn *precisely* when to time your transactions. Part 4 documents how you would have performed in the past by following our guidelines. The truly *phenomenal results* that you would have enjoyed are shown in our carefully constructed market experiment. Finally, we discuss the pros and cons of tax-sheltered retirement plans and show you how to set up the best one for yourself, or your company. Special emphasis is given to *IRA accounts* and *corporate pension* and *profit sharing plans.*

The authors are grateful to many friends and colleagues for their helpful suggestions, encouragement, and assistance. We owe a special word of thanks to Kevin Cassidy for his valuable assistance in helping us with our research, and to Walt and William Roudeau of Growth Fund Research for providing numerous charts and other helpful data. We are also indebted to Eugene Larson, Donald Charlesworth, and Dr. Robert Crouch of the University of California, Santa Barbara. These individuals provided many helpful suggestions and have significantly improved the content, exposition, and overall quality of the book. We are also appreciative of publisher and author permission to quote various published works. Any errors are, of course, the sole responsibility of the authors.

West Los Angeles, Donald D. Rugg
California Norman B. Hale

Contents

Introduction

If you are like most investors, you probably have found it very difficult to select good stocks. Our research revealed nine major reasons why investors, particularly small investors, often make foolish investment decisions:

1. Failure to develop a sound strategy.
2. Bearing either too much or too little risk.
3. Poor investment selection.
4. Poor timing.
5. Inadequate diversification.
6. High transactions costs.
7. Poor advisers.
8. Failure to control emotions—especially greed and fear.
9. Paying excessive taxes.

The typical investor does not possess the knowledge, time or desire to undertake the research necessary to avoid these errors. So what recourse does he or she have? In this book we propose the intermediate to long-term trading of no-load mutual funds. Our approach is to invest in small high-performance, no-load mutual funds during favorable periods in the stock market. During down or sideways markets, all money is placed in high-yielding money

market funds. The objective is to reap substantial profits in rising markets and to protect these gains during down periods. Sounds simple, doesn't it? It is!

Any aggressive investor who followed this approach since 1962 would have seen an initial investment of $10,000 grow to well over $740,000 by 1982. This represents an average annual rate of return of 24.8 percent per year for the entire period. Even more surprising is the consistency of the results. Out of the nine transactions recommended by this system since 1962, no losses were incurred—despite the fact that three of the sharpest stock market drops of this century occurred during this period. The drops occurred during 1966, 1969-70, and 1973-74. This performance is documented in Chapter 10.

We believe the program described in this book offers most investors the best opportunity to make above-average profits in the stock market. It does so because it allows investors to make maximum use of the one major advantage they have over big institutions—the *flexibility of being small.* Big institutions cannot move from equities to cash and back to equities without incurring large transactions costs. However, an individual or retirement plan investor can easily move in and out of no-load funds for no cost at all. While large institutional investors are locked into their investment during down markets due to their enormous size, the small no-load fund investor is sitting safely in high-yielding money market funds.

This book will also assist you in knowing yourself. Every investor who wishes to progress beyond the novice stage must carefully evaluate his or her emotional nature, attitudes toward risk, and economic and family situation. Chapter 1 of this book shows you not only how to undertake such an evaluation but also how to use this information to determine what *risk exposure* level is most suitable for you. We believe you'll find the simple exercises we provide to be both enjoyable and informative. Once you have determined what risk-exposure level is most appropriate for yourself, your next question is how to determine which funds are best for you. The solution to this problem is outlined in Chapters 2 through 6.

Chapters 7 through 9 of this book are devoted to improving your investment timing. These chapters discuss what the authors

believe are the best monetary, psychological, and cyclical indicators for forecasting future trends in stock prices.

The fund program we advocate also solves the problems of *inadequate diversification.* The only funds that pass through our fund-screening process are diversified no-load funds. These funds achieve efficient diversification by placing only a limited sum of money in any given stock or industry. Thus, no-load investors are automatically protected from having "all their eggs in one basket."

No-load funds also shield you from *excessive transactions costs.* Most no-load funds can be bought and sold for no cost whatsoever. Those that do charge a redemption fee normally set it at a very low level and almost always remove it after a short period of time. The second factor contributing to low transactions costs is that our fund program involves infrequent trading; we attempt only to catch major trends in stock prices. For both reasons, high transactions costs are no problem for no-load investors.

The seventh pitfall mentioned above is *poor advice.* Many investors rely almost totally upon individuals who, because of ignorance, incompetence, or conflicts of interest, provide low-quality guidance. The obvious solution is to avoid dependence upon others by becoming self-reliant and learning how to select good advisors.

The eighth factor which prevents many investors from achieving investment success is *failure to control the emotions of fear and greed.* This lack of self-discipline has resulted in large losses and much worry for many investors. Buy how can one overcome these emotions? One way is to become more aware of them by studying the damage which they have inflicted on countless investors throughout history. Our chapter on investor psychology (Chapter 8) provides such a historical perspective by focusing upon many humorous but nevertheless tragic examples. Perhaps more important, the rules and procedures we define in the fund program leave no room for emotions. Thus, they help shield you from making impulsive choices.

The final obstacle to successful investing is paying excessive taxes. Many individuals and businesses have overlooked the opportunity to save tremendous amounts of tax dollars by taking advantage of IRA, Keogh, and corporate retirement plans as well

as charitable trusts. A discussion of these plans, together with their ideal suitability to no-load mutual fund investing, is presented in the final two chapers of this book.

In summary, this book was written to help you understand why you may have failed to invest successfully in the past and to show you how to overcome these problems in the future. If you follow the program outlined in this book, you will become a much better investor.

part 1

Self-Evaluation

1

Know Yourself

The basis of any successful investment program is a well-thought-out strategy. In this sense, successful investing is much like playing successful football. Both rely heavily upon a good game plan, an imaginative play book, and much practice to improve execution. Without this prior planning, it would be almost impossible for a football team to successfully run a single play—let alone win a game. Similarly, without investment planning you are unlikely to succeed as an investor.

To develop a good strategy, a coach must first evaluate his own players, the personnel on opposing teams, and the rules under which the game is played. Based on this information, his own goals, attitudes toward risk, and general understanding of the game, he drafts a game plan and selects the key plays to be used. Similarly, you must carefully evaluate yourself, know your major life goals, your attitudes toward risk, and have a good grasp of investing *before* developing your own investment program. The remainder of this chapter discusses the first steps in this process—analyzing your life situation and your life goals and identifying your attitude toward risk.

ANALYZE YOUR LIFE SITUATION

The first step in formulating an investment program is to carefully analyze your life situation. There are a wide variety of factors surrounding the life of an individual which influence the individuals investing. A partial list of these factors is presented in Table 1-1. Note that five major categories are shown: family status, personal characteristics of family members, current level of wealth, current and other future income levels, and life goals.

Variations in any of these elements may have a substantial impact on your investment strategy. For example, a 25-year-old man with a wife, five children, and an income level of $25,000 per

Table 1-1
Life situation variables relevant to investment decisions

I.	Family status.	
	1.	Marital status.
	2.	Number of dependents.
II.	Personal characteristics of family members.	
	1.	Age.
	2.	Sex.
	3.	Health.
	4.	Education.
III.	Current level of wealth.	
	1.	Business ownership.
	2.	Current savings.
	3.	House.
	4.	Automobiles.
	5.	Bonds and securities.
	6.	Real estate.
	7.	Jewelry.
	8.	Precious metals.
	9.	Other.
IV.	Current and other future income levels.	
	1.	After tax take-home pay.
	2.	Investments.
	3.	Trusts.
	4.	Gifts.
	5.	Other.
V.	Life goals.	
	1.	Business or career objectives.
	2.	Future wealth and income levels.
	3.	Retirement age.
	4.	Leisure time.
	5.	Family size.
	6.	Charitable donations.
	7.	Other.

year would have vastly different investment requirements than a 50-year-old man with no dependents and an income of $100,000 per year. The young man should probably place his savings in very safe and liquid investments so that he can purchase a home, provide a good education for his children, and meet unanticipated emergencies. The older man has many fewer responsibilities and can justifiably place a substantial portion of his savings in more risky and less liquid assets in hopes of increasing his retirement income. Although this example is intentionally extreme and may seem self-evident, the fact is many people almost totally disregard these considerations. Such carelessness has, and will continue to have, tragic personal consequences for many investors and their families.

To avoid such mistakes you should carefully evaluate your own situation. One useful way to accomplish this is to calculate both your current and expected future income and expenditure levels. Although your estimates will probably be quite crude, they will serve an extremely useful purpose. They will not only help you avoid making serious mistakes but they will assist you in planning for your future and developing a sound investment strategy. You should revise these estimates fairly frequently to reflect any future changes in your goals, attitudes, and life situation.

Most of the factors you will need to consider to make these calculations are listed in Table 1-2. The size of each of these

Table 1-2
Income and expenditure variables

I. Current and future income.
 1. Growth rate in earnings (estimated).
 2. Investment profits.
 3. Social security payments.
 4. Pension income.
 5. Expected inheritances.
 6. Expected gifts.
 7. Other.
II. Current and anticipated future expenditures.
 1. Housing, furnishings, and maintenance.
 2. Transportation (auto).
 3. Food.
 4. Clothing.
 5. Emergencies (legal, medical, etc.)
 6. Recreation.
 7. Other.

factors is likely to depend heavily upon the life situation variables listed in Table 1-1. You should carefully consider how the factors in Table 1-1 will influence your future income and expenditure levels. You should take special care in estimating the size of your expenditures—for it is easy to underestimate the cost of many items, such as a home, furnishings, or a good education for your children. It is also easy to overlook some crucial expenditures like insurance costs or the cost of saving an emergency fund to protect your family against unforeseen contingencies such as illness or unemployment.

Once you have estimated your future income and expenditure levels, it is a simple matter to calculate how much you expect to save in the future. The savings level during each year is simply the difference between the expected income and expenditure levels for that year. A rough approximation of your future savings level is an invaluable planning tool. In addition to providing you with a clear picture of your present financial situation, it can also help you better understand how this situation would change if you were to make different vocational, family, and lifestyle decisions. This may lead you to revaluate some of your major life goals, such as your future spending plans, your intended age of retirement, your desired retirement income, your desired family size, and the relative importance to you of work versus leisure.

If you do not undertake a comprehensive evaluation of your situation, you may end up making critically important lifetime decisions without investigating all the options open to you. In addition, you may underestimate the impact which decisions made today will have on the attainment of your future goals. As a result you may make some very tragic mistakes—like failing to adequately plan for your retirement or needlessly neglecting consumption during younger years due to an unfounded fear of poverty during retirement. Don't allow this to happen to you. Plan for your future.

If you have undertaken the self-evaluation recommended above, you will now have a much clearer picture of what your future savings level will be, given your present plans. If the indicated saving level is not satisfactory, you will have a better idea of how to modify your plans to achieve your desired level of savings. Once you have decided upon the savings program that you can afford and achieve, you must determine how, when, and

where you will invest your savings. You cannot possibly do this effectively until you thoroughly understand both the risks involved in investing and your capacity to bear these risks.

DETERMINE HOW MUCH RISK YOU ARE WILLING TO ACCEPT

A second important ingredient in formulating an investment program is a careful assessment of your attitudes toward risk. Such awareness and self-evaluation are vitally important for two reasons. First, the degree of risk assumed by the investor is one of the most important determinants of investment performance. Second, investors have widely different capacities for accepting risk.

Types of Risk

The obvious first step in such self-evaluation is to familiarize yourself with the three major types of investment risk: (1) market risk, (2) interest rate risk, and (3) purchasing power risk. Although these risk categories apply to every type of investment, we shall concentrate on them only as they relate to securities.

Market risk results from price fluctuations which are related to the fundamental business conditions and investor psychology. These price fluctuations frequently result from changes in investor expectations regarding the current and future state of the economy. Many broad underlying factors may be responsible for changes in these expectations, including wars, elections, governmental policy changes, balance-of-payments considerations, and money market conditions. These price fluctuations may also be influenced by changes in the fundamental economics of a company as reflected through the growth and stability of its earnings. The most common factors influencing earnings are supply and demand conditions within relevant industries, changes in the competitive position of a firm within the industry, tax legislation, management changes, strikes, write-offs due to bad investments, governmental regulations, and lawsuits. Market risk may be measured by several different techniques, although the beta coefficient is probably used most frequently. A beta coefficient is simply the ratio of the average price performance of a given stock or

mutual fund relative to that of some market average. For example, a ratio of 2.0 would indicate that a security tended on average to move about twice as rapidly as the general market.

The second component of risk, interest rate risk, is caused by changes in the interest rates. This risk is most serious for holders of bonds or fixed income investments. The value of these bonds and fixed income investments, by definition, move inversely with changes in the market rate of interest.

This is best illustrated with a simple example. Assume that bond A is purchased for $1,000 and that it pays 12 percent or $120 per year to the holder in perpetuity. Now let us suppose that the interest rate on a newly issued bond, type B (which is identical in every respect to bond A), rises to 15 percent due to a new tight-money policy by the Federal Reserve Board. Thus a type B bond offers $150 per year in perpetuity. What now happens to bond A? The answer is that people who hold type A bonds will sell them on the market in order to purchase the new higher yielding type B bonds. Thus, the supply of type A bonds to the market by investors increases and the price of these bonds will fall until the yield is equal to 15 percent—the yield on type B bonds. This occurs when the price of type A bonds reaches $800. If, on the other hand, interest rates had declined to 9 percent on bonds of type B, the opposite situation would have occurred. The price of type A bonds would then have *increased* to $1,333, where the yield would then be equal to 9 percent.

Table 1-3 shows how the yields on long-term U.S. Treasury bonds have changed from 1942 to 1980. During this period, the trend has been steadily upward and bond prices have fallen dramatically. The cause of this significant rise in interest rates was, and continues to be, the high rate of inflation and the deficit financing undertaken by the government.

The third type of risk, purchasing power risk, is the risk of inflation. The fact that inflation decreases the purchasing power of the dollar is familiar to every consumer. This problem has been with us for some time and has accelerated to the double-digit level in recent years. Table 1-4 shows what has happened to the purchasing power of the dollar, as measured by the Consumer Price Index and the Wholesale Price Index, since 1941. Note that the dollar has steadily *decreased in value* and that the rate of decline has accelerated since 1970. The main cause of these price increases

Table 1-3
Yields on long-term treasury bonds

Year	Treasury Bond Yields (percent)	Year	Treasury Bond Yields (percent)
1980	10.81	1960	4.01
1979	8.74	1959	4.07
1978	7.89	1958	3.43
1977	7.06	1957	3.47
1976	6.78	1956	3.08
1975	6.98	1955	2.84
1974	6.99	1954	2.55
1973	6.30	1953	2.94
1972	5.63	1952	2.68
1971	5.74	1951	2.57
1970	6.59	1950	2.32
1969	6.10	1949	2.31
1968	5.25	1948	2.44
1967	4.85	1947	2.25
1966	4.66	1946	2.19
1965	4.21	1945	2.37
1964	4.15	1944	2.48
1963	4.00	1943	2.47
1962	3.95	1942	2.46
1961	3.90		

Source: *Economic Report of the President,* (Washington, D.C.: U.S. Government Printing Office, 1981).

is the recent rapid expansion in the money supply, increases that are attributable to excessive levels of government spending and the associated monetization of debt by the Federal Reserve. Today a dollar will buy less than 20 percent of what it would 40 years ago. All indications are that inflation is likely to continue into the future.

Risk and Rate of Return

Any investor who intends to progress beyond the novice level must have a thorough understanding of how different types of investments are affected by each type of risk. The investor should also be aware of the relationship between market risk and the rate of return on investments. In general, the more market risk you are willing to assume, the higher will be your expected rate of return in up markets and the higher your losses in down markets. This trade-off relationship is well documented and exists because most investors prefer safe investments.

Table 1-4
Consumer and wholesale prices (1967 equals 100)

Year	Consumer Prices	Wholesale Prices
1980	246.8	268.7
1979	217.4	235.6
1978	195.4	209.3
1977	181.5	194.2
1976	170.5	183.0
1975	161.2	174.9
1974	147.7	160.1
1973	133.1	135.7
1972	125.3	119.1
1971	121.3	113.9
1970	116.3	110.4
1969	109.8	106.5
1968	104.2	102.5
1967	100.0	100.0
1966	97.2	99.8
1965	94.5	96.6
1964	92.9	94.7
1963	91.7	94.5
1962	90.6	94.8
1961	89.6	94.5
1960	88.7	94.9
1959	87.3	94.8
1958	86.6	94.6
1957	84.3	93.3
1956	81.4	90.7
1955	80.2	87.8
1954	80.5	87.6
1941	44.1	45.1

Source: *Federal Reserve Bulletin*, July, 1981.

Our fund program takes advantage of the high upside rate of return achievable during bull markets by investing in performance-oriented no-load equity funds. During bear markets, we avoid the large losses suffered by such investments through switching out of these funds into high-yielding money market mutual funds.

This simple relationship between market risk and reward does not hold for purchasing power risk. During periods of rapid inflation, all long-term bonds and most types of stocks and mutual funds suffer large price declines. Investors who follow our program will be protected from such losses as they will be in

highly liquid money market funds during these periods. The yields on these funds tend more or less to match the existing rate of inflation.[1]

Obviously, there is no perfect investment. You cannot enjoy both a *high rate of return and low levels of risk.* Because of this dilemma, you must think very carefully about the combination of risk and return that best meets your own needs.

Setting your risk level, and hence your expected rate of return, is without a doubt the single most important decision you will make as an investor. This decision may determine whether or not you will be able to achieve many of your most important life goals. It may, for example, influence the date of your retirement, your retirement income, the leisure time available during your working years, your standard of living, or many other important aspects of your life.

The overriding importance of achieving a high rate of return on your investments can be illustrated with a simple example.

Let us compare the amount of wealth accumulated at age 65 by three different individuals—Mr. Timid, Mr. Normal, and Mr. Aggressive. Let us assume that all three persons are now 30 years of age, have an income of $20,000 per year, $10,000 of investable savings, and that they expect to save 15 percent of all their future earnings. Let us further assume that each man will achieve a maximum income of $80,000 per year in 35 years when he retires, and that the three men are identical in every other respect (such as family size and life goals), bar one: They have different preferences toward risk and opt for different types of investments. Mr. Timid hates risk and places all his money in a savings and loan at 7 percent interest. Mr. Normal is willing to accept more risk and places his money in blue-chip common stocks, earning an average of 9 percent on his money. Mr. Aggressive is willing to accept more risk and invests in aggressive mutual funds, earning an average annual rate of return of 16 percent.

Let us now examine the expected wealth levels of each man when he reaches age 65, his point of retirement. The differences are rather astonishing! Mr. Timid has a wealth level of $1,040,000, Mr. Normal a level of $1,195,000, and Mr. Aggressive an almost

[1]Investors who wish to profit during periods of accelerating inflation must own real assets—such as gold, gold stocks, or no-load gold funds.

incredible level of $6,235,000—over five times that of Mr. Normal and about six times that of Mr. Timid. The moral to this story is that over the long run it normally pays to bear risks.

An even more surprising fact is that your wealth level at age 65, for any given savings level, depends just as much upon the rate of return you earn on your investments as it does on the rate at which your salary grows.[2] Think of it! The rate of return on your investments contribute as much to your retirement wealth level as does your success on the job (salary growth). Despite this fact, most people devote much more time to achieving job success than investment success.

Maybe you should give your investments more consideration in the future. We do not mean to imply that you should neglect your profession in order to imporve your investment results. Rather, we simply suggest that you should probably pay more attention to your investing and to the risk levels which you are willing to bear.

ASSESS YOUR RISK TOLERANCE LEVEL

Once you, the investor, have an adequate appreciation of the different types of risks and their relationship to the expected rate of returns, you must decide how much risk you are willing to assume. It is not possible to construct foolproof guidelines for determining the appropriate level. However, you should thoroughly review your family situation, personal goals, and all the other factors mentioned in the previous section before making your final decision. You should also carefully assess your own attitudes or preferences toward risk and your emotional makeup. To help you in this endeavor we have developed a simple self-evaluation procedure—one which will enable you to place yourself into one of four basic risk categories. These risk categories are: (1) aggressive, (2) moderate, (3) conservative, and (4) extremely conservative. These four categories are defined in terms of market risk—that is, risk due to fluctuation in stock prices in general.

Persons in the aggressive category are willing to accept relatively high levels of market risk to achieve high returns on their

[2]This has been demonstrated by Professor Shelton of the University of California at Los Angeles.

investments. Persons in the moderate category are still willing to assume some market risk, though considerably less than persons in category 1. Persons in the conservative category are willing to sacrifice above-average rates of returns to achieve higher safety of principal and larger amounts of current income. Persons in the final category do not wish to bear any market risk whatsoever. They should not invest any of their money in the stock market.

To help you determine which category is most suitable for you, we have developed a simple self-testing procedure. It involves answering two sets of questions. The first set of questions is designed to help you identify your own *attitude toward risk*. In answering them, try to think carefully about past experience in your life that relate to investing, gambling, winning, and losing at parlor games, your vocational choice, and so on. The questions are:

1. Do you like to gamble?
2. Do you perform well under pressure?
3. Are you relatively immune to excessive worry?
4. Would you prefer to buy a risky stock rather than placing your money in a safe savings account?
5. Do you have confidence in most of your own decisions?
6. Do you prefer to manage your own investments?
7. Are you able to successfully control your emotions when investing?

If you have six or seven *yes* answers, you probably belong in category 1. If you only have one or two *yes* answers, you probably should be in category 4. If you have between two and five affirmative responses, you probably belong in either category 2 or 3.

But this is only half the test—your answers only reflect your *attitudes* toward risk; they do not consider the second important element—your family situation and your *ability to bear risk*. You might very well be an aggressive investor at heart but unable to assume much risk due to a combination of family and life factors—such as dependent children, imminent retirement, or inadequate family income.

The second set of questions is designed to help you assess your ability to bear risk. Ask yourself:

1. Do I have sufficient income to meet my basic needs?
2. Do I have an adequate level of life, health, and casualty insurance?
3. Have I saved enough liquid assets (such as a savings and loan account or a cash reserve fund) to tide me over should I lose my main source of income for four to six months?
4. Am I free from large financial burdens?
5. Can I afford to lose a sizable portion of my money in the stock market?

If your answer to all of these questions is *yes*, you can place yourself in the aggressive risk category. If you have any *no* answers, you should place yourself in the fourth category—for you cannot afford to risk your money in the stock market.

You have now placed yourself in a risk category on the basis of both your *attitude* toward risk bearing and your financial *ability* to bear risk. But what if the two risk categories differ? We suggest you resolve this dilemma pragmatically. You should place yourself in the *less risky* category. For example, if you are an aggressive investor on the basis of your attitude toward risk but an extremely conservative one on the basis of your financial situation, you should put yourself into the extremely conservative category. If, on the other hand, you can afford to bear much risk but are extremely conservative emotionally, you should also put yourself into category 4.

Each of you should know the risk category to which you *initially* belong. You must realize, however, that both your financial and emotional ability to bear risk may change over time as your life situation, goals, and attitudes change. So, from time to time, you should go back and retake the test.

A warning is now in order—this scheme is not infallible. You should not follow it blindly without asking yourself whether or not you are comfortable with your risk category. If you are not, the best rule of thumb is probably to assume risk up to the point at which it begins to cause you undue worry (for either emotional or financial reasons) and begins to interfere with your sleep.

For corporate investors, the above process may not be applicable since the goals and objectives of many individuals may need to

be considered. Moreover, additional constraints may exist such as the pension reform law, contractural obligations, and long-term financial commitments. Given this additional complexity, it may be wise to seek outside professional assistance in determining the most appropriate goal for your portfolio.

part 2

Selection of No-Load
Mutual Funds

Chapter 1 described how to go about selecting
an appropriate risk category for yourself. To
accomplish this you were shown how to evalu-
ate your life situation, your attitude toward risk,
and your ability to bear risk.

Having selected an appropriate risk category
you must now choose the best performing in-
vestment vehicle consistent with this risk cate-
gory. As was mentioned in the Introduction,
our investment approach requires selecting no-
load stock funds in rising markets and no-load
money market funds in falling stock markets. In
the following five chapters we present the crite-
ria for choosing *both* no-load stock funds and
no-load money market funds. We also briefly
discuss the history of mutual funds and their
advantages relative to other investments.

The background material on investment
companies (mutual funds are a type of invest-
ment company) is presented in Chapter 2. More
precisely, we discuss the concept, historical

background, and various types of investment companies. The objective of this chapter is simply to familiarize you with investment companies—with a specific emphasis on no-load mutual funds.

Chapter 3 presents the major arguments for and against the ownership of no-load mutual funds relative to stocks.

Chapters 4 and 5 are devoted to selecting no-load stock funds. The selection process is shown to involve three steps. The first step is to identify those funds which fit into your defined risk category. The second step involves selecting the best performing funds within this group. The final step, which is presented in Chapter 5, is a refined screening process in which the surviving funds are evaluated for general suitability, past and potential performance, portfolio effectiveness, fund operations, potential pitfalls, and certain miscellaneous considerations. By following the procedures outlined in this chapter you will be able to select the stock funds most suitable for your investments.

The final chapter in Part 2 deals with the selection of no-load money market funds. Since money market funds are a relatively new investment instrument, they are discussed in considerable detail. Subsections of this chapter focus upon the various types of money market instruments, the concept of money market funds, and procedures for selecting money market funds.

When you finish Part 2, you will know how to select those equity and money market funds that are both consistent with your risk preferences and likely to be among the best future performers.

2

What Is an Investment Company?

Anyone who is the least bit familiar with the stock market should know that stock market investing is filled with perils and risks. Yet, a constant stream of investors, expecting to find some sort of money tree, ignore these risks and blindly enter into Wall Street. To their dismay they discover that it is a cut-throat game dominated by professionals—typically this type of investor ends up a loser. However, even those investors well versed in the ways of Wall Street are by no means assured of success. How than can an investor be a winner at this treacherous game? We believe the answer begins with investment companies.

The term *investment companies* might be unfamiliar to you, but it is likely that you are familiar with the term *mutual fund*. A mutual fund is simply one of two main types of investment companies. The other type is a closed-end investment company. The main goal of this chapter is, in addition to describing this distinction in detail, to discuss the two main types of mutual funds—load funds and no-load funds.

To accomplish this task, the present chapter is divided into four sections. The first section discusses the basic concept behind investment companies. Section two provides a brief historical perspective which describes how investment companies evolved over time. Section three discusses the two major types of invest-

ment companies—mutual funds and closed-end investment companies. The fourth and fifth sections describe the two main types of mututal funds, load funds and no-load funds, and compare their relative desirability by examining purchase fees, performance results, and operating expenses. The final section is a summary of the key points discussed in this chapter.

THE CONCEPT

The investment company concept is simple. Investors with similar investment goals pool their money into a fund. This money is entrusted to a manager who for a fee handles the portfolio management duties. The investment methods, policies, and types of investments the portfolio manager intends to employ are outlined in the prospectus of the fund. Investment companies generally place their assets in stocks, bonds, or money market instruments. During recent years, many funds have decided to place their investments into portfolios of gold stocks, foreign securities, or municipal bonds.

Investment companies issue shares—just like corporations—in order to establish the proportions of ownership. Once an investment company's shares are issued, its price will fluctuate according to how well the stocks, bonds, and other assets of the portfolio perform. Thus, shareholders participate in the profits or losses of the fund.

Investors use the services of investment companies for many reasons, though the two most commonly cited are diversification and professional management. Diversification, which simply means to spread one's capital among many stocks within differing industries, is desirable because it reduces investment risk. Most investors lack the large sums of money necessary for proper diversification: therefore, many investors wisely turn to diversified investment companies. Similarly, since most investors lack the time, skill, and knowledge possessed by professional portfolio managers, they often decide to purchase professionally managed mututal funds. A full discussion of the advantages and disadvantages of mutual funds (the type of investment company with which we will deal) is contained in Chapter 3.

HISTORICAL BACKGROUND

Investment companies have been in existence since the early part of the 19th century. They originated in Europe and spread to the United States where they began forming in the latter part of the 19th century. Their first real public recognition occurred during the speculative frenzy of the 1920s. Unfortunately, many of these firms succumbed to the severe bear market of the 1930s. Those that survived were especially unpopular as they were singled out by the Securities and Exchange Commission (SEC) as being one of the worst manipulators of the securities markets during the 1920s.

As a result of the abuses that took place in the securities markets during this period, several new laws were enacted. These acts included the Federal Securities Act of 1933, The Federal Securities Exchange Act of 1934, and the Federal Investment Company Act of 1940. Among other things, these acts were designed to curtail abusive tactics of investment companies and to protect the purchasers of investment company shares. After World War II, these

Figure 2-1
Growth of investment company assets, 1940-1979

Growth of investment company assets since 1940

Year	Mutual Funds	Closed-End Companies*	Total
1979	$97,053,100,000	$6,873,179,000	$103,926,279,000
1978	58,144,400,000	6,116,700,000	64,261,100,000
1977	51,479,800,000	6,283,700,000	57.763,500,000
1976	54,174,600,000	6,639,046,000	60,813,646,000
1975	48,706,300,000	5,861,300,000	54,567,600,000
1974	38,545,599,000	5,294,000,000	43,839,599,000
1973	49,310,700,000	6,622,700,000	55,936,700,000
1972	62,456,500,000	6,742,800,000	69,199,300,000
1971	58,159,800,000	5,324,300,000	63,484,100,000
1970	50,654,900,000	4,024,200,000	54,679,100,000
1969	52,621,400,000	4,743,700,000	57,365,100,000
1968	56,953,600,000	5,170,800,000	62,124,400,000
1967	44,701,302,000	3,777,100,000	48,478,402,000
1966	36,294,600,000	3,162,900,000	39,457,500,000
1964	30,370,300,000	3,523,413,000	33,893,713,000
1962	22,408,900,000	2,783,219,000	25,192,119,000
1960	17,383,300,000	2,083,898,000	19,467,198,000
1958	13,242,388,000	1,931,402,000	15,173,790,000
1956	9,046,431,000	1,525,748,000	10,572,179,000
1954	6,109,390,000	1,246,351,000	7,355,741,000
1952	3,391,407,000	1,011,089,000	4,942,496,000
1950	2,530,563,000	871,962,000	3,402,525,000
1948	1,505,762,000	767,028,000	2,272,790,000
1946	1,311,108,000	851,409,000	2,162,517,000
1944	882,191,000	739,021,000	1,621,212,000
1942	486,850,000	557,264,000	1,044,114,000
1940	447,959,000	613,589,000	1,061,548,000

*Including funded debt and bank loans.
Source of data: Open-end—Wiesenberger Investment Company Service, 1960-79; Investment Company Institute, 1940-58 (data include ICI member companies only). Closed-end—Wiesenberger Investment Company Service, 1948-79; and Investment Company Institute, 1940-46.
Source: Wiesenberger Financial Services, Investment Companies (New York, 1980), p. 12.

regulations and a strong economy helped to restore investor confidence, and investment companies regained popularity. Investment company assets increased from about $2 billion in 1946 to about $104 billion in 1979—truly a phenomenal growth record. This spectacular growth in assets is demonstrated on Figure 2-1. Also notice the tremendous increase of assets from 1978 to 1979. This increase has further accelerated during 1980 and 1981 and is largely attributable to the rapid proliferation and popularity of money market funds. These funds (which will be discussed in

detail in Chapter 6) have stability of principal and high current income as their primary objectives and have appealed to investors troubled by the inflation, economic uncertainties, international unrest, and volatile financial markets experienced during the past decade.

MAJOR TYPES OF INVESTMENT COMPANIES

There are two major types of investment companies—*mutual funds* (sometimes referred to as open end investment companies), and *closed-end investment companies.* Although both types are similar in that they provide professional management and diversification, they differ in the following respects: the *method of purchase*, the *number of shares outstanding*, and the *relationship of share value to market value.* To highlight these major differences between mutual funds and closed-end investment companies, Table 2-1 was constructed.

Table 2-1
Mutual funds compared with closed-end investment companies

	Method of Purchase	Number of Shares Outstanding	Redeem Shares at Net Asset Value
Mutual fund	Salesman or direct from fund	Fluctuates	Yes
Closed-end investment company	Stock exchange	Fixed	No

Let's first examine mutual funds. Mutual fund shares are purchased either through a mutual fund salesman, a stockbroker, or directly from the fund. Mutual funds offer continuous sales and redemptions of their shares. As a result the number of shares outstanding fluctuates according to the amount of sales and redemptions. When sales exceed redemptions, the number of shares outstanding increases (and vice versa).

Mutual fund shares can be purchased or redeemed at the net asset value (abbreviated NAV) per share (disregarding any sales fees). The NAV per share is computed by dividing the net assets of the fund by the number of shares outstanding. Thus, when you

invest in a mutual fund, you are assured that you can redeem your shares at their fair market value. The redemption of shares at the NAV is one of the main features that have made mutual funds so popular.

In contrast, the shares of closed-end investment companies are traded on the stock exchange. This means that the prices of these funds are determined solely by investors. Consequently, the prices of closed-end investment companies are influenced by changes in both the NAV and investor expectations. Closed-end investment companies normally trade at either a discount or a premium. A *discount* takes place when the shares of closed-end investment company trade at a price below the NAV. For instance, if the NAV is $10 and if the price of the shares if $7, then there is a discount of 30 percent. On the other hand, under more favorable conditions, some closed-end investment companies may sell at prices well above their NAV. For instance, ASA (a closed-end investment company which specializes in gold shares) typically sells at a *premium* when gold shares are popular. Although the demand for shares of closed-end investment companies have fluctuated considerably over the years, they have historically sold at a discount.

Since the shares of closed-end investment companies are sold on the stock exchange, the number of shares outstanding is fixed.[1] Thus, changes in the size of closed-end investment companies are due predominantly to changes in the value of securities held by the fund.

While closed-end investment companies have produced performance results comparable to mutual funds, they have never gained the popularity of mutual funds. The fact that closed-end investment company shares can't be redeemed at NAV probably has discouraged many investors from purchasing these shares. This is one reason why we do not use closed-end investment companies in our investment approach. A second reason is that it costs more to purchase shares of closed-end investment companies than it does to purchase shares of a no-load mutual fund.

It is interesting to note that mutual funds originally started as

[1]Capital gains distributions and rights to purchase additional stock may increase the number of shares outstanding.

closed-end investment companies. The motivation of management behind switching from a closed-end investment company to a mutual fund is that mutual funds have no limits to the number of shareholders or the amount of assets that may be managed. Consequently, the future management fees are potentially much larger for mutual funds. In addition, shareholders may benefit from this switch since they are guaranteed redemption at NAV, which is normally higher than the current market price of their closed-end shares.

Now that you have some familiarity with the two major types of investment companies, let's examine in depth the type of investment company employed in our approach—the mutual fund.

TYPES OF MUTUAL FUNDS

In this section we will examine and compare the two major types of mutual funds, namely, load funds and no-load funds. The only significant differences between these two types of funds are the sales fee and the method of purchase. The sales fee is called the load. thus, load funds have a sales fee, whereas no-load funds do not. Load fees are normally about 8.5 percent of the purchase price on investments under $10,000. The other major difference is that load funds are purchased from a stockbroker, insurance agent, or mutual fund salesman, while no-load funds are purchased directly from the fund. You might say that the difference between buying load funds and no-load funds is similar to the difference between buying retail and wholesale. That is, load funds are marked up in price, while no-load funds have no such markup.

As of the writing of this book, there are about 350 load funds and 150 no-load funds (excluding money market funds). The greater number of load funds is largely due to the marketing efforts of stockbrokers and other mutual fund salesmen in marketing these funds. Salesmen have no incentive to sell no-load funds to their clients because they do not generate commissions by doing so.

Since no-load funds have no sales force to promote their shares, their only sales methods are advertising, word of mouth, and

performance results. Yet, even without a marketing force their popularity has increased markedly as is evidenced by the growth in numbers of no-load funds. Figure 2-2 contains a graph showing the cumulative growth of no-load funds from 1940 through 1980. From 1966 through 1980, the average annual growth rate has been 13 percent per year.

There are many reasons for the popularity of no-load funds. First, investors are attracted to no-load funds because of the low transactions costs. When you compare the costs of brokerage fees to no-load funds, it's easy to understand why no-load funds have grown to be so popular (the cost of no-load funds will be compared to those of both load funds and stocks in Chapter 3).

Second, it appears that no-load funds are popular because the results of no-load fund investors have turned out better than load fund investors. This has been validated by the research of Sheldon Jacobs in *Put Money in Your Pocket*. Jacobs found that no-load investors are better able to select the best performing funds than are load fund investors. Jacobs came to the foregoing conclusion by classifying both load and no-load funds according to performance in both up and down markets and then tallying the amount of assets held by each performance category.

The Forbes rating system was used to categorize each fund's performance—Forbes categories range from A to F in a descending order (funds in category A performed the best, while funds in category F performed the worst). Jacobs found that in up markets no-load investors placed 68 percent of their assets in funds rated B or better, while only 52 percent of the load investors placed their assets in funds rated B or better. In addition, in up markets the no-load investors placed only 4 percent of their assets in funds rated D, while 32 percent of the load investors had their money in funds rated D. It appears that the load fund investor may be reluctant to withdraw or switch funds because of high initial cost.

A third possible reason why no-load funds are becoming so popular is that no-load investors may derive greater satisfaction from being responsible for the management of their own money.

We have examined several reasons why no-load funds are popular. Now, let's compare several characteristics of load and no-load funds and examine their impact on net profitability.

Figure 2-2
Cumulative yearly total of no-load funds registered for public sale*

*Includes all funds with a sales load of 2 percent or less.
Source: *Growth Fund Guide*.

COMPARISON OF LOAD AND NO-LOAD FUNDS

We will compare load and no-load funds in the following three areas: the profit impact of load fees, performance results, and operating expenses.

Impact of Load Fees on Profitability

As was mentioned previously, the sales fee differentiates the load fund from the no-load fund. We shall now examine the impact which the load fees have on investment profitability.

Most load funds have a sales fee of 8.5 percent on a purchase of $10,000 or less (load fees typically decline as the purchase size gets larger). This means that with an initial investment of $10,000 the load fee will be $850, leaving the investor with $9,150 as the net investment. If you divide the amount of net investment ($9,150) into the load fee ($850), the cost becomes 9.3 percent. Thus, 9.3 percent of the invested capital is lost through commissions. This

Figure 2-3
Twenty-year investment of $10,000 in a load and no-load mutual fund (10 percent annual return compounded)

cost is terribly large, but its real significance emerges when the effect on compounding is considered. If the performance is the same for both the load and the no-load funds, then (due to the compounding effect) *the growth of the no-load investment will always be faster* than that of the load investment.

The compounding effect is illustrated in Figure 2-3. In this chart we are comparing the net result of $10,000 invested in both a no-load and load fund (the load fee is 8.5 percent) over a twenty-year period. The performance of both funds is assumed to be compounded at 10 percent per year. You can see that the no-load investment starts in a more favorable position, and throughout the life of the investment it continues to move at a faster pace than the load fund investment. The difference in profitability at the end of the 20 years is $5,717.67. Paying the load fund sales fee is obviously a tremendous handicap.

Performance

Some individuals have alleged that the performance of load funds has been better than that of no-load funds, thus justifying the sales fee. Statictical research proves otherwise—as several major studies clearly demonstrate that there is no appreciable correlation between sales fees and performance. According to the SEC sponsored *Institutional Investor Study*: "There is no appreciable difference between the performance of funds which charge sales loads and those which do not."[2] Another major study, *Mutual Funds and Other Institutional Investors*, came to a similar conclusion: "If there is a relationship between performance and sales charges, it appears to be negative. The funds with the lowest sales charges (including the no-load funds) seem to perform slightly better than the other funds, but the differences are minor."[3]

The combined research of thse two studies conclusively shows that load funds did not outperform no-load funds. Any allegations to the contrary are false.

[2]Securities and Exchange Commission, *Institutional Investor Study Report 2* (Washington D.C.: U.S. Government Printing Office, 1971), p. 372.

[3]Irwin Friend, Marshal E. Blume, and Jean Crockett, *Mutual Funds and Other Institutional Investors* (New york: McGraw-Hill, 1970), p. 58.

Operating Expenses

The operating expense of a mutual fund is the cost of operation and is normally expressed as a percentage of the net average assets. Operating expenses include management fees, legal fees, custodial fees, auditing fees, printing costs, and other miscellaneous costs. The difference in operating expenses between load and no-load funds is an area filled with misconceptions. Why? Because some load fund proponents have presented a misleading picture to investors. Although the fees are slightly higher for no-load funds, the fact is that operating expenses are not significantly different between the two. This is demonstrated in Table 2-2 which compares the operating expenses for load and no-load funds. Notice in most size categories the expenses are not significantly different, with the possible exception of the $1-$5 million category.

Table 2-2
Operating expenses of load and no-load funds

Assets ($ in millions)	No-Load (percent)	Load (percent)
$1,000 plus	0.51	0.38
$300-$1000	0.57	0.53
$100-$300	0.60	0.70
$50-$100	0.92	0.82
$20-$50	1.02	0.93
$10-$20	1.08	1.02
$5-$10	1.34	1.14
$1-$5	1.91	1.34

Source: Wiesenberger Financial Services, *Investment Companies* (New York, 1980).

ARE LOAD FUNDS WORTH IT?

Since it has been shown that there are no significant differences between no-load and load funds in terms of operating expenses and performance, how can one justify paying the load fee? There is no justification in the opinion of the authors.

The truly unfortunate result of the load fee is that it hurts both the assets of the investor and the assets of the fund. Monies received for the sales fee go to the sales organization, not into the

fund portfolio. Thus, the fund loses a substantial amount of capital that could be productively added to the portfolio. With no-load funds 100 percent of the money sent to the fund is invested.

Another hazard of the load fund sales fee is the locked-in feeling that many investors experience. After paying the 8.5 percent sales fee, their investment must appreciate 9.3 percent before they reach the break-even point. If the performance of their load fund equals the historic average performance of the Dow Jones Industrial Average (DJIA), it will take a whole year before one is able to break-even. This locked-in feeling has caused many investors to continue holding their load funds even though performance has been quite disappointing. Many load fund investors, only desiring to get their original investment back, have had to wait years. Other less fortunate investors have never been able to recoup their original purchase price.

The load fund investor is also at a decided disadvantage compared to the no-load fund investor as he or she cannot fully profit from timing investment transactions to stock market cycles. Load funds demand long-term investing, and as a consequence, much flexibility is lost. Thus, purchasing a load fund requires giving up both money and flexibility. You earned your own money, why not keep it for yourself by investing in no-load funds?

SUMMARY

This chapter presented a brief discussion of three main types of investment companies, namely, closed-end investment companies, load funds, and no-load funds.

The most important findings presented in the chapter is that no-load funds are preferable to both load funds and closed-end investment companies, since the cost of purchasing them is less while their performance is just as good as if not superior. Hence, we recommend that only no-load funds be purchased by individuals desiring the advantages provided by investment companies. But are no-load funds superior to investing directly in common stocks? This topic is addressed in the following chapter.

3

Advantages and Disadvantages of No-Load Mutual Funds

Many noted economists, financial writers, and investment counselors have stated that no-load mutual funds are, in most cases, the best investment vehicle for the small investor. For instance, Paul Samuelson, the internationally known economist stated in *Newsweek* on July 12, 1971, that "a small man—anyone with a portfolio of, say under $100,000—is unlikely to do as well investing his own money as he can do in a no-load mutual fund." And Raymond Dirks, who tells the story of the Equity Funding fraud in his book *The Great Wall Street Scandal*, stresses the need for diversification and recommends no-load mutual funds as one of the best ways for the small investor to achieve diversification.

If no-load funds are highly recommended by many experts, why, then aren't more investors placing their capital in these funds? We have found two primary reasons—many investors simply don't know that no-load funds exist, and some investors who have heard about no-loads really don't understand them. Because of the "knowledge gap" that surrounds these vehicles, we shall now discuss their main advantages and disadvantages.

ADVANTAGES OF NO-LOAD MUTUAL FUNDS

There are numerous advantages of no-load funds; however, we limit the scope of our discussion to the following five categories: (1) reduction of risk, (2) reduction of transactions costs, (3) professional management, (4) reduction of anxiety, and (5) the potential for superior performance.

Reduction of Risks

The greatest advantage which no-load mutual funds offer the typical investor is a reduction in the risks associated with investing in the stock market. This risk reduction is attributable to two factors. First, it enables the investor to reduce market risk because the portfolios of well-managed mutual funds are *efficiently diversified*. Second, because of this diversification, the price movements of mutual funds shares are much *easier to predict* than individual stock prices. Let's now discuss each of these points in detail.

Diversification. The term *diversification* means to spread one's capital among many stocks and industries. If one's assets are spread into many different stocks, then the damage caused by unforeseen developments in any single company are greatly diminished. Thus, the catastrophic effects of financial disasters, such as the Equity Funding fraud, are greatly reduced. Nobody knows how many financial scandals the future has in store for us—why subject yourself to these large risks when they can be virtually eliminated by proper diversification?

Diversification of one's assets into many *industries* is also of tremendous importance. If a portfolio contains many different stocks that are concentrated in one or two industries, the risk exposure is also great because the prices of stocks in a given industry tend to move together. The universally disastrous fall in the share price of mobile home and toy stocks during the 1973-74 bear market should vividly illustrate this point.

An additional advantage of an efficiently diversified portfolio is the protection afforded by geographical diversification. If an earthquake, flood, hurricane, or other natural disaster caused destruction to a particular geographical sector, the adverse financial effects will not have a significant impact on a well-diversified

Table 3-1
Nicholas Fund

Schedule of investments

December 31, 1981 (Unaudited)

COMMON STOCKS—78.2%

Shares or Principal Amount	Quoted Market Value (b)	Shares or Principal Amount	Quoted Market Value (b)
Advertising Agencies—2.9%		**Energy Related—4.7%**	
13,400 BBDO International, Inc. $	532,650	10,000 Anglo Energy Limited	221,250
30,000 Interpublic Group of Companies, Inc. .	978,750	25,000 Nowsco Well Service Ltd	331,250
7,000 Ogilvy & Mather, International	220,500	50,000 Petrolane, Inc.	850,000
	1,731,900	30,000 Phoenix Resources Company	525,000
		10,000 Pioneer Corp	298,750
		23,000 Santos Ltd.	176,824
Airlines—1.7%		20,000 Weatherford International	385,000
15,000 Frontier Airlines, Inc.	330,000		2,788,074
25,000 Midway Airlines, Inc.	306,250		
90,000 Republic Airlines, Inc.	371,250	**Entertainment—1.1%**	
	1,007,500	27,000 Viacom International, Inc.	648,000
			648,000
		Food & Beverage—4.8%	
Banks—8.7%		40,000 Collins Foods International, Inc.	555,000
5,000 American Security Corporation	213,750	84,000 Dean Foods Company	1,554,000
19,500 Atlantic Bancorporation	468,000	5,000 Denny's Inc.	146,250
20,109 BayBanks, Inc.	1,035,614	25,000 G. Heileman Brewing Co., Inc.	606,250
18,000 First Alabama Bancshares, Inc.	522,000		2,861,500
18,100 First Bank Systems, Inc.	628,975		
33,000 First Security Corporation	688,875	**Food Retailers—3.3%**	
5,000 First Union Bancorporation	125,000	9,100 Big V Supermarkets	114,887
21,000 First Union Corporation	498,750	9,000 Food Town Stores, Inc.	342,000
10,000 Industrial National Corporation	268,750	40,000 Jewel Companies, Inc.	1,515,000
7,000 Mercantile Bancorporation, Inc.	189,000		1,971,887
12,000 Mercantile Bankshares			
Corporation	198,000	**Health Care—6.4%**	
21,000 Society Corporation	378,000	33,750 American Medical International, Inc. .	877,500
	5,214,714	18,000 Biochem International, Inc.	159,750
		30,000 Community Psychiatric Centers	1,001,250
		40,000 Manor Care, Inc.	825,000
		55,000 National Medical Enterprises, Inc. ...	955,625
Consumer Products—5.2%			3,819,125
15,000 Dibrell Brothers	307,500	**Industrial Products & Services—8.5%**	
10,000 Lane Company, Inc.	377,500	35,000 Bandag, Inc.	879,375
29,000 Parker Pen Company	416,875	20,000 Harper Group	700,000
14,000 Robbins & Myers, Inc.	329,000	77,000 Kaman Corporation	1,386,000
5,000 Philip Morris, Inc.	243,750	38,000 Herman Miller, Inc.	874,000
42,000 Sonesta Int'l Hotels	451,500	17,700 Pioneer Standard Electronics, Inc. ...	216,825
40,000 Towle Manufacturing Co.	780,000	20,000 The Rolfite Company	100,000
25,000 Tultex Corporation	228,125	8,000 Sonoco Products Company	194,000
	3,134,250	30,000 Sun Chemical Corporation	716,250
			5,066,450

portfolio. Stop for a moment and reflect upon instances when natural disasters have helped plunge the price of certain stocks.

A well-managed no-load mutual fund will always spread its assets into a variety of different industries and stocks. A good example of an efficiently diversified fund portfolio is that of the Nicholas Fund, as is shown in Table 3-1. Notice that the assets are spread into 17 industries and 62 individual issues. Further notice

Table 3-1 *(concluded)*
Nicholas Fund

Shares or Principal Amount	Quoted Market Value (b)	Shares or Principal Amount	Quoted Market Value (b)
Insurance—10.0%		**Technology—4.4%**	
45,000 American Income Life Insurance Co..	984,375	40,000 Canadian Marconi Corporation	1,060,000
40,000 Foremost Corporation of America	1,190,000	40,000 Lanier Business Products, Inc........	740,000
10,000 Hanover Insurance Company	325,000	20,000 Lear Siegler, Inc....................	580,000
39,000 Preferred Risk.....................	828,750	25,000 Norstan, Inc.	231,250
25,000 Progressive Corporation (Ohio)......	812,500		2,611,250
50,000 Protective Corporation	1,162,500		
38,000 Transport Life Insurance	684,000	TOTAL COMMON STOCKS	46,788,225
	5,987,125		
Printing & Publishing—7.2%			
105,000 Bowne & Company, Inc..............	1,798,125	**SHORT-TERM INVESTMENTS—21.5%**	
30,000 Media General, Inc..................	1,177,500	4,500,000 U.S. Treasury Bills, 11.30%, due	
16,000 Meredith Corporation	1,008,000	March 18, 1982	$4,398,750
24,000 Webb Company	342,000	4,000,000 U.S. Treasury Bills, 11.93%, due	
	4,325,625	April 29, 1982	3,853,600
Real Estate—1.0%		4,600,000 Bank Repurchase Agreement, U.S. Treasury Note, due August 15, 1985 acquired under repurchase agreement with the First Wisconsin National Bank of Milwaukee to yield 11.0% (c)..............	4,600,000
34,400 Punta Gorda Isles, Inc..............	309,600		
14,000 Stewart Information Services Corp. ...	336,000		
	645,600		
		TOTAL SHORT-TERM INVESTMENTS	12,852,350
Retail Trade—8.3%		TOTAL INVESTMENTS—0.3% .	59,640,575
23,800 Conna Corporation	285,600	Cash and receivables less	
99,250 Heck's Inc.........................	1,042,125	liabilities—	172,577
150,000 Pic N Save Corp....................	2,400,000	TOTAL NET ASSETS (a)	$59,813,152
80,000 Service Merchandise Company, Inc. .	940,000		
24,600 Shop & Go........................	307,500		
	4,975,225		

(a) Percentages for the various classifications relate to net assets.
(b) Each common stock is valued at the last sale price reported by the principal security exchange on which the issue is traded, or if no sale is reported, the latest bid price. Common stocks which are traded over-the-counter are valued at the latest bid price.
(c) Upon demand of the Fund or the bank, the bank is required to repurchase the security at cost and accrued interest.

that no industry has more than 11 percent of the fund's capital and that no stock has more than 4 percent. Simply stated, diversification is cheap insurance against the adverse occurrences that take place in our unpredictable world.

Diversification also helps reduce the market risk resulting from the price volatility caused by institutional investors. More precisely, since institutions dominate the New York Stock Exchange (nearly 70 percent of the dollar volume trading on the NYSE is done by institutions), the liquidity of the market (the ease with which stocks may be bought and sold) is reduced; hence, the price volatility is increased.

The danger of this volatility is that large losses can be incurred

if your portfolio is not adequately diversified. For example, in 1972 Levitz Furniture Corporation, an institutional favorite at that time, fell from $47 to $33 in a time span of less than one-half hour. If Levitz had comprised a significant portion of your portfolio, your portfolio would have suffered a substantial loss. Levitz is only one example among many stocks that have fallen precipitously during the last decade.

It is unforeseeable that a well-diversified no-load mutual fund could ever fall as drastically as Levitz did in the above example. To illustrate, even in a period of panic selling—as occurred on November 19, 1973 (during the "energy crisis"), when the Dow Jones Industrial Average (DJIA) fell 29 points (3.2 percent)—the largest percentage drop of all nationally quoted funds was 6 percent by the Nicholas Strong Fund. The gist of this discussion is that well-diversified no-load funds normally won't experience an extreme percentage change, whereas with individual issues, large percentage changes can occur anytime.

We believe that as institutional dominance grows, the desirability of no-load mutual fund investing will also grow. Investors will increasingly realize that no matter how carefully they choose their individual issues they can be hurt badly without warning. The no-load investor, due to the benefits of diversification, is well protected.

The manner in which mutual funds reduce risk (relative to stocks) through diversification is depicted in Figure 3-1 which shows the risk-reward trade-off offered by eight mutual funds and eight blue-chip stocks.[1]

The most desired position in Figure 3-1 is toward the upper left—where the rate of return is high and the risk level is low. As we would expect, there is no fund or individual firm that rates best in terms of both rate or return and risk. To have a high rate of return, greater risks must be assumed; and to have a low degree of risk, a low rate of return must be accepted. One way to choose your investment is to find a rate of return you desire to achieve, then find the investment vehicle which offers this return for the least amount of risk (or vice versa). For instance, American Investors Fund has an average return of close to 20 percent, approximately

[1]It is necessary to point out that the definition of risk is still a subject of controversy. We recognize that variability is only one method of measuring risk.

Figure 3-1
Risk-reward relationship of selected mutual funds and stocks

Key:
1. American Investors Fund.
2. Dreyfus Fund.
3. Fidelity Fund.
4. Washington Mutual Investors Fund.
5. Axe-Houghton Fund A.
6. Investors Mutual.
7. Financial Industries Income Fund.
8. Northeast Investor Fund.

Source: Haim Levy and Marshall Sarnat, "Investment Performance in an Imperfect Securities Market and the Case for Mutual Funds," *Financial Analysts Journal*, March-April 1972, p. 80.

equal to Colgate and American Sugar, but the amount of risk is much lower. Hence, investing in American Investors Fund is clearly preferable to investing in either Colgate or American Sugar.

One can easily see that mutual funds almost invariably are preferable to investing in individual blue-chip stocks, for the funds form a "line" to the left of the cluster of these stocks. That is, they provide the same average return for a lower amount of risk.

A final risk-reducing attribute of no-load funds is the high degree of liquidity which they provide. No-load fund shares may be redeemed (converted to cash) at their actual market value at

the close of any business day. The desirability of this feature will no doubt be appreciated by any reader currently locked into an unsuccessful tax shelter, corporate venture, or raw land speculation.

Predictability. The second advantage resulting from the risk reduction attributable to efficient diversification is that the price movements of mutual funds are more predictable than those of individual stocks. By this we mean that *price movements of mutual funds tend to correlate more closely to the market direction than do individual stocks*. Let's look at some examples. First, examine Table 3-2. This table compares the annual number of

Table 3-2
A comparison of common stocks and no-load mutual funds (percent)

	NYSE Common Stocks		NYSE Composite	No-Load Mutual Funds	
Year	Gainers	Losers	Index	Gainers	Losers
1968	79%	21%	+ 9.4%	100%	0%
1969	17	83	−12.5	3	97
1970	41	59	− 2.5	17	83
1971	66	34	+12.5	92	8
1972	55	45	+14.3	75	25
1973	12	88	−19.6	0	100

Source: Wiesenberger Financial Service, *Investment Companies* (New York, 1969-74).

gainers versus losers for all the common stocks listed on the New York Stock Exchange (NYSE) and all no-load mutual funds tabulated in Wiesenberger's *Investment Companies*. Take a look at 1971, a year in which the NYSE Composite Index rose 12.5 percent. During this favorable period, only 66 percent of all common stocks were gainers, whereas 92 percent of all no-load mutual funds recorded advances. Notice also that in other bull market years (1968 and 1972) the no-load mutual funds had a much higher percentage of gainers than did common stocks. Not surprisingly, in bear market years (when our investment program seeks to keep you out of the market entirely), no-load mutual funds fared much worse than common stocks in terms of the percentage of gainers. Clearly, no-load mutual funds are more likely to move in the direction of the stock market than are

common stocks. Therefore, if you are able to recognize market trends, well-diversified no-load mutual funds are by far the more predictable investment vehicle.

Reduction of Transactions Costs

Transactions costs are the costs associated with buying and selling issues. For our purposes we shall define transactions costs as the dollar value of time expended on investments plus any commissions costs. Let's first look at the time expenditure aspect.

Time expenditure. Time equals money is a widely accepted truism; the more successful the individual, the more meaningful this statement becomes. Most investors place a high value on their time and want to minimize the time spent on investment research. Unfortunately, research, which involves choosing the best individual issues within the best industries and timing any desired purchases in accordance with stock market cycles, is a very time-consuming process.

Our investing method greatly simplifies the issue selection problem, as we are dealing solely with no-load mutual funds. Therefore, fundamental research is substantially diminished.

Instead of involving themselves in a maddening search among the thousands of publicly traded issues, fund investors calmly select a fund and time their investment to cycles, within the stock market. The probable result of using this method is less time expended on investment research, higher profits, and more time for the good things in life.

In addition to reducing time expended on research, no-load mutual funds may also *reduce time spent on record-keeping*. We all know that maintaining records of stock market transactions can be a burden. If there is much turnover in your portfolio, then record-keeping and the resultant computations for tax purposes can become a headache. No-load mutual funds provide relief here, as record-keeping is greatly simplified. Mutual fund investors have at their fingertips all the information necessary for tax computations. Capital gains distributions and dividend distributions are computed by the fund and sent directly to the shareholders. So, when tax time comes, mutual fund investments may provide a pleasant bonus.

Low costs. In a world in which rising prices are becoming accepted as a way of life, it is rare and refreshing to find something whose price has not increased. The *sales fees* of no-load funds is one such exception—they are still zero. However, although no-load funds have no sales fees, they do charge for operating expenses and may charge for early redemptions. Operating fees, as a percentage of the assets managed by the fund, range from less than 0.50 percent to over 1.50 percent. These expenses are a cost the investor must bear *every year* (unlike the brokerage fee which is a once-and-for-all charge).

Redemption fees are fees that some no-load funds charge to discourage short-term trading of their fund shares. The no-load funds that have redemption fees typically charge 1 percent, but eliminate them once a specific length of ownership has been met (generally three to nine months). Investors who follow our guidelines will normally avoid such fees.

Despite the fact that no-load funds do have some fees, these costs are quite reasonable in relationship to the fees encountered in other types of investments. Comparing the costs of no-load funds and other investments, such as a home, gold, or stock options, is something you may want to study on your own. We believe you will discover that the costs of no-load funds are generally quite low.

These low transaction costs relative to other investments provide one final and tremendously important benefit. They provide the no-load investor with the *flexibility* to switch investments in accordance with changing market conditions without incurring a high sales charge. This feature is vital to our recommended investment strategy as you shall see in Part 3.

Professional Management

No-load funds are normally managed by highly qualified portfolio managers. These individuals are specialists who work full time at the job of managing money. They possess expertise in the areas of economics, accounting, finance, investments, and many others. Although money management is a difficult job requiring a variety of technical skills, many individual and corporate inves-

tors ignore these needed prerequisites. If these investors understood the difficulties involved in managing money, the need for professional management would no doubt be more clearly understood. Unfortunately, it is normally the sophisticated investor rather than the beginner that fully appreciates the reduced burden, responsibility, and peace of mind afforded by professional management. Ironically, these are the very investors who least need these services.

No-load funds are excellent places to obtain high-quality professional management. Many no-load funds are managed by large investment firms that use the fund as a showcase for their investment talents. Thus, the fund managers have an extra incentive to perform well.

Reduction of Anxiety

Another problem confronting investors handling their own stock market investments is that of psychological discomfort. Most investors constantly live with a certain amount of anxiety and fear. Anxieties are generally the result of one or more of the following: (1) lack of experience, (2) lack of a discipline or strategy, (3) lack of self-control, or (4) lack of a "success" attitude. Unfortunately, most people lack the ability to effectively deal with these anxieties and, as a result, frequently make foolish and costly emotional decisions. The loss of self-esteem or self-worth which inevitably accompanies such bad decisions can be difficult to accept.

The anxieties associated with investing may also have an adverse effect on the health and life expectancy of investors. Many investors have developed ulcers or jumped out a window as a direct result of their market failures. Anxieties may also create problems with interpersonal relationships and hence harm marriages, friendships, and careers.

We believe that investing in no-load funds can help reduce some of the anxieties associated with investing. Our previous discussion has shown that no-load funds offer many anxiety-reducing advantages—such as efficient diversification and professional management. These advantages help to reduce risk and

decrease the burden of investing. As a consequence, anxieties may be lessened and a better quality of life made possible.

Potential Performance

A final attribute provided by no-load funds is the potential for superior performance during bull markets. This potential is convincingly portrayed by Table 3-3, which summarizes the investment results provided by several of the best performing no-load mutual funds from the market low registered in 1974 to April 30, 1981. Notice that the top performing fund, 44 Wall Street, appreciated by 1,615 percent over the period of approximately 6½ years. This corresponds to an average compounded appreciation rate of 53 percent per year. The fifth best fund, 20th Century Select, managed to appreciate by 838 percent, which translates into an annualized appreciation rate of over 38 percent per year. It is doubtful that even the most aggressive investor would be disappointed with these results.

Table 3-3
Top performing no-load funds

Fund	Total Performance (percent)
1. 44 Wall Street	1,615
2. 20th Century Growth	1,280
3. Evergreen	917
4. Pennsylvania Mutual	915
5. 20th Century Select	838

Source: *Growth Fund Guide.*

DISADVANTAGES OF NO-LOAD FUNDS

There is one main disadvantage associated with investing in no-load mutual funds, namely, poor performance during bear markets. During down markets, the performance of growth oriented mutual funds has been consistently worse than the major market averages. For example, 44 Wall Street Fund decreased in value by an amazing 81 percent from April 1972 to its low in December 1974.

We must emphasize that this poor down-market performance is not a problem in our investment approach because we strive to hold no-load stock funds *only* during rising markets. However, poor down-market performance may be a problem for the no-load investor who employs a buy-and-hold philosophy.

Prior to discussing the poor down-market performance of no-load funds we feel it first necessary to examine both the average performance of all mutual funds and the average performance of no-load funds. Much controversy surrounds the performance record of mutual funds, and we would now like to set things straight.

Mutual Fund Performance

The performance results of mutual funds have been examined in several research studies. The research studies that we examined included the following: *The Statistical Survey of Investment Trusts and Investment Companies*,[2] *A Study of Mutual Funds*,[3] *Mutual Funds and Other Institutionsl Investors*,[4] and *Institutional Investors and Corporate Stock—A Background Study*.[5] All these research studies came to the same basic conclusion: the performance of all-load and no-load mutual funds did not differ significantly from that of the relevant market averages. However, if we dig beneath the surface we find an interesting fact—*growth funds* outperformed all the major market averages during the 1960-69 period (from 1965 to 1969 the growth funds far outperformed the market averages). This is validated in *Institutional Investors and Corporate Stock*; this study found that the cumulative return from the growth funds from 1960 to 1969 was 145 percent, which compares to a 60 percent return for the Dow Jones Industrials and a 111 percent return for the Standard & Poor's 500 during this same period. It's quite obvious that growth funds did

[2]Securities and Exchange Commission. *The Statistical Survey of Investment Trusts and Investment Companies* (1927-35), (Washington, D.C.: U.S. Government Printing Office, 1939).

[3]Securities and Exchange Commission, *A Study of Mutual Funds* (1953-58), (Washington, D.C.: U.S. Government Printing Office, 1962).

[4]Irwin Friend, Marshal E. Blume, and Jean Crockett, *Mutual Funds and Other Institutional Investors* (1960-68), (New York: McGraw-Hill, 1970).

[5]Securities and Exchange Commission, *Institutional Investors and Corporate Stock—A Background Study* (1960-69), (Washington, D.C.: U.S. Government Printing Office, 1971).

significantly outperform the market during this period of generally rising prices.

How did no-load funds fare during the 1960-69 period? Our calculations, which were based upon data compiled by Growth Fund Research, Inc., showed that the average no-load funds had a cumulative return of 152 percent during this period.[6] This means that from 1960 to 1969 the average performance of no-load funds was superior to both the DJIA and the Standard & Poor's 500. This superior no-load performance came as no surprise to us, for the no-load funds have a high proportion of aggressive growth and growth funds within their ranks. Because these no-load funds took higher risks, they enjoyed higher returns; hence, we see why the average no-load fund was able to outperform the major market averages from 1960 to 1969.

Poor Down-Market Performance

We have seen how well the average no-load fund performed during a generally rising market (1960-69), but how have no-load funds performed during a generally declining market? To undertake such a study we compiled from *Investment Companies* the volatility (relative to the NYSE Composite Index) of no-load funds during the rising and falling markets from November 10, 1969, to February 11, 1974.[7] The results of this research are listed in Table 3-4; note that the average volatility is listed for all no-load funds (excluding bond and income funds) and for maximum capital gains no-load fund.

As you examine Table 3-4 you will soon notice that in each of the declining periods (columns 1, 3, 5, and 7) the average no-load fund had greater volatility than the NYSE; therefore, on each of these occasions these funds performed worse than the general market. The same relationship holds true for the maximum capital gains funds, with the only difference being that since their volatility was somewhat higher, their performance was even worse.

[6]*Growth Fund Research*, Special Study Report #12, 1971.

[7]Wiesenberger Financial Services, *Investment Companies* (New York, 1974), pp. 154-259.

Table 3-4
No-load mutual fund volatility, November 1969 to February 1974

	(1) Declining Period, 11/10/69 to 5/26/70	(2) Rising Period, 5/26/70 to 4/28/71	(3) Declining Period, 4/28/71 to 11/23/71	(4) Rising Period, 11/23/71 to 1/11/73	(5) Declining Period, 1/11/73 to 8/24/73	(6) Rising Period, 8/24/73 to 10/26/73	(7) Declining Period, 10/26/73 to 2/11/74
All no-load funds* ...	1.18	1.11	1.12	0.97	1.37	1.26	1.17
Maximum capital gains funds	1.36	1.26	1.12	0.99	1.51	1.41	1.30

*Excludes bond and income funds.
Source: Wiesenberger Financial Services, *Investment Companies* (New York, 1974), pp. 154-59.

If we calculate the cumulative performance results from November 10, 1969, to February 11, 1974, we find the no-loads performed 48 percent worse than the NYSE Composite Index. Even if we start from May 26, 1970, the beginning of a significant market advance, and conclude on February 11, 1974, we find that on a cumulative basis the average no-load fund performed 39 percent worse than the NYSE Composite Index. The results for maximum capital gains no-load funds are equally poor.

Clearly, any better than market performance obtained during rising markets was given up and then some during declining markets. This is, of course, the precise reason why our investment strategy strives to avoid holding no-load stock funds during down markets.

Why poor down-market performance? We have seen that no-load funds perform poorly during down markets. The question that remains is why don't no-load mutual fund managers protect their shareholders' assets by acting defensively during these adverse periods? We believe there are four main reasons.

First, all mutual fund managers are required by law to state their investment policies in their prospectuses and to adhere to these policies over time. It is not possible for many fund managers to eliminate losses in down markets, since by moving into defensive positions they may violate the very policies to which they are committed. All they can do is strive to minimize losses.

Second, many mutual fund managers fear being caught with a high cash position during a strong bull market; therefore, many of them are reluctant to act defensively by moving from stocks into cash.

Third, moving from stocks into cash may be a costly process—particularly if the stocks are thinly traded issues or if they are sold in large blocks. The sale of a thinly traded issue or a large block of stock may severely depress the price of the stock. Unless the fund manager expects a substantial decline in his issues, he is not likely to liquidate his position.

Fourth, to qualify as a regulated investment company, which is important in terms of federal income taxes, less than 30 percent of gross income in any fiscal year must be derived from selling securities held for less than three months. This regulation inhibits moving from stocks to cash on a short-term basis which, under certain circumstances, may be the most prudent course of action.

Our investment program recognizes the limitations under which fund managers operate, and we attempt to take advantage of their strengths and avoid their weaknesses. That is, we seek to exploit the offensive ability of no-load fund managers by holding funds during rising markets, and to avoid their weaknesses (poor down-market performance) by switching to defensive positions in down markets.

4

How to Select the Best
Performing No-Load Funds

At the start of Chapter 1 we pointed out that a well-thought-out strategy is the basis of any successful investment program. To illustrate the importance of an investment strategy, we compared investing to playing football. It was emphasized that strategy in football involved drafting a game plan, selecting the key plays, and evaluating and selecting the players.

The material in this chapter corresponds to evaluating and selecting the players, which, for our purposes, are the best performing no-load funds. To prevent any confusion we would like to point out that this chapter focuses solely upon the selection of no-load funds that invest primarily in stocks, as opposed to funds investing in money market instruments. The selection of money market funds is undertaken in Chapter 6.

There are four key steps in the process of selecting no-load funds. They are as follows:

1. Identify those funds whose objectives coincide with your own.
2. Identify the best performing funds within this group.
3. Screen the best performers for their general suitability.
4. Carefully evaluate the remaining funds and select the ones in which you will invest.

Let's briefly examine each of the four steps. The first step, identifying those funds whose objectives coincide with your own, is designed to help you determine what type of fund will best satisfy your needs. Three general types of funds, which correspond to the first three investor risk categories of Chapter 1, are discussed, namely, aggressive growth funds, moderate growth funds, and conservative growth funds. In step 2 you will be shown how to obtain a list of such funds and, more importantly, how to identify the best performing funds within this group. Steps 3 and 4 involve screening these best performing funds by using the criteria we have laid down in the Preliminary and Final Selection Processes, discussed in Chapter 5. Upon completing the Final Selection Process you should be able to select at least two funds that best suit your own special needs.

MEETING YOUR INVESTMENT OBJECTIVES

Knowing yourself and defining your investment goals, as was discussed in Chapter 1, are the foundation of an intelligent investment approach. It was also pointed out that, based upon this self-evaluation, each investor must select his or her own risk category. In this section we shall describe precisely how investors can identify those funds whose investment objectives are consistent with their defined risk category.

Before proceeding to this discussion, let's briefly review the essential points made in Chapter 1 regarding the assessment of your risk tolerance level. In the discussion in Chapter 1, four risk categories were defined on the basis on one's attitude and ability to bear risk. Investors in the *aggressive* category are willing to accept high risks to achieve a rapid growth of capital. Current income is not a major factor for such persons. Investors in the *moderate* category, as the title suggests, are willing to accept moderate risks to achieve a high to moderate growth of capital. For these investors, current income is subordinated to capital growth. The *conservative* category contains individuals who wish to accept only minimal risk and, as a result, are willing to accept a moderate to low rate of return. These investors place a relatively high premium on current income. The final category, category 4, is for the most conservative investor who wishes to minimize risk

exposure. Persons in this category are primarily interested in current income as opposed to capital gains.

If you have given careful thought to the questions posed in Chapter 1—and have reached answers concerning them—you should know to which category you currently belong. If you have not yet determined where you belong, we urge you to do so before proceeding further.

The three *types* of funds we shall discuss in detail, which correspond respectively to risk categories 1, 2, and 3, are *aggressive growth funds, moderate growth funds,* and *conservative growth funds.* Individual no-load mutual funds are placed into these three categories on the basis of their volatility characteristics. For those of you who aren't familiar with the term *volatility,* it is frequently defined by comparing the price movement of a fund to the price movement of a market index. For instance, if a mutual fund increases by 15 percent in a given year and the NYSE Common Stock Index gains 10 percent, then we can say that the fund has a volatility of 1.5 (for that year). When volatility is defined in the above manner, the volatility coefficient, 1.5, is referred to as a beta coefficient.[1] The average volatility level (beta) of the different types of funds are as follows:

Aggressive growth	1.75 and above
Moderate growth funds	1.25 up to 1.75
Conservative growth funds	Less than 1.25

To obtain beta measures for any mutual fund, load or no-load, simply consult Wiesenberger's *Investment Companies.* Within the Wiesenberger publication, which is available in many libraries, turn to the "Price Volatility of Mutual Fund Shares" section—this lists the volatility of mutual funds during both rising and falling markets. All you need do is find those funds whose volatility in *rising markets* complies with your investment objectives.

[1] Beta measures are actually obtained by correlating the performance relationship between a fund and the market with the use of regression analysis.

In addition to the different objectives that funds offer in terms of volatility, there are many different means by which funds may reach these objectives. For example, although two funds may have the same goal of capital appreciation through bearing high risks, one fund may invest primarily in the shares of mining firms, while the other fund may invest primarily in the shares of manufacturing firms. Alternatively one fund may frequently switch its assets resulting in a high turnover rate, while the other fund may employ a buy-and-hold philosophy resulting in a relatively low turnover rate.

Although the investment objectives and means by which the funds reach their objectives are important, your main consideration in choosing a fund will be expected performance results. No matter what the objectives of a fund, it must be able to perform.

Let's now examine and compare each type of fund on the basis of their expected performance, income yields, and general fund operations.

Aggressive Growth Funds

Aggressive growth funds have as their major goal the rapid growth of capital; hence, they may be called maximum capital gains funds. These funds may use leverage, sell short, buy puts and calls, and use other speculative practices to achieve these high gains. The suitability of these speculative practices to our investment program will be explored in the final section. These funds generally are highly volatile, moving at a pace of from two to five times that of the general market; hence, they typically perform very well in bull markets and very poorly in bear markets. The 44 Wall Street Fund, whose price chart is shown on Figure 4-1 for a period encompassing parts of both a bull and bear market, is a good example of an aggressive growth fund. The high upside volatility of this fund during bull markets is demonstrated by the steep angle of ascent during 1971 and the first part of 1972. During this period, the NYSE Composite Index increased by 23 percent, whereas 44 Wall Street increased by 94 percent. Thus, an investor who held 44 Wall Street during this period did about four times as well as a person holding a portfolio that equaled the NYSE. However, volatility is a two-edged sword as is shown by the

Figure 4-1
44 Wall Street Fund: An aggressive growth fund (price history, 1970-1981)

Source: *Growth Fund Research.*

performance of 44 Wall Street during the bear market of 1973 and 1974. During this period, the NYSE Composite Index lost 44 percent, whereas 44 Wall Street fell by 81 percent. Hence, anyone holding the fund during this period would have done nearly two times more poorly than the NYSE Composite Index.

Aggressive growth funds should not be abandoned because of this high downside volatility. Our investment approach strives to be in a cash position during such declines, thus exposure to downside movements is minimized. In this way we extract the

upside profits while minimizing the downside risk. This approach can be very profitable—as you shall see in the market experiment (Chapter 10).

However, not all aggressive growth funds have such a large downside volatility because some funds try to anticipate downside market movements by moving into cash. A good example of an aggressive fund that tries to anticipate market moves is the Janus Fund, a chart of which is shown in Figure 4-2. Notice that during

Figure 4-2
Janus Fund: An aggressive growth fund (price history, 1970-1981)

Source: *Growth Fund Research.*

1973 and 1974, when 44 Wall Street Fund was falling from 8 to 1.5, the Janus Fund only fell from about 4.2 to 3.1. This strong relative performance resulted from the fact that Janus anticipated the terrible market decline and maintained a high cash position during that period. However, our program is not involved with downside performance, and we would select Janus only if its upside performance potential met our criteria.

Funds, such as Janus, that anticipate market declines normally exhibit very high turnover rates in their portfolios.[2] In the Janus example, the turnover rates from 1971-1973 were 367 percent, 169 percent, and 396 percent.

We recommend that fund investors switch out of *any* aggressive growth fund during down markets. Why gamble your money on the likelihood that the fund manager will make the correct move! You can liquidate your fund shares yourself and put the proceeds into cash without having to incur this worry.

One final point will now be raised. All aggressive growth funds choose their stocks primarily for rapid growth of capital, and any income generated is typically insignificant. The average income offered by such funds is normally around 1 percent, though there is sometimes a considerable variation between different funds. Any investor who is dependent upon current income is advised to avoid aggressive growth funds.

Moderate Growth Funds

Moderate growth funds correspond to risk category 2 and should appeal to investors who are willing to accept moderate levels of risk to achieve higher than average capital gains. Moderate growth funds seek high-capital appreciation through employing less risky means to achieve performance than an aggressive growth funds. These funds normally choose their stocks on the basis of above-average growth of capital over the long term; and investment practices such as using leverage, selling short, buying options, or purchasing letter stock are rarely used. Since moderate growth funds are not as volatile as aggressive growth funds, they generally do not perform as well in a rising market, nor do they decline as much in a falling market. Moderate growth funds normally move from 1.25 to 1.75 times as far as the broad market averages in both directions.

The Weingarten Equity Fund, whose price movements from 1970-1981 are shown in Figure 4-3, is a good example of a moderate growth fund. During the 1971-72 bull market, the fund increased by 61 percent. This is to be contrasted with the 94 percent

[2]The turnover rate is the rate at which the fund buys and sells securities.

Figure 4-3
Weingarten Equity Fund: A moderate growth fund (price history 1970-1981)

Source: *Growth Fund Research.*

increase enjoyed by 44 Wall Street during the same period. However, during the bear market of 1973-74, the fund only fell 56 percent in contrast to the 81 percent fall experienced by 44 Wall Street. Clearly, the fund is less volatile than 44 Wall Street.

The income yields on growth funds are normally over twice as large as the yields on aggressive growth funds, having averaged about 2 to 3 percent during recent years. Such funds, like the aggressive funds, should obviously not be held by persons for whom a high-income yield is an important factor.

Conservative Growth Funds

The final fund category, conservative growth funds, is for conservative investors (category 3) who wish to avoid high volatility. Conservative growth funds seek long-term capital appreciation and current income and are frequently called growth income funds or quality growth funds.

Conservative growth funds are relatively stable in their price movements, and thus the volatility of these funds is generally lower than for moderate growth funds. The beta level of such funds, as was mentioned above, is less than 1.25. As a result, the profit potential of conservative growth funds is typically lower than for moderate growth funds. Income yields of conservative growth funds are generally higher than those received from growth funds, averaging from between 3 to 6 percent.

A good example of a conservative growth fund is the David L. Babson Fund, whose price movements from 1970 to 1981 are shown on Figure 4-4. The reader should compare the steepness of

Figure 4-4
David L. Babson Fund: A conservative growth fund (price history, 1970-1981)

Source: *Growth Fund Research.*

these price moves with those exhibited by both the 44 Wall Street Fund and the Weingarten Equity Fund (Figures 4-1 and 4-3). The much reduced price volatility should be readily apparent.

The main disadvantage of conservative growth funds is their sluggish performance during rising markets. These funds tend to appreciate at a far slower rate than the other types of growth funds.

A comparison of the performance results of the average aggressive growth, moderate growth, and conservative no-load funds is presented in Table 4-1. Note that on average the aggressive

growth funds outperformed the moderate growth and conservative funds during rising years, but that these funds were generally poor performers during bear market years like 1973 and 1974.

	Performance		
Year	Aggressive Growth Fund	Moderate Growth Fund	Conservative Growth Fund
1971	+53.0	+34.0	+18.7
1972	+15.8	+14.0	+13.8
1973	−35.9	−29.5	−12.2
1974	−25.1	−29.3	−22.8
1975	+65.7	+40.4	+31.5
1976	+41.3	+37.2	+27.1
1977	+15.6	+14.3	− 1.9
1978	+23.9	+19.2	+ 7.5
1979	+57.3	+43.4	+46.8
1980	+51.5	+47.1	+33.4

Source: *Growth Fund Guide*, March 1975 and January 1981.

Now that we have examined the different risk categories, the next step is to obtain a list of those funds that fit into each category. (Be advised that these risk categories may change over time.) Let's now turn to the topic of identifying the best performing funds.

IDENTIFYING THE BEST PERFORMING FUNDS

The most important step in the fund selection process is to identify the best performing funds in your risk category. How do you determine performance? Let's see.

The best method of identifying superior performing funds is to use a fund advisory service. These services provide much vital information including performance data during rising and falling market periods. This breakdown of performance data is necessary because our investment approach strives to hold funds only during *rising* markets. Thus, we wish to examine market performance during recent rising periods of market activity.

To illustrate, Figure 4-5 shows the performance data for a selected group of no-load mutual funds. From the data contained in this figure, funds may be compared to one another, as well as to

Figure 4-5
Mutual fund performance data

FUND	Rank	A to F Late 1974 Low to 4/30/81	Rank	B to F Mar.1980 Low to 4/30/81	Rank	C to F 11-12/80 High to 4/30/81	Rank	D to E 12/80-2/81 Low to 4/81 High	Rank	E to F Apr.1981 High to 4/30/81
AGGRESSIVE GROWTH										
Amer. Invest.	(18)	+421.6%	(4)	+106.0%	(13)	+ 0.7%	(5)	+23.6%	(26)	- 9.2%
Constellation	(11)	+557.5%	(5)	+102.9%	(23)	- 5.4%	(13)	+16.7%	(10)	- 2.1%
Evergreen	(3)	+917.6%	(14)	+69.8%	(19)	- 3.2%	(22)	+11.4%	(6)	- 1.6%
Explorer	(19)	+421.2%	(7)	+91.8%	(3)	+ 7.8%	(6)	+21.9%	(4)	- 1.5%
44 Wall St.	(1)	+1615.3%	(3)	+113.0%	(12)	+ 1.2%	(3)	+25.8%	(8)	- 1.8%
Hart. Lever.	(16)	+458.4%	(1)	+150.1%	(15)	- 0.5%	(4)	+24.1%	(21)	- 3.1%
Pa. Mutual	(4)	+915.0%	(11)	+76.7%	(9)	+ 4.0%	(19)	+13.3%	(7)	- 1.6%
Scud. Devel.	(6)	+697.3%	(6)	+92.4%	(4)	+ 7.4%	(9)	+21.4%	(9)	- 1.8%
20th Growth	(2)	+1280.4%	(2)	+116.1%	(17)	- 1.4%	(7)	+21.8%	(12)	- 2.1%
GROWTH										
Acorn	(8)	+597.4%	(19)	+63.4%	(6)	+ 5.2%	(16)	+14.9%	(13)	- 2.2%
Columbia Gr.	(21)	+336.4%	(16)	+68.1%	(11)	+ 1.8%	(12)	+17.5%	(16)	- 2.4%
Dreyfus #9	(13)	+497.4%	(13)	+70.1%	(18)	- 2.7%	(17)	+14.1%	(11)	- 2.1%
Lindner	(7)	+618.4%	(12)	+70.4%	(1)	+18.7%	(2)	+27.3%	(3)	- 1.3%
Mathers	(9)	+596.8%	(15)	+69.5%	(7)	+ 4.7%	(11)	+19.8%	(23)	- 4.6%
Nicholas	(12)	+513.0%	(10)	+78.2%	(2)	+10.7%	(8)	+21.7%	(1)	- 1.0%
Weingarten	(10)	+571.0%	(9)	+79.4%	(24)	- 8.7%	(20)	+13.3%	(20)	- 3.0%
QUALITY GROWTH										
Babson	(26)	+139.0%	(26)	+37.8%	(22)	- 4.5%	(25)	+ 7.4%	(14)	- 2.2%
Energy	(22)	+328.5%	(25)	+39.7%	(25)	-11.5%	(26)	+ 6.1%	(22)	- 4.2%
Guardian	(23)	+307.0%	(23)	+45.0%	(20)	- 4.2%	(24)	+ 9.4%	(17)	- 2.4%
Johnston	(25)	+184.0%	(24)	+40.0%	(16)	- 0.6%	(18)	+13.8%	(18)	- 2.4%
New Era	(24)	+297.4%	(18)	+64.3%	(26)	-12.0%	(15)	+15.1%	(25)	- 6.4%
SPECIAL SITUATIONS										
Dreyfus 3rd	(14)	+495.1%	(21)	+52.8%	(21)	- 4.4%	(23)	+ 9.8%	(15)	- 2.2%
Equity Inc.	(20)	+404.6%	(20)	+57.0%	(5)	+ 6.3%	(14)	+16.5%	(5)	- 1.6%
Mutual Shrs.	(15)	+483.4%	(22)	+48.5%	(8)	+ 4.0%	(21)	+12.2%	(2)	- 1.1%
Sher. Dean	(17)	+446.0%	(17)	+64.5%	(14)	+ 0.7%	(1)	+28.0%	(24)	- 5.2%
20th Select	(5)	+838.1%	(8)	+90.9%	(10)	+ 2.1%	(16)	+20.8%	(19)	- 2.6%
AVERAGES										
Aggressive Growth		+809.4%		+102.1%		+ 1.2%		+20.0%		- 2.8%
Growth		+532.9%		+71.3%		+ 4.2%		+18.4%		- 2.4%
Quality Growth		+251.2%		+45.4%		- 6.6%		+10.4%		- 3.5%
DJ Average		+ 72.7%		+31.3%		- 0.2%		+12.7%		- 2.6%

Source: *Growth Fund Guide*, May 1981.

the DJIA. It is especially important to examine *recent* periods of upside and downside market action. Upside performance of the DJIA is shown for the period designated as D to E, whereas downside performance is shown for period E to F. To illustrate, during the period D to E, the best performing aggressive growth fund was 44 Wall Stree (up 25.8 percent), and the best quality (conservative) growth fund was the New Era (up 15.1 percent). This may be compared with the DJIA during this up move which is shown to be +12.7 percent. Note also that the *average* performance of aggressive growth, growth, and quality growth are shown to be consistent with our performance expectations (aggressive funds did best on average during this rising period).

To obtain the recent performance of all funds in your risk category, we suggest that you obtain a copy of the Weisenberger's *Investment Companies* as it provides detailed statistics on every mutual fund. This is normally available in most major libraries. Once you have data concerning mutual fund performance, the next step is to select the best performing funds. Let's now see how funds within each risk category should be selected.

Aggressive Growth and Growth Funds

The selection process for aggressive growth and moderate growth funds is the same: Examine the most recent performance during an intermediate rising market (we define intermediate as one to six months). That is, we recommend that within your risk category you rank all those funds you are watching according to their performance in the most recent intermediate rising market. To illustrate, let's say that you are an aggressive investor (risk category 1) and that you select your funds from those listed in Figure 4-5. You would simply rank the aggressive funds by performance in the period from D to F. It's quite obvious that 44 Wall Street was the best performer with a +25.8 percent, Hartwell Leverage was second best with +24.1 percent, American Investors was third with +23.6 percent, and so on.

Conservative Growth Funds

Although conservative growth funds are usually purchased by investors with a buy-and-hold philosophy, we believe the best

formance in the period from D to F. It's quite obvious that 44 Wall Street was the best performer with a +25.8 percent, Hartwell Leverage was second best with +24.1 percent, American Investors was third with +23.6 percent, and so on.

Conservative Growth Funds

Although conservative growth funds are usually purchased by investors with a buy-and-hold philosophy, we believe the best results will be obtained by using proper timing (as is discussed in Chapters 7 through 10). An investor whose long-run objectives include growth of capital and current income can often maximize both elements by switching between a conservative growth fund and a money market fund (as our indications dictate).

The performance of conservative growth funds, like that of aggressive growth and moderate growth funds, should also be examined in terms of the most recent intermediate rising market. However, if current income is a significant factor in your investment objectives, then you should select the best performing funds that meet your income requirements.

Selecting the Best Performers

Based on the above performance ranking procedure, you should select the *top five or six funds for further evaluation*. Write to each of these funds for a prospectus and read each one carefully.[3] The information contained in these documents will be used in the next chapter to further screen the funds and ultimately to make the final fund selection. Once you have gathered your material, the final selection is relatively simple, and should take no more than an evening's work.

[3]It is required by law that you receive a prospectus prior to investing in any publicly held mutual fund.

5

Which Fund Is Best for You?

Now that you have identified the best performing funds, you must screen these funds to determine which funds are most suitable for yourself. This screening process is undertaken in two separate steps. The first step, *Preliminary Selection Process*, is performed to eliminate those funds in which you cannot invest and which are unlikely to perform well in the future. It involves determining whether (1) the fund qualifies under federal and state regulations, (2) the asset size is within our guidelines, and (3) the minimum investment is compatible with your intended investment. The second and more comprehensive step is the *Final Selection Process*. Here you will be shown how to evaluate no-load funds on the basis of (1) past performance, (2) potential performance, (3) portfolio effectiveness, (4) fund operations, (5) possible pitfalls, and (6) other considerations.

PRELIMINARY SELECTION PROCESS

The Preliminary Selection Process is performed most simply if you keep a tally sheet, such as the one shown in Table 5-1. The sheet is constructed so that the competing funds are listed in the rows of the table. The major attributes of these funds that are relevant to the initial screening process are listed in the columns. Let's now briefly discuss each of these attributes.

Table 5-1
Preliminary Selection Process Sheet

Fund	Qualifies under State and Federal Regulations	Size of Minimum Investment	Asset Size ($ millions)
A			
B			
C			
D			
E			
F			

Does the Fund Qualify under Federal and State Regulations?

No publicly held mutual fund may be legally sold in the United States unless it is registered with the Securities and Exchange Commission (SEC). The SEC is responsible for regulating the securities markets; hence, they look closely at those funds applying for registration and keep a watchful eye on them after they are registered. The SEC is largely responsible for ensuring that mutual funds disclose all relevant information in their prospectuses (omissions or misstatements will prevent a fund from being sold), and for preventing unfair or illegal practices. In short, the SEC is there to protect fund shareholders. Therefore, we recommend you make sure that any fund you purchase is registered with the SEC.

Mutual funds not registered with the SEC are often referred to as "offshore" funds. These funds circumvent regulatory bodies (such as the SEC) by establishing themselves in countries where few if any regulations exist regarding the operations of mutual funds. In theory, a fund establishes itself "offshore" in order to avoid burdensome and restrictive regulations (such as exist in the United States and Great Britain), but in many instances these funds are nothing more than a convenient vehicle for "fleecing" investors.

An excellent example of an offshore fund that misled its customers was that of the United States Investment Fund, which was registered in the Bahamas. This fund, believe it or not, called itself

a "liquid real estate fund." That is, the fund stood ready to redeem shareholders investments in the fund at any time, but was 80 percent invested in real estate (20 percent was in cash for the redemptions). The concept was, of course, completely absurd because their real estate holdings were not liquid. However, a greedy and credulous public poured $100 million into the fund, only to see sales loads and exhorbitant management fees of various sorts sharply reduce their capital. In the end the fund collapsed because bank liquidity was suspended, but not before the management made millions of dollars off the misguided shareholders.

Other examples of questionable offshore funds include the Real Estate Fund of America (similar to the United States Investment Fund) and the Fund of the Seven Seas (nobody was quite sure what they did with their investors' money, except that they had several pictures of ships in the prospectus). These funds were among the wildest of all the offshore funds. The Latin American sales director for these funds admitted the following:

> Asked how many countries his sales area covered, he said, "Twenty-nine." Asked in how many it was legal to sell the fund shares, he said, "Only two" One of his salesmen was accustomed to getting money out of Brazil by canoeing across the river into Paraguay.[1]

It's easy to see why we recommed only SEC registered funds.

State regulations. The state regulations, which are called Blue Sky Laws, vary from state to state; hence, it's hard to generalize about their role. However, they do add to the legal protection of investors, and in some cases impose special requirements on investment policies.

Most of the funds with which you will deal meet the Blue Sky Laws throughout most of the nation. However, some funds—particularly the speculative ones—may not. If any of the funds you have selected in your performance research do not qualify for sale in your state, you must, of course, eliminate them as a potential investment.

[1]Charles Raw, Bruce Page, and Godfrey Hodgson, *Do You Sincerely Want to Be Rich?* (New York: Viking Press, 1971), pp. 156-57.

What Is the Minimum Investment Size?

Every mutual fund has a minimum investment. Generally this minimum investment is a few hundred dollars, but for a few funds it may be as high as tens of thousands of dollars. Check to see which funds have minimum investment limits that you can meet. If the minimum is above your intended investment, you must delete the fund from your list.

Is the Asset Size within Our Guidelines?

We have established recommended guidelines for minimum and maximum asset limits. The precise asset limits we have set for each type of fund are as follows:

	Minimum ($ millions)	Maximum ($ millions)
Aggressive growth funds	$5	$ 80
Moderate growth funds..............	5	100
Conservative growth funds	5	300

The primary reason why we set a minimum asset size is because funds with less than $5 million in assets tend to be erratic performers. This is most easily seen by observing Table 5-2, which shows how no-load growth funds performed according to asset size during 1971 and 1972, the latest years for which this detailed breakdown was readily available. Note that under each asset size category, both the number of funds under examination and the number of funds that declined is listed.

Let's first examine the 1971 performance results for those funds below $5 million in assets. Notice that these funds averaged 15.9 percent return, the second worst performance percentage of all the categories listed in this table. One reason why funds within this category didn't perform well relative to the others is depicted in the column listing the number of declining funds—there were seven funds that were losers within the "below $5 million category." Since there was only one declining fund within the re-

Table 5-2
No-load growth fund performance by asset size*

	Asset Size ($ millions)							
	Below $5	$5-$10	$10-$50	$50-$100	$100-$500	$300-$500	$500-$1,000	$1,000+
1971 results:								
Performance (increase)	15.9%	22.3%	22.1%	14.0%	18.2%	φ†	30.5%	φ
Number of funds	54	15	27	6	9	0	1	0
Number of declining funds	7	1	0	0	0	φ	0	φ
1972 results:								
Performance (increase)	5.1%	7.8%	9.7%	8.5%	13.29%	18.0%	φ	14.9%
Number of funds	61	11	36	10	9	1	0	1
Number of declining funds	22	3	5	3	1	0	φ	0

*Includes the following classifications from *Investment Companies*: maximum capital gain, growth, and growth income.
Source: Wiesenberger Financial Services, *Investment Companies* (New York 1972 and 1973).
† Not applicable.

maining asset categories, funds within the smallest category were clearly the most erratic performers.

In 1972, the performance results for funds below $5 million once again demonstrated erratic performance. First, with an average appreciation of 5.1 percent, this was the worst performing group within all the asset categories. Second, and this is the major drawback, 22 of the funds in the less than $5 million category showed losses for the year. Any way you look at it, funds within the under $5 million asset group were the least desirable, a circumstance which persists to the present time. Hence, you see why we avoid recommending this group entirely.

The maximum allowable asset sizes were established because there are substantial disadvantages to excessive size. The major disadvantages of excess size are loss af agility, flexibility, and liquidity. All these disadvantages combine to inhibit performance and, in some cases, increase risk. The relationship between size and performance is discussed in *Institutional Investors and Corporate Stock* which states, ". . . year to year comparisons of the growth funds since 1967 reveal that size has been significantly correlated with performance, the highest rates of appreciation being by the smaller funds."[2] Simply stated, large size inhibits performance.

To illustrate, for the 12-month period preceding June 30, 1981, 9 of the 10 top performing no-load funds had less than $100 million in total assets. Similar results have been recorded during the past decade for a large majority of 12-month time periods. Hence, we recommend maximum asset limits of $80 and $100 million for aggressive growth and moderate growth funds, respectively.

FINAL SELECTION PROCESS

Now that you have carefully screened funds on the basis of their stated objectives, past performance, and general suitability (Preliminary Selection Process), you are ready to select those specific funds that are best for you. To do this you must study the remain-

[2]Raymond W. Goldsmith, ed., *Institutional Investors and Corporate Stock* (Cambridge, Mass.; National Bureau of Economic Research, 1973), pp. 260-61.

ing candidates quite carefully. In particular you should examine the following aspects of each fund: (1) past performance (2) potential performance, (3) portfolio effectiveness, (4) fund operations, (5) potential pitfalls, and (6) several miscellaneous considerations. The remainder of this chapter provides detailed guidelines for evaluating each of these important factors.

To assist you in this process we have constructed Table 5-3 in

Table 5-3
Final Selection Process Sheet

Criterion	Funds					
	A	B	C	D	E	F
1. Past performance						
2. Potential performance						
Payout period						
Cash position						
Net cash inflow						
3. Portfolio effectiveness						
Number of issues in portfolio						
Number of industries in portfolio						
4. Fund operations						
Performance incentives						
Leverage						
Operating expenses						
Redemption fees						
5. Potential pitfalls						
Letter stock						
Puts and calls						
Short selling						
New funds						
Litigation						
Daily quote						
6. Other considerations						
Capital gains distributions						
Dividend distributions						
Purchase and redemption						

which we outline the major steps that must be taken. Notice that columns are provided in which you can record the pertinent data for each competing fund. This convenient format will facilitate your selection process as it permits a simple but thorough comparison of each fund.

Before discussing each factor listed on the Final Selection Pro-

cess it is first necessary to weigh the importance of each category. Categories 1 through 4 deal with positive factors; thus, the better the results from these categories the more desirable the fund. These four categories are listed in a descending order of importance. Thus, category 1 is the most important, while category 4 is the least important. Category 5 lists six factors which are potential pitfalls and which could render a fund unsuitable for investment. The sixth category, other considerations, lists three factors which are important in purchasing mutual fund shares. While these three factors are less important than those listed in categories 1 through 5, you should nevertheless be aware of them.

Past Performance

The most important consideration in selecting a fund is performance. Since you have already determined the past performance of these funds in accordance with the guidelines provided in the previous chapter, simply enter the percentage gain for each fund. Remember, these percentage gains are for the most recent major advance in the stock market.

Potential Performance

Evaluating potential performance is a very important factor in selecting an appropriate fund. We have found the following three measures to be the best indicators of potential performance:

1. Payout period.
2. Cash position.
3. Net cash inflow.

A discussion of each measure follows.

Payout period. The payout period is defined as the amount of time (in years) it will take before the cumulative earnings of an issue equals its current price. For example, if annual earnings of XYZ company are expected to remain steady at $2 per year and the current price of the share is $12, then it will take *six* years before earnings will pay off the purchase price. Hence, the payout period is six years. The practical value of the payout period is that it is an

Figure 5-1

Panograph ®: Showing payouts of stocks based on price, earnings, and growth rate

Current price is market price at first of month.

Current annual earnings is 12-month profit to end of most recently reported period. This may be either year-end or interim.

Compound growth rate is either average annual growth in per share profits for past five years of growth rate in latest reporting period, whichever is lower.

Payout is the number of years for earnings, compounding at indicated rate to accumulate so they equal current market price.

Reprinted by permission of John S. Herold, Inc., 35 Mason Street, Greenwich, Conn. 06830.

excellent method of comparing the performance potential of different funds. The lower the payout period, other things being equal, the more desirable the fund.

The simplest way to compute the payout period is to calculate the *average growth rate of earnings* and the current *P/E (price earnings) ratios* for the 10 *largest portions held by each fund*. If we know these two values, we can then calculate the number of years it takes for earnings, compounded at the determined growth rate, to accumulate until they equal the current market price. We can do this quite simply by employing a chart (produced by John S. Herold, Inc.) called the panograph. This chart is shown in Figure 5-1 on the previous page. Note that the horizontal axis measures the current P/E ratio and that the compounded growth rate in earnings is measured along the curved lines of the chart. The resulting payout period is indicated on the vertical axis. To illustrate the use of the panograph, let's use our earlier example. If the current earnings are $2 per share and the share price is $12, then the ratio of current price to current annual earnings is 6 (our P/E ratio). Also, if the level of earnings remains $2 indefinitely, then the growth rate in earnings is zero. If we locate the point on the chart where the P/E ratios of six intersects the zero growth rate in earnings line, a payout period of six years is indicated on the vertical axis. If, alternatively, we had a 40 percent annual growth rate in earnings, then the chart tells us it would only take three years for earnings to accumulate before equaling the current market price.

As you study the panograph it should become obvious that the higher the earnings growth rate and the lower the P/E ratio become, the lower the payout period. As we indicated above, the lower the payout period the higher the expected performance; therefore, the funds with the lowest payout period are the most desirable (provided that the other factors are held constant). Our research has found that a payout period of less than eight years should normally provide good results.

Now let's use the payout period for purposes of comparing funds. Below is a list of the earnings growth rates and P/E ratios for several no-load mutual funds as reported by the *Aggressive Growth Funds Report*:

Fund	Earnings Growth Rate (percent)	P/E Ratio
Acorn	57	24
Columbia Growth	49	15
Afuture..........................	45	22
Edie Special	27	23
New Horizons	26	31
Redmond Growth	29	16
Nicholas Strong	37	18

Let's now obtain the payout period of each fund by using the panograph and compare this with each fund's performance during an intermediate rising market period. The results are as follows:

Panograph Position	Payout Period (years)	Performance	Percent
1. Columbia Growth	4-5	1. Afuture	42
2. Acorn	5	2. Nicholas Strong......	40
3. Afuture	5-6	3. Columbia Growth	34
4. Nicholas Strong......	5-6	4. Acorn	32
5. Redmond Growth	6-7	5. Edie Special	30
6. Edie Special	7	6. New Horizons........	27
7. New Horizons........	8-9	7. Redmond Growth	25

Interestingly enough, the four funds with the most favorable position on the panograph were the four funds with the best performance. Conversely, the three funds whose position was least favorable were the three whose performance was the lowest.

Although the panograph can be helpful, do not expect it to produce precise answers concerning performance. Remember, the earnings growth rate is computed from the 10 largest portfolio holdings of each fund; therefore, it is only an *approximation* of the total portfolio. In addition, there are many factors beyond the earnings growth rate and the P/E ratio that influence performance. We shall soon discuss some of these. Before we turn to these other factors, let's first discuss the manner in which the average

earnings growth rates and P/E ratios for the 10 largest holdings in a funds portfolio can be calculated.

There are three steps involved in this computation process:

1. Determine which companies are the 10 largest portfolio holdings (according to market value) by looking at the latest quarterly report of each fund you are analyzing.
2. Ascertain the percentage increase in earnings per share, for each company over the most recent 12-month period. The data necessary to compute earnings growth rates can be found in Standard & Poor's (which is in most major libraries).
3. Determine the simple average of these earnings growth rates.[3]

To illustrate, let's say the 10 largest holding and the earnings growth rates are as follows:

Company	Earnings Growth Rate
Citicorp	9
Helmerich & Payne	27
Lubrizol	23
Coca-Cola	11
Standard Brands Paint	11
Communications	58
Warner McDonalds	20
Bally Mfg.	46
Eastman Kodak	16
Total	221
Average growth rate	22.1

The average earnings growth rate of the 10 largest holdings is very significant for it tells us what type of earnings growth the fund management seeks in structuring its portfolio. It also gives us a partial basis for comparing funds because fund prices are likely to go up faster if the earnings growth is more rapid. In addition, it helps us in identifying how aggressive the fund is. Aggressive growth funds tend to have a high average earnings growth rate, while conservative funds tend to have a lower average earnings growth rate.

[3]It would be preferable, though not necessary, to take a weighted average using the market value of the stocks held as weights.

Determining the average current P/E ratio of the 10 largest holdings of a fund is as important as determining the earnings growth rate—for the combination of the earnings growth rate and the P/E ratio gives us a generally reliable basis by which to compare the performance potential of different funds (the payout period).

Computing the average current P/E ratio of the ten largest holdings is easy. All you have to do is obtain the current P/E ratios of the 10 largest portfolio holdings (current P/E ratios can be found in the major daily newspapers) and average them.[4] Let's take the average P/E ratio for the same companies we used in the earnings growth rate example:

Company	P/E Ratio
Citicorp	6
Helmerich & Payne...........................	18
Lubrizol	10
Coca-Cola....................................	10
Standard Brands Paint	10
Warner Communications	20
McDonalds	11
Bally Mfg.	11
Eastman Kodak	10
Total	106
Average P/E ratio	10.6

Once you have calculated the average earnings growth rate (22.1 percent) and P/E ratio (10.6) for the ten largest holdings, the payout period is easily calculated by using the panograph in Figure 5-1. Plotting out data from the above example, we find that the point of intersection on the panograph lies between five and six years. Since the payout period is less than eight years, we should expect good results from this portfolio.

A word of warning: the panograph cannot be expected to produce superior results when the 10 largest portfolio holdings differ vastly from the rest of the portfolio. It is a good idea to quickly examine the total portfolio when you are studying earnings growth rates and P/E ratios.

[4]If weighted averages are taken for growth rates, then weighted averages must also be taken here.

Cash position. The second factor we shall discuss under potential performance is the cash position of the mutual fund. The cash position of a fund is simply the percentage of assets that are currently being held in cash or instruments easily convertible into cash (liquid assets such as government securities, certificates of deposit, etc.). A high cash position generally suggests that the fund management is avoiding stocks because they expect declining stock prices. A low cash position means that either the fund management is expecting rising prices or that the management does not adjust to anticipated market fluctuations by moving into or out of stocks.

The cash position of a mutual fund is easy to calculate. Simply subtract any bank borrowings from the sum of all cash investments held by the fund and divide this total by the amount of all assets (this data is available in the fund prospectus). If a positive number is calculated, it shows the percentage of cash held by the fund. If a negative number emerges, it indicates that the fund is operating in a net leveraged or margined position. To illustrate, the cash position of various no load mutual funds is presented in Table 5-4. Notice the wide variations in the amount of cash held by the various funds, namely, 35.5 percent cash position by the Lindner Fund to a leveraged 20.0 percent position by the 44 Wall Street Fund (leveraged means the fund has borrowed money from a bank).

We normally prefer those funds with a low cash position because these funds are the ones which advance most sharply in the initial stages of a bull market. We usually recommend that all funds with a cash position exceeding 15 percent be deleted from the selection process. However, as the cash position can change rapidly, we recommend that you continue to follow these funds for possible future purchase.

Net cash inflow. The final factor influencing the potential performance of a fund is its net cash inflow. The net capital flow of a fund is defined as the dollar difference between the sales and redemptions of fund shares. If investors are purchasing more shares than they are redeeming, then there is a positive capital flow or *capital inflow*. If the reverse is true, then there is a negative capital flow or *capital outflow*.

There are several reasons why funds experiencing a capital inflow have advantages over those experiencing a capital outflow

Table 5-4
Cash position table

Fund	Cash (percent)	Assets ($ millions)	Date
Acorn	19.0	$117.0	6/22/81
American Investors	3.0	212.0	6/25/81
Babson	8.3	285.1	6/19/81
Boston Capital	2.8	233.0	5/29/81
Columbia Growth	3.8	37.0	5/29/81
Constellation....................	(7.0)*	43.4	6/18/81
Dreyfus #9	6.8	139.0	6/26/81
Dreyfus 3rd	13.7	116.0	6/26/81
Energy	18.1	375.3	5/31/81
Equity Income	5.6	190.0	6/24/81
Evergreen........................	7.0	99.5	6/18/81
Explorer	24.0	43.7	6/19/81
44 Wall Street	(20.0)*	167.0	6/15/81
Guardian	17.0	186.4	5/31/81
Hartwell Leverage	13.0	23.0	6/17/81
Lindner	35.5	21.1	6/24/81
Mathers.........................	3.4	222.3	6/17/81
Mutual Shares....................	19.8	134.7	6/18/81
New Era	14.4	518.9	5/31/81
Nicholas	14.3	63.9	6/18/81
Pennsylvania Mutual..............	(10.0)*	37.0	6/29/81
Scudder Development	10.2	80.0	3/31/81
Sherman Dean	8.5	8.1	6/26/81
20th Growth	2.7	264.5	5/31/81
20th Select......................	1.1	27.7	5/31/81
Weingarten	3.0	47.5	6/18/81

*Net leverage position.
Source: *Growth Fund Guide*, July 1981.

(or those with a balanced flow). First, during a rising market new investment opportunities constantly arise. With a capital inflow the fund manager can take advantage of these opportunities without disrupting the existing portfolio. Second, the existing portfolio will not have to be disrupted in order to meet share redemptions. Third, stock market correction can be advantageously exploited by the purchase of additional stocks. Finally, due to the above reasons, a capital inflow (if not excessive) can make a portfolio manager's job easier, thereby improving the decision-making environment.

The most important fact about net capital flows is that funds experiencing a capital inflow tend to perform better than those

without an inflow. The effect of capital flows on performance has been evaluated by Melvin Roebuck as follows:

> If a fund's net new-money flow during a year amounts to 200 percent or more of the net assets it held at the start of the year . . . the fund should end that year in the top 25 percent of its class in performance. If a fund's net assets rise by more than 36 percent in a year as a result of new money coming in, the fund is likely to (outperform) the average fund in its class. If a fund shows a net new-money flow of much less than 36 percent a year, defer buying its shares. If, for six months or more, a fund whose shares you own shows a negative new-money flow . . . the fund's subsequent growth is likely to be less than the average of its class.

Due to the significant relationship that exists between net capital flows and performance, we recommend that you strive to purchase those funds with the most favorable net capital flows *relative to the other funds*. That is, although a strong capital inflow is desirable, the important element is the relative capital flows.

But how can one determine capital flows? It's easy. Just compare the percentage change in the share price to the percentage change in the total net assets under management. If the percentage change in the total net assets under management is greater than the percentage change in the price, then there is a capital inflow.

To illustrate, let's assume that a fund has $1,000,000 under management and a share price of $10 for each of its 100,000 shares outstanding. One month later the fund is managing $1,500,000 and has a price of $12 per share. Has there been a net capital inflow or outflow? The answer is an inflow, because the net assets under management increased by 50 percent (from $1,000,000 to $1,500,000) while the net asset value per share increased by only 20 percent (from $10 to $12). More precisely the $500,000 increase in assets under management was caused by a $200,000 capital appreciation ($2 per share times 100,000 shares) and by a net capital inflow of $300,000.

Portfolio Effectiveness

The effectiveness of a portfolio depends primarily upon the manner in which the portfolio's assets are diversified among

different *issues* and *different industries*.[5] The simplest way (though not the most precise) to evaluate the efficiency of diversification is to examine what limitations have been put on fund managers concerning the *percentage* of assets that may be placed into any single issue or industry. The fund is probably adequately diversified if no more than 5 percent of its assets can go into any individual stock and these stocks are diversified into 10 or more industries. Thus, a well-diversified portfolio would hold at least 20 different stocks which are diversified into as least 10 different industries. Of course, these stocks and industries should have been carefully chosen according to their performance potentials.

We recommend that you use these guidelines to determine whether your portfolio has been effectively diversified. If a portfolio is not effectively diversified, delete it from the list—why subject yourself to this added portfolio risk when you can achieve sufficient volatility without it.

If the fund has a high cash position (over 30 percent to 40 percent), these guidelines may be misleading. In such cases we urge you to examine the percentage limitations mentioned earlier.

Fund Operations

The fifth category in the Final Selection Process is fund operations. There are four factors that we will examine within this category. They are: (1) performance incentives, (2) leverage, (3) operating expenses, and (4) redemption fees. As was mentioned previously, these four factors are typically of lesser importance than the factors listed in categories one through four, yet they must still be considered.

Performance incentives. Some mutual funds have established a system of compensation to reward their investment advisor based on performance. This is known as a performance incentive. Performance incentives typically work as follows: if the fund performance outperforms a specific market index over a specified time period, the managers receive a bonus. If the fund underperforms

[5]Although there are additional factors you may desire to research, such as the portfolio turnover rate, we believe they are of secondary importance. Whether or not you wish to evaluate them is a matter of individual taste.

this market index, the managers must refund a portion of the management fee.

Weingarten Equity Fund is one fund that has had a performance incentive system for its managers. Fox example, during 1971 and 1972, the fund performed well and the managers received a bonus of $158,573. However, in 1973, due to poor relative performance, the managers had to refund $49,851 of their management fees.

Performance incentives are, in the authors' opinion, a somewhat positive factor. Fund management is more likely to put out a maximum effort when confronted with the reality of a possible bonus or refund.

Leverage. Leverage is the use of money borrowed from a bank to increase the total assets of a portfolio. The underlying idea is to increase volatility and, hopefully, fund performance through the judicious use of leverage. The maximum leverage permitted by law for mutual funds is 33 1/3 percent.

In our investment program leverage can be a positive factor— for a fund that is in a leveraged position during a rising market has a high probability of being a good performer. Properly employed, leverage can improve your investment results; however, be aware that leverage is a two-edged sword. Only very aggressive investors (risk category 1) should seek out funds that employ leverage.

Operating expenses. Mutual funds have overhead costs, called operating expenses, just like any other business. Operating expenses include the management fees, as well as other expenses incurred during the course of business. The dollar cost of operating expenses may be found in the prospectus under the statement of income and expenses. A copy of the operating expenses of the Rowe Price New Era Fund for 1979 is shown in Table 5-5. Notice that management and custodian and transfer fees are the largest entries on Table 5-5.

To compare operating expenses between mutual funds, the ratio of *operating expense to average net assets* must be calculated. This ratio is normally expressed as a percentage and is listed in the prospectus under "Per Share Income and Capital Changes." The operating expense ratio differs widely between funds though it generally varies between 0.50 percent and 1.50 percent. The ex-

Table 5-5
Operating expenses of the Rowe Price New Era Fund, 1979

Expenses:	
Investment advisory fee	$1,188,052
Custodian and transfer agent fees	194,835
Legal and auditing fees	33,972
Registration fees and expenses	41,510
Stationery, printing and postage	83,487
Stockholder' reports	48,415
Directors' fees	10,417
Miscellaneous	4,859
Total expenses	$1,605,547

Source: *Rowe Price New Era Prospectus,* 1980.

pense ratio for Price New Era during 1979 was a very reasonable 0.67. Unless a fund has an extremely high expense ratio, this should not have any bearing on the fund you select. Most funds with high expense ratios are very small, and small funds are eliminated by the asset size criteria mentioned earlier. If a fund has good performance, this can definitely outweigh a higher than normal operating expense.

Redemption fees. Many no-loads charge a redemption fee to discourage individuals from trading the funds on a short-term basis. Redemption fees usually range in cost from 1 percent to 2 percent of the investment, though the fee is almost always eliminated after a specific length of ownership is reached—normally between six months and one year.

The redemption fee is of little significance in our investment approach, since our investment approach emphasizes intermediate to long-term ownership of funds (for periods long enough to eliminate most fees). However, under certain circumstances we may be forced to sell much earlier than anticipated and an unexpected redemption fees may be encountered. Thus, funds with no redemption fees are desirable. Nevertheless, in relationship to the importance of performance, the redemption fee is a relatively minor consideration.

Potential Pitfalls

The fifth category in the Final Selection Process is potential pitfalls of fund ownership. There are six factors that, in our

opinion, can make a fund undesirable for investment purposes. These factors are:

1. Letter stock.
2. Puts and calls.
3. Short selling.
4. New funds.
5. Litigation.
6. Lack of a daily quote.

The first three factors are listed in the prospectus under the title "Investment Restrictions." The fourth factor, new funds, can be determined by ascertaining the date at which the fund was first offered to the public. This is contained in the prospectus under the description of the fund. The fifth factor, litigation, is normally discussed in some detail in the prospectus. The final factor, the lack of a daily quote, is easily determined by looking in any major newspaper. Each factor will now be discussed in turn.

Letter stock. Letter stock is a special type of stock that is purchased directly from a corporation (instead of on the stock exchange), with certain restrictions attached to its marketability.[6] The major restriction is that this type of stock must normally be held for two years before it can be sold. The only ways to get around this restriction are to get the issuing corporation to register the stock with the SEC (which is a long, expensive process), or to find someone else who will agree to hold the stock for the two-year period (which is very unlikely).

Because of the restrictions attached to letter stock, it's easy to see that it's a very risky way to play the stock market. After all, who wants to be stuck with letter stock during a bear market? Yet, several mutual funds were heavy purchasers of letter stock during the late 1960s. Let's look at one of these funds to see why it held letter stock and to see how the fund performed.

The Mates Fund provides us with an excellent example of a fund holding letter stock. Between April and July 1968, the Mates Fund filled its portfolio with substantial amounts of letter stock. All the letter stock acquired at that time by this fund was purchased at a discount from the market value of the corresponding unrestricted stock, but the letter stock *was valued by the fund at or near the market value*. In other words, the letter stock was purchased below market value but valued in the portfolio at or near market value! The result of this practice was instant

[6]Letter stock is also referred to as restricted stock or a private placement.

performance—from April to November 1968, the Mates Fund gained a spectacular 116 percent, while the NYSE Index was up 20 percent. However, this truly amazing performance was brought to an abrupt halt on December 20, 1968, when one of Mate's largest letter stock holdings, Omega Equities, was suspended from trading by the SEC. Because Mates had substantial holdings in Omega Equities (22 percent of the funds assets were in letter stock and 20 percent in unrestricted stock of Omega Equities), the fund was forced to suspend shareholder redemptions until July 22, 1969. When the shareholders were finally allowed to redeem their shares, the net asset value (NAV) of the fund had fallen drastically from its former level.

Puts and calls. Puts and calls are options to sell or buy stock at a specified price during a specified period of time—usually 3, 6, or 9 months. Options may be used either as a hedge, which is a conservative move to guard against undue risk, or as a means to aggressively add leverage to the portfolio. The drawback of options is that they have a limited life as there is an expiration date after which the option is worthless.

For our purposes it is best to avoid mutual funds that contain options in their portfolios, no matter what the purpose. We are not interest in options as a hedging technique, since we seek to be in cash during down markets. During bull markets, we believe that an adequate level of volatility can be achieved with stocks alone—without the added risk that is imposed by the limited life of the option. In addition, it is quite possible that a fund could be stuck with puts during a bull market, resulting in substantial losses.

Short selling. Selling short is a method by which an investor can profit from a declining stock. Many mutual funds have a provision to sell short, and some of these funds do, in fact, establish short positions. Our research indicates that fund managers generally have not been able to use short selling effectively. Since our investment approach strives to be in a cash position during down markets, short selling does not interest us. Avoid any fund that has any short positions. [7]

[7] It is not important that a mutual fund has a provision to sell short, as long as this option is not exercised.

New funds. In the author's opinion, new funds, any fund with less than a year in operation, should always be avoided. Such funds are undesirable because they lack a track record. There are no previous performance results to analyze, and hence these funds cannot be adequately evaluated. Our research indicates that there is no consistent relationship between new funds and investment performance. In other words, a new fund is just as likely to finish in the top 10 percent as it is to finish in the bottom 10 percent. There are too many good funds with proven track records to risk placing your assets in the hands of unproven managers. Hold off buying a new fund until at least two-year performance results are in. More conservative investors may even want to wait longer. There will be plenty of other good funds in the meantime.

Litigation. Any pending litigation against a mutual fund or the fund adviser will be listed in the prospectus. Litigation must be aasessed as to its probable impact upon the shareholders of the fund. In some instances it may be harmless; in other instances it may be disastrous. Make sure you fully understand the nature and possible consequences of the litigation. If there is even a remote chance that litigation may adversely affect the share price, the fund should be avoided. Check into litigation before you invest.

Lack of a daily quote. Most of the funds that meet our criteria for selection are quoted daily in most newspapers. However, a few funds are quoted only on a weekly basis. A daily quote is highly desirable—for you should follow your funds on a daily basis. If you are unable to locate a daily quotation for a fund, write to the fund, and ask them where a daily quote may be obtained. If you are unable to uncover some means of receiving a daily quote don't invest in the fund.

Other Considerations

There are three miscellaneous considerations that must be discussed, namely, (1) capital gains distributions, (2) dividend distributions, and (3) purchases and redemptions.

Capital gains distributions and dividend distributions. Capital gains distributions are payments made by the fund to the shareholders. These payments result from the profits realized on the

sale of securities; they may be taxed either as ordinary income (short-term capitals gains) or as long-term capital gains. Of course, whether the distributions are taxed at short-term or long-term tax rates depends upon whether or not the fund held the securities for at least one year. Capital gains distributions are typically paid annually.

Dividend distributions are payments made to shareholders which result from the dividend income earned on the fund's investments. These distributions are taxed at ordinary income rates and may be distributed quarterly, semiannually, or annually.

The rationale behind capital gains and dividend distributions is the prevention of double taxation. If a mutual fund distributes at least 90 percent of its income (dividends and short-term capital gains), then the shareholders will be responsible for taxes—not the fund. In this manner double taxation is avoided.

We advise that all investors, *except those who need income*, to reinvest their dividend and capital gains distributions in the fund. When you reinvest these distributions, the fund will automatically credit your account with additional shares.

We should point out that the dates of capital gains and dividend distributions *may* affect your timing in purchasing a fund. Why? Because there are tax advantages in buying a fund *after* the capital gains and dividend distributions have taken place. Perhaps the story in the next paragraph best illustrates the tax advantages gained by buying a fund after the distributions have taken place.

Filthy Rich Investors Fund is selling at $10 per share. Two wealthy investors, Mr. Foolish and Mr. Wise, each intend to buy $100,000 worth of the fund. Mr. Foolish decides to buy the fund immediately without checking into the dates of capital gains and dividend distributions. Mr. Wise spends a little time to ascertain these dates. He finds that if he waits two weeks he will not be eligible for these distributions. So, he patiently waits for two weeks. In the meantime, Mr. Foolish has received a notice from the fund informing him that his distributions are equal to $1 per share or $10,000. Unfortunately, all of these distributions are taxed at his ordinary income tax rate of 50 percent. Thus, Mr. Foolish must pay $5,000 in taxes on this income. Mr. Wise, on the other hand, is not eligible for these distributions because he did

not purchase these shares until after the distributions took place. Thus, he is not confronted with an immediate tax liability on the distributions. Mr. Wise is initially $5,000 ahead of Mr. Foolish.

Moral of this story: Beware of distributions; Uncle Sam owns a part of them as soon as you do.

Purchases and redemptions. When purchasing or redeeming shares from a mutual fund, you should determine the *fastest* method of doing so. Purchase and redemption methods may vary from fund to fund, but there is always one way which is the fastest. For example, some funds accept purchases sent by wire, some accept telephone purchases, while still others only accept written applications. Read the prospectus to get details on how to purchase and redeem shares. If you have any questions, contact the transfer agent of the fund.

It is generally best to leave the share certificate with the transfer agent of the fund for safekeeping. In this way there is no possibility for you to lose the certificate. However, if you need the certificate for collateral or you would rather have physical possession of it, then ask the transfer agent to send it to you.

PUTTING IT ALL TOGETHER

All factors in the Final Selection Process have now been discussed. If you have followed our advice by listing all of this data in Table 5-3 (the Final Selection Process Sheet), then you have a good basis by which to compare and select funds. Your job now is to sort through all these factors and find the funds most suitable for you.

Let's quickly run down the factors in the Final Selection Process for purposes of reiterating their importance.

First, and most important, you must look at past performance. Clearly the "bottom line" of performance results is your most important consideration in choosing a fund (unless there are serious pitfalls).

Second, you must evaluate potential performance. This category is most useful for differentiating between funds that have similar performance records. For instance, if two funds increased 50 percent in the most recent intermediate rising period, then you should select the fund with the best potential performance. We

recommend that you place particular emphasis on the payout period as a means of differentiating equally good performing funds.

Third, the portfolio effectiveness category is most useful in identifying those funds whose performance was due to luck or imprudent portfolio diversification. By examining the structure of the fund's portfolio, you should have a good indication of how the performance was actually achieved.

Fourth, you should examine the factors listed in fund operations; namely, performance incentive, leverage, operating expenses, and redemption fees. Recognize that these factors are of lesser importance than the factors listed in categories 1 through 3.

Fifth, you should scrutinize the funds for any of the six pitfalls we have listed. As we mentioned before, these factors should be avoided because they unnecessarily increase the risk of your investment. Any one of these six pitfalls may make a fund unsuitable for investment.

Sixth, there are three miscellaneous factors listed under "other considerations." These three factors have little to do with the desirability or undesirability of the fund; they simply focus upon the mechanics of purchasing and redeeming funds.

The criteria listed in this chapter are strongly recommended guidelines. It is important that *you use these criteria to choose your funds*.

Tracking

The final task that must be performed, beyond following our timing indicators (as discussed in Chapters 7 through 9), is tracking your fund or funds. That is, you must watch the performance of both prospective purchases and of those funds you already own. To accomplish this, we recommend that you *record* the performance of each fund you are following. This should be done on at least a weekly basis (some people may wish to do it on a daily basis).

Having carefully discussed the selection of no-load equity or stock funds, we must now turn our attention to the selection of no-load money market funds.

6

How to Select Money Market Funds

If you know about the struggle between the bulls and the bears, then you know that the bear is a beast you inevitably will encounter. When confronted with a prolonged bear market, it is advisable for most investors to reduce their equity investments. Under these circumstances you must ask yourself the following question: How can I best employ my idle cash? Shall I put it in a bank? U.S. Treasury bills? Bonds? Certificates of deposit? or where?

Finding the best method of employing idle cash is a problem that has long perplexed investors. This problem grows even more complex during periods of high inflation. Why? Because rates of return must keep pace with inflation in order to maintain purchasing power. Thus, what is needed is an investment that is *high yielding.* But high yields alone do not satisfy all our needs—for as we await the next bull market we also need *safety of principal* and *liquidity.* In addition, the investment must be within the reach of the small investor—thus, the *minimum investment* must be *small.* Let's see how some traditional investments fare in terms of safety, liquidity, high yields, and the size of the minimum investment.

Let's first examine *banks.* The rate of return on bank accounts during inflationary periods are typically less than the rate of

inflation. What about long-term deposits? Although long-term deposits pay higher rates, they lack liquidity. Obviously banks don't satisfy our needs—for although they are generally safe and the minimum investment is small, they do not have adequate liquidity or sufficiently high yields.

What about *bonds?* Although rates of return on bonds may be attractive, you will be exposing yourself to considerable money market risk. Since bonds are long-term investments and have a fixed yield, you leave yourself open to potentially large capital losses. Thus, bonds fall short of our requirements in terms of safety.

How about *U.S. Treasury bills?*[1] Treasury bills may be attractive in terms of rates of return, liquidity, and safety—but you are faced with a problem. To purchase a Treasury bill you must have at lease $10,000 (as of the writing of this book). Thus, Treasury bills may have an excessively large capital requirement for many investors.

What about *negotiable certificates of deposit?*[2] Although the yields, liquidity, and safety of this instrument are usually quite high, negotiable certificates of deposit fall short of our needs in one main respect—the minimum investment is $100,000 which is far beyond the reach of most investors.

At this point you may be disillusioned—but don't despair. There is a solution to the problem of employing your idle cash—simply place your cash in a no-load mutual fund that invests solely in short-term money market instruments. This type of mutual fund is commonly called a money market fund or liquid asset fund.

Why are money market funds the solution? Because they meet *all* our needs in terms of safety of principal, liquidity, high yields, and minimum investments.[3] Although these four factors (plus others) are discussed in detail later in this chapter, let's now briefly discuss how money market funds satisfy each of these

[1]Treasury bills will be discussed in detail in the section entitled "Types of Money Market Instruments."

[2]Certificates of deposit will be discussed in detail in the section entitled "Types of Money Market Instruments."

[3]The degree of safety of principal may vary from fund to fund. The risks involved in each type of money market instrument and categorizing each fund by risk are presented later in this chapter.

factors. First, money market funds typically have diversified port-folios of high-quality, short-term money market instruments; therefore, these funds offer safety of principal. Second, since money market funds allow investors to purchase or redeem their shares at their discretion, they are highly liquid. Third, due to the large assets and professional management of money market funds, you are able to own an interest in the highest yielding money market instruments currently available in the market-place. Finally, since the minimum investment of money market funds generally range from $100 to $5,000, they are within the reach of most investors.

The increased popularity of money market funds is illustrated in Figure 6-1 which shows the total assets held by money market funds since they were first introduced in 1973. Notice that by the middle of July 1981 the total assets held by all such funds was $186

Figure 6-1
Assets of money market funds

billion! The enormity of this number is revealed by the fact that cumulative investment in all equity mutual funds is now close to $40 billion, or less than one quarter of the amount held by money market funds.

This phenomenal growth is attributable in part to the fact that money market funds best satisfy all the criteria outlined above, namely, safety, liquidity, high yields, and a small minimum investment. The importance of these attributes has been increasingly realized by the public as it has sought shelter from the turbulent financial markets of the past decade. In addition, the corrosive impact of inflation on low-yielding deposits in banks and savings and loan associations has also helped fuel this expansion.

The popularity of money market funds is likely to increase as long as yields remain high relative to competing financial instruments. At the present time the government is deregulating other financial (and nonfinancial) institutions and easing its crusade against the merger of *large* corporations. This should ultimately enable other institutions to compete more favorably with money market funds, a development that may some day slow the rapid growth rates experienced in recent years.

The remainder of this chapter is devoted to a discussion of money market funds and how they fit into the mutual fund program. There are five major sections within the chapter. The first two sections provide background material which describes the nature of the money market and identifies the main types of instruments that are traded within this market. The third section describes the advantages offered by money market funds and their suitability for investors with different risk objectives. The fourth section presents guidelines for selecting those funds consistent with your risk objectives that are likely to perform best in the future. The final section is a summary of the key ideas presented in the chapter.

WHAT IS THE MONEY MARKET?

Prior to discussing money market funds, it is first necessary to explain the meaning and importance of the *money market*. The money market is the marketplace where short-term credit instruments are bought and sold. This market, like the stock market, is

an auction market for most instruments. That is, it is a market in which competitive forces determine both price and yield. On the other hand, the money market differs from the stock market in that it has no specific location but rather is comprised of various institutions throughout the nation where money market transactions take place. These institutions, many of which are located in New York City, include the following: banks, government securities dealers, commercial paper dealers, bankers' acceptance dealers, and money market brokers.

The money market plays a significant role in our economy for three main reasons. First, it offers borrowers a marketplace where short-term financing may be obtained. Many borrowers, such as the U.S. government, banks, and corporations, find that issuing short-term credit instruments is a desirable method of satisfying some of their debt needs. For instance, borrowers like General Motors Acceptance Corporation need the flexibility of short-term financing due to the cyclical nature of the auto industry and their continuously changing financial needs. Therefore, they tap the money market by issuing commercial paper.

Second, the money market is significant because it offers lenders a place to invest their funds. Due to the normally high degree of liquidity and low risk of principal, many lenders find money market instruments suitable for their investment needs. For instance, if an oil company accumulates cash reserves, it will normally prefer to put this money to work by purchasing money market instruments. Individual investors are also important participants on the lending side of the money market.

The third reason why the money market plays a significant role in our economy concerns the Federal Reserve Board. The purchase and sales of U.S. government securities by the Federal Reserve Board, which is frequently referred to as *open-market operations,* is an important tool for implementing monetary policy. When the Federal Reserve Board wants to *ease* monetary policy, it *buys* U.S. government securities; and when it wishes to *tighten* monetary conditions, it *sells* these securities. The successful implementation of sound monetary policy is, of course, a very important factor in successfully controlling inflation and providing the environment for a prosperous economy.

As you can see, the money market meets a real need in our society. Through the money market the short-term credit re-

quirements of both borrowers and lenders are satisfied. Thus, the money market offers a means by which capital that might otherwise sit idle can be used productively. Let's now turn to a discussion of the instruments that comprise the money market.

TYPES OF MONEY MARKET INSTRUMENTS

Although there are many different types of money market instruments, our interests lie solely with those which are held most frequently by money market funds. Prior to discussing each of these instruments we must point out that there are trade-offs, involving risk and reward, between the different alternatives. Those instruments that have the highest yields also have the highest risks, while those with the lowest yields have the lowest risk. It is important to first understand the risks and rewards of each money market instrument before selecting the money market fund most suitable for yourself.

There are eight types of money market instruments that we shall discuss. First, we shall look at those instruments that are issued and backed by the U.S. government and by federal agencies. Instruments issued by the U.S. government and the federal agencies are the least risky instruments; hence, their yields tend to be below that of all other instruments. Second, we shall examine those instruments that are issued and backed by domestic commercial banks. These intruments include the following: repurchase agreements, certificates of deposit, bankers' acceptances, and documented discount notes. Bank-issued instruments are higher in risk and yield than government and federal agency instruments. Third, we shall examine commercial paper. Commercial paper is an unsecured money market instrument issued by corporations. The yields and risks on commercial paper are among the highest of all money market instruments. Finally we shall discuss Eurodollar instruments. Eurodollar instruments, U.S. short-term assets in *foreign* banks, are typically riskier than any of the above-mentioned money market instruments: hence, yields tend to be higher relative to the other instruments. Each of these eight money market securities will, in the following section, be categorized according to our four risk categories (aggressive, moderate, conservative, and extremely conservative).

Before entering into a discussion of money market instruments we wish to inform you that this section is highly technical; if you only desire to learn how our money market fund program is carried out, you may want to skip this section entirely and begin reading the next section entitled "What Is a Money Market Fund." Those of you who are interested in obtaining an understanding of each money market instrument are advised to go ahead and read this section.

U.S. Government Securities

These are securities that are both issued and backed by the U.S. government. Government securities are issued by the U.S. Treasury for the purpose of financing the federal debt. The principal and interest on these securities are backed by the taxing power of the federal government; therefore, these securities are rated highest of all the money market instruments in terms of safety. Since these securities are quite safe, their yields are typically the lowest of all money market instruments.

There are three main types of U.S. government securities—treasury bills, notes, and bonds.

Treasury bills are issued with the shortest maturities of all government securities—the maturities are three months, six months, or one year. Treasury bills maturing in three months or six months are sold on a weekly basis, while those maturing in one year are sold monthly. Treasury bills require an initial investment of $10,000, but additional purchases may be made in multiples of $5,000. Treasury bills account for the largest portion of all securities issued by the government and, in fact, are the most widely held liquid investment in the world. They are highly desirable investments for money market funds, as well as many other individuals and institutions, due to their short maturities and high liquidity. As a result they are actively traded in the secondary market.[4]

Treasury notes are the intermediate-term government securities with maturities ranging one to seven years. Unlike treasury

[4]The secondary market is where instruments may be bought and sold after the initial purchase and before the date of maturity.

bills, these securities are not issued on a periodic basis but rather are issued whenever the treasury finds its debt needs dictate their issuance. Treasury notes require an initial investment of $1,000, and additional purchases may be made in multiples of $1,000. Although treasury notes are highly liquid (due to an active secondary market), these securities are not as widely held by money market funds as are treasury bills, due to the greater interest rate risk.

Treasury bonds are long-term government securities having maturities of about 20 to 25 years. Treasury bonds, like treasury notes, are issued whenever the treasury deems it necessary. The initial investment is also $1,000 with additional purchases in multiples of $1,000. Treasury bonds are never purchased by money market funds due to the high risk caused by their long period to maturity.

All of these government securities have two things in common. First, they are all initially sold on an *auction* basis. Thus, the initial yields of these securities are determined by competitive bids in the auction market. Second, all government securities may be sold in the *secondary market* prior to maturity.

Since government securities are very safe (if held to maturity) and highly liquid, they are popular with conservative investors. However, all classes of investors may find refuge in government securities during periods of great economic uncertainty.

Federal Agency Securities

Federal agency securities are securities issued by various federal agencies for the purpose of financing their lending programs. The federal agencies that issue securities include the following: the Federal House Loan Bank, Bank for Cooperatives, Federal Intermediate Credit Banks, Federal Land Banks, the Export-Import Bank, Farmers Home Administration, Federal Housing Administration, Small Business Administration, Tennessee Valley Authority, Federal Home Loan Mortgage Corporation, the Commodity Credit Corporation, and the U.S. Postal Service. Federal agency securities, as opposed to government securities, are generally not sold on an auction basis. Instead the issuing agency consults with various institutions (such as the Federal

Reserve and the Treasury) in order to determine the yield for the issue. The vast majority of securities issued by federal agencies have maturities of one year or less. The minimum initial purchase price of these securities varies from agency to agency.

Since most of these securities are backed indirectly by the taxing power of the U.S. government, they are very safe investments. In fact, there never has been a default on any of these securities.

Although the *risks* of investing in federal agency securities are not substantially different from U.S. government securities (in some cases they are the same), the *yields* on federal agency securities are typically higher. Therefore, many investors prefer to purchase federal agency securities rather than U.S. government securities.

The liquidity of these securities varies from agency to agency depending upon the activity in the secondary markets. Securities issued by the Federal Land Banks, the Federal Intermediate Credit Banks, and the Federal National Mortgage Association have active secondary markets and are highly liquid. The secondary market for the rest of the federal agency securities are not as well established; hence, they may lack liquidity.

Extremely conservative investors should invest only in U.S. government securities or federal agency securities.

Repurchase Agreements

A repurchase agreement involves the sale of any money market instrument with the provision that this instrument be resold to the seller on an agreed-upon future date. For the use of the borrowed funds, the issuer of the repurchase agreement agrees to pay the lender a fixed amount of interest. Although repurchase agreements can theoretically be established for any money market instrument, U.S. government and federal agency securities are the principal types of securities traded in this manner.

Repurchase agreements are issued primarily as a means of raising temporary funds by commercial banks and U.S. government securities dealers. For instance, if a government securities dealer needs to raise funds for purposes of financing its inventory position, it might sell some of its government securities under a

repurchase agreement. The attractiveness of issuing a repurchase agreement is that the issuer can tailor the instrument to his own special needs and be assured that the underlying securities will be returned when desired.

Maturities on repurchase agreements are usually seven days or less, and vary according to one of the following three types of repurchase transactions: overnight transactions, open transactions, and *fixed-date transactions.*

Overnight repurchase transactions constitute the shortest maturity of any money market instrument, having a maturity of one business day, and they are the most widely used type of repurchase agreement. An *open repurchase transaction* is a means by which an overnight transaction may be extended on an indefinite basis; such agreements are effective until one of the parties decides to terminate it. Repurchase agreements may also be bought under a *fixed-date repurchase transaction* for periods longer than one day. Under this type of agreement the length of maturity is agreed upon when the instrument is issued. All three types of repurchase transactions offer both issuers and purchasers a means of adjusting their short-term liquidity needs.

Since the issuer of a repurchase agreement must surrender underlying securities as collateral, repurchase agreements are as safe as the underlying securities. However, there is some risk that the issuing party will be unable to make its interest payment (the interest that is paid by the issuer in addition to the interest of the underlying securities) to the lending party. For example, if a bank sells treasury bills to a money market fund under a repurchase agreement and the bank subsequently fails, then the money market fund may never receive any interest on the repurchase agreement from the bank (though it would receive both the principal and interest from the underlying Treasury bill).

Due to the interest paid by the issuer, yields on repurchase agreements are higher than yields on the underlying securities being traded. The main factors that influence the size of these yields are the interest rates on federal funds, the interest rates on all money, and the maturity of the agreement. Since repurchase agreements are a means of raising the effective yield of an instrument, these vehicles are frequently utilized by money market funds.

Certificates of Deposit

A certificate of deposit (commonly called a CD) is a receipt for having deposited funds at either a bank or a savings and loan. In return for depositing funds the issuer of the CD agrees to repay the amount of the deposit plus interest on a specified date. Yields on CDs tend to be higher than for government agency securities, but competitive with other bank-issued money market instruments (such as bankers' acceptances) and commercial paper of similar maturities. Maturities on CDs range from 30 days to several years.

There are two main types of CDs, *negotiable* CDs and *ordinary* CDs. Negotiable certificates of deposit differ from ordinary certificates in two main respects. First, negotiable certificates of deposit can usually be sold prior to maturity in the secondary market, whereas ordinary certificates of deposit must be held to maturity (or penalties are involved). Second, negotiable certificates are sold in denominations of $100,000, whereas ordinary certificates of deposit are sold in amounts less than $100,000.

In terms of safety of principal and interest, CDs are as safe as the soundness of the issuing institution. Therefore, as long as the issuing bank is liquid, there should be no problems with safety.

The liquidity of CDs boils down to the following question: Can the CDs be sold in the secondary market on short notice and at a fair market price? The liquidity or marketability of CDs is dependent primarily upon the identity of the issuing bank and the denomination of the CD. The identity of the issuing bank is typically the most important factor influencing marketability. CDs of large, well-known banks are normally far more marketable than those issued by smaller, lesser known banks. Since yields are inversely related to marketability, it follows that the CDs of small institutions provide yields above those offered by larger institutions.

A second factor influencing marketability is the denomination of the CD. Since dealers like to trade in units of $1 million, certificates with smaller denominations are less marketable and, as a consequence, must offer higher yields.

Depending upon the marketability of the instrument, CDs may be purchased by investors in the aggressive, moderate, or conservative risk categories.

Bankers' Acceptances

A banker's acceptance is defined as a draft or bill of exchange which is accepted by a bank or trust company. Before we continue, let's first explain what is meant by a bill of exchange. A bill of exchange is defined as a promissory note used in international trade in which the drawer unconditionally guarantees to pay to the drawee a sum of money at a given date. For instance, if an American business needed short-term financing in order to import a large quantity of television sets from a Japanese exporter, it might establish this financing by means of a bill of exchange. But, as we pointed out, a bill of exchange is only a promissory note; if the American importer and Japanese exporter have never done business before, then the Japanese exporter will demand some guarantee that he will be paid. So, the American importer will go to a bank to seek an "acceptance." When a bill of exchange is "accepted" (which means it is unconditionally guaranteed) by the bank, it is then known as a banker's acceptance. With the banker's acceptance the Japanese exporter can rest assured that he will receive payment.

Bankers' acceptances are negotiable and may be traded in the secondary market. The issuing bank therefore has the option of keeping the acceptance for its own account or selling the acceptance in the secondary market at a discount. Maturities on bankers' acceptances range from 30 to 270 days, but most expire within 180 days.

What are the risks involved in the ownership of bankers' acceptances? The risks are limited to the ability of the issuing bank to fulfill its guarantee. Therefore, as long as the issuing bank is sound, there should be no problems in terms of safety.

How about the yields and liquidity of bankers' acceptances? The yields on bankers' acceptances are competitive with other bank-issued instruments and commercial paper. Similarly, the liquidity of bankers' acceptances is dependent upon the same factors as for CDs, i.e., the identity of the issuing bank and the size of the denomination. Instruments issued by large, well-known banks are normally highly liquid.

As with CDs, the suitability of bankers' acceptances to different types of investors is primarily dependent upon the quality of the issuing bank.

Documented Discount Notes

Documented discount notes, which may also be called *bank guaranteed letters of credit,* are a means by which businesses raise funds through the sale of notes which are guaranteed by a bank. Let's focus upon an example of how a documented discount note arises. If a business needs to raise funds and finds that its bank has no money to lend, the business may decide to generate funds by selling a documented discount note. In order to obtain the bank guarantee (to support the notes), the business must have a letter of credit from a bank. With the letter of credit, the notes are guaranteed and are therefore more attractive to investors (assuming the issuing bank is sound). The investor, such as a money market fund, may purchase these documented discount notes from the guaranteeing bank.

Since there is no secondary market for these notes, they lack liquidity. However, as these notes are usually of short maturity—usually about 30 to 35 days—this compensates somewhat for the lack of a secondary market. Yet, if a money market fund with an almost exclusive portfolio of documented discount notes were faced with massive investor redemption, serious problems could result.

These notes normally have higher yields than other bank-issued instruments. Therefore, money market funds that purchase document discount notes are often among the highest yielding funds.

These notes, like CDs and bankers' acceptances, are as safe as the soundness of the guaranteeing bank. Yet, there is an additional source of safety in that banks are required to use the same standards of financial strength that ordinary borrowers must meet when qualifying a business for a letter of credit. Therefore, the business selling the notes must be financially sound before the bank will issue the required letter of credit.

Documented discount notes, just like the other bank-issued instruments, are suitable for aggressive, moderate, and conservative investors depending upon the size of the issuing bank.

Commercial Paper

Commercial paper is a short-term promissory note issued by a business. Commercial paper is usually unsecured; therefore, only

the largest, most creditworthy companies are able to tap this market. Participants on the borrowing side of this market include both sales finance companies (such as Ford Credit Corporation) and nonfinancial companies (such as Xerox Corporation). Participants on the lending side of the commercial paper market include financial and nonfinancial corporations and individuals.

There are two major types of commercial paper—*directly placed paper* and *dealer's paper*. Directly placed paper is sold to buyers by a large sales finance company, such as General Motors Acceptance Corporation or Sears Roebuck Acceptance Corporation, *without* the use of a dealer. Only those firms that have large sales finance companies normally find it economically feasible to maintain the necessary staff to directly place their paper. Directly placed paper accounts for the largest portion of all outstanding commercial paper and normally exhibits a maturity of between 3 and 270 days.

Dealer's paper is commercial paper sold by corporations to specialized dealers who, in turn, sell this paper to other investors. The dealer's paper market is used by corporations that find the cost of directly placing their paper prohibitive. Maturities on dealer's commercial paper range from 30 to 180 days.

Yields on commercial paper are competitive with bank-issued instruments (such as CDs and bankers' acceptances) of similar maturities, and liquidity is normally quite high. Prime commercial paper is also reasonably safe despite the fact that such paper is usually unsecured. However, even prime rated paper can turn sour—as was demonstrated by the famous Penn Central bankruptcy.

Commercial paper is, in the authors' opinion, suitable only for investors in the aggressive and moderate risk categories (see section entitled "Types of Money Market Funds").

Eurodollar Instruments

Eurodollars are simply U.S. dollar deposits placed with banks outside the United States. Eurodollars are no different from any other U.S. dollars except that the dollars are in the hands of a foreign bank. Eurodollars make up the major part of an interna-

tional money market known as the Euromoney market. The Euromoney market is where the world's major currencies are traded—the most notable currencies include Swiss francs, British pounds, German marks, Canadian dollars, and Japanese yen.

Participants in the Eurodollar market include central banks, commercial banks, corporations, and individuals. Banks are the primary participants in this market, and the Eurodollar market serves as "an international pool of bank liquidity."[5] That is, liquidity shortages and surpluses of banks may be smoothed out by using this market. Corporations are also important participants in the Eurodollar market, as they frequently use this market to deposit surplus funds or to borrow for short-run financing purposes. Individuals also participate in the Eurodollar market for purposes of borrowing and lending—though they are relatively unimportant.

The Eurodollar market, like the money market in the United States, has no specific location. This market is comprised of dealers in the major financial centers of Europe—especially in London. London is the center of the Eurodollar market for two reasons. First, London has traditionally been an international finance center. Second, and more importantly, London Eurobanks are "treated as a sort of extraterritorial market" (which means they are not subject to British banking regulation—such as reserve requirements).[6] This freedom from regulation has attracted many bankers.

Purchasing Eurodollar instruments involves greater risk than the purchase of U.S. money market instruments for several reasons. First, as we just pointed out, many Eurobanks (like in London) are unregulated—this opens the door to potential problems. Second, in some instances short-term deposits at Eurobanks are lent out for medium-term loans—obviously this is a risky practice. Third, sometimes the final use of the money in a Eurodollar loan is unknown to the lender—certainly this violates sound banking procedure. Fourth, the viability of the Eurodollar market is dependent upon confidence in the U.S. dollar.

Due to the high degree of risk with Eurodollar instruments,

[5] Herbert V. Prochnow, ed., *The Eurodollar* (Skokie, Ill.: Rand McNally, 1970), p. 106.
[6] Ibid., p. 110.

yields on these instruments are usually substantially higher than instruments issued by domestic banks. These instruments are suitable only to those investors in the aggressive category.

What Is a Money Market Fund?

A money market fund is a mutual fund that invests its assets only in highly liquid money market instruments. The choice of money market instruments depends upon the investment policies and restrictions of the fund. To illustrate, let's examine the portfolio of the Scudder Cash Investment Trust shown in Table 6-1. Notice that this portfolio is diversified among four types of money market instruments—repurchase agreements, commercial paper, certificates of deposit, and bankers' acceptances. Notice also that

Table 6-1

SCUDDER CASH INVESTMENT TRUST

SCHEDULE OF INVESTMENTS, JUNE 30, 1980

	Maturity	Principal Amount	Cost	Market Value (Note A)
SECURITIES HELD UNDER REPURCHASE AGREEMENT—2.4%				
Repurchase Agreement with State Street Bank at 8.00%, collateralized by Federal National Mortgage Association Discount Notes due 8/1/80	7/1/80	$ 4,810,000	$ 4,811,068	$ 4,811,068
COMMERCIAL PAPER—59.9%				
CONSUMER—8.2%				
DRUGS & TOILETRIES—8.2%				
Warner-Lambert Co. 9.625%	7/11/80	$ 8,000,000	$ 7,978,611	$ 7,978,611
Pfizer, Inc. 9.875%	7/18/80	7,000,000	6,967,358	6,967,357
Warner-Lambert Co. 8.125%	7/31/80	2,000,000	1,986,458	1,986,458
			$ 16,932,427	$ 16,932,426
FINANCIAL—26.1%				
CREDIT & FINANCE—26.1%				
General Electric Credit Co. 11.0%	7/3/80	$ 6,000,000	$ 5,996,333	$ 5,996,332
U.S. Steel Credit Corp. 13.125%	7/3/80	5,000,000	4,996,354	4,996,354
General Motors Acceptance Corp. 11.0%	7/7/80	2,000,000	1,996,333	1,996,333
Sears Roebuck Acceptance Corp. 10.25%	7/16/80	3,000,000	2,987,188	2,988,437
Shell Oil Credit Corp. 10.25%	7/17/80	5,000,000	4,977,222	4,978,536
Mobil Oil Credit Corp. 9.5%	7/18/80	5,000,000	4,977,569	4,977,569
Ingersoll-Rand Financial Co. 8.25%	7/25/80	3,000,000	2,983,500	2,983,500
Amoco Credit Corp. 7.9%	7/28/80	7,000,000	6,958,524	6,958,524
U.S. Steel Credit Corp. 9.125%	7/29/80	5,000,000	4,964,514	4,964,513
Mobil Oil Credit Corp. 8.125%	8/1/80	2,800,000	2,780,410	2,780,409
ARCO Credit Corp. 8.35%	8/11/80	10,000,000	9,904,903	9,904,902
			$ 53,522,850	$ 53,525,409
MANUFACTURING—9.1%				
CHEMICAL—4.3%				
Dow Chemical Co. 8.25%	8/4/80	$ 4,000,000	$ 3,968,833	$ 3,968,833
Union Carbide Corp. 8.125%	8/26/80	5,000,000	4,936,806	4,936,805
			$ 8,905,639	$ 8,905,638

holdings in the last three categories are widely diversified among different issuers to further reduce risks.

Money market funds differ from mutual funds holding stocks in that these funds generally sell at a fixed price, such as $1 per share. Your return from a money market fund is represented by the accumulation of additional shares—not by changes in the net asset value. For example, if you were to invest $10,000 in a money market fund that had a net asset value (NAV) of $1, you would have 10,000 shares; and if over a year's time your return was equal to 10 percent, you would have accumulated another 1,000 shares.

The yield of a money market fund is the method by which performance can be measured. These yields are reported on a weekly basis in *The Wall Street Journal, Barrons,* and many local newspapers. In general, the yields on most money market funds have far exceeded those available from other financial institutions with similar maturities and the same degree of liquidity. This, in turn, has been a major impetus behind their phenomenal growth during recent years.

There are three major categories of no-load money market

Table 6-1 *(continued)*

	Maturity	Principal Amount	Cost	Market Value (Note A)
PETROLEUM-SERVICE & EQUIPMENT—4.8%				
Halliburton Co. 8.375%	7/24/80	$ 10,000,000	$ 9,946,493	$ 9,946,493
UTILITIES—16.5%				
PUBLIC UTILITIES—COMMUNICATIONS—10.2%				
Pacific Telephone & Telegraph Co. 8.75%	7/10/80	$ 4,000,000	$ 3,991,250	$ 3,991,250
Pacific Telephone & Telegraph Co. 8.875%	7/11/80	5,000,000	4,987,674	4,987,673
Ohio Bell Telephone Co. 8.4%	7/29/80	7,000,000	6,954,266	6,954,266
Indiana Bell Telephone Co. 8.875%	7/30/80	5,000,000	4,964,253	4,964,253
			$ 20,897,443	$ 20,897,442
PUBLIC UTILITIES—ELECTRIC—6.3%				
Northern Indiana Public Service 8.375%	7/7/80	$ 5,000,000	$ 4,993,020	$ 4,993,020
Florida Power Corp. 8.8%	7/21/80	5,000,000	4,975,555	4,975,555
Oklahoma Gas & Electric Co. 8.75% ...	8/1/80	3,000,000	2,977,395	2,977,395
			$ 12,945,970	$ 12,945,970
Total Commercial Paper		$123,800,000	$123,150,822	$123,153,378
CERTIFICATES OF DEPOSIT—9.2%				
Northern Trust Co. 9.375%	7/11/80	$ 5,000,000	$ 5,000,000	$ 5,000,000
First Nat'l. Bank of Minneapolis 8.375% .	7/28/80	5,000,000	5,000,000	4,999,264
First Nat'l. Bank of Minneapolis 8.2% ...	8/8/80	4,000,000	4,000,000	4,000,000
Philadelphia Savings Fund Society 8.25%	8/25/80	5,000,000	5,000,000	4,995,468
Total Certificates of Deposit		$ 19,000,000	$ 19,000,000	$ 18,994,732

Table 6-1 *(concluded)*

	Maturity	Principal Amount	Cost	Market Value (Note A)
BANKERS' ACCEPTANCES—29.0%				
Morgan Guaranty Trust 9.6%	7/7/80	$ 3,000,000	$ 2,995,200	$ 2,995,200
Seattle First Nat'l. Bank 8.14%	7/15/80	4,000,000	3,999,409	3,999,409
Valley Nat'l. Bank 12.45%	7/16/80	3,000,000	2,984,438	2,987,274
Nat'l. City Bank of Cleveland 9.4%	7/21/80	5,000,000	4,973,889	4,974,277
Pittsburgh Nat'l. Bank 8.25%	7/21/80	9,000,000	8,958,750	8,958,750
U.S. Nat'l. Bank of Oregon 9.85%	7/22/80	4,000,000	3,977,017	3,979,233
Riggs Nat'l. Bank 9.45%	7/31/80	5,000,000	4,960,625	4,960,625
Continental Illinois Nat'l. Bank 8.25% ...	8/1/80	6,000,000	5,957,374	5,947,945
Bank of America 8.45%	8/1/80	3,000,000	2,978,170	2,978,170
Bank of New York 8.45%	8/5/80	3,000,000	2,975,354	2,975,354
Continental Illinois Nat'l. Bank 8.15% ...	8/11/80	3,000,000	2,972,154	2,972,154
Nat'l. Bank of Detroit 8.3%	8/22/80	3,000,000	2,964,033	2,964,033
Republic Nat'l. Bank—Dallas 8.3%	8/25/80	9,000,000	8,885,875	8,885,875
Total Bankers' Acceptances		$ 60,000,000	$ 59,582,288	$ 59,578,299
TOTAL INVESTMENTS		$207,610,000	$206,544,178‡	$206,537,477
SUMMARY:				
Investments as shown above		100.5%		$206,537,477
Other assets and liabilities (net)		(.5%)		(1,004,723)
Net assets		100.0%		$205,532,754

‡Cost for federal income tax purposes.

mutual funds based upon the clientele to which they are oriented. The largest category in terms of total assets are the funds sponsored by broker-dealers such as Merril Lynch or E. F. Hutton. As of December 1981, there were 37 such funds with a combined asset value of over $95 billion. The next largest category consists of the 93 funds oriented to individual investors. These funds, which are often sponsored by large mutual fund organizations such as the Dreyfus Corporation or T. Rowe Price Associates, had a combined asset value of approximately $55 billion. The smallest group of funds are those oriented to institutional investors such as bank trust departments and trust companies. At the present time there are 29 of these funds with a combined asset value of about $33 billion.

Money market funds within any of the above categories are suitable for purposes of our investment program.

During recent years, an entirely new type of money market fund has also emerged—namely, tax-free money funds. These funds combine the features of a municipal bond fund and a

money market fund. Municipal bond funds provide income which is free from *federal* income tax, a feature which appeals to investors in high income tax brackets. However, most outstanding municipal bonds have long-term maturities and are therefore far more risky and volatile than a money market fund.

To overcome this problem the tax-free money funds invest exclusively in municipal bonds which are close to maturity, typically having two to four months of remaining life or in various types of short-term municipal notes. By doing so the risks associated with fluctuating interest rates are greatly reduced and are similar to those associated with regular money market funds. While these funds may appeal to certain investors, we do not recommend them for our investment program for several important reasons.

First, there are a limited number of municipal bonds in existence at any one time that are due to mature within three or four months. As more and more tax-free money funds are introduced, there is a distinct possibility that there won't be enough suitable bonds to go around. Thus, these funds will be forced to depend more and more on an increased supply of short-term municipal notes. However, since municipalities use revenues from these bonds to finance *long-term* projects, such as water pipelines and sewers, they may not accommodate the tax-free funds by issuing *short-term* money market instruments as this would necessitate continual refinancing. This short-term refinancing would, in turn, greatly increase the financial risk to the issuing municipality which, we believe, will be unacceptable to many of them in the long run. However, thus far the municipalities have responded to the increased demand by issuing more short-term paper.

This scarcity of maturing municipal bonds is presently causing several adverse side effects for investors in tax-free money funds. First, due to the intense competition for these expiring bonds, their prices have been bid up and, as a result, their yields have been kept at relatively low levels. At the present time the yields on tax-free money funds average about 50 to 60 percent of those available from traditional money market funds. In addition, any fixed-dollar expense has a more adverse relative impact upon yields for a low-yielding fund than for a high-yielding fund. For example, assume that funds A and B each have $100

million in assets and that each fund has $1 million in legal, accounting, printing, and management fees. Let's also assume that fund A, a money market fund, earns $14 million on its investments, whereas fund B, a tax-free fund, earns $7 million. The $1 million in expenses will reduce the dividend payout of fund A from $14 to $13 million, or by about 7.1 percent. However, the payout of fund B will fall from $7.0 million to $6.0 million or by 14.3 percent. Obviously, fixed expenses have a more negative impact on the lower yielding tax-free fund.

Another disadvantage to tax-free fund investors is that tax-free funds have had to extend their maturities to purchase an adequate amount of suitable bonds. For example, at the present time the average maturity of the tax-free money market funds reported in the Wiesenberger Investment Company Service is 85 days, whereas the maturity for money market funds is about 22 days. This longer maturity increases the risk of owing tax-free funds and is definitely an undesirable feature.

Another feature which increases risk is the higher default risk for municipal bonds compared with money market instruments (many of which are backed directly or indirectly by the federal government). Many municipal bonds defaulted during the Depression which occurred in the United States during the 1930s, whereas no paper backed directly or indirectly by the federal government experienced a similar fate.

One final factor deserves serious consideration. During the last year, Congress has reduced the maximum tax rate on unearned income from 70 percent to 50 percent. This has reduced the tax savings from municipal bonds for high-bracket investors rather markedly. For example, before the recent change a 7 percent tax-free yield for a 70 percent bracket investor was equivalent to a taxable yield of over 23 percent. Now, the same 7 percent tax-free yield is equivalent to only a 14 percent taxable yield. Thus, tax-free income is much less desirable than it was in previous years. In addition, the new capital recovery factors (depreciation allowances) for real estate and capital equipment investments should permit many investors to reduce their taxable incomes substantially and, thus, to further reduce their tax burden. This would further undermine the desirability of tax-free income from municipal bonds.

Given the reduced desirability of these funds and their increased risks, we believe that you will be well advised to avoid them entirely and to focus upon regular money market funds.

ADVANTAGES TO INVESTING IN A MONEY MARKET FUND

There are numerous advantages of money market fund investments. In particular, there are six which the authors believe merit special attention. The first four were briefly mentioned at the beginning of this chapter, namely, *safety of principal, high liquidity, high yields,* and *small minimum investment.* In addition to these four, *low-cost professional management* and *low purchase or redemption fees* must also be discussed. Let's now examine each of these advantages.

Safety of Principal

One of the primary objectives of a money market fund is safety of principal. When we speak of safety of principal we don't mean absolute safety (as there is no investment that is absolutely safe), but rather we are referring to the low risk of loss of principal. If you compare money market funds to other investments such as stocks and bonds, you will find that money market funds are usually far safer. What makes money market funds so safe in terms of preserving capital? The answer is simple—diversification and short-term maturity.

Diversification. Diversification is an important element in any portfolio of money market instruments because it reduces business risk. Just as it is unwise to commit all of your investment capital to one common stock, it is also foolish to commit all your liquid capital to one money market issue (excluding U.S. government and government agency securities).

Money market funds typically diversify their assets among several types of money market instruments and, within each type of instrument, they diversify among issuers. For instance, a money market fund may purchase commercial paper from a variety of corporations, certificates of deposit from a variety of banks, and U.S. government agency securities from several agencies.

Thus, if one asset were to fail, the adverse impact on the portfolio would be greatly reduced.

In addition to the advantages of owning several different types of assets which are issued by many different issuers, money market funds also offer a *diversification* of maturities. For example, focus upon the portfolio of the Reserve Fund as shown on Table 6-2. Notice that under the "Days to Maturity" column several instruments mature in 1 day, another in 4 days, and so on down to an instrument that may mature in as many as 84 days. With various

Table 6-2

THE RESERVE FUND, INC. — STATEMENT OF INVESTMENTS — MAY 31, 1979

CERTIFICATES OF DEPOSIT (92.1%) (95% in Foreign Branches of U. S. Banks)	% Face Rate	Days to Maturity	Cost	Value* (Note 1)
Bank of America	10.00-11.00	5-76	$ 71,472,882	$ 72,560,668
Bankers Trust Co., New York	10.19-10.31	1-32	69,053,702	69,192,620
Manufacturers Hanover Trust Co.	10.00-12.15	27-75	67,765,606	68,367,384
Citibank, N.A., New York	10.23-10.77	12-61	61,137,152	61,485,761
First National Bank, Chicago	10.26-10.80	11-70	60,189,555	60,799,544
Chase Manhattan Bank	6.40-11.70	1-60	59,140,047	59,926,718
Morgan Guaranty Trust Co.	10.17-12.20	4-75	58,320,950	58,976,250
Chemical Bank, New York	10.25-11.69	19-55	55,137,188	55,916,473
Continental Illinois N.B.	10.35-10.55	5-84	55,030,806	55,622,143
Mellon Bank, N.W., Pittsburgh	10.39-12.08	5-67	53,667,545	54,398,876
First National Bank, Boston	10.40-10.85	7-70	40,020,839	40,541,904
Crocker National Bank	10.41	91	40,000,985	40,000,985
Bank of New York	10.25-10.85	4-62	39,076,013	39,583,786
Wells Fargo Bank	10.30-11.20	26-62	39,081,282	39,533,536
Security Pacific N.B.	10.31-10.47	6-13	35,000,000	35,301,997
Republic N.B., Dallas	10.22-10.45	7-63	32,035,535	32,078,532
United California Bank	10.31-11.45	7-82	25,526,948	25,779,086
Texas Commerce Bank	10.50-11.64	11-69	21,156,329	21,465,895
Detroit Bank & Trust Co.	10.35-10.82	21-63	21,023,991	21,165,593
Bank of Tokyo Trust Co., N.Y.	10.30-10.80	27-49	20,000,000	20,303,435
Rainier National Bank, Seattle	10.40-10.56	20-60	20,011,496	20,293,272
Harris Trust & Savings Bank	9.13-10.65	40-77	20,064,233	20,248,652
Seattle First National Bank	10.30-10.60	20-61	20,004,582	20,195,412
First City N.B., Houston	10.37-12.20	7-54	16,224,649	16,420,921
Irving Trust Co., New York	10.52-11.80	4-67	16,191,143	16,391,984
United States Trust Co., N.Y.	10.31-10.37	14-28	12,000,000	12,002,859
Equitable Trust Co., Baltimore	10.30	60	10,000,000	10,000,000
First National Bank, Dallas	10.65	47	9,000,000	9,121,471
National Community Bank of N.J.	10.40	6	6,000,000	6,041,647
Winters Natl. Bank and Trust Co., Dayton	10.31	25	6,000,000	6,010,278
Rhode Island Hospital Trust N.B.	10.30	32	6,000,000	6,003,502
American Savings & Loan Assn., Cal.	10.35	14	5,018,254	5,110,085
National Bank of Detroit	10.43	39	5,002,997	5,077,605
The Northern Trust Bank, Chicago	10.65	42	5,004,026	5,067,308
J. Henry Schroder Bank & Trust Co., N.Y.	10.44	4	5,000,000	5,040,600
The First N.B. & T. Co. of Tulsa	10.35	6	5,000,000	5,034,539
Old Stone Bank, Providence	10.65	69	5,000,000	5,034,047
The Sumitomo Bank of California	10.45	7	4,000,000	4,096,634
The First National Bank of Atlanta	10.35	54	4,000,000	4,042,923
Birmingham Trust National Bank	11.13	55	3,092,043	3,118,297
American Bank and Trust Co., Baton Rouge	10.50	1	3,000,000	3,042,890
Central Bank of Birmingham	10.20	25	3,000,000	3,005,948
California First Bank, San Francisco	12.0	33	1,047,743	1,050,539
Total Certificates of Deposit			1,113,498,521	1,124,452,599
SECURITIES HELD UNDER REPURCHASE AGREEMENTS (4.6%)				
With Lehman Government Securities, Inc., collateralized by:				
Fed. Home Loan Corp.	10.0	1	16,200,000	16,205,220
Fed. Natl. Mtg. Assn. discount notes	10.0	1	13,650,000	13,672,864
With Ehrlich-Bober Government Securities, Inc. collateralized by:				
Fed. Home Loan Corp. discount notes	10.0	1	9,350,000	9,365,662
Fed. Natl. Mtg. Assn. discount notes	10.0	1	9,465,000	9,471,433
With Discount Corp. collateralized by:				
Manufacturers Hanover bankers acceptances, due 147-176 days	10.0	1	8,000,000	8,000,000
Total Securities Held Under Repurchase Agreements			56,665,000	56,715,179

Table 6-2 *(concluded)*

	Days to Maturity	Cost	Value* (Note 1)
U.S. Government Obligations (2.0%)			
Fed. Natl. Mtg. Assn. discount notes	53-54	24,379,250	24,653,076
Documented Discount Notes (1.3%)			
First National Bank of Atlanta	1-5	5,898,890	5,997,265
Fidelity Union Trust Company, Newark	20-46	4,883,292	4,954,721
State Street Bank & Trust Co., Boston	20-77	2,935,795	2,951,367
Security Pacific N.B. ...	71	1,362,665	1,371,704
Total Documented Discount Notes		15,080,642	15,275,057
TOTAL INVESTMENTS (100.0%)		$1,209,623,413	$1,221,095,911

*Investments are stated at fair value plus accrued interest receivable.

†Aggregate cost for federal income tax purposes was $1,209,623,413.

Gross portfolio yield—10.29 percent (annualized, not compounded, valuing securities at fair value). The dollar-weighted average maturity of the portfolio is 37 days; the longest maturity is 91 days.

instruments maturing every few days the portfolio can be "rolled over" and kept current with changes in money market rates. This reduces the risk of abnormally large changes in value caused by changes in the value of assets of a given maturity.

Money market funds, like the Reserve Fund, generally purchase money market instruments with very *short-term maturities.* By holding only short-term maturities, these funds are able to virtually eliminate interest rate risk. Even though the prices of money market instruments may change (due to the inverse relationship between prices and interest rates), by holding the instrument to maturity any price changes are irrelevant because face value is paid at maturity. In contrast to bonds, which have long-term maturities, money market instruments are much lower in terms of the potential for capital losses due to changes in interest rates. We advise that you limit your investments in money market funds to funds with average maturities of less than 60 days. The Reserve Fund would have fallen within this guideline as its average maturity was just 37 days.

High Liquidity

When we speak of liquidity we are referring to the ease with which shares may be converted to and from cash. A high degree of liquidity means that shares may be easily converted to cash. Since money market funds strive to purchase only short-term money market instruments, which are easily bought and sold on short notice, they are highly liquid. What does this mean to you as an investor? It means that you may purchase or redeem shares at your

discretion. Thus, you need not be concerned about the holding period of your investments. You can hold the fund for as short as one day or as long as several years—it s up to you! This high degree of liquidity means that you are not "locked into" your investment and that you can take advantage of any new investment opportunity that may suddenly develop.

Money market funds often offer several convenient means by which shares can be redeemed. Some funds allow you to redeem by telephone or by telegraph, and payments are normally issued within one day. Other funds offer a check-writing privilege where you may write a check against your money market investment, thereby redeeming your shares. This check-writing feature is especially attractive to our investment program as you can switch from a money market fund to a stock fund with your money working for you continuously until the check clears. Suffice it to say, the high degree of liquidity offered by money market funds may mean extra profits for you.

High Yields

Cash funds strive to maintain the highest possible yields while minimizing risk. What kind of yields can you expect from these funds? That is difficult to say because the yields of money market instruments constantly fluctuate with changes in inflation rates, loan demand, and other conditions affecting the money market. An example of the possible range of yields that may be encountered during a given period is shown in Figure 6-2 which documents the yield history of the Reserve Fund on a month-end basis during 1980 and the first part of 1981. During this period, the yield of the Reserve Fund ranged from a low of 8.3 percent to a high of 17.9 percent with an annual average yield of 13.5 percent.

Whatever the circumstances, these funds pick out the highest yielding short-term money market instruments consistent with their safety objectives. Thus you are assured of superior returns in addition to the other advantages mentioned earlier.

Low-Cost Professional Management

Successful investing in the money market requires specialized knowledge of the money market, money market instruments,

Figure 6-2
Reserve Fund field history, 1980-1981

*Average annualized net yield for the indicated months.

economics, international finance, and many other subjects. Money market funds have professional portfolio managers who possess this specialized knowledge and are able to employ it to maximize fund performance. Another attractive aspect of this professional management is that it costs so little—management fees are usually less than one half of 1 percent.

Professional money fund managers can do many things that an individual investor normally cannot undertake. First, since money market portfolio managers are constantly in touch with conditions in the money market, they are able to adapt their portfolios quickly in anticipation of changing circumstances. For instance, if money market rates were rising, the portfolio managers could take advantage of this by purchasing very short-term instruments. Second, because these managers keep in close touch with the money market, they are able to search out the highest yielding securities. Indeed, they generally call several money market dealers to locate the most favorable terms by which to buy or sell money market instruments. Third, these portfolio managers have the background and resources necessary to thoroughly research the financial condition of institutions who issue money market instruments; therefore, the ownership of poor-quality instruments is generally avoided. Fourth, money market portfolio

managers work full time to provide high-quality management. All four of the reasons suggest that money market portfolio managers are generally better able to manage money market investments than are individual investors.

Low Purchase or Redemption Fees

Most money market funds are no-load funds—that is, there are no fees whatsoever for purchasing or redeeming shares. Yet, you should be aware that there are a few money market funds that do charge either a purchase or redemption fee; we advise that you steer clear of these funds. The hazards of load fees were discussed in Chapter 2; however, the negative effect of load fees is far more severe on a money market fund than on a stock fund because a load fee adversely affects liquidity. It is highly important in our investment approach that you have the flexibility and liquidity to buy and sell when our indicators (as discussed in Chapters 7 through 9) provide timing signals.

Small Minimum Investment

The minimum initial investments required to open an account at a money market fund are typically from $1,000 to $5,000, but some funds require as little as $100. At first glance this may not seem like an important advantage of the money market funds, but it most certainly is. Why? Because most money market instruments have much higher minimum investments. Remember that negotiable CDs are sold in denominations of $100,000 and Treasury bills required a minimum investment of $10,000. The fact is that the money market is geared to large institutions dealing with millions of dollars. Money market funds offer smaller investors a means to indirectly purchase these desirable large denomination instruments.

DETERMINING THE RISKINESS OF MONEY MARKET FUNDS

In our discussion of money market instruments we indicated there are differences in risks between alternate types of instruments. We also explained that the quality of the institution issu-

ing the instrument is an important factor influencing risk. We would now like to indicate that there are considerable risk differences in the portfolios of different money market funds. Thus, a money market fund, just like a stock fund, may be classified according to risks. The objective of this section is to present guidelines for the classification of these funds.

In keeping with our previous categorization of risk (as was discussed in Chapter 1), we have constructed Table 6-3 which

Table 6-3
Risk categorization of money market instruments

Type of Instrument	Risk Category			
	(1)	(2)	(3)	(4)
Eurodollar..............	Yes	No	No	No
Commercial paper	Yes	Rated P-1 or A-1	No	No
Documented discount notes.........	Yes	At least $1 billion assets or $75 million net worth	At least $2 billion assets or $100 million net worth	No
Bankers' acceptance............	Yes	Same as above	Same as above	No
Certificates of deposit	Yes	Same as above	Same as above	No
Federal agency securities	Yes	Yes	Yes	Yes
U.S. government securities	Yes	Yes	Yes	Yes
Repurchase agreements of federal agency and U.S. govt. securities	Yes	Yes	Yes	Yes

contains our four risk categories—aggressive (1), moderate (2), conservative (3), and extremely conservative (4). This table shows whether or not a given money market instrument is *allowed* in the portfolio of a fund in each category and, in addition, if there are

any additional limitations such as the size of the issuing bank or the rating of commercial paper.

Let's first focus upon risk category 1, the agressive category. Any of the eight money market instruments are allowable investments, and in addition, there are no restrictions in terms of the quality of instruments. Investors in category 1 seek the highest possible yield with little regard to risk.

Category 2, the moderate risk category, is similar to category 1 in terms of the types of instruments that are allowable investments with one major difference—Eurodollars are no longer an allowable investment. In addition, there are some minor differences between categories 1 and 2 in terms of restrictions regarding the quality of the instruments. First, note that there is now a restriction involving commercial paper—it must be rated A-1 by Standard & Poor's or Prime-1 by Moody Investors Service. Due to this restriction, category 2 funds avoid lower quality commercial paper. Second, observe that all bank-issued instruments, which includes documented discount notes, bankers' acceptances, repurchase agreements, and CDs, must be purchased from banks that either have total assets of at least $1 billion or a net worth (capital, capital surplus, and undivided profits) of $75 million. In addition, these banks must be a member of the Federal Deposit Insurance Corporation (FDIC). In summary, those investors in risk category 2 are looking for high yields but are striving to avoid exceptionally high risks.

Risk category 3, the conservative risk category, is somewhat more restrictive than category 2. Notice that commercial paper (which is unsecured) is not an allowable investment in category 3. Also notice that all bank-issued instruments must be purchased from banks with either total assets of at least $2 billion or $100 million net worth. These banks must also be members of the FDIC. In summary, those investors in risk category 3 are desirous of avoiding any unsecured instruments and of seeking out only high-quality bank-issued instruments.

Risk category 4, the very conservative category, differs markedly from categories 1, 2, and 3 in that only federal agency securities, U.S. government securities, and repurchase agreements of these instruments are allowable investments. Those investors in risk category 4 are seeking to minimize risk.

At this point we must caution that the categories on Table 6-3 are intended only as a guideline. For example, you may find that although you are a moderate investor in stock funds, you are a more aggressive investor in money market funds because of the inherent safety of these vehicles.

In addition, you may want to switch risk categories in response to economic conditions. For instance, if the banking system appears to be particularly weak, then investors in categories 1, 2, and 3 might find it advisable to retreat to risk category 4. On the other hand, when economic conditions are strong, then some investors may desire to switch to a higher risk category. The important thing is that you choose a risk category that is suitable for yourself. If you find yourself losing sleep because of your money market fund investment, you may wish, just as with stock funds, to switch to a lower risk category. Alternatively, if you feel constrained, then it's advisable that you switch to a higher risk category. Nevertheless, we strongly recommend that you closely follow our procedures when beginning your fund program.

Now that you know how to categorize money market funds according to risk exposure levels, you must assemble the prospectus of suitable funds and select those which are consistent with your desired risk exposure level. To simplify this task we recommend that you consider only those funds that have been in existence for more than four years and that have at least 1 billion under management. These funds not only have experienced portfolio managers but also have usually been quite competitive with other funds in terms of yield and customer services. We also advise that you limit your investments to those funds that have average maturities of less than 60 days as was mentioned above.

The next section will show you how to select from this list of suitable alternatives the best individual money market fund.

SELECTION OF MONEY MARKET FUNDS

Once you have obtained a list of candidate funds that are suitable for your risk category, you are ready to select the one fund that is best suited to your individual needs. To help facilitate this selection process, we have constructed Table 6-4. Note first of all that the funds that fall into your risk category are listed in the

left-hand column. The next three columns list the most recent averate *30-day yield* produced by each fund, the *minimum allowable investment*, and *the method of redemption*. The extreme right-hand column is left open for miscellaneous comments. For instance, if the distribution of dividends is an important factor for you, then you should enter dividend distribution data in this column.

Table 6-4

	(1) Rate of Return (percent)	(2) Minimum Investment	(3) Method of Redemption	(4) Other
Fund A	9.75	$1,000	One-day wire	
Fund B	9.00	2,000	Checking	
Fund C	9.50	1,000	Checking	
Fund D	10.00	5,000	One-day phone	
Fund E	8.50	1,000	One-day wire	
Fund F	8.00	2,000	One-day phone	

Let's now consider a hypothetical example of how an investor might use this table in the selection process. Let's say that our investor intends to place $3,000 in a money market fund that offers a check-writing privilege. The first step that must be taken is to examine the minimum investment column to see if the required minimum investment can be met. Notice that fund D must be eliminated due to its $5,000 minimum investment. Next, column 3 must be examined to see if the fund offers a check-writing privilege. Since only funds B and C offer such a privilege, funds A, E, and F must also be eliminated. Thus, our investor is left with two funds, B and C. Since this investor has no preferences in column 4, the "other column," the only task is to choose the highest yielding fund. Since fund C yields more than fund B (9.50 percent versus 9 percent, the $3,000 should be placed in fund C.

Let's take another example. Assume that an individual with $4,000 to invest desires only a one-day redemption and has no other preferences. Which fund is most desirable for this investor? The answer is fund A because it is the highest yielding fund that

meets this individual's minimum investment and redemption preferences.

The above procedures should enable you to find the best possible fund consistent with your desired risk level. However, since most money market funds maintain high-quality diversified portfolios of money market instruments with suitable average maturities and services, and since the risk levels for such funds are extremely low, many investors may wish a simplified selection procedure. We first recommend that you obtain prospectuses from any five no-load money market funds. In selecting a fund, simply eliminate those that (1) have average maturities over 60 days, (2) have been in existence for less than 4 years, and (3) have less than $1 billion under management. Select the fund with the highest yield, and you will probably do almost as well as those who undertake a complete analysis.

SUMMARY

This chapter presented a background study of the money market, the characteristics of eight money market instruments, and a detailed discussion of money market funds. In addition, we classified these funds by risk and showed you how to select the best fund that meets your own personal needs.

This chapter concludes Part II of our book which deals with the selection of mutual funds. The next subject to be discussed is investment timing.

part 3

Timing of Investment Decisions

Part 2 described how investors can select a no-load fund that is consistent with both their attitudes toward risk and the trend of the stock market. During bull markets, we argued that the investors should hold small no-load equity funds which are adequately diversified. During bear markets, we suggested that it is best to hold diversified no-load money market funds.

But how can we determine the trend of the market? Unless we can do this, we won't know whether to buy a money market fund or an equity fund, and the approach outlined in Part 2 will be of little value.

The goal of the three chapters presented in this section is to remedy this problem by providing a set of market timing indicators. The indicators are designed to identify *major* turns in the stock market—turns that are normally followed by a one-to-three-year movement in the major stock market averages. We have found that trading funds on the basis of these longer term

121

trends is much more profitable than either short-term trading or long-term buy-and-hold strategies.[1]

Aggressive investors who bought and sold the no-load mutual funds recommended by the fund strategy on the basis of these timing indicators would have earned 24.8 percent annually on their money over the last 19 years. Put another way, investors who started with $10,000 would have seen their money grow to over $740,000 during this period.

The indicators we use fall into the following three categories: (1) monetary, (2) psychological, and (3) cyclical. The monetary and psychological indicators will be used to identify important buying opportunities, whereas the cyclical indicators will be used to determine the best time to sell your no-load mutual funds.

The first and perhaps the most important category, the monetary indicators, is presented in Chapter 7. To provide the reader with a better understanding of why these tools are so important, this chapter begins by discussing how money is defined, and how it influences inflation, interest rates, and stock prices. Once this background information has been discussed, we present a discount rate decision rule which provides a very simple signal for timing the purchase of mutual funds.

Chapter 8 presents an indicator which measures investor psychology. This indicator is based upon the premise that professional investors, like novices, consistently allow their emotions (mainly greed and fear) to interfere with their investment decisions. Some experts believe that this emotionalism is caused by a type of mob or crowd psychology which occasionally

[1]The term *short-term trading* refers to trading periods ranging from a few days to several weeks.

results in rampant fear or exuberance on the part of the investors. As a consequence, stocks periodically become overvalued or undervalued. The indicator we present, the mutual fund cash position, is designed to measure these emotional extremes at market lows and to determine when stocks should actually be purchased.

The final indicator, which is presented in Chapter 9, reflects the *cyclical* conditions of the stock market and is used to identify favorable selling junctures. The precise indicators we shall employ are the 39-week moving averages of the Dow Jones Transportation and Utility Averages (DJTA and DJUA) used in combination with the 10-month moving average of the specific no-load mutual fund under consideration. Although monetary, fundamental, and psychological factors cause much of this cyclical behavior, the precise mechanism is not known and a separate analysis of these cyclical forces is warranted.

7

Money, Credit, and Stock Prices

Changes in monetary conditions are one of the important determinant of stock prices because of the effect which these changes have on interest rates and the general economy. This is born out by historical evidence—there has never been a sustained bull market without the proper monetary climate. Our main goal is therefore to find an indicator which accurately measures this climate and allows us to forecast the future trend of stock prices.

A second goal is to explain, in a very simple manner, *why* changes in monetary conditions have had such an important influence on stock prices. We believe this discussion will help to broaden your general understanding of the stock market and its relationship to economic and monetary conditions.

To accomplish these dual objectives, this chapter has been divided into three sections. Section one discusses precisely what is meant by the term *money*. Section two explains the process through which altered monetary conditions influence the economy in general and equity prices in particular. The third section discusses the discount rate decision rule.

WHAT IS MONEY?

Money is a financial asset that is used by society to serve as a *medium of exchange*, a *store of value*, and a *unit of account*.

As a *medium of exchange*, money is used to facilitate the

transactions or exchanges that take place between individuals within the economic system. These transactions may involve any combination of goods, services, or other assets. For example, a lawyer who wants to sell his labor services in order to obtain other goods and services does so by first selling these services for money and then using this money to purchase the desired commodities. In a similar manner, an individual wishing to sell bonds and purchase stocks must first sell the bonds for money and then use the money to purchase stocks.

The main virtue of money transactions is that they are much less costly to enact than are barter transactions. This reduction in transaction costs encourages individuals and businesses to *specialize* in the production of goods and services for which they are skilled and to *exchange* their output for those goods and services they ultimately wish to consume. This specialization and exchange, in turn, greatly increases the amount of goods and services a society can produce to satisfy the needs of its citizens. Thus it is largely responsible for the high standard of living enjoyed by citizens in modern industrialized countries.

The second function of money is that it must serve as a *store of value*. By this, we mean that a given dollar amount of money must be able to purchase roughly the same amount of goods and services over a fairly extended period of time. For example, if $10,000 will buy the same car today or ten years from now, a person can safely store his purchasing power in the form of money and wait to buy the car some time in the future. However, if there is a severe price inflation such that the $10,000 will only buy a bicycle in three years, then money is not a good store of value and people will not wish to hold it as such. Instead, they will prefer to hold other real assets, such as real estate or precious metals.

The final function of money is that it must serve as a *unit of account*. This means that all present and future prices are measured in money units. The valuations of everything in the same units greatly simplifies accounting procedures and permits easy comparisons of prices between all types of goods, services, and assets in the same way that our unit of measurement, the foot, facilitates easy comparison of dimensions. In this sense it also serves to reduce the cost of transacting in society—for it permits an easy comparison of prices by buyers and sellers alike.

In summary, the primary function of money is to reduce the cost of transacting in society by serving as a medium of exchange, a store of value, and a unit of account. To jointly satisfy these roles, the commodity money must possess several specific physical qualities.

First, it must be *portable* and have a high value per unit of weight. Clearly, iron ore, coal, or wheat will not do. Can you imagine carrying around a 100-pound iron ingot to pay for lunch!

Second, it must be *durable*. One must be able to store money for long periods of time without having it deteriorate physically. Obviously, tomatoes won't do. Imagine saving up for a car, then going to retrieve your tomatoes, only to find they had rotted away in your safe.

Third, money must be *divisible* without loss of value. It is mandatory that the money be easily divided into smaller units to permit small purchases.

Fourth, money must be *consistent in quality* and *easily recognizable*. It follows that all units (of a given denomination) must be identical and that they should have obvious features. Coins and paper currency meet this requirement, whereas coal and tomatoes do not.

During short periods of history, various commodities have served as money without possessing all of these attributes. However, for a commodity to survive as money over an extended period of time, it must not only possess these attributes but must also possess a fifth attribute. It must be *generally accepted by the public* as a medium of exchange, a store of value, and a unit of account. People must be willing to accept it in exchange for other goods and services, to hold it as a store of value, and to measure transactions, both present and future, in money units.

To be generally accepted for all these functions, the public must be *confident* of its value. This confidence will exist only if the supply of money is limited relative to all other goods and services. In modern societies, this is normally the responsibility of the government—for the government typically controls the money supply.

In certain ways the government exercises its duty quite diligently. Under no circumstances will governments permit the private issuance of nongovernment controlled money, as was

common practice during earlier periods of history. This undoubtedly has greatly enhanced the confidence of the public in the nation's currency. Also, all governments vigorously prosecute counterfeiting activity. The fact that relatively few counterfeit bills are in existence also serves to increase the confidence of the public.

However, most governments of the world are failing miserably in perhaps the most important area of all—restraining the *legal* issuance of money. In recent years most industrialized countries have increased their national money supply at ever increasing rates.

When the supply of money increases at faster and faster rates, we know, from an abundance of historical evidence, that the price level will increase accordingly. When price levels increase, the value of money falls and the public understandably becomes less confident in money as a store of value.

But why do governments persist in increasing the money supply at such high rates? Unfortunately, until recently few governments fully understand the important role played by money or their responsibility for achieving monetary stability. As a result, governments, when pressed by national emergencies (such as wars) or expensive but politically popular programs (such as welfare or social security), usually decide to finance a portion of these programs by printing money or by forcing central banks to buy government bonds. Both activities will increase the supply of money.

By increasing the supply of money the government may be able to avoid raising taxes to pay for its new programs. But don't be fooled. Society does not avoid paying the bill. The sad fact is that by inflating the money supply and eventually the price level, the actual cost of such programs is probably much greater than it would otherwise have been. These added costs to society are caused by two factors—inflated price levels and resource misallocations caused by unanticipated increases in prices.

Inflated price levels mean that fewer goods can now be bought with the money held by the public. Where do the remaining goods and services go? To the government, of course—to run its expanding programs.

Perhaps the most devastating effect of price inflation is that it is

usually unanticipated by the public. As a result, the financial planning of individuals, businesses, and governments is thrown off. This, in turn, may cause businesses to fail, people to be thrown out of work, and the abandonment of important capital expenditure projects. Unfortunately, no one gains from such occurrences (bar a few speculators)—not even the government. These costs are a dead weight loss to society.

Before proceeding to the next section, one popular misconception must first be laid to rest. Many people have suggested that money must have some intrinsic value. They go on to argue that all paper money, unless backed dollar for dollar by gold or silver, is nothing less than a fraud perpetrated by the government upon society. This allegation is completely false. Paper money *can* be as good as gold, provided the government judiciously controls its supply. The fact that paper currencies have survived over time is strong evidence as to their viability.

However, as was suggested above, governments do have a terrible track record at living up to their monetary responsibilities. If governments shirk these responsibilities, the gold and silver bugs may be correct—but for the wrong reasons. The paper currency will fail because the government did not properly control the money supply, and not because money must be backed by gold and silver.

MONEY, INTEREST RATES, AND THE STOCK MARKET

Now that we have discussed the nature of money, we are ready to explain how changes in the money supply influence stock prices. Changes in the supply of money influence stock prices primarily through its impact on interest rates. Most of you probably know that changes in the money supply will normally cause changes in interest rates. During periods of monetary constriction, interest rates tend to *increase*; during periods of monetary ease, interest rates tend to *fall*. But most of you probably don't realize that this relationship is only valid when the period of monetary expansion and contraction is relatively short-lived. If monetary change occurs over an extended period of time, the exact opposite relationship is true—tight money causes *lower* interest

rates, and easy money causes *higher* interest rates. Why does this reversal occur? Because extended periods of monetary change (in one direction) will cause either inflation of disinflation, which, in turn, exerts a reverse effect on the trend of interest rates.

Before we can successfully show how changes in interest rates influence stock prices, we must first discuss how short-term and long-term changes in the money supply cause interest rates to change. Let's now turn to a discussion of each question.

Interest Rates and Short-Term Changes in the Money Supply

When the money supply is increased for short periods of time (no longer than a few months), market interest rates will generally fall. This relationship is easily explained by using supply and demand analysis to examine conditions in the credit market for loanable funds.

The supply of loanable funds comes most directly from banks, savings institutions, and insurance companies who wish to lend money to earn a rate of return higher than they must pay for deposits. The amount of money these institutions have available for loans depends ultimately upon the amount of money supplied by the Federal Reserve System and the willingness of individuals and businesses to deposit money in these financial institutions. Both of these factors, in turn, depend upon the current state of the economy and the economic goals of the nation.

The demand for loanable funds comes from individuals in all sectors of the economy—private, business, or government who wish to borrow money for any purpose. Private citizens, for example, may demand loanable funds to finance home purchases, automobiles, college eduction for their children, and almost any other type of good or service. Businesses, on the other hand, may wish to borrow funds to build new factories, finance accounts receivable, or finance inventory holdings. The demand for loanable funds by both private citizens and business is also dependent upon the general state of the economy. It tends to *increase* during boom periods and *contract* during recessions.

The demand for loanable funds by the government, on the other hand, is just the reverse. Governments normally borrow

more during recessions (to finance larger budget deficits) and less during boom periods.

The manner in which these supply and demand curves interact to determine the market interest rate is shown in Figure 7-1.[1] The

Figure 7-1
The supply and demand for loanable funds

equilibrium rate is determined by the point at which the two curves intersect and is shown in this example to be 15 percent. However, if the supply of money is for some reason *increased* by the Federal Reserve System, then the supply curve will shift to the *right* (to S_2), indicating that more money is available for lending. As a result, the market interest rate will fall from 15 percent to let us say 12 percent. If the Federal Reserve had tightened monetary policy, the reverse would be true—interest rates would have increased above 15 percent. In summary, a short-run increase in the supply of money will cause interest rates to *decrease*, whereas a short-run decrease will cause interest rates to *increase*.

[1]Market interest rates will differ depending upon risk, time to maturity, and liquidity of the particular issue.

Be careful to avoid making the erroneous conclusion that all changes in interest rates are caused by changes in the money supply. Interest rates may also change because there is a change in the demand for loanable funds. For example, if the economy enters a recession and unemployment increases, many people may decide to postpone buying automobiles, houses, and other goods and services. As a result, the demand curve for loanable funds would shift down and interest rates would be driven down.

Interest Rates and Long-Term Changes in the Money Supply

The previous paragraphs showed that in the short run, interest rates move in an opposite direction to changes in the money supply. However, in the long run, new forces will be brought to bear which completely change this relationship.

This can be shown most easily by following a simple example. Let's assume that the government rapidly increases the money supply for a period of several years. From the above discussion, we know that interest rates will initially be driven down sharply due to a large increase in the supply of loanable funds. But what happenns to these newly created loanable funds? Do they remain idle? Of course not. Individuals and businessmen who borrowed this newly created money did so only because they intended to purchase something they wanted, such as a car or an office building.

To illustrate, let's suppose that many consumers who had previously put off buying a new Chevrolet, due to high interest rates, now decide to buy one. As the Chevrolet dealers sell more cars, their inventories will be reduced and they will order more cars from General Motors. But General Motors can produce only so many Chevrolets without increasing the size of its plants. Since General Motors observes what is perceived as a new increase in demand for Chevrolets, it realizes that it can earn more profits by expanding operations. Hence, it will build new plants or reopen ones that were previously closed. But to operate the new plant it must hire more workers and purchase more coal, steel, plastics, rubber, and other raw materials.

In summary, the auto manufacturer has, as a result of its decision to increase operations, increased the demand for real

estate, buildings, labor, coal, steel, plastics, and so on. Do you think the prices of all these goods are affected by this increase in demand? You're right—the prices of all these goods and services will eventually be increased.

But remember this is just an illustrative example for the Chevrolet market. In reality, similar demand increases are induced for Fords, Chryslers, new homes, televisions, vacations, and almost everything else produced in society. When the total impact of all this new spending (attributable to the extended increase in the money supply) is added together, it is easy to see that the prices of most all goods and services will eventually rise. But we refer to this phenomenon by another familiar name—inflation.

Inflation will have a tremendous impact on interest rates for two reasons. First, we know that bankers will not lend out money at the low interest rates knowing that the loans will be repaid in deflated future dollars. Bankers will demand higher interest rates to compensate for this loss in purchasing power.

At the same time consumers and business firms will begin to *anticipate* that inflation will continue and possibly increase in the future. To avoid paying higher prices for goods and services tomorrow, they will *increase* their demand for loanable funds so that they can make their desired purchases (such as a new home) at today's lower price.

A second consideration is that consumers will actually increase the amount of goods and services they demand above normal levels since they expect to pay back their loans with deflated future currencies. But by increasing the demand for loanable funds, interest rates are bid up to higher levels.

Thus an easy monetary policy will, if continued long enough, create inflation which, in turn, will force up interest rates. This relationship between rates of change in the money supply, inflation, and interest rates is one of the best documented relationships in all of economics. It holds true today in *all countries of the world*—and it has held true *throughout history*.

Although the above example focuses upon continued monetary expansion, a similar example could be constructed for monetary contractions (or reductions in the rate of monetary expansion). Here we would find that monetary contractions would cause disinflation, which, in turn, would force interest rates down

to lower levels. A slow down in the rate of monetary growth is one of the policies that President Reagan is advocating to help reduce interest rates. If this approach is given enough time to work it should produce the desired result.

Interest Rates and Stock Prices

The above discussion explains how changes in the money supply affect interest rates. But how do changes in interest rates affect stock prices? There are *three* influences—a *portfolio effect*, a *discounting effect*, and a *corporate profits effect*.

The *portfolio effect* will entice investors to sell stocks and buy bonds because when interest rates rise, the yields paid on bonds will increase relative to the dividends paid on stocks. Thus people who hold stocks can earn a higher average yield on their portfolio by selling some low dividend stocks and purchasing higher yielding bonds.

The second effect of changing interest rates is a *discounting effect*. An increase in long-run interest rates means that individuals are, in general less willing to give up money today to receive a given amount of income tomorrow. This means that future dollars are now valued less highly than previously. It follows that investors will now value future corporate earnings less highly as well. They will therefore pay less today for any future level of corporate earnings. This means that the price to earnings ratios for common stocks will be bid down, and with them, the prices of these stocks.

The third impact operates through changes in corporate profits. Corporate profits are influenced by two factors, namely, *sales volume* and *profit margins*. When a temporary *decrease* in the money supply pushed *up* interest rates, we know that total spending for goods and services will *fall* because fewer people will be willing to borrow money to purchase goods and services. Thus sales volumes are reduced and corporate profits fall, provided profit margins remain the same. But profit margins also tend to decrease, since output prices typically fall faster than do production costs in periods of contraction—largely because of the exist-

ence of fixed wage contracts. Thus, corporate profits are reduced by both a decrease in sales volume and a fall in profit margins. It is a well-known fact that stock prices tend to decrease when corporate profits fall.

Thus rising interest rates tend to reduce stock prices for all three reasons. The reverse would be true if interest rates were to fall.

DISCOUNT RATE DECISION RULE

The previous section described the framework through which changes in the supply of money influence the price levels of common stocks. Money supply changes first induce changes in interest rates, which, in turn, influence stock prices through portfolio, discounting, and corporate profit effects. In practice these factors have the largest influence on stock prices near major market lows.

One of the best indicators for identifying important market lows is the Discount Rate Decision rule, as discussed by Growth Fund Research, Inc. The discount rate is the interest rate the Federal Reserve Banks charge member commercial banks (such as the Bank of America) to borrow money. In practice, the Federal Reserve is considered to be the "lender of last resort" and will normally lend money to banks on a short-term basis to assist them in meeting their legal reserve requirements. The Federal Reserve seeks to limit such borrowing to a relatively small percentage of member bank reserves and takes a dim view of banks that repeatedly abuse their borrowing privilege.

The most important aspect of the discount rate is that it serves as a signal to the financial community concerning the future trend of interest rates and the general ease or tightness of credit. When the Federal Reserve decreased the discount rate, it makes borrowing from the Fed cheaper and encourages credit expansion by the banking system. This is normally viewed very favorably by the financial community. The signal is viewed with particular favor when the discount rate is reduced two times in succession as this is perceived to be a strong indication that the Fed has adopted a more accommodative monetary policy. It is not surprising that

stock prices have, in general, increased substantially after such a signal.

The relationship between successive reductions in the discount rate and the level of prices is depicted in Table 7-1 for the period from July 10, 1962, to April 27, 1981. Please notice that the date on which the second successive discount rate cut occurred is presented in the first column of the table and that the associated closing price of the Dow Jones Industrial Average (DJIA) is shown in the second column. Column 3 and 4 show the date and price level of the DJIA at the market peak following each signal. The next two columns show the percentage gain in the DJIA from the date of the original signal to the subsequent market top and the associated time period in question. Please realize that this calculation does not include dividends nor does it make allowances for taxes or commissions. The reader should also realize that this exercise is solely for illustrative purposes as it assumes perfect timing at market tops—an achievement that no investor could have duplicated. However, it does help identify the potential usefulness of the discount rate decision rule as a buy indicator.

Table 7-1
Discount rate buy signals, 1962-1981

(1) Signal Date	(2) DJIA	(3) Peak Day	(4) DJIA	(5) Gain (percent)	(6) Months
7/10/62	586.01	2/9/66	995.15	69.8	43.0
12/4/70	816.06	1/11/73	1051.70	28.9	25.0
12/6/71	855.72	1/11/73	1051.70	22.9	13.0
1/6/75	637.20	9/21/76	1014.79	59.3	20.5
6/13/80	876.37	4/27/81	1024.05	16.9	10.0
Average				39.6	22.3

Source: Growth Fund Research.

Please notice that the indicated percentage gains varied from a low of 16.9 percent to a maximum of 69.8 percent and that the average gain was a respectable 39.6 percent. Also notice that the average time period between each signal and the subsequent market peak was 22.3 months. However, the reader should note that there was considerable variation as the shortest period was 10 months, whereas the longest was 43 months.

If we ignore the overlapping signal given in 1971, we can calculate the cumulative return that an investor could hypothetically have earned over the entire period buying on the indicated buy dates and selling on the corresponding peak days. After a sale the investor is assumed to place all the proceeds into money market instruments until the next buy signal at which time it is reinvested into the market. A person who invested $10,000 on July 10, 1962, and who followed this strategy would have seen his or her investment grow to $40,759 by April 27, 1981. This may be contrasted with a simply buy-and-hold strategy where the initial $10,000 investment would have grown to only $17,475. These figures do not include dividends which comprise a very important part of the total return earned on common stocks. They also make no allowance for the interest income that could have been earned in money market instruments during the approximately 9½ years when the investor would have been out of the market entirely. The above considerations would have more than doubled the $40,759 figure specified above. Finally, imagine what the return would have been for an aggressive investor who purchased volatile no-load mutual funds—investments which typically increase from two to five times as much as the DJIA during rising markets.

Interestingly, a new buy signal was rendered by the discount rate rule on December 4, 1981, with the DJIA at 892.69. If the market behaves as it has on average in the past, the DJIA could easily advance to new all time highs in the next two to three years. Of course, as the reader must surely realize, no indicator is foolproof, and this signal must simply be viewed as an encouraging development rather than a guarantee of future advances.

Any reader wishing to track this indicator will find it to be a simple task since the discount rate is reported each week in *Barrons, The Wall Street Journal*, and many daily newspapers.

8

Investor Psychology

Any astute investor can tell you that far more than fundamentals are involved in analyzing the stock market. Admittedly, profit margins, earnings growth rates, and other fundamental factors are important, but, like bread without butter, something is missing. That missing ingredient is investor psychology, for *regardless of fundamentals*, market movements are ultimately propelled by individuals. Therefore, to truly understand the stock market you must first understand human behaviour as it relates to investing—such is the aim of this chapter.

Our presentation of investor psychology is divided into four sections. Section one examines human emotions as they relate to investment decisions. Section two, entitled "The Madness of Crowds," studies the psychology of crowd behavior and provides several interesting historic examples. The third section shows you how to "beat the crowd" through the use of *contrary thinking*. As you will see, investment success is dependent, to a large extent, upon your ability to act contrary to "the crowd." The fourth section introduces the "contrary opinion indicator" we shall be using to measure investor psychology—the average cash position of mutual funds. This indicator is used to provide buy signals which tell you when to purchase no-load mutual funds.

INVESTORS AND EMOTIONS

We are often told that clear, cold objectivity is a vital prerequisite to investment success—yet how often do most investors ignore this advice? Regrettably, many investors react primarily to the emotions of greed and fear. Greed often entices investors to accept excessive risk, buy on tips, or rush into investments without adequate research. Fear, on the other hand, has frequently caused many investors to "freeze up" in critical situations and to forego taking proper action. If has also compelled many persons to sell prematurely, often at or near major market bottoms. Driven by greed and fear during bull and bear markets, many investors have been locked into a vicious cycle of repeated losses.

Is there a way to end these losing habits? Yes! By vowing *never to make a stock transaction while your emotions dominate your intellect.* Whenever you find yourself ready to make a transaction while emotionally excited, we suggest that you remember the above rule and do the following: Make a list of pro and con arguments regarding your proposed transaction. You'll be surprised what a sobering effect these arguments will have upon your decisions.

THE MADNESS OF CROWDS

"Anyone taken as an individual is tolerably sensible and reasonable—as a member of a crowd, he at once becomes a blockhead," were words of wisdom stated by the German poet Friedrich Schiller. Crowd psychology is a fascinating subject. Psychologists, sociologists, and other students of human behavior have long been attracted to the study of this topic. One of the best books on crowd psychology, *The Crowd*, was written by Dr. Gustave Le Bon in 1895.[1] His observations are as valid today as they were at the time of its writing.

In defining a crowd, Le Bon suggests that a crowd is not necessarily a group of individuals in close physical proximity. It may be composed of any number of isolated individuals as long as they have a *determined object.* For example, after the Japanese bombed Pearl Harbor in 1941, virtually everyone in America became part of a crowd because we had a determined object—to seek revenge

[1]Gustave Le Bon, *The Crowd* (Dunwoody, Ga.: Norman S. Berg, 1968).

against the Japanese. Thus the citizens of our nation were a crowd despite being scattered in a geographical sense.

But what about the stock market and all those diverse investors—are they also a crowd? Yes, because they have a common goal (a determined object), namely, to profit through investing in stocks. Furthermore, even small individual investors can be brought into close contact with Wall Street by calling a broker, reading periodicals, or by tuning in the financial news on radio or television.

If you accept the premise that stock market investors behave in a crowd like manner, then it should be evident that the study of crowd behavior can help your investment performance. The first step in studying crowd behavior is to examine the type of transformations which occur when individuals become members of a crowd. Let's see what Dr. Le Bon can teach us.

Dr. Le Bon tells us that "a crowd thinks, feels, and behaves on a much lower level than the customary levels of individuals who compose it" and that "the debasement becomes deeper as the crowd increases in size." With nearly 35 million investors, we must have, at best, a very low thinking breed.

In addition to operating at a lower than customary level, the individuals comprising the crowd also undergo drastic emotional changes. As Le Bon points out, "impulsiveness, irritability, incapacity to reason, the absence of judgment and of the critical spirit, the exaggeration of the sentiments . . ." are the fundamental characteristics of a crowd. Now we are getting to the heart of the matter—the crowd is an emotional creature. But it is a special kind of emotional creature, for according to Dr. Le Bon "the sentiment of responsibility which always controls individuals disappears entirely." But actually we knew that anyway—just sit back for a moment and remember mob scenes such as a crowd of wild cowboys getting ready for a "hanging party." Simply stated, a crowd thrives on emotions.

Le Bon's studies of crowds led him to the opinion that a crowd is a step backward in the ascent of man—"Isolated, he may be a cultivated individual; in a crowd, he is a barbarian—that is, a creature acting by instinct." If that's not enough, Le Bon went on to say, "From the moment that they form part of a crowd, the learned man and the ignoramus are equally incapable of observation." Unquestionably, Dr. Le Bon was very "down" on crowds.

The primary lesson to be learned from our discussion of crowd

behavior is that *people do things in a crowd that they would never do if they weren't part of a crowd*. The stock market provides us with myriad examples of people doing things they would never do if they were acting alone. To illustrate just how irrational people can become when members of a crowd, let's look at some interesting historic examples of crowd madness.

The Mississippi Scheme

The Mississippi Scheme is a story of 18th century France. This story focuses upon the behavior of the people (the crowd) and its consequences for the French economy. We believe this is an example you will not forget.

After the death of Louis XIV in 1715, the Duke or Orleans, acting as the regent, took charge of the French government. France at that time had severe economic problems, which were largely due to the excessive government spending of Louis XIV. (Sound familiar?) The national debt was 3,000 million livres, annual tax revenues were only 145 million livres, and annual government expenditures were 142 million livres. With only a 3 million livres surplus, the government was unable to pay even the interest on the national debt.

Government officials were desperate to find ways to stimulate the economy and restore the people's faith in the government. In the midst of this chaos, John Law, a Scottish friend of the Duke of Orleans, put forth his theories on finance and commerce. He suggested that France adopt a paper currency as a supplement to the existing metallic currency. He expounded on the benefits of a paper currency and how it would restore strength to the treasury and the government. He also proposed that he start a bank in France which would be responsible for managing the revenues of the government. Due to Law's friendship with the Duke of Orleans, his proposals were accepted; he was given permission to start a bank and to institute a paper currency for the country.

Law's bank was so successful that branches sprung up in major cities throughout the nation. More importantly, the economy began to pick up as commerce improved and faith in the government increased. Law had suddenly become a national hero.

Since Law's bank had proved to be so successful, the Duke of Orleans changed the bank from a private to a public institution

and changed its name to the Royal Bank of France. The Duke also made another change: he ordered that 1,000 million livres of paper currency should be printed. This extreme expansion in paper currency proved, at a later date, to be a grave mistake (of course, if you remember the lessons of Chapter 7 you already know the result of excessive growth in the money supply).

In the meantime, Law had secured from the regent the right to start a corporation. The purpose of this corporation was to trade in the area of the Mississippi River and in Louisiana (which at that time belonged to France), areas rumored to be abundant in precious metals. The capitalization of this corporation consisted of 200,000 shares, with each share selling for 500 livres. Because of the success of Law's bank, the people of France were eager to purchase shares in Law's corporation. The Duke of Orleans, pleased by the apparent prosperity that Law had brought to France, continued to bestow privileges upon him. These new privileges, such as a monopoly on the selling of tobacco, only made the public more eager to own shares in the new corporation.

Upon receiving a trading monopoly with several foreign countries, Law changed the name of his firm to the Company of the Indies and announced that a dividend of 200 livres would be paid for every share then worth 500 livres. The public went wild. Visions of endless wealth had seized people from all walks of life. Many Frenchmen spent entire days in front of Law's house in a frantic scramble to acquire shares of his corporation. The speculative frenzy became so violent that accidents occurred constantly and soldiers had to be called in to disperse crowds.

Many Frenchmen were confident that France had reached the point of permanent prosperity, and successful speculators were of the opinion that there were no limits to their wealth. Anyone that spoke contrary to these views was called a fool.

The Company of the Indies had become such an important object of attention that many found it difficult to concentrate on their professions. One story has it that a doctor, so concerned about his shares, could not concentrate on medicine. He apparently had purchased his shares just prior to a temporary decline in price. The doctor was so disturbed that when he was measuring the pulse of a patient he muttered "It falls! It falls! Good God! It falls continually!" The patient, believing the doctor to be referring to her pulse, said, "I am dying! It falls! It falls! It falls!" The

doctor apologetically explained, "I was speaking of the stocks. The truth is, I have been a great loser, and my mind is so disturbed, I hardly know what I have been saying."[2]

Although the shares of Law's company experienced temporary declines from time to time, the primary direction still remained upward and new highs were seen continually. Thus the delusion remained intact. But, as so many principles of sound financial management had been violated, the downfall of Law and his schemes was inevitable.

The downfall began with problems in the banking system. The total amount of paper currency, which had remained at the reasonable figure of no greater than 60 million livres under Law's private bank, had increased to about 2,600 million livres under the Royal Bank of France. As the people became aware of the dubious value of the paper currency, banks became swamped with people desiring to exchange their paper for metallic currency. Law, now the comptroller-general of finances, and the Duke of Orleans knew they were in deep trouble. In a desperate attempt to restore order they decreed that no citizen could have more than 500 livres of metallic currency in his possession. Despite a severe penalty for violating this law, metallic currency was still hoarded by the public. The result was mass arrests and a populace pushed to the brink of revolution.

While all these problems were occurring with the French currency, the share price of Law's company was falling precipitously. Few people still believed that the Mississippi River area was abundant with precious metals. The madness that had earlier filled the people of France with such optimism had completely reversed itself—the people were in a panic, and tremendous capital losses were suffered by shareholders.

Mr. Law, formerly hailed as a national hero, became the object of hatred throughout France. So hated was Law that one irate songwriter actually suggested that Law's paper currency should be put, "to the most ignoble use to which paper can be applied."[3] Law left France a near beggar and was forced to resume his former life as a gambler.

The Mississippi Scheme is an excellent illustration of how

[2]Charles MacKay, *Extraordinary Popular Delusions and the Madness of Crowds* (New York: Noonday Press, 1932), p. 19.
[3]Ibid., p. 37.

greed and fear can be pushed to extremes. In this example, rumor and expectations were the basis behind the buying frenzy. Acting out of greed, rather than sound investment principles, the people of France deluded one another into believing they had a source of unlimited wealth. When the delusion was ultimately exposed, panic set in. After the entire episode had ended, speculators unable to accept the blame for their avaricious ways and sheeplike behavior, blamed Law as if he had stolen their money like a common thief.

Tulip Mania

In Holland during the early part of the 17th century, tulips became a very fashionable item to own. The upper class became so enthralled with tulips that it was considered very poor taste not to own any. Soon this demand for tulips spread to the middle class, and soon afterwards even those of lesser means sought to own them. As the demand for tulips increased, the price also increased.

The price of tulips quickly rose to extraordinary heights, and individuals of all walks of life were attracted to tulip speculation. Ordinary vocations were forsaken in favor of speculating in tulips. The prices of tulips rose to such heights that in one trade the following 12 items were traded for a single tulip root: "Two lasts of wheat, four lasts of rye, four fat oxen, eight fat swine, 12 fat sheep, two hogsheads of wine, four tuns of beer, two tuns of butter, one thousand pounds of cheese, a complete bed, a suit of clothes, (and) a silver drinking cup."[4]

Tulips were in such great demand that the stock exchanges in the major cities established markets for them. Speculation became rampant, and the prices of tulips continued to advance. The Dutch people began to believe that permanent prosperity was a certainty. Individuals from all walks of life—"nobles, citizens, farmers, mechanics, seamen, footmen, maid-servants, even chimney-sweeps and old clothes-women"—"dabbled in tulips."[5] Many individuals went so far as to sell their homes in anticipation of amassing great wealth from tulip speculation.

There reached a point in speculative frenzy when wise speculators recognized the eventual downfall of tulip prices and began

[4]Ibid., p. 91.
[5]Ibid., p. 9.

selling their bulbs. Tulip prices soon began to plummet. Panic was rampant. As the prices plunged, so did the fortunes of many investors. Many individuals that were wealthy prior to the tulip mania were now bankrupt. The economy of Holland also suffered greatly from the tulip mania, and many years passed before the nation regained its economic strength.

Though this example involved tulips rather than shares of a corporation, the story is similar to the Mississippi Scheme in that greed, fear, and crowd madness were responsible for the situation.

The fact that these examples all took place in past centuries and in foreign countries makes it easy to criticize their behavior. But, haven't Americans recently gone through similar experiences? Hasn't crowd madness occasionally overcome our own stock exchange? Let's see.

The New York Stock Exchange (NYSE)

During the latter part of the 1920's, the New York Stock Exchange (NYSE) became quite well known to Americans. In fact, America was obsessed with Wall Street. It appears as if nearly every American with any savings had plunged into the stock market. Bellhops, shoeshine boys, janitors, cab drivers, as well as the middle and upper classes, were all buying shares. Wall Street was very optimistic, as evidenced by the quadrupling of the Dow Jones Industrial Average (DJIA) from 1925 to 1929. To emphasize this ebullient mood, here are some quotes from *The Wall Street Journal*:

> Some traders are so bullish they have stopped naming tops for certain stocks and say they will never stop going up. (July 8, 1929)
>
> We will continue in a major bull movement indefinitely. (July 9, 1929)
>
> The public appetite for securities continues unabated. (September 19, 1929)

The vast majority of the public had convinced themselves that stock prices could defy gravity and continue upward forever; and, unfortunately, some noted economists and businessmen reinforced this belief. For example, on October 15, 1929 (just two weeks before the great crash), Professor Irving Fisher, an econo-

mist at Yale University and considered to be one of the greatest native American economists, stated that stock prices "have reached what looks like a permanently high plateau; I expect to see the stock market a good deal higher than it is today within a few months."[6] On the same day, Charles E. Mitchell, who was president of the National City Bank of New York, voiced similar optimism as he said, "The markets are generally now in a healthy condition . . . values have a sound basis in the general prosperity of our country."[7] However, by 1929, the prices of shares on the stock exchange had been pushed to extreme heights. Here are some highs achieved by a few of the major corporations listed on the NYSE:

American Telephone & Telegraph	310 1/4
General Electric	403
Otis Elevator	445 3/4
Union Pacific	297 5/8
U.S. Steel	261 3/4

As we all know from hindsight, the decline from these excessive highs was catastrophic and the ensuing bear market lasted nearly three years. In July 1932, the DJIA bottomed out at a price of about 41 (from a high of over 380 in 1929). Here are the low prices of the five stocks mentioned above:

American Telephone & Telegraph	75 1/2
General Electric	8 1/2
Otis Elevator	9
Union Pacific	29 1/8
U.S. Steel	21 1/4

In contrast to the optimism of 1929, here are some pessimistic statements as they appeared in *The Wall Street Journal* in 1932:

[6]Goromwx Rees, *The Great Slump* (London: Weidenfeld and Nicholson, 1970), p. 47.
[7]John Kenneth Galbraith, *The Crash* (Boston: Houghton Mifflin, 1972), p. 99.

> At the moment there is little incentive for the purchase of stocks. (May 24, 1932)
>
> With so many important matters still undecided, the market offers little incentive to the investor. (July 1, 1932)
>
> Practically all the news covering business continues discouraging. (July 6, 1932)

The above statements were made when the DJIA was near its low and poised for a dramatic advance.

The bear market from 1929 to 1932 destroyed many people, both financially and psychologically. Many investors couldn't believe that their money had just "disappeared." Unable to accept the blame for their mistakes, the public sought a scapegoat. Just as Frenchmen blamed John Law for the disastrous end of the Mississippi Scheme, Americans blamed the short seller for their losses. Although short selling had little to do with the severe bear market, many Americans successfully convinced themselves that the "evil" short sellers were to blame for their misfortunes.

In the three aforementioned examples of crowd madness, the inevitable result was financial disaster for many investors. However, this type of disaster need never affect you, for there is a means by which you can use this very madness to your own advantage. How? By becoming a contrary thinker.

CONTRARY THINKING

The concept of contrary thinking is quite simple—it is to think and act in a manner opposite to that of the majority. With respect to investing, this means to buy when the majority of investors reach the peak of pessimism and to sell when the majority of investors reach the peak of optimism. Or, as John Templeton, manager of the successful Templeton Growth Fund, stated, "Buy when things look terribly bad, and sell when things look terribly good."[8]

Contrary thinking has also been described as an approach in which the logical becomes illogical and the illogical becomes logical. It is out of this paradox that successful investing is born. Why? Because at market peaks—when investors' expectations are highest—investors are most fully invested and their potential

[8]*Forbes*, July 1974.

buying power is lowest. Conversely, when investor expectations are lowest, their buying power is highest. Since it takes money to fuel a market move, it's no surprise that market peaks occur at the height of investor expectations and that market bottoms occur at their low point. Thus, the market is likely to do the opposite of what the majority expects.

This was certainly true at the 1929 market top. The vast majority of investors were so bullish that they could see no limit to their potential gains. To the true contrarian, such an investment climate would indicate that it's time to sell.

It was also true at the market bottom in 1932 when most investors felt there was little incentive to purchase stocks. As we saw, this was one of the most opportune buying points of this century. Let's see how contrary opinion worked in some examples other than the 1929-32 market crash.

In January 1973, the DJIA was over 1,000. At that time Barron's published a three-part series containing the views of 10 financial experts regarding the outlook for the market. Amazingly, all 10 experts agreed that the market should be bullish in 1973, thus the title of this article was "Not a Bear among Them." When asked to estimate at what level the Dow Jones Industrials would close in 1973, the general consensus was that it would be approximately 1,200. In any case, all the experts felt that 1973 would see some sort of market rise. These experts were *dead wrong*. In January 1973, the Dow Jones Industrials peaked and started downward. As we all know, 1973 turned out to be a horrible bear market year as the Dow Jones Industrials closed the year around 850—about 350 points below the target specified by the experts.

Other experts experienced similar embarrassments. In 1972, at the Fifth Annual Institutional Investor Conference, airlines were selected as the best industry for investment for the remainder of that year. How did the prediction of these experts turn out? Not very well. The airline group fell 50 percent from the time of the conference to the end of the year. Once again, contrary opinion proved to be correct.

The difficult aspect of contrary thinking is that it is hard for many people to act against the crowd; or to put it another way, it is easy to be swayed by the crowd. To illustrate, imagine that you're in a crowded movie theater and everyone starts to run for the exits

because someone yells "fire!" Would you be able to remain calm and seek out the best solution, rather than running with the crowd? Think about that for awhile!

MUTUAL FUND CASH POSITION

If it is so difficult to act contrary to the crowd, then how can an investor learn the discipline of contrary thinking? It's simple, by the use of a time-tested contrary opinion indicator—the mutual fund cash position. The mutual fund cash position is defined as the average percentage of cash (including the money market instruments discussed in Chapter 6) held in the portfolios of mutual funds.[9] To calculate this index you simply divide the total amount of cash held by mutual funds by the total amount of mutual fund assets. The statistical information regarding mutual fund cash can be obtained monthly from the Investment Company Institute, which is located in Washington, D.C. Unfortunately, there is approximately a three-week lag from the end of the month until the information is released.

The average cash position of mutual funds provides an accurate measurement of the bullish or bearish sentiment of fund managers in particular and professional investors in general. As we learned previously, excessive sentiment on one side of the market normally portends a movement of prices in the opposite direction. Thus, a large increase in the percentage of mutual fund assets held in cash indicates that fund managers are bearish and that the market is probably near an important low. Conversely, a low cash position implies that fund managers are bullish and that the market may be near a significant peak.

The actual relationship between the NYSE composite index and the cash position of mutual funds is displayed in Figure 8-1 for the period between 1957 and 1982. The inverse relationship depicted should be obvious—mutual fund managers, as a whole, are most heavily invested in equities at market peaks and most heavily invested in cash at market bottoms. Thus, the majority of mutual fund managers are very poor at market timing.

[9]The cash held by money market funds is not included in these statistics because this money does not reflect the behavior of mutual fund managers concerning common stock investments.

Figure 8-1
Mutual fund cash position, 1957-1982

Source: *Growth Fund Guide*, December 1981.

The mutual fund cash position has proved to be an excellent indicator of major market *bottoms*. Notice in Figure 8-1 that during the last several months of the bear markets of 1962, 1966, 1970, 1974, and 1978 the mutual fund cash position moved in an uninterrupted upward path until it peaked.

The best decision rule is to buy into the stock market when the mutual fund cash position index first declines after having risen continuously for at least four months provided that (1) the DJIA has declined at least 20 percent since the preceding market peak and (2) at least three years have elapsed since the prior mutual fund cash position buy signal. Using this 20 percent stipulation and the three-year time period greatly reduces the chances of being whipsawed during bear market rallies.

The five major buy signals given by this indicator are shown in Table 8-1. This table identifies the date when the buy signal first appeared, the level of the DJIA at that time, the date and level of

the low in the DJIA, and the percentage difference between the Dow level at the time of signal and the actual market bottom. As you can see, this indicator has an excellent record, having signaled an average of 12.0 percent from the actual low in the market.

Table 8-1
Buy signals of the mutual fund cash position from 1961 to 1981

Appearance of Signal		Date and Level DJIA Bottom		Percentage Difference between Signal and
Date	Level	Date	Level	DJIA Bottom
1. November 21, 1962	635	June 1962	535	18.7
2. December 21, 1966	805	October 1962	744	8.2
3. September 21, 1972	745	May 1970	631	18.1
4. November 21, 1974	608	December 1974	577	5.4
5. April 21, 1978	813	March 1978	742	9.6
Average				12.0

Despite this excellent record, the reader should be aware that this decision rule, like any market indicator, is not foolproof. Indeed, it is advisable to view any market timing tool within the framework of overall economic, financial, political, and market conditions and with respect to other market timing indicators. In this regard, the reader is advised to be especially cautious if the mutual fund cash position indicator registers a buy signal at a time when the inflation is accelerating, interest rates are increasing, and the economy is booming—for these circumstances are not normally encountered at major lows in the stock market.

9
Cyclicality

Securities prices, like many other natural phenomena, exhibit a very clear-cut *cyclical* pattern over time. There is a definite tendency for the prices of most securities, and hence the broad market averages, to register cyclic lows approximately every 4 to 4½ years. This four-year cycle is shown for the Dow Jones Industrial Average (DJIA) in Figure 9-1. Notice that the time period between cyclic lows since 1949 had been 51, 53, 52, 52, 44, 56, and 42 months, respectively.

At the present time there is no clear-cut explanation for this cyclic phenomenon, though many possible explanations have been suggested. Some people feel that the underlying cause of this cycle is the fact that presidential elections are held every four years in this country and that incumbent politicians try to "pump up" the economy in an attempt to win votes. Others believe that it is the behavior of the Federal Reserve Board that causes the rhythmic fluctuations, a behavior which in part results from political pressures exerted in major election years. If this is so, why does this same cycle exist in other countries which have key national elections other than every four years? And why did this relationship exist prior to the establishment of the Federal Reserve System in 1913?

Figure 9-1
Cyclic lows of the Dow Jones Industrial Average
THE MAJOR MARKET AVERAGES

Confronted with these facts, other persons have gone so far as to suggest that stock prices are controlled by the movements of the planets, by sun spots, or by some mystical powers that influence the behavior of individual investors and those of corporate officials and politicians as well!

At the present time no one really knows what factors influence this cyclicality in stock prices. It is our belief that these cycles are probably caused by a combination of monetary, fundamental, and psychological considerations, and that other physical factors, not thoroughly understood or identified by science, may in turn partly explain variations in the above basic causes. Perhaps some type of electromagnetic radiation, climactic factors, or other real phenomena combine to influence the behavior of individuals through changing blood chemistry or thought patterns.

Though the cause of this cyclic behavior is unknown, it is indisputable that this four-year cycle does exist. It is also true that both shorter and longer cyles exist and that these cycles, when superimposed upon one another, explain much of the price behavior observed in the stock market. The manner in which these cycles interact to influence stock prices is probably explained best in J. M. Hurst's book, *The Profit Magic of Stock Transaction*

Source: *3-Trend Security Charts* (Boston: Securities Research, June 1975). Notations are authors'.

Timing.[1] Mr. Hurst points out that the low points (troughs) of shorter cycles tend to coincide with those of longer cycles. According to Mr. Hurst, this *synchronous* behavior explains why the stock market lows shown in Figure 9-1 tend to be "V" shaped, whereas market tops tend to be more rounded.

Mr. Hurst has developed an excellent technique through which it is possible to harness the impact of cyclicality to help improve stock transactions timing. Unfortunately, his technique is far too complex for inclusion in this book. Fortunately, a simpler technique exists which can help us take advantage of the cyclicality in stock prices. This technique involves smoothing cycles with the use of *moving averages*.

MOVING AVERAGES

A moving average is simply the average price of a stock or market index calculated periodically over some designated time period. To calculate a moving average, it is necessary to total the individual closing prices for each period in question, say, 39

[1] J. M. Hurst, *The Profit Magic of Stock Transaction Timing* (Englewood Cliffs, N.J.: Prentice-Hall, 1970).

weeks and to divide this total by the number of weeks in the period, i.e., 39. This average price is then plotted along with the price data for the most recent week. To calculate the moving average for the next week, we simply *add* the new closing price and *subtract* the closing price from 39 weeks ago, again dividing the new total by the period over which the average is being taken—39 weeks.

The effect of a moving average is to greatly *reduce* the magnitude of all cyclic fluctuations with a duration of less than the time span of the moving average and to *highlight* those fluctuations with time spans greater than that of the moving average. For example, the 39-week moving average would greatly reduce cyclical fluctuations of, say, 10 or 20 weeks, but would highlight fluctuations of 80 weeks, 160 weeks, or longer.

In general we wish to *buy* stocks (no-load mutual funds) when the moving average we are using turns flat or up (i.e., when the trend of cycles longer than 39 weeks are beginning to turn up) and to *sell* stocks when this moving average is flat or turning down.[2]

In addition to the direction of the moving average, a second condition must also hold—the actual price of the market index must *break above* this moving average when it becomes flat or turns upward and must *break below* the moving average when it becomes flat or turns downward. When the price data breaks through its moving average, it is likely that the sum of all shorter cycles has also begun to turn in the direction of the longer cycles (those reflected in the moving average). Thus, for example, when the market index breaks above its flat or rising 39-week moving average, it is likely that cycles both longer and shorter han 39 weeks are trending up. We therefore expect that the future price behavior of the index is up and that it is an advantageous time to purchase a no-load mutual fund (we know from Chapter 3 that the price of diversified no-load funds moves with the market averages). Conversely, when the market index breaks below its flat or falling 39-week moving average, we strongly suspect that both short and long cycles are down and that future price behavior will

[2] We define a flat moving average as one which has two consecutive weeks of equal price (the price is taken to the first decimal place). For example, if the 39-week moving average of the DJIA had two consecutive weeks of 885.3, that would be considered a flat moving average. To be rising, a moving average must simply have a new reading above its previous level. A falling moving average is, of course, exactly the opposite.

be down as well. Hence, this is a signal to sell no-load mutual funds.

To illustrate the use of moving averages, a plot of the 13-, 26-, and 39-week moving average of the DJIA for the period April 1980 to December 1981 is presented in Figure 9-2. Each of these moving averages has been calculated on a weekly basis and plotted along with a bar graph of the DJIA. Notice that the 13-week moving average fluctuates the most, whereas the 39-week moving average is the least volatile. This is to be expected since the shorter moving average is much more sensitive to volatile short-term price movements than is the longer average which greatly dampens their influence.

Figure 9-2
Moving averages of the Dow Jones Industrial Average

Source: *3-Trend Cycligraphs* (Boston: Securities Research Co., October 1981).

Short-term stock market traders often use very short-term moving averages with periods of 20, 10, or even 5 days to assist them with their timing decisions. However, there is an abundance of empirical evidence suggesting that stock prices move in a "random walk" over short periods of time and that short-term timing is unlikely to be successful. This evidence confirms the research of the authors and is a major reason why we have adopted a longer term investment strategy. We have found that the most useful time period for a moving average is 39 weeks for a market index and 10 months for an individual no-load mutual fund.

Notice that the 39-week moving average shown in Figure 9-2 rendered both a buy and a sell signal within the time frame shown. A buy signal was registered in the middle of June 1980 when the moving average first flattened out and when the DJIA index was itself *above* this moving average. Also notice that a sell signal was registered in the summer of 1981 when the 39-week

moving average began to decline and when, at the same time, the index of the DJIA was *below* the moving-average line.

Although the 39-week moving average of the DJIA is a useful indicator, our research has revealed that this tool has several important shortcomings. First, both the buy and sell signals generated by this indicator have typically been triggered too late. This lack of sensitivity would have forced us to forego significant profits and, on several occasions, would have produced losses. In addition, due to the substantial divergence that has taken place within the various sectors of the securities markets over the last decade, this indicator has been especially deficient in identifying turning points for top performing no-load mutual funds. To solve these problems, we decided to search for a combination moving average that is more sensitive to the no-load mutual funds in which we will be investing.

MONEY AND MOVING AVERAGES

In our quest for a more sensitive cyclic indicator, let us first return to the subject of money and stock prices as discussed in Chapter 7. In that chapter we stressed the importance of monetary conditions and its effect on interest rates and stock prices. Because of this well-documented relationship, we decided to focus our attention on the Dow Jones Utility Average (DJUA) and the Dow Jones Transportation Average (DJTA).

But why should we expect these two market averages to be more sensitive to monetary changes than the DJIA? The reason is fundamental. Changes in monetary conditions first influence interest rates which, in turn, are an important determinant of earnings for utilities and transportation firms. Let's examine this more closely.

Utilities have immense capital needs, and to meet these needs they must borrow heavily from the capital market—this, of course, results in a constant turnover of debt. While the need for debt is continuous, the level of interest rates, and hence the cost of debt, changes rapidly with monetary conditions. Therefore, since utilities have a high proportion of debt in their capital structures, the cost of debt is an important and volatile element of their total costs. But their ability to pass these costs on to the consumer (as an

industrial concern would most likely do) is restricted because all rate increases must be approved by the proper regulatory bodies. Therefore, *although the cost of debt can change rapidly, the rates utilities may charge the public tend to change slowly.* Hence, utilities normally feel a profit "squeeze" during periods of soaring interest rates.

Transportation firms, such as railroads and airlines, are in a similar situation in that they too are heavily dependent upon debt. Thus, the level of interest rates is also an important determinant of earnings for these firms.

In contrast to utilities and transportation firms, industrial firms typically have a lower proportion of debt in their capital structure. Although the level of interest rates definitely influences the earnings of these firms, it typically does not have the same impact it does with utility and transportation firms. In addition, under normal conditions (without a price freeze) increased costs may be passed on in the form of higher prices. Because of the lower dependence upon debt and the greater flexibility in price, changes in the earnings of industrial firms typically are not affected as severely as those of the utilities and transportation companies.

We have seen why both utilities and transportation firms are highly sensitive to changes in interest rates, but the question remains—are these changes reflected in the stock market? Indeed, are the 39-week moving averages of these indicators more accurate for timing purposes than the 39-week moving average of the DJIA?

To answer the above questions we compared the buy and sell signals of the 39-week moving averages for all three Dow Jones averages. Signals were calculated using the same decision rule as mentioned previously (i.e., buy when the market average breaks above its flat or rising moving average, and sell when the market average breaks below its flat or falling moving average).

Our expectations were generally met—we found the moving averages of the DJUA and DJTA to be more accurate for timing purposes than the DJIA. Yet a problem remained—all three of the Dow Jones averages frequently signaled on an intermediate-term basis, which resulted in whipsaws. To remedy this problem, we decided to use combinations of 39-week moving averages for the

Dow Jones averages. More precisely, we required that the 39-week moving averages of at least two Dow Jones averages must be triggered before a valid signal is registered. To illustrate, if we were using the DJIA and the DJTA, then a signal would be acted upon only when both moving averages signaled. It makes no difference which of the moving averages gives the first signal—all that is required is that both moving averages give the same signal.

After trying several combinations of moving averages, we found that the best results were obtained by using the DJTA in combination with the DJUA. We also discovered that while this combination of moving averages gave good sell signals, the buy signals were most definitely of inferior quality. The main reason for this occurrence, as is illustrated in Figure 9-1, is that market tops tend to be fairly broad—extending over many months—whereas market bottoms are typically "V" shaped and occur quite abruptly. Since market lows tend to be "V" shaped, longer term moving averages cannot possibly turn up until well after the actual low in the market. Consequently, we shall use the moving average of the DJTA and DJUA solely as a sell indicator.

MOVING AVERAGES OF MUTUAL FUNDS

However, even this indicator is deficient at those times when there is a significant divergence between the top-performing no-load mutual funds and the major stock market averages as has been the case through much of the last decade. To overcome this problem we have added a third moving average to those specified above—the 10-month moving average of the individual no-load mutual fund in which we have made our investment.

For this indicator, as was the case with the moving averages discussed previously, a sell signal is registered when the 10-month moving average is flat or trending down and when the price of the individual fund lies below this moving average. We employ a 10-month moving average for several reasons. First, we have found that by employing a slightly longer period we are better able to avoid costly whipsaws. Second, as you will soon discover, a 10-month moving average is far easier to compute than a 39-week moving average since fewer calculations need to be made and since we simply divide the sum of the previous 10 monthly closing

prices by 10 (i.e., we simply move the decimal point one place to the left). Finally, 10 months is very close to 39 weeks so we are still focusing primarily upon the same longer term cycles.

In summary, the sell signal we shall employ in the market experiment outlined in the following chapter is to apply the above-described moving-average decision rule to the 39-week moving average of the DJUA, the 39-week moving average of the DJTA, and the 10-month moving average of the actual no-load fund in which we are invested. The sell signal to be acted upon is given at the time when the *last* of the three moving averages flashes its individual sell signal. Finally, if this signal occurs within six months of a new buy signal, it should be disregarded and considered to be invalid. The application of this rule to investing in no-load mutual funds will be covered in detail in the following chapter.

part 4

Market Experiment

10

Market Experiment

The investment approach described in this book is to invest in small no-load mutual funds during favorable periods in the stock market and to invest in high-yielding liquid assets, such as no-load money market funds, during unfavorable periods. Although our approach is simple in concept and implementation, it nevertheless covers all relevant aspects of establishing an investment program.

The first step in developing your investment program, which was discussed in Chapter 1, is to select a suitable risk category for yourself. You were shown how such a selection is dependent upon a careful evaluation of your life situation, your attitude toward risk, and your ability to bear risk. This aspect of investing, which is so often neglected by investors, deserves very careful thought because your expected rate of return is largely determined by your risk level.

The second step in constructing your investment program is to select the best investment vehicle given your defined risk category. We argued in Chapters 2 through 6 that no-load mutual funds, because of their many advantages, were the most desirable vehicle for most investors. In these chapters we also described in detail precisely how to select the best performing no-load funds for your

defined risk category. These selection guidelines were given for both no-load stock funds and no-load money market funds.

The final portion of our investment program deals with the timing of mutual fund selections. Three highly reliable timing indicators were presented in Chapters 7 through 9—the discount rate decision rule, the mutual fund cash position, and the 39-week moving averages of the Dow Jones Transportation and Utility Averages (DJTA and DJUA) in combination with the 10-month moving average of your selected no-load mutual fund. Taken together, these timing indicators tell you whether it is appropriate to hold a no-load stock fund or a no-load money market fund.

We argued that this approach, in addition to producing excellent performance results, shields you from the major pitfalls that typically plague most investors, namely, poor investment selection, poor timing, inadequate diversification, high transactions costs, poor advice, and lack of emotional control.

In the market experiment we will show you how the entire no-load fund program would have performed during each market cycle since 1962. More precisely, we identify the precise *buy* and *sell* signals that were given by our indicators and specify the exact *no-load mutual fund* that would have been selected given our fund selection process. Also, to illustrate the importance of choosing your risk level, separate performance results are given for aggressive, moderate, and conservative risk categories. As you shall see, the differences are rather dramatic.

Besides presenting performance results, the market experiment serves a second important purpose—it ties together our entire investment approach and shows you how to implement your own program. Before presenting the market experiment, let us first review the individual timing indicators, demonstrate how they are used together, and summarize the basic fund selection process.

TIMING INDICATORS

Discount Rate Decision Rule

Of the three timing indicators presented in this book you were first introduced to the discount rate decision rule. This indicator is a most valuable timing tool because it reflects monetary conditions, which in turn influence future prospects for the general economy. The discount rate decision rule is used solely as a buy

indicator and provides a signal on the day when the Federal Reserve discount rate is *reduced* for the second successive time.

Mutual Fund Cash Position

A thorough analysis of the stock market demands that the human element be examined; thus, we have developed a buy indicator to measure human emotions—the mutual fund cash position. This indicator, which reflects the degree of optimism or pessimism of professional money managers, has an excellent track record at identifying market bottoms. Since 1962, the five buy signals given by this indicator occurred on average only 12 percent from the actual market lows.

Buy signals are generated when the mutual fund cash position index first delines after having risen continuously for at least four months provided that (1) the Dow Jones Industrial Average (DJIA) has declined at least 20 percent since the preceding market peak and (2) at least three years have elapsed since the prior mutual fund cash position buy signal.

Moving Averages

In addition to the influence that monetary conditions and investor psychological conditions have on stock prices, there are additional factors, such as fundamentals, politics, international developments, and the prospects for competing investments (such as real estate or gold), which also affect the level of stock prices. Fortunately, there is an indicator which reflects all these factors—moving averages.

As we stated in Chapter 9, the stock market has shown a definite pattern of reaching major lows about every four years. We have found that it is most profitable to trade no-load funds on the basis of this 4-year cycle, and, in addition, we have discovered that a 39-week or a 10-month moving average provides the best *sell* signal for trading over this cycle.

The precise sell signal we use is based upon the 39-week moving average of two interest sensitive market indexes, the DJUA and DJTA, used in conjunction with the 10-month moving average of the individual fund in which we have made our investment. Please recall that a valid sell signal is registered for a fund on the

day when the *last* of the above three moving averages itself flashes a sell signal. Also recall that each moving average flashes a sell signal when the slope of the moving average is flat or negative and when the associated price level lies below the moving average.

PUTTING THE INDICATORS TOGETHER

Now that each of the three indicators has been briefly discussed, let's examine the precise manner in which they should be used in the forthcoming market experiment. A buy signal is generated when either the mutual fund cash position of the discount rate decision rule first registers a buy signal. Upon receiving such a signal, no-load stock or equity mutual funds are purchased, regardless of whether they are aggressive, moderate, or conservative in nature. These funds are then held until the moving-average decision rule registers a sell signal for the individual fund in question. After receiving a sell signal, the no-load equity fund is liquidated and the proceeds are placed into a money market mutual fund.

Table 10-1 lists all of the buy signals that have been registered

Table 10-1
Buy signals, 1962-1982

Four-Year Cycle	Decision Rate Decision Rule	Mutual Fund Cash Position Index
1	**7/10/62**	11/21/62
2	None	**12/21/66**
3	12/04/70	
	12/06/71	**9/21/70**
4	1/06/75	**11/21/74**
5	6/13/80	**4/21/78**
6	**12/04/81**	12/21/81

by the discount rate decision rule and the mutual fund cash postion between the period 1962 and 1982. Please notice that this table identifies the specific four-year cycle in question in the first column and that the precise dates for the discount rate decision rule and the mutual fund cash position index are presented in the next two columns. The first signal registered, the one that would have been acted upon, is set in *boldface* type. Notice that for all but one of the four-year cycles (cycle 2), both indicators registered

a clear buy signal. Also notice that valid signals were registered in the years 1962, 1966, 1970, 1974, 1978, and the end of 1981. On four out of the six occasions the first indicator to produce a signal was the mutual cash position. This is not surprising since extreme investor pessimism, which is so accurately measured by the indicator, almost always occurs at major stock market lows.

On the average the most reliable indicator has been the mutual fund cash position as it has not missed calling an important market turn over the last 20 years. In contrast, the discount rate decision rule completely missed the 1966 bear market low and issued a redundant signal in 1971. Although the second signal produced in 1971 did not initiate any further buying activity in our market experiment, you may regard this as a favorable occurrence and as an opportunity to commit additional funds to the market. In addition, if one of your no-load funds is performing poorly, this would be an excellent time to consider switching to a better fund.

The partial sell signals produced over the last 20 years by the 39-week moving averages of the DJUA and DJTA are shown in Table 10-2. Please realize that these are not complete or valid sell

Table 10-2
Sell signals of the Dow Jones Utility and
Transportation Averages

	Signal		Signal
1	6/11/65	5	4/01/77
2	11/03/67	6	12/29/78
3	3/21/69	7	3/28/80
4	6/09/72	8	8/21/81

signals since the third moving average, the 10-month moving average of the individual fund in question, is not shown. Notice that a total of eight partial signals have been generated. Once we identify the precise funds to be used in the market experiment it will be a simple task to identify valid sell signals. If an individual fund flashes a partial sell signal before the relevant date identified in Table 10-2, then the date shown in the table will identify a *valid* selling point for that fund. If, on the other hand, the fund flashes a sell signal after the identified date, then the last moving average to signal, and the one to be acted upon, will be that of the fund itself.

In addition, if the fund does not flash a sell signal at any time before the next buy signal is given, then the fund should not be sold. This is in fact just what happened for many of the best no-load mutual funds during the period from 1974 thorough 1981. Indeed, the preliminary sell signals indicated in the table for the years 1977, 1978, and 1980 were never confirmed by the 10-month moving averages of most top performing no-load funds. Finally, if a sell signal is registered within six months of a new buy signal it should be disregarded and considered to be a false signal.

The reader should also realize that the preliminary sell signal issued in March 1969 was redundant since no intervening buy signal had been issued subsequent to the prior sell signal in November 1967. Whenever a second sell signal is issued in this manner, it should be viewed as a confirmation of the negative trend and a reaffirmation that one should be defensively positioned in no-load money market funds. However, in practice it may be appropriate to reevaluate your money market fund at this time to see if a significantly better fund is available. If so, you may wish to switch to the superior fund to improve your anticipated performance.

Despite the fact that each of our indicators have produced excellent buy and sell signals in the past, we feel it our duty to warn you that they are by no means perfect and that unprofitable trades or whipsaws are possible. In addition, there is no guarantee that these indicators will perform as well in the future as they have in the past. The reader should also realize that the indicators we have presented greatly simplify the extremely complicated task of attempting to time the stock market. The market is, in fact, influenced by many factors that have not been addressed in this book such as underlying economic conditions, political developments, and competition from other investment markets . It follows that there are many other stock market indicators (which are beyond the scope of this book) that may provide valuable information for the no-load fund investor.

Another factor that the investor should keep in mind is that the forthcoming market experiment has been presented in a simplified fashion to keep the length and complexity of this book to

what the authors feel is a reasonable level. For example, in our experiment we assume that *all* funds would be moved into or out of the market upon receiving a buy or sell signal. In practice, an investor is probably better served by making commitments to or withdrawals from the market on a sequential basis. There may also be times when it is advisable to violate one of our rules due to unforeseen developments beyond the scope of this book.

Nevertheless, we believe that the indicators discussed in this book will continue to provide excellent market signals in the future and that when combined with the many important benefits of a no-load mutual fund, you will be far more likely to achieve superior investment results than the typical investor.

Now that you are familiar with the individual timing indicators and how they will be used, our next task is to apply them to our fund selections. Let's first review the fund selection process and show which funds would have been chosen for aggressive, moderate, and conservative risk-taking investors. Following that, we shall present the performance results achieved for each of these investors—given the above buy and sell signals.

NO-LOAD FUND SELECTION

The goal of the fund selection process is to determine, given your risk category, which fund is likely to perform best in the upcoming market environment. The basic steps that must be taken in this process are to first identify those funds whose objectives coincide with your own and second, to select the best performing funds from that group.

Once you narrow down the list of all available no-load funds to the best performing ones within your risk category, you must then screen these funds for their general suitability. This is accomplished by simply running your list of funds through the Preliminary Selection Process. This screening process eliminates those funds that fail to meet the following criteria: appropriate state and federal regulations, minimum investment size compatible with your financial position, and an asset size that falls within our suggested guidelines.

The only remaining step is to take those funds which survive

the Preliminary Selection Process and scrutinize them according to the five criteria specified in the Final Selection Process. First and foremost, funds are examined according to how well they performed in the *most recent* intermediate rising period in the market. Without question, *past performance* is the most important factor in fund selection (barring a major pitfall). Second, the *potential performance* is evaluated. Here, funds are compared to one another in terms of their payout periods (earnings growth rate and P/E ratio), their cash position, and their net cash flows. The results of the potential performance can help you differentiate between funds with similar past performances. The third major category—*portfolio effectiveness*—simply requires examining whether or not the funds are adequately diversified. In the fourth category, specific aspects of *fund operations* are checked. These aspects include whether or not performance incentives and leverage are employed (both are desirable), and whether or not operating expenses and redemption fees are excessive. The fifth category—*potential pitfalls*—is an important part of the Final Selection Process because a fund should be eliminated if it contains even one of these drawbacks. The potential pitfalls include the following: holding letter stock, holding puts and calls, short selling, new funds (less than two years of operation), litigation that may hurt shareholders, and the lack of availability of a daily quote. Once you have completed this analysis, the selection process is complete.

Applying the Fund Selection Process

Let's now apply the fund selection process by showing which funds have been selected given the above criteria. We shall illustrate the selection process by giving examples for aggressive, moderate, and conservative investors for the period between 1962 and 1982. The indicated selections will then be used in the market experiment.

Aggressive fund selection. We shall demonstrate how the selection process would have been carried out during the July 21, 1970 buy signal. The first thing you would do is select those no-load funds which exhibited the highest volatility during the most recent rising market. After thoroughly researching the market performance of volatile no-load funds during this period, you

would have come up with the following six funds: (1) Afuture, (2) Hartwell & Campbell, (3) Hartwell and Campbell Leverage, (4) Investment/Indicators, (5) Nicholas Strong, and (6) Pennsylvania Mutual.

The next step is to subject these six funds to the Preliminary Selection Process. To pass this test the fund must have an asset size between $5 million and $80 million, must meet state and federal regulations, and must have a minimum investment compatible with your own resources. These funds all meet the asset size criteria, and since we shall assume they meet the other two criteria, all these funds are advanced to the Final Selection Process.

In the Final Selection Process the real "weeding out" takes place as four funds are eliminated in swift order: Nicholas Strong is eliminated because it's a new fund (less than two years' operation), Hartwell & Campbell Leverage is eliminated because of its letter stock holdings, and both the Hartwell & Campbell and Pennsylvania Mutual Fund are nondiversified—thus they fail to meet our portfolio effectiveness criteria. We are now left with the Investment/Indicators Fund and Afuture Fund. Their respective past performance results (i.e., most recent intermediate rising market performance) were nearly equal, being 25 percent and 23 percent. Since Afuture's potential performance was better, it was our choice.

The same selection procedures were applied during the four other instances when our timing indicators generated a new buy signal. The resulting selections were as follows:

Aggressive investor selections

7/10/62	American Investors Fund
12/21/66	American Investors Fund
9/21/70	Afuture Fund
11/21/74	20th Century Growth Investors
12/04/81	Constellation Growth Fund

Please notice that no new fund was purchased during the 1978 buy signal because no intervening sell signal had been registered for the 20th Century Growth Investors Fund.

Moderate investor selections. The moderate investor would take the same steps as the aggressive investor with the exception

that less volatile funds would be involved. These funds would still have above-average volatility during rising markets and beta coefficients in the range of 1.25 and 1.75. If you had been a moderate investor as of the buy signal on September 21, 1970, you would have selected the following five growth funds as candidates: (1) Columbia Growth, (2) Mathers, (3) Rowe Price New Horizons, (4) Smith Barney, and (5) Weingarten Equity.

You would have, of course, first subjected these funds to the Preliminary Selection Process. For the moderate investor, the asset size guidelines range form $5 to $100 million. Therefore, the Rowe Price New Horizons Fund would have been eliminated as its asset size was above the $100 million limit. The Weingarten Equity Fund would also have failed this test as its assets were well below the minimum size. The other three funds met our recommended asset size guidelines, and we shall assume they also qualified under state and federal regulations, and that they had a required minimum investment compatible with your financial means.

Next you would subject the three candidate funds to the Final Selection Process. You would find that none of the three funds exhibited any pitfalls, nor did they differ appreciable in fund operations and portfolio effectiveness. Therefore, past and potential performance became the key selection criteria. In this regard, the Columbia Growth Fund was tops with a past performance of 22 percent, while the Mathers Fund appreciated by 19 percent, and the Smith Barney Fund gained 17 percent. Since there were no substantial differences between the funds in terms of potential performance, the Columbia Growth Fund was our selection.

The funds that would have been selected at the other major buy signals are presented below:

Moderate investor selections

7/10/62	Penn Square Fund
12/21/66	Energy Fund
9/21/70	Columbia Growth Fund
11/21/74	Weingarten Equity Fund
12/04/81	Weingarten Equity Fund

Again notice that no new fund was selected in 1978 since no intervening sell signal had been registered for the Weingarten Equity Fund.

Conservative investor selection. Selecting conservative growth funds differs somewhat from aggressive growth or moderate growth fund selections, as dividend income may now be a relevant factor. The conservative investor should still concentrate on selecting those funds with the greatest potential for capital appreciation, given his or her income needs. In our selection process, we shall assume that dividends are a relatively unimportant factor; thus we shall concentrate on those conservative growth funds with the best chances for capital appreciation. As of the September 21, 1970, buy signal, the conservative growth funds which demonstrated the highest volatility during rising markets (and hence the best potential for capital appreciation) were: (1) David L. Babson Investment Fund; (2) Growth Industry Shares; (3) de Vegh Mutual Fund; (4) Johnston Mutual Fund; (5) Rowe Price Growth Stock Fund; and (6) Scudder, Stevens & Clark Common Stock Fund.

Since the recommended asset size guidelines for conservative growth fund selection are quite flexible ($5 million minimum, $300 million maximum), all but the very large Rowe Price Growth Stock Fund passed this criterion. Assuming that each of the remaining funds presented no problems in terms of a minimum investment size and meeting state and federal regulations, all the remaining funds are advanced.

Now we come to the more comprehensive Final Selection Process. We find that all five funds have no pitfalls and rate more or less the same in terms of fund operations and portfolio effectiveness; therefore, past and potential performance shall be the final judges. In terms of past and potential performance, we find that the Scudder, Stevens & Clark Common Stock Fund rates highest and is therefore our selection. Conservative investor selections at other buying points are listed below:

Conservative investor selections

7/10/62	Scudder, Stevens & Clark Common Stock Fund
12/21/66	Scudder, Stevens & Clark Common Stock Fund
7/21/70	Scudder, Stevens & Clark Common Stock Fund
11/21/74	David L. Babson Investment Fund
4/21/78	Price New Era Fund
12/04/81	David L. Babson Investment Fund

Notice that a new fund would have been selected in 1978 since a sell signal was in fact issued for the David L. Babson Investment Fund prior to April 21, 1978. This may be contrasted to the absence of such a signal for the aggressive and growth funds discussed previously.

PUTTING IT ALL TOGETHER

Thus far in this chapter we have discussed how the fund program works, how to use our timing indicators, and what funds would have been selected given our fund selection procedures. Now it is time to put everything together and show how well our investment selections and timing indicators would have performed in the past.

Before we begin discussing the performance results, let's first explain exactly how the hypothetical experiment was run. In each of the examples we arbitrarily start with an initial investment of $10,000. At each buy signal we assume that the investor becomes 100 percent invested in no-load equity funds (i.e., all $10,000 is placed in our first fund selection on July 10, 1962), and at every sell signal we assume a 100 percent move to cash.[1] Upon moving to cash, prior to 1973, we are assuming an investment in 3-month U.S. government Treasury bills.[2] Subsequent to 1973, we place our money in a high-quality no-load money market fund—the Reserve Fund. The Reserve Fund was one of very few money market funds available in 1973 and has maintained a suitable portfolio of money market instruments ever since. Similar results would have been produced by many other money market funds.

Two final points should be mentioned. First, to simplify our calculations, all dividends and capital gains distributions of equity funds are taken in cash and assumed to be held without interest until the fund is sold, at which time both the proceeds and the accumulated distributions are reinvested in Treasury bills or the Reserve Fund. Second, to increase the realism of our example, we assume that there is a one week delay when buying or selling Treasury bills or money market funds.

[1]Moving from fully invested to fully in cash is an aggressive strategy, and many investors may desire to use a sequential buying approach.

[2]Treasury bill rates of return were obtained from the *Federal Reserve Bulletin*, using the market yields of these securities.

Aggressive Investor

The results achieved by the aggressive investor are shown in Table 10-3. Note that the following items are listed in the table: the signal registered, the date on which it occurred, the stock fund selection, the cash instrument selection, the net asset value (NAV) at the time of each signal, the percentage gain or loss from each investment, the associated increase or decrease value, the dollar value of all equity fund distributions, and the ending value after each sale.

We start our investment program with the first buy signal (generated by the discount rate decision rule) on July 10, 1962, with a hypothetical investment of $10,000. Our first no-load fund selection is that of the American Investors Fund. This fund, as we pointed out before, met our criteria in terms of asset size and past performance, as well as all the other factors listed in the Preliminary Selection Process and Final Selection Process.

The American Investors Fund was held continuously from the date of initial purchase until a sell signal was registered on September 30, 1966. In practice, if we had found a significantly better performing fund during this time period, we probably would have switched funds. Of course, tax consequences must be considered when examining the feasibility of such a move.

Over the four-year period during which this fund was held, it gained a whopping 135.19 percent in NAV. This produced a gain of $13,519, which when added to the cumulative fund distributions of $2,115 resulted in an ending value of $25,634.

After selling the American Investors Fund on September 30, 1966, our assets would have been moved into 3-month Treasury bills. Over the short period during which the timing indicators kept us out of the market, the Treasury bills produced a gain of 0.91 percent. Thus we gained $233 to make our total investment worth $25,867.

Our next buy signal was registered by the mutual fund cash position indicator on December 21, 1966. Since American Investors was still the best performing no-load fund that met our criteria, it was once again selected. Over the next 15 months the NAV of the fund increased by 9.09 percent. This added $2,351 in profits, which when added to the $2,858 of fund distributions brought our cumulative total to $31,076.

Table 10-3
Performance results: Aggressive investor

Signal	Date	Stock Fund	Cash Instrument	NAV	Percentage Change NAV	Change in Value	Equity Fund Distributrions	Ending Value
Buy........	7/10/62	American Investors		11.82				$ 10,000
Sell........	9/30/66			27.80	135.19	$ 13,519	$ 2,115	25,634
Buy........	10/07/66		T bills					
Sell........	12/14/66				0.91	233	—	25,867
Buy........	12/21/66	American Investors		31.13				
Sell........	2/29/68			33.96	9.09	2,351	2,858	31,076
Buy........	3/07/68		T bills					
Sell........	9/14/70				16.39	5,093	—	36,169
Buy........	9/21/70	Afuture		6.27				
Sell........	1/31/73			12.10	92.98	33,630	10,789	80,588
Buy........	2/07/73		Reserve Fund					
Sell........	11/14/74				17.04	13,732	—	94,320
Buy........	11/21/74	20th Century Growth		1.92				
Sell........	9/30/81			10.87	466.14	439,663	192,423	726,406
Buy........	10/07/81		Reserve Fund					
Sell........	11/28/81				1.92	13,947	—	740,353
Buy........	12/04/81	Constellation Growth		17.29				Open position

Average annualized rate of return: 24.8 percent.

In early 1968, the stock market turned down and the moving averages registered a sell signal on February 29, 1968. At that time we once again would have placed our money into Treasury bills and would have avoided the severe bear market of 1969-70 when the DJI declined by 36 percent. During the 30-month period while we were out of the market, we gained 16.39 percent from our Treasury bill investments and the value of our portfolio reached a new high of $36,169.

On September 21, 1970, the mutual fund cash position indicator once again registered a buy signal. At that time, the two best performing no-load funds were Nicholas Strong and Afuture. However, the Nicholas Strong Fund had not been in operation for two years; therefore, we selected the Afuture Fund. The results produced by this fund were spectacular! From our buy signal to our sell signal on January 32, 2973, we gained 91.98 percent. This superior performance added $33,630 in profits which, when added to the cumulative dividend distributions of $10,789 brought our total to $80,588.

While the bear market was eroding stock prices during 1973 and 1974, we once again moved to a cash position by investing in the Reserve Fund. Because of the very high yields obtained from money market instruments, we were able to actually enjoy a 17.04 percent gain during this difficult period. While the 1973-74 bear market saw the DJIA lose almost 40 percent, we gained $13,732, making our cumulative total $94,320.

On November 21, 1974, the mutual fund cash position indicator once again provided us with an excellent buy signal. Our selection this time was the 20th Century Growth Investors Fund. From the initial buy signal until the eventual sell signal on September 30, 1981, this fund increased in value by a spectacular 466.14 percent. When we include this gain plus all distributions, our cumulative total is increased to the whopping sum of $726,406. We then placed all funds into the Reserve Fund for a short period earning 1.92 percent and thus increased our total to $740,353. A new buy signal was registered on December 4, 1981, by the discount rate decision rule, and we selected Constellation Growth Fund for our investment. This investment is still in effect as of the writing of this book.

How many investment approaches have turned $10,000 into $740,353 in 19.4 years without subjecting the investor to extreme risks? This represents an annual rate of return of 24.8 percent per year. We believe few investors matched this kind of performance over the time period of our experiment, a period which saw three of the worst bear markets in stock market history (1966, 1970, and 1973-74). Now, let's see how the moderate investor faired relative to the aggressive investor.

Moderate Investor Performance Results

The moderate investor, as we pointed out in Chapter 4, will be holding funds which are less risky than the aggressive growth funds. Therefore, given the direct relationship between risk and reward, we should expect lower performance results for the moderate investor. Let's examine the record.

The results of the moderate investor are shown on Table 10-4. Note that this table is constructed in exactly the same fashion as Table 10-3. The first indicated fund selection—Penn Square—turned in excellent results with a gain of 67.47 percent. As a consequence, our initial $10,000 investment increased by $6,747, which when added to equity fund distributions of $1,776 brought our total to $18,523.

Following our Treasury bills investment, which gained $1,169, we would have invested in the Energy Fund. The Energy Fund gained 15.86 percent over our holding period which when added to the distributions paid by the Energy Fund increased our total to $26,893.

From our sale of the Energy Fund until our purchase of the Columbia Growth Fund, we would have gained $2,767 from Treasury bills investment. We therefore had $29,660 to invest in the Columbia Growth Fund. During the period this fund was held, it produced a gain of 36.81 percent plus distributions. Consequently, the value of our portfolio would have increased to $43,480.

During the 1973-74 bear market, we would have placed all our money in the Reserve Fund. The 17.04 percent return earned in this money market fund added an additional $7,409 to our portfolio, which demonstrates that no-load money market funds can indeed produce substantial returns.

Table 10-4
Performance results: Moderate investor

Signal	Date	Stock Fund	Cash Instrument	NAV	Percentage Change NAV	Change in Value	Equity Fund Distributrions	Ending Value
Buy........	7/10/62	Penn Square		11.99				$ 10,000
Sell........	7/30/65			20.08	67.47	$ 6,747	$ 1,776	18,523
Buy........	8/07/65		T bills		6.31	1,169	—	19,692
Sell........	12/14/66							
Buy........	12/21/66	Energy		12.99				
Sell........	2/28/68			15.05	15.86	3,123	4.078	26,893
Buy........	3/07/69		T bills		10.29	2,767	—	29,660
Sell........	9/14/70							
Buy........	9/21/70	Columbia Growth		10.73				
Sell........	1/31/73			14.68	36.81	10,918	2,902	43,480
Buy........	2/07/73		Reserve Fund		17.04	7,409	—	50,889
Sell........	11/14/74							
Buy........	11/21/74	Weingarten		7.06				
Sell........	8/31/81			26.55	276.06	140,484	26,167	217,540
Buy........	9/07/81		Reserve Fund		3.57	7,766	—	225,306
Sell........	11/28/81							
Buy........	12/04/81	Weingarten		28.05				225,306
Sell........	*							

Average annualized rate of return: 17.4 percent.

* Still in effect.

Our next fund selection was the Weingarten Fund which was held until August 31, 1981, at which time it produced a tremendous gain of 276.06 percent plus distributions, bringing the portfolio value to $217,540. After a brief period in the Reserve Fund, the portfolio increased to a value of $225,306. The next fund selection, which was once again the Weingarten Equity Fund, came on December 4, 1981, and was signaled by the discount rate decision rule. This position remains in effect at the present time.

The average annual rate of return for the moderate investor over the 19.4-year period was 17.4 percent per year. How did the moderate investor fare compared to the aggressive investor? Exactly as risk-reward ratios would suggest—the aggressive investor far outperformed the moderate investor, earning an annual rate of return of 24.8 percent versus 17.4 percent.

Conservative Investor Performance Results

Of our three investor categories, conservative investors bear the least amount of risk. They select funds on the basis of both growth of capital and income. The time-proven direct relationship between risk and reward would suggest that conservative investors will normally receive lower rewards than their more aggressive counterparts.

Table 10-5, which is constructed in the same fashion as Tables 10-3 and 10-4, shows the investment performance for the conservative investor. Rather than going over each market trade again, we shall simply report the overall results.

The original $10,000 invested by the conservative investor would have grown to $128,458, which amounts to an average annual rate of return of 14.1 percent. Although the conservative no-load investor finished in last place among our three no-load categories, he would still have far outpaced the typical buy-and-hold investor.

Risk versus Reward—Lessons of the Market Experiment

Clearly the most important lesson to be learned from the market experiment is that greater risks normally go hand in hand with greater rewards. With respective dollar results of $740,353,

Table 10-5
Performance results: Conservative investor

Signal	Date	Stock Fund	Cash Instrument	NAV	Percentage Change NAV	Change in Value	Equity Fund Distributrions	Ending Value
Buy....	7/10/62	Scudder, Stevens & Clark		8.77				$ 10,000
Sell....	6/30/65			11.88	35.46	$ 3,546	$ 1,539	15,085
Buy....	7/07/65		T bills		6.67	1,006	—	16,091
Sell....	12/14/66							
Buy....	12/21/66	Scudder, Stevens & Clark		11.57				
Sell....	11/03/67			12.12	4.75	764	862	17,717
Buy....	11/10/67		T bills		18.20	3,224	—	20,941
Sell....	9/14/70							
Buy....	9/21/70	Scudder, Stevens & Clark		8.58				
Sell....	6/09/72			11.55	34.61	7,248	2,733	30,922
Buy....	6/16/72		Reserve Fund		20.50	6,339	—	37,261
Sell....	11/14/74							
Buy....	11/21/74	David L. Babson		7.51				
Sell....	4/01/77			9.17	22.10	8,235	2,938	48,434
Buy....	4/08/77		Reserve Fund		5.93	2,872	—	51,306
Sell....	4/14/78							
Buy....	4/21/78	Price New Era		10.36				
Sell....	8/31/81			21.14	104.05	53,384	19,280	123,970
Buy....	9/07/81		Reserve Fund		3.62	4,488	—	128,458
Sell....	11/28/81							
Buy....	12/04/81	David L. Babson		12.75				Open position

Average annualized rate of return: 14.1 percent.

$225,306, and $128,458 for the aggressive, moderate, and conservative investors, there is no question that bearing greater risks would have paid off handsomely.

Another lesson learned from the market experiment is that for each risk category the timing changes we made greatly improved overall performance compared with a simple buy-and-hold strategy for any of the funds initially selected. The superior performance is caused by two underlying factors. First, our fund selection techniques kept us in funds with superior current performance rather than allowing us to languish in former "star" performers that have lost their previous prowess. In addition, our market timing indicators have allowed us to avoid the worst part of most bear markets—times when even the best funds normally register losses.

Despite the above successes this approach, like any active investment program, has one important shortcoming—you normally have to pay taxes whenever you sell a fund for a profit. However, there are now numerous ways to overcome this problem by constructing your own tax-deferred retirement plan. A thorough discussion of the options currently available to individuals, partnerships, and corporations is the topic of the next two chapters.

11

Tax Shelter Your Future with an Individual Retirement Account (IRA)

In Chapters 1 through 10 we described how investors can establish and operate their own personal investment program through investing in no-load mutual funds. Only one final question remains unanswered—how to prevent Uncle Sam from confiscating a large chunk of your investment profits.

It's human nature to dislike paying taxes, and most investors search far and wide for ways to reduce or avoid them. Unfortunately, in many instances tax shelters are quite risky. Frauds, perpetual losses, and catastrophies have often turned the "advantages" of many tax-sheltered investments into nightmares. Investments such as real estate, cattle feeding, and oil drilling ventures are some of the more familiar tax shelters that have left many investors disillusioned. A well-conceived and well-managed tax shelter can be a fabulous asset, but in the authors' opinion, the demand for really good tax-sheltered investments far exceeds the available supply. Oftentimes the title *tax shelter* is placed upon an investment which, under any other title, could not be marketed successfully.

An additional problem concerning tax-sheltered investments is the current unfavorable government attitude towards them. The U.S. government has devoted considerable effort to reducing or

eliminating many tax shelters. Why? Because the U.S. Treasury seeks to maximize its revenues and because liberal legislators wish to transfer wealth from more affluent to less affluent persons. In fact, the word tax shelter currently carries a negative connotation in the eyes of the government. Any investor involved in tax-sheltered investments is subject to the whims of the government. Fortunately, the no-load fund investor may be able to take advantage of several tax shelters which the government—believe it or not—is actually encouraging, namely, Individual Retirement Accounts (IRA), Keogh plans, and corporate retirement plans. Keogh plans and corporate retirement plans will be discussed in Chapter 12.) While government sentiment toward tax-sheltered investments has become increasingly hostile, legislators now view retirement plans favorably. As a consequence, a qualified retirement plan may be the best tax shelter available to you.

In addition to being a terrific tax shelter, your qualified retirement plan could easily become the most important source of retirement income for your family. In fact, it could easily make the difference between a comfortable retirement free of financial worry and one of partial dependence on family, charity, or the social security system.

The social security system, which today is a mainstay for millions of elderly citizens, is confronted with extremely serious long-term problems. According to actuarial experts, the promised future benefits of the system far exceed anticipated revenues. The main cause of this unfortunate situation is that the government has greatly increased benefit payments during recent years. This is especially serious since the current reserves of the Social Security Trust Fund are but a minute fraction of outstanding commitments. Most of the money paid out each year comes from the *current* contributions of workers—not from Trust Fund assets. In prior years this was no problem since there were many more wage earners than pensioners. Fox example, in 1950 there were 11.7 wage earners per pensioner and there was little difficulty supporting beneficiaries. However, in 1980 the ratio fell to about 2.6 to 1, and the projection of most actuaries is that the ratio will fall to 1.9 to 1 by the year 2020 as today's "war babies" enter their retirement years. Obviously, the burden on active wage earners is becoming extreme as fewer and fewer workers must support the growing benefits of more and more retirees.

What is the solution to this problem? In theory it is simple. The system must either increase tax revenues or reduce benefits. During recent years, social security taxes have been increased dramatically and have become a substantial burden to most taxpayers. For example, the annual tax burden on an employee with an income of $30,000 has increased from $30 in 1937 to $1,975 in 1981. This represents an astonishing increase of 6,583 percent in just 44 years. Equally sobering is the realization that the same amount must also be paid by employers bringing the combined contribution in 1981 to $3,950! If you have the same income and are self-employed, the burden is even worse as you would be required to pay nearly $2,800 in 1981. Unfortunately, social security taxes are already scheduled to increase dramatically in coming years. It is unlikely that working taxpayers will tolerate large increases much longer. Indeed, the signs of a "taxpayer revolt" are already apparent and have been embedded in law through such legislations as California's Proposition 13 and the Economic Recovery Tax Act of 1981. It is likely that this resistance to higher taxes will sooner or later be applied to social security taxes.

The alternative of having to reduce benefits in some socially and politically acceptable manner appears to be the more likely approach to finding a solution. This may involve either extending the age at which a participant is first eligible to receive benefits, reducing benefits for retirees with an income or net worth above some predetermined level, or any of a variety of other alternatives. The question you must ask yourself is simply this: Are you willing to gamble a comfortable retirement on what the eventual solution to this problem will be or would you rather provide for your own future by setting up an appropriate self-controlled retirement plan? We suggest that you give very serious thought to this important question.

Fortunately, the Economic Recovery Tax Act of 1981 has expanded the opportunities for most taxpayers to save for retirement and reduce taxes. It has done so by significantly increasing both the accessability and allowed contributions to IRAs and by upping the maximum allowable contribution to Keogh plans. Government planners and politicians no doubt recognize that part of the long-run solution to the social security problem may be to encourage individuals to provide for their own retirement. In our opinion, these new retirement incentives are just the beginning of

many forthcoming changes designed to encourage retirement planning and personal saving.

INDIVIDUAL RETIREMENT ACCOUNT (IRA)

An IRA is a personal retirement plan that allows you to enjoy tax benefits while saving for retirement. The eligibility to these plans was increased significantly by the Economic Recovery Tax Act of 1981. Beginning in January 1982, anyone under the age of 70½ with earned income (this includes wages, salaries, professional fees, commissions, tips, bonuses, and any type of self-employment income) can make tax-deductible contributions to an IRA. Prior to the new law, individuals covered by corporate retirement plans or Keogh plans were not allowed to establish an IRA. This is no longer the case.

The new law also liberalizes the annual tax-deductible contribution that may be made to such plans. Under the old law there was a maximum contribution of $1,500 with the additional condition that the total contribution could not exceed 15 percent of earned income. The new law allows you to contribute 100 percent of earned income up to a maximum of $2,000. Thus, a person with only $2,000 of earned income can contribute the entire amount into an IRA. If you are married and both you and your spouse work, each of you can set up a separate IRA plan and make the allowed contribution. Thus, your combined contribution would be $4,000 per year. If your spouse does not work, a second spousal IRA may be established and your maximum contribution to both plans becomes $2,250. The only restriction is that no more than $2,000 can be contributed to either plan.

A desirable feature of these plans is that all contributions are voluntary and may be discontinued whenever you wish. However, you must be careful not to exceed the allowed limit since an annual 6 percent penalty is levied on all excess contributions.

Tax Advantages

The establishment of an IRA provides you with two very important tax advantages. First, all contributions to an IRA are tax deductible. This means that every year you can set aside up to $2,000 of earnings which are not subject to federal taxes. To

illustrate, if you are in a 40 percent tax bracket, a $2,000 contribution to an IRA saves you $800 in federal taxes. Thus the after tax cost to you of investing this amount is really just $1,200. If you are in a higher tax bracket or if your state permits deductions for IRA contributions, your tax savings would be even higher.

The second, and potentially more important tax-shelter benefit, is that any income or capital gains realized by your IRA portfolio is allowed to accumulate *tax free* until you decide to withdraw money from the account. This normally occurs during retirement, a time when most individuals are in lower tax brackets.

The combined impact of these important tax advantages is truly phenomenal as is illustrated in Table 11-1. The data in this

Table 11-1
Capital accumulation with and without an IRA plan

Starting Age	10 Percent		15 Percent	
	IRA	Non-IRA	IRA	Non-IRA
25	$885,200	$199,600	$3,558,200	$507,300
35	329,000	94,500	869,500	180,900
45	111,500	41,000	204,900	60,600
55	31,900	13,800	40,600	16,300

table assumes that an individual in the 50 percent tax bracket makes the maximum allowable contribution of $2,000 each year into an IRA account and that the investment is allowed to accumulate tax free until age 65, at which time the individual decides to retire. Notice that the table identifies various starting ages which determine the period over which the annual contributions are made and allowed to compound tax free. Notice also that the table compares the actual investment results of an IRA plan with those that would occur if no IRA plan had been established for two assumed annual rates of return, namely, 10 and 15 percent per year.

To be conservative, we have assumed that the non-IRA investor must pay an average tax rate of 30 percent each year on all pretax returns. This lower rate is used because many investors will be able to achieve long-term capital gains on part of their portfolio, gains that are taxed at a maximum rate of 20 percent in contrast to

the 50 percent rate levied on dividend income, interest payment, and short-term capital gains. Thus, the pretax returns of 10 percent and 15 percent are reduced to aftertax returns of 7 percent and 10.5 percent for non-IRA investors. Finally, please realize that the amounts shown for the IRA investor do not reflect the taxes that must be paid when funds are ultimately withdrawn from the plan. This has been omitted because the average tax on withdrawals could vary between 0 percent and 50 percent depending on the unique tax circumstances of each investor.

The withdrawal rates could easily be well below the maximum 50 percent rate for several reasons. First it is likely that a retired taxpayer may be in a lower tax bracket during retirement since earned income is often much less. Second, most investors will elect to withdraw funds over an extended period of time to help them minimize their tax payments. Finally, with the substantial assets they will have acquired, they may be in a position to purchase tax-sheltered investments to reduce their tax liability.

An examination of Table 11-1 reveals several interesting facts. First, the IRA investor is obviously able to accumulate capital at a much faster rate than the non-IRA investor. For example, an individual starting at the age of 25 and earning an annualized rate of return of 15 percent per year will be able to accumulate $3,558,200 over the 40-year period in contrast to the $507,300 that could be saved by the non-IRA investor. Thus, the IRA investor is able to save over seven times as much money. In the unlikely event that the IRA investor must pay taxes at the maximum rate of 50 percent when withdrawing funds, he or she will still have $1,799,100 compared to $507,300 for the non-IRA investor or over 3½ times as much money. The reader should realize that inflation will almost certainly reduce the purchasing power or both amounts.

Second, notice that the relative benefit of an IRA plan is greatest for those who are able to earn higher rates of return on their portfolios. For example, a 25-year-old investor who earns 10 percent per year does only about four times as well as a non-IRA investor ($885,200 versus $199,600), whereas at the 15 percent rate this investor does over seven times as well. Individuals earning higher rates of return would do even better.

A final observation is that the earlier you begin making contributions to your IRA plan the more you will be able to accumulate.

While this seems quite obvious on the surface, the differences it can make are not. To illustrate, suppose you are 25 years old and decide to put off funding your IRA plan until age 35 because you want to use the $2,000 per year to make payments on two new cars—one today and the second in five years. If you can earn 15 percent on your portfolio, the table shows us that you will have reduced your retirement nest egg from $3,558,200 to 869,500, or by $2,688,700. Incredible isn't it! Omitting ten payments of just $2,000 per year costs the retirement fund over $2.5 million. Most people are not aware that the dollars saved during their younger years are so important or that even modest consumption expenditures will greatly limit their financial well-being in later years.

Other Advantages and Disadvantages

While the main advantages of IRA plans are the initial tax savings and the tax-free compounding discussed earlier, there are several other desirable features. First, all contributions are voluntary and you may elect to change your custodian at any time provided you transfer all funds to a new custodian that has been approved by the IRS. Thus, you are not locked into any institution and are free to seek out the best location for your account. In addition, if you should die before withdrawing all your money, the remaining balance is tax free to your beneficiary until the time at which the money is actually withdrawn from the account.

A very important feature is that the establishment of an IRA plan tends to stimulate an enhanced awareness of the importance of saving and wise investing. This is not only good for the individual making the discovery but also benefits the country as a whole. It provides a source of much needed capital to rebuild our deteriorating factories and to develop new industries. Among other things, this should ultimately lead to the formation of new jobs, an increase in the real income levels of our citizens, and an improvement of our ability to compete successfully in world markets. The main disadvantage of an IRA plan is that there is a penalty of 10 percent for withdrawing funds prior to the age of 59½. Many people assume that this would "lock them in" for an unacceptably long period of time. While this is true to some degree, a 10 percent penalty is certainly not prohibitive. In fact, if you have been participating in the plan for a number of years and

if you have been earning a good rate of return on your portfolio, you should be able to pay the penalty and still be far ahead of the person who has never established a plan.

A second disadvantage is that all withdrawals are taxed as ordinary income even if you earned long-term capital gains on the investments in your portfolio. The best solution to this problem is to strive to keep your tax bracket as low as possible when you withdraw funds. This can be accomplished by purchasing or constructing your own tax-shelter investments (perhaps with your withdrawn funds), by making gifts to charity, or by other tax-saving techniques.

Two additional disadvantages are that you may not borrow money on your IRA account nor can you invest your plan assets into collectibles such as gold coins or art. While these do limit your flexibility somewhat, they are of limited significance compared to the tremendous advantages mentioned earlier.

Withdrawal of Funds

Prior to accumulating funds within your IRA plan you will no doubt want to know the withdrawal options that are open to you. According to the current law, withdrawals may commence any time after you reach the age of 59½ and must commence by the time you become 70½. If any disbursement is taken before the age of 59½, the amount taken is subject to regular income taxes plus a 10 percent tax penalty. However, this rule does not apply in the case of death, disability, or reclaiming excess contributions. After age 70½ there are severe penalties for failing to withdraw at least the minimum required distribution in any one year. You may choose among several allowed withdrawal options, the most favorable of which may be to withdraw funds based upon the joint life expectancy of you and your spouse.

SWITCHING ASSETS

In most IRA plans it is not possible to switch assets, say from a mutual fund to cash and back into a mutual fund, because the plan administrator won't allow it. The administrator, often a bank, life insurance company, or mutual fund, usually restricts the right to switch assets. However, from previous chapters we

know that even the best equity funds go down in bear markets. How then can an IRA investor switch assets on the basis of the guidelines provided in this book? There are two ways in which the switching of assets may be controlled by the investor: (1) select a plan administrator that allows you to make the investment decisions, (2) buy into a "family" of mutual funds that contains at least one money market fund and one equity fund, and that allows you to switch between funds.

There are relatively few firms that specialize in the administration of IRA plans that will allow you to make your own investment decisions. The main benefit to establishing this type of plan is that you will be able to switch into any stock fund, bond fund, or money market fund whenever you wish. The resulting flexibility is certainly ideal for our no-load investment program.

There are, of course, costs associated with establishing such a plan. You must normally pay a setup fee, an annual administration fee (which varies according to the amount of money in the plan), and there may be fees assessed when you make transactions. Moreover, there may be costly delays involved in executing a switch. Nevertheless, many individuals may find that the benefits outweigh the costs.

A second way to participate in the fund program, while at the same time enjoying the tax advantage offered by the IRA plan, is to buy into a "family" of no-load mutual funds. These funds allow you to switch your monies between individual money market and equity funds with a toll-free phone call. These switch fund organizations are ideal for our investment program since you can set up an IRA under their prototype plan and then switch your assets among a number of funds whenever you choose. What does it cost to have an IRA plan with a switch fund organization? There is typically a $5 setup fee and a $5 annual administration fee—that's all!

In summary, the advantages of switch funds include the following: (1) you may choose among several no-load funds (typically, a growth fund, a conservative growth fund, a money market fund, and a bond fund); (2) you may usually switch funds whenever you desire for no cost; (3) you may execute your fund switches via a toll-free telephone number; and (4) the setup and administration costs for an IRA plan are minimal. Certainly this "family" of funds offers a highly attractive package.

12

How to Save Taxes with Keogh and Corporate Retirement Plans

In the previous chapter you saw how any individual with earned income is now eligible to establish an IRA account. Many individuals with earned income generate all or part of this income from their own business. If you fall into this category, you can multiply the tax-shelter benefits in the previous chapter many times by establishing either a Koegh plan or a corporate pension and/or profit-sharing plan. This chapter discusses how these plans may be established and why no-load mutual funds are an ideal investment vehicle for plan assets.

KEOGH PLAN

The Keogh plan was named after the legislator who sponsored the Employment Retirement Act of 1962. This bill was favorably modified by the Employment Retirement Income Security Act of 1974, which is commonly referred to as ERISA, and was once again modified by the Economic Recovery Tax Act of 1981.

Eligibility

To be eligible for a Koegh plan you must (1) work for yourself, (2) be unincorporated, and (3) file for self-employed social secur-

ity. However, you are not precluded from establishing a Keogh plan if you derive income from self-employment, even though you are an active participant as an employee in your employer's corporate retirement plan. For example, an individual energetic enough to work as an accountant for a corporation during the day and run a private accounting practice during the evening could set up a Keogh plan for the income earned in his own accounting business.

Contributions

You may be wondering how much money can be contributed to a Keogh plan each year. The answer is any amount you want with a maximum limit of $15,000 or 15 percent of self-employment income, whichever is less (prior to the 1981 reform the limit was $7,500). Whatever monies are contributed to the fund are paid in pretax dollars. In other words, Keogh plan contributions are considered a tax deduction. In addition, the new law allows a Keogh plan participant to establish a separate IRA plan and make additional deductible contributions of up to $2,000. However, the Keogh plan participant can elect to make an additional $2,000 contribution to his own Keogh plan rather than establishing a separate IRA plan. In either case, the participant's total retirement plan contributions may be as high as $17,000.

Advantages

The Keogh plan offers the same basic advantages as an IRA account. First, you lower your current income taxes—as Keogh contributions are tax deductible. Second, you can defer any income or capital gains that you realize until you make withdrawals from the plan. Third, this deferral of taxes permits you to take advantage of the lower tax bracket you will probably enjoy during your retirement years. Fourth, a Keogh plan offers you a great deal of flexibility in managing your investments—for you need not worry constantly about the impact of taxes on your investment decisions. Ultimately all of these advantages boil down to one thing—more profits for you.

Most of the other features, advantages, and disadvantages of

IRA plans also apply to Keogh plans. One exception is that Keogh contributions may be made beyond the age of 70½.

The profit potential of a Keogh plan may be calculated by referring to Table 11-1 in Chapter 11, the same table used in evaluating the benefits of IRA plans. The only adjustment needed is to multiply the cumulative benefits in the IRA and non-IRA columns by a number representating the size of your annual Keogh contribution relative to the assumed $2,000 IRA contribution. For example, if you make a Keogh contribution of $15,000 per year, then you would multiply the amounts in the table by 7.5 (i.e., $15,000 ÷ $2,000). To illustrate, if you began making a $15,000 per year contribution at age 45 and earned 10 percent on your portfolio, you would accumulate $832,250 (7.5 × $111,500) and $307,000 (7.5 × $41,000), respectively, in your Keogh and non-Keogh savings plans.

Despite these significant benefits, very few people are apparently aware of the advantages offered by Keogh plans. According to recent statistics, less than 15 percent of eligible individuals have established such plans. The authors expect this condition to change over time as Keogh plans become better known and as better investment vehicles, such as switch funds, continue to be developed.

CORPORATE RETIREMENT PLANS

Corporate retirement plans, like Keogh and IRA plans, allow you to deduct plan contributions from your taxable income and to defer paying taxes on any income or capital gains generated by your investment.[1] The main advantage offered by these plans is that the allowed contributions, and thus tax savings, are normally far greater.

In recent years most employees have placed an increased emphasis on the retirement plan offered by their company as they have become more aware of the need to provide for their later years. This awareness is likely to come into increasingly sharp focus as people learn more about the perilous condition of the social security system! In fact, many employees are already placing greater emphasis on retirement programs in deciding which

[1]There are exceptions to the tax deductibility of employee contributions into certain plans.

job to accept. In addition, the decision of existing employees to remain with their present employer is influenced more and more by the financial incentives provided by their present retirement program.

Employers are also aware of the importance of their retirement plans. These plans have an important impact on their ability to attract good employees, to provide incentives for key workers, and to help their employees provide for retirement. However, an employer must carefully weigh the benefits from offering a superior plan with the costs, financial risks, and legal risks which are involved. As we shall soon see, these costs and risks can be reduced substantially with the use of no-load mutual funds.

Another important aspect of corporate retirement plans is the wide variety of options that are currently available. This flexibility is critical because companies operate under widely differing circumstances and often have very dissimilar reasons for establishing such plans. For example, a professional person, such as a lawyer or accountant, may have set up a plan to take advantage of the large contributions and tax benefits that are possible with defined benefit pension plans. In contrast, a small but growing company may wish to provide key personnel with a strong financial incentive to increase productivity and profits. It may therefore wish to establish a profit-sharing plan. Alternatively, a large corporation may provide a retirement plan for the primary purpose of attracting and keeping good workers. Such firms are likely to select some type of money purchase pension plan.

Obviously, the best plan for any given company depends on many factors such as the size of the company, its financial resources, the present and future prospects of the business, the types of workers employed, the salary levels of the workers, the goals of its managers, as well as many other considerations. The goal of the remainder of this section is to briefly outline some of the key factors that should be considered when first establishing a retirement plan and to discuss the desirability of no-load mutual funds as a vehicle for investing plan assets.

Establishing Your Retirement Plan

The first steps in deciding what type of retirement plan is best for your company must be a thorough evaluation of the past,

present, and likely future circumstances surrounding your business, together with a clear determination of your main goals and objectives. Since a thorough evaluation of your company and your objectives is a fairly involved undertaking, we suggest that you begin by first finding a knowledgeable pension plan consultant to assist you with your decision. A number of pension plan consulting firms, lawyers, and accountants specialize in this area and can provide you with extremely valuable guidance.

In selecting a consultant we suggest that you keep two things in mind at all times. First, realize that many lawyers, accountants, and pension consulting firms are primarily in the business to *sell* you some type of financial product, such as insurance, syndications, or load mutual funds (you should know better). We suggest that you avoid such individuals and firms entirely as they have an inherent conflict of interest. They make their money by selling you a product, not by providing you with the best possible advice. For example, many plans set up by insurance companies require you to buy large amounts of costly life insurance which you probably don't need. Such plans severely limit your flexibility and are likely to greatly diminish the overall investment success of your plan. Unfortunately, a large number of practitioners fall into this category. Second, we recommend that you make sure the consultant helping you is a true specialist in this area with a good track record of helping firms such as your own. Avoid individuals or firms where pension planning is an insignificant part of their business.[2]

A good consultant will not only help you set up the best possible plan for your company but will also help you determine the most efficient way to administer and monitor your plan over time.

Let's now turn to a brief discussion of the main plan options that are currently available. Corporate retirement plans may be broken down into two basic categories: defined contribution plans and defined benefit plans. Defined contribution plans are, in turn, divided into profit-sharing plans and money-purchase pension plans. The key features of each plan are summarized in Table 12-1.

[2]If you would like the name of a good pension plan consultant in your area, please feel free to contact Charlesworth & Rugg, Inc., 10850 Wilshire Boulevard, Suite 600, West Los Angeles, California 90024 (213-474-1055). This firm provides investment advisory services for individual and corporate clients in the areas of no-load mutual funds and market timing and is not itself involved in either pension plan formation or administration.

Table 12-1
Comparison of corporate retirement plans

(1)	(2) Defined Contribution	(3)	(4)
			Defined Benefit
Features	Profit-Sharing Plan	Money Purchase Pension Plan	Defined Benefit Pension Plan
Maximum allowable contribution	15% of participant conpensation or $45,475, whichever is less*	25% of participant compensation or $45,475, whichever is less*	Amount needed to determine the predetermined retirement benefit of 100% of compensation or $136,425, whichever is less*
Obligation of corporation to make annual contributions	Optional	Mandatory	Mandatory
Treatment of forfeitures	Added to account balances of remaining participants	Used to reduce corporate contribution	Used to reduce corporate contribution
Favored employees	Normally favors *younger* participants	Normally favors *younger* participants	Normally favors *older* participants
Administrative and setup costs	Relatively low	Moderate	Relatively high

*The figure shown is subject to cost-of-living increases.

Let's examine each plan in detail and begin with profit-sharing plans. The maximum allowable contribution to a profit-sharing plan is 15 percent of participant compensation up to a maximum of $45,475 for the year 1982. This maximum dollar contribution is subject to cost-of-living increases and will therefore be increased in coming years.

These plans provide great flexibility and relatively low risks to employers since contributions are normally optional. However, they are less favorable to participants since future contributions are uncertain, being dependent upon both the profitability of the company and a favorable decision by management. If a participant leaves the firm before being fully vested, the resulting forfeitures are added to the account balances of remaining participants, a feature which benefits long-term employees. These plans also tend to favor young employees and are usually fairly easy to administer.

A money-purchase pension plan differs considerably from a profit-sharing plan. First, the maximum allowable contribution is increased to 25 percent of participant compensation, although the same maximum dollar amount of $45,475 still applies (as of 1982). Also notice that pension contributions are a mandatory obligation of the corporation. In other words the corporation must continue to make contributions whether or not it is earning a profit. Since this can be a tremendous burden to a company during unprofitable periods, these plans should be adopted with caution by firms that experience substantial fluctuations in profitability. Another distinctly different feature is that all forfeitures are used to reduce required corporate contributions into the plan. For firms with long vesting periods and high employee turnover, this can greatly reduce the expense to the corporation. These plans also tend to favor younger employees and involve moderate setup and administrative costs.

You may also set up a combination of defined contribution pension and profit-sharing plans with the maximum combined contribution being the minimum of 25 percent of participant compensation or $45,475. Combined plans are normally adopted by firms wishing to provide both a solid retirement program and a strong incentive to increase performance and profitability.

Defined benefit plans are potentially much more beneficial than defined contribution plans since there is no dollar limit to contributions. The maximum allowable contribution to a defined benefit plan is simply the amount needed to determine a predetermined retirement *benefit* of either 100 percent of compensation or $136,425 (as of 1982), whichever is less. Imagine what you could accumulate if you contributed $50,000 per year for 20 years and earned 15 percent on your money.

The magnitude of allowable contributions depends upon actuarial computations involving the following variables: the age level of participants, the life expectancy of the participants as defined by mortality rates, the estimated future compensation level of the participants, an assumed cost-of-living adjustment, an assumed rate of return on investments, a specified retirement age, and the manner in which compensation is defined. By modifying one or more of the above assumptions, a company can significantly alter the future level of contributions and the manner in which the benefits will be shared among different employees.

While these plans offer tremendous flexibility, they can also be quite risky since the employer has a mandatory obligation to provide a specific level of future retirement benefits to its employees. As a consequence, the future level of company contributions depends, among other things, upon the actual investment performance of the portfolio relative to the assumed investment rate of return. If the portfolio earns a rate of return below the assumed rate, the company must increase its future contributions. On the other hand, if the portfolio earns a rate of return well above the assumed rate of return, then future contributions may be reduced. Obviously, good investment decisions are of critical importance.

You should also realize that employee forfeitures are used to reduce corporate contributions and that these plans tend to favor older participants. They are also somewhat more expensive to administer.

All of the above plans may be modified to provide benefits to different segments of your work force. This is normally accomplished by selecting different plan participation rules, by adopting different vesting schedules, or by integration with social security.

Participation in a corporate retirement plan may be regulated to some degree by age, years of service, and hours of work per year. Current law permits employers to restrict participation to employees over 25 years of age, to those employees with over one year of service, and to persons who work at least 1,000 hours per year. The intent of the law is to limit participation to key long-term employees. Thus, it is possible to exclude part-time workers and workers with high history of job turnover, namely, those under 25 years of age and those with less than one year of service.

It is also possible to choose a wide variety of vesting schedules—although the range of options has been restricted by recent pension reform legislation. At the present time, an employer may elect to have all employer contributions vest immediately, an option clearly in the best interest of the employee, but must allow for complete vesting no later than 15 years into the future. This 15-year vesting is only permitted if partial vesting begins no later than 5 years into the future and increases steadily to the 15th year. Later vesting will benefit employers with money purchase pension plans or defined-benefit plans because forfeitures will be greater. For profit-sharing plans, later vesting benefits the remaining participants, individuals who are frequently key employees or owners of the corporation.

An employer may also elect to have a money-purchase pension plan or a defined-benefit pension plan integrated with social security. This simply means that corporate contributions are intended to augment the benefits provided by the social security system. The main impact of integration is to greatly reduce or eliminate company contributions for employees with low-income levels and to provide maximum benefits for higher paid employees.

Once you have determined the best type of plan to establish for your company, you must draft a plan document, seek approval by the Internal Revenue Service, and provide for an efficient ongoing administration of your plan. Your pension plan consultant should be able to assist you with each of these tasks so that you obtain the best possible individualized plan and the most efficient on going administration services. Fees for these services vary depending upon the number of persons in the plan, the type of plan, and the activity of plan participants. Annual fees for single employee defined contribution plans normally begin in the area of $300 to $400 per year. While no one likes to pay fees, the time

and effort involved in attempting to do this by yourself would probably make these fees look like a bargain.

A second option is to use a prototype plan offered by a no-load mutual fund. As you might suspect, most no-load mutual fund organizations restrict your investments to their own funds, a limitation that is quite serious since it greatly reduces your investment flexibility and hence your ability to invest plan assets in the best performing no-load mutual funds. This will almost certainly limit your future investment performance and thus impair the overall success of your plan. Moreover, most no-load funds do not offer defined benefit pension plans which are likely to be of primary interest to many firms. In the authors' opinion, most corporations will do far better by establishing a personalized retirement plan.

One final caveat must now be mentioned. New legislation has been introduced in congress which could significantly alter the allowed contributions and operations of pension plans for certain corporations. You should carefully discuss these or any other proposed law changes with your pension plan consultant before making a final decision on your retirement plan.

Investing Plan Assets

Once you have established your corporate retirement plan, the next step is to select a specific investment objective for your plan. Since the assets in most corporate plans are intended to provide for the retirement of your employees, you will probably want to be reasonably conservative with your investments. Another factor arguing for a fairly conservative objective is that your plan probably includes individuals with varying attitudes toward bearing risk. Under such circumstances it is usually wise to choose a fairly conservative investment program.

An equally compelling reason is that the trust advisory committee for your plan, which is usually composed of key employees, has a fiduciary responsibility to make "prudent" investment decisions. This so called "prudent man doctrine" was laid out in the Employment Retirement Income Security Act of 1974 (ERISA). Unfortunately, the act does not clearly define what the term prudent means, a fact that has created a good deal of confusion with the investment community. However, one thing is quite

clear—individual trustees can be sued personally for making imprudent decisions. This ambiguous situation, together with the underlying fiduciary risk, means that you should be quite careful about selecting your investment objective.

While the above considerations argue for a more cautious posture, you must not lose sight of the fact that retirement plans normally have a very long-term time horizon. As a consequence, a primary consideration must be to earn a rate of return high enough to stay ahead of inflation.

An abundance of historical information reveals that over the long run most common stocks and equity mutual funds have been one of the best possible hedges against inflation. On average they have far outperformed bonds, money market instruments, commodities and, yes, even real estate. With proper investment selection and the careful use of market timing, common stocks offer the potential to far exceed the inflation rate as was clearly demonstrated in the market experiment presented in the last chapter.

It is critically important for you to balance the need to limit investment risks with the reality that you must bear some risk to stay ahead of inflation. For most retirement plans the logical risk objective would probably be either growth or growth with income, although other possibilities are certainly not precluded.

The investment approach suggested in this book is especially attractive for retirement plans. It not only offers the potential for excellent long-run performance results as was demonstrated in Chapter 10, but it also provides an additional benefit that should be of vital interest to a trustee concerned with fiduciary risks under the "prudent man doctrine"—it reduces these risks substantially.

Perhaps the most important risk reducing feature is that any no-load fund passing our screening process must be *diversified*. Diversification, as was discussed at length in Chapter 3, enables you to greatly reduce investment risks. In addition, diversified investments are more predictable for timing purposes, since they tend to track market cycle more closely than do nondiversified investments.

A portfolio of several no-load mutual funds further increases diversification as you would probably be holding indirect positions in from 150 to 300 individual common stocks. In contrast, a typical investment counselor or bank trust department cannot

begin to offer the same type of diversification due to high transaction costs and the limited number of issues which they usually approve for purchase. It is hard to imagine that a company using diversified no-load funds would ever be criticized for failing to provide adequate diversification. This is definitely not the case for many existing retirement plans, a fact that is unfortunately not clearly understood by many well-meaning trustees.

In addition to reducing fiduciary risks through broad diversification, no-load funds offer additional safety features. First, no-load mutual funds are tightly regulated by the Securities and Exchange Commission.[3] Under these regulations they must publically disclose a great deal of information not required of bank trust departments, investment counselors, syndicators, insurance companies, and others. Perhaps most important, they must provide accurate past performance data and daily net asset value quotations. A fiduciary can therefore carefully scrutinize the past and present performance of a no-load mutual fund.

Most other institutions do not publish their overall track records in a way that leads to clear comparisons. For example, performance results are frequently presented for the *past* experience of all *current* clients rather than the *actual* performance experienced by *all* past clients. This can be quite misleading even though it may sound reasonable on the surface. To illustrate, assume that an investment counselor had 100 clients last year, that the top 50 earned 30 percent but that the bottom 50 lost 10 percent and subsequently left the investment counselor. If you show the past results of current clients, it is +30 percent, since the dissatisfied losers are no longer with the firm. This would obviously be a gross distortion of true past performance, which was only 10 percent.

There are also a number of statistical techniques and definitions of performance that can produce misleading comparisons of actual results. To illustrate, assume that your investment of $10,000 goes up by 100 percent and then falls by 50 percent. It follows that your portfolio went from $10,000 to $20,000 and back to $10,000, providing you with a zero rate of return. However, if you use an arithmetic average rate of return, you compute the

[3]This, of course, is not true for foreign or "off shore" funds.

average return to be plus 25 percent $\left(\dfrac{+100\% - 50\%}{2} = +25\%\right)$.
This number is clearly misleading, especially if you are comparing it with a number computed in the proper way.

These types of problems are completely avoided with no-load funds since the SEC requires that all performance data be computed on a fair and comparable basis. Why not be sure that you know that you're getting by dealing with a no-load mutual fund.[4]

No-load mutual funds also protect you from other potential violations of the "prudent man rule." More precisely, you need not worry about being criticized for not securing the best commission discounts, for not obtaining the best executions or for churning the account because you pay *no commissions* when buying a no-load fund and everyone buys and sells a no-load mutual fund at the same price (the net asset value of the fund at the close of the business day).

In summary, it is unlikely that fiduciaries could be criticized for investing in a well diversified no-load mutual fund with a superior past track record, provided that the fund has an investment objective consistent with the one set out by your plan.

However, if you are planning to switch funds from time to time along the general lines recommended in this book, you may want to consider retaining an investment advisor or investment counselor to further reduce your fiduciary risk. While you probably run minimal risks by purchasing no-load funds, you definitely will subject yourself to some risk if you make market timing and fund switching decisions. This is especially true if you are not skilled in this area. Most pension plan trust committees recognize this fact and do seek outside investment advice. All that you need to do is make sure that your advisor is an expert in the areas of mutual funds and market timing.

One final point should be mentioned concerning corporate retirement plans. If you have been an active participant in most corporate retirement plans and you terminate employment for any reason, you may establish an IRA Rollover account. By establishing such a plan you may move all your vested benefits to any

[4]Incidentally, bank-polled funds are not regulated by the SEC and may not be directly comparable to no-load funds.

organization with an approved IRA Rollover plan—such as a family of no-load mutual funds. In fact, you can remove the money from your prior plan and invest it in more than one family of no-load mutual funds. As a result you will be able to determine how your money is invested and, if you wish, to participate in the investment program recommended in this book. If you are approaching retirement or considering changing jobs you should give this careful consideration.

TRUSTS

No-load funds are also excellent investment vehicles for trusts that have been set up to limit or defer paying taxes or to avoid probate. For example, no-load funds are an ideal vehicle for trust funds established for the benefit of children or other family members. They can greatly reduce the burden and responsibility of making investment decisions, a factor that may be of vital importance to a busy executive or a retired person who travels frequently.

No-load funds are also excellent investment vehicles for use in charitable unitrusts (and other charitable trusts) established by tax exempt charitable institutions. In addition to providing an initial tax deduction, these trusts provide the donor with a life-long stream of income which is usually based upon a fixed percentage of the future *market value* of the portfolio of assets which they donate. Upon their death, all the remaining assets in the trust go to the selected charity.

Most people establishing such a trust are not only concerned about donating the remainder interest in the trust to a worthy charity but are also concerned about the investment performance and tax treatment of the trust distribution which they receive during their lifetime. The better the long-run performance of the trust, the greater their future income will be and the larger their ultimate gift to their chosen charity. Furthermore, if growth funds are selected, most of their income payment will be taxed as long-term capital gains—a decidedly beneficial tax advantage. Unfortunately, many such trusts established by universities, religious organizations, and foundations have invested their assets primarily in bonds with two unfortunate consequences. First,

bonds have performed very badly and have eroded the real corpus of the trust and, hence, the income real stream of the donor. Second, annual payments to the donor are taxed unfavorably as ordinary income—not as long-term capital gains. If you plan to establish such a trust, be sure to select a sensible investment objective and make sure your charity will manage your donation wisely, perhaps using no-load mutual funds.

There are many other excellent uses for no-load mutual that space does not permit us to address. We must simply conclude by wishing you the best of luck with your future investing.

Index